IMAGES
of Rail

BROOKLYN STREETCARS

IMAGES
of Rail

BROOKLYN STREETCARS

Branford Electric Railway Association

ARCADIA
PUBLISHING

Published by Arcadia Publishing
Charleston, South Carolina

Library of Congress Catalog Card Number: 2007935340

For all general information contact Arcadia Publishing at:
Telephone 843-853-2070
Fax 843-853-0044
E-mail sales@arcadiapublishing.com
For customer service and orders:
Toll-Free 1-888-313-2665

Visit us on the Internet at www.arcadiapublishing.com

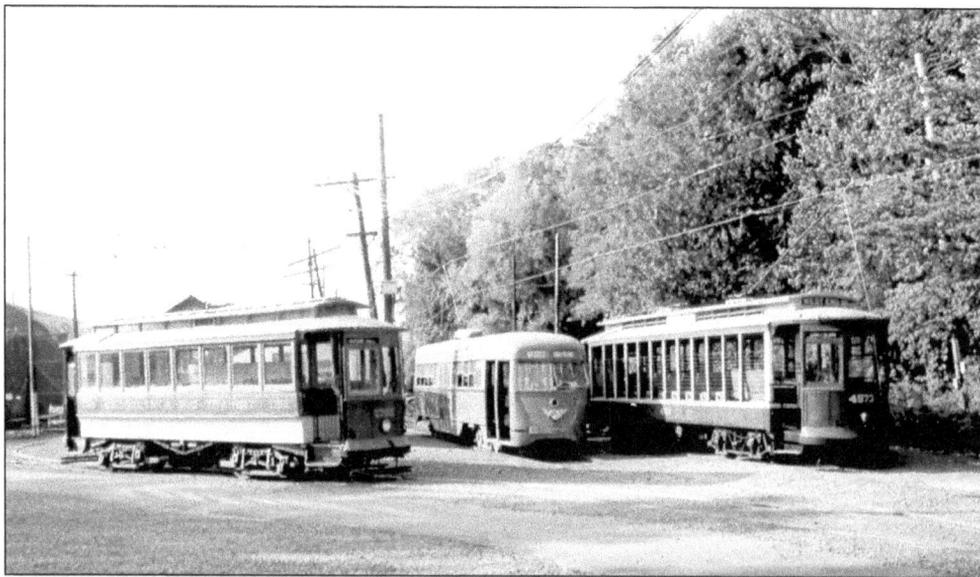

Brooklyn streetcars are shown in service in September 2007. No. 1792 (Laclede Car Company, 1898), No. 1001 (St. Louis Car Company, 1936), and No. 4573 (Laconia Car Company, 1906) operate at the Shore Line Trolley Museum in Branford, Connecticut. (Mike Schreiber photograph.)

CONTENTS

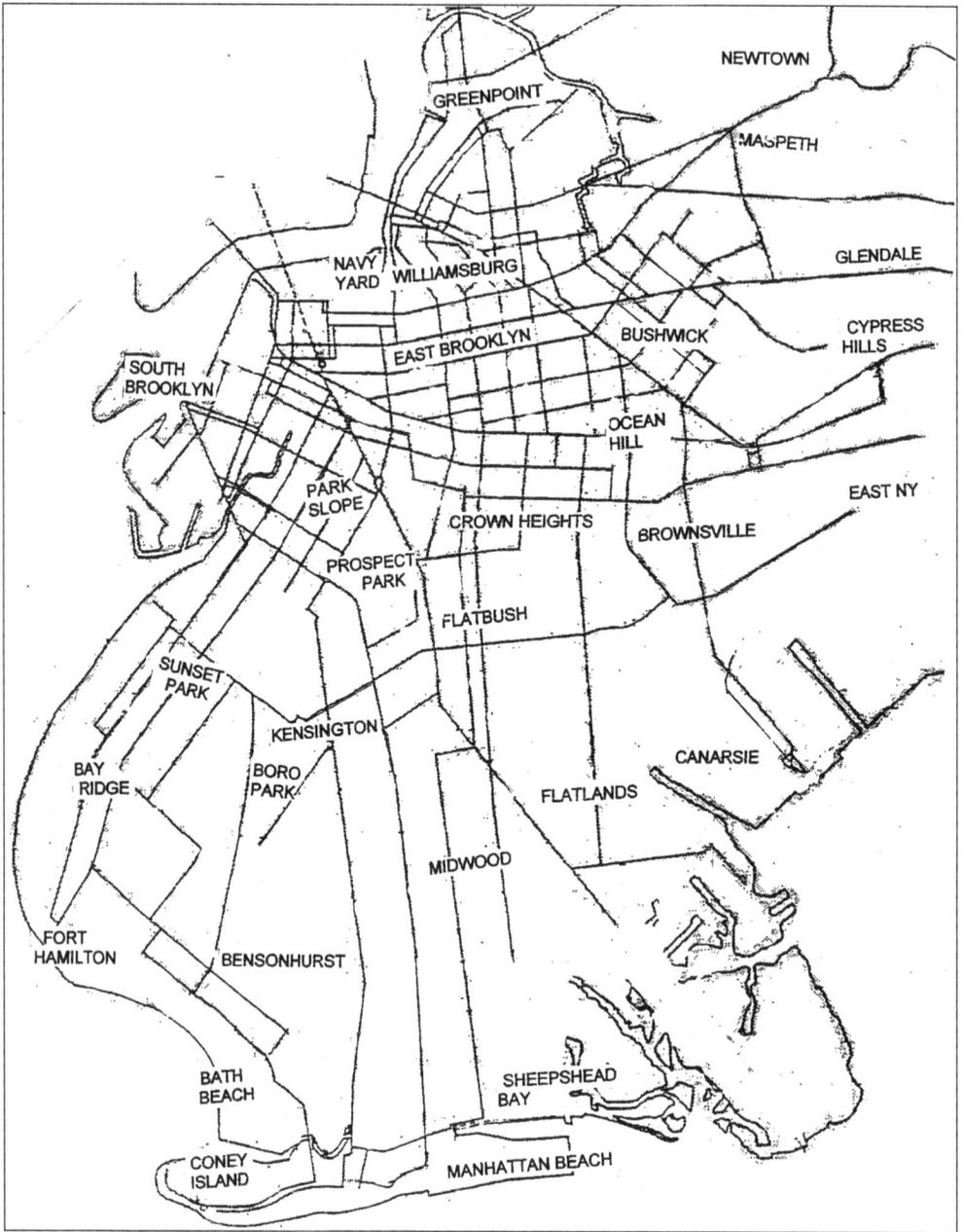

Pictured here is a map of Brooklyn.

INTRODUCTION

We would like to show you Brooklyn and its streetcars. For 102 years, from 1854 until 1956, the cars served the city and borough with several extensions into Manhattan and Queens. This was the Brooklyn Rapid Transit Company, its subsidiaries, and its successors—the Brooklyn-Queens Transit Corporation, New York City Board of Transportation, and New York City Transit Authority.

The photographs in this book are laid out along Brooklyn's car lines. They start in downtown, head south to Gravesend Bay and Coney Island, proceed north through the center of Brooklyn, go east a short way into neighboring Queens County, then come back into Brooklyn and down to Jamaica Bay. Enlargements of a mid-1930s Brooklyn-Queens Transit map are included to guide you on your journey. The only alteration made to the maps was the insertion of street names.

The railway did not just serve these streets. It served the people who lived, worked, and visited these streets. Most of the pictures included in this book show the people, buildings, clothes, automobiles, and other features of daily life at the time the photographs were taken. We also hope to illustrate some of the changes that took place in these communities over the years.

Having stated what we intend to do in this book, we should also tell you what we are not trying to do. It is impossible to present a meaningful history of trolley lines without examining the history of the places through which they ran, so we are not preparing a chronology of the local streetcar operation. Neither have we prepared an illustrated roster of the street railway equipment used in the area. Some facts about the cars, neighborhoods, structures, or companies shown will be included in the captions.

Our objective in compiling this book is to raise funds for the rehabilitation of Brooklyn Rapid Transit elevated car No. 197 at the Shore Line Trolley Museum. The photographs come from the collection of the late Edward B. Watson, former museum president and trustee, and Arthur J. Lonto, former museum trustee (shown as EBW/AJL); the collection of Frank Pfuhler, No. 197 project director (shown as FP); and the Branford Electric Railway Association Library collection (shown as BERA).

We realize that some readers may desire more information than could possibly be included in a 128-page book. The museum staff would be pleased to provide additional data, if available. Contact us at the Shore Line Trolley Museum, 17 River Street, East Haven, Connecticut 06512. Meanwhile, enjoy your trolley tour of Brooklyn.

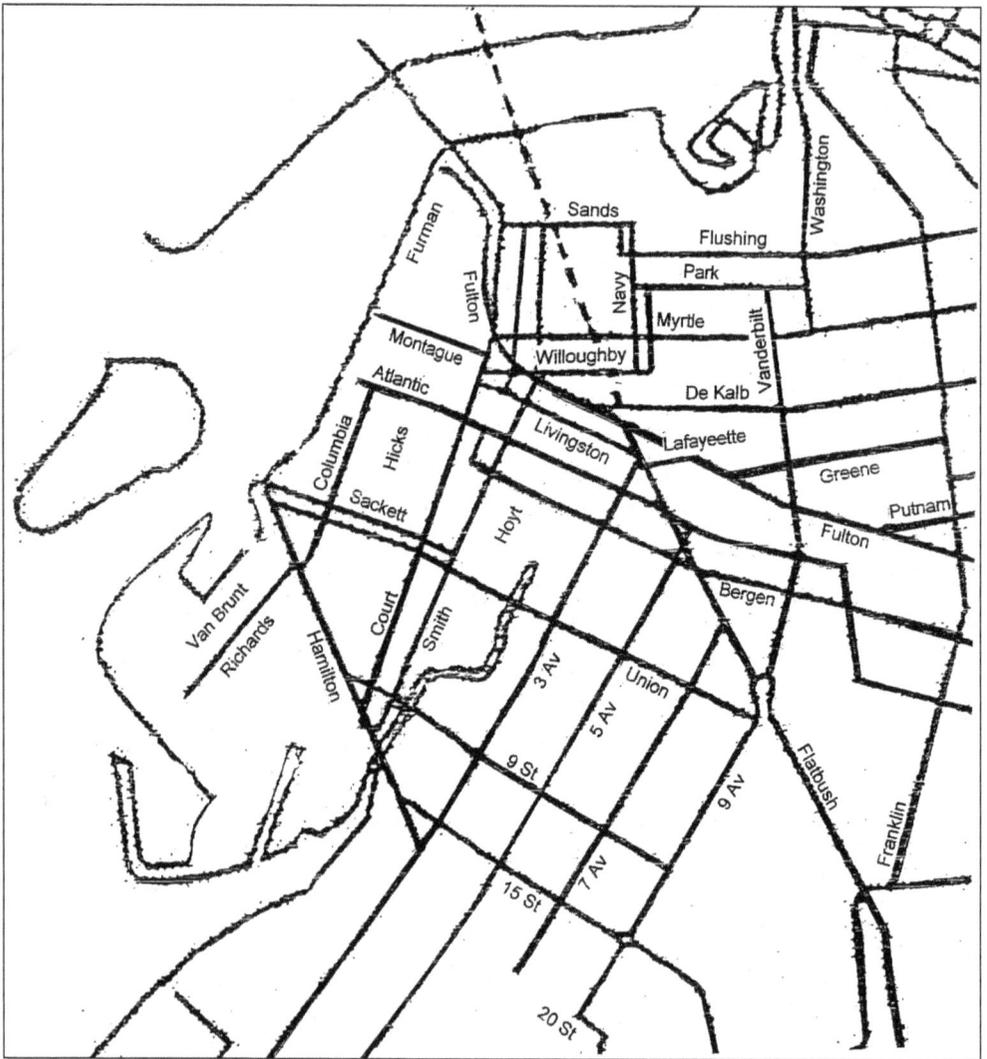

This map details the town of Brooklyn, including downtown, South Brooklyn, Gowanus, and Park Slope.

One

THE TOWN OF BROOKLYN

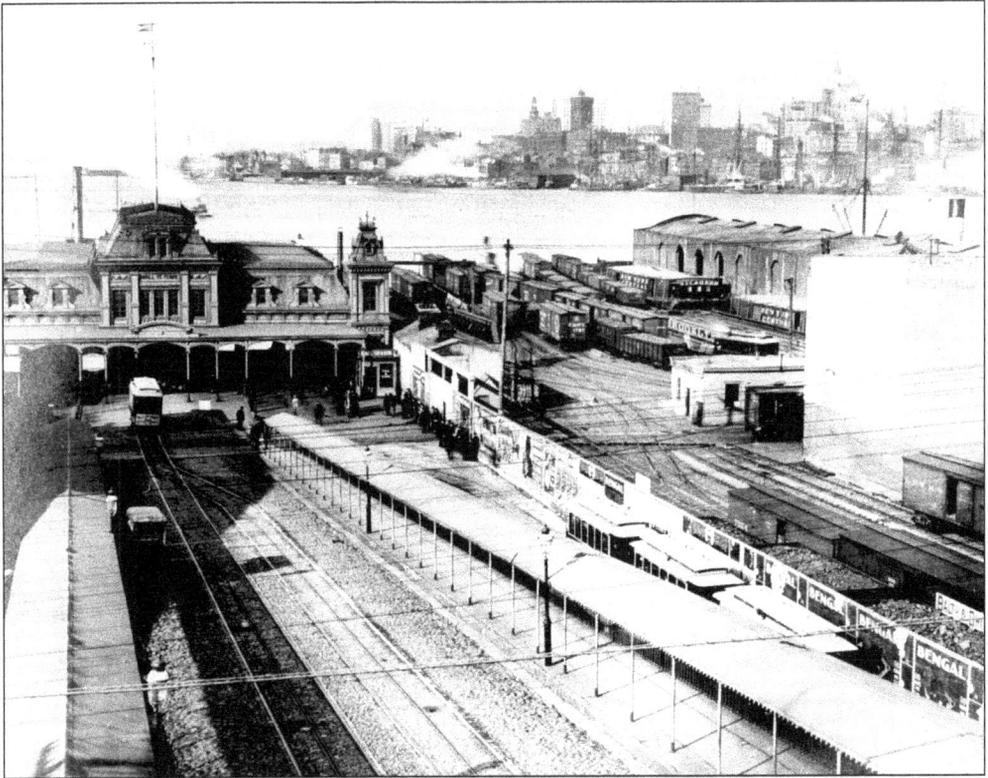

Cable car No. 5 waits in front of the Wall Street ferry building at the foot of Montague Street on November 24, 1899. The half-mile line up a 9.5-percent grade from the ferry to Court Street opened on July 20, 1891. It was built by the Brooklyn Heights Railroad, which, through its subsidiaries, ultimately controlled nearly all the electric railways in Brooklyn. Three extra cars not in service are stored on the track on the north side of the line to the right of the covered walkway. (EBW/AJL.)

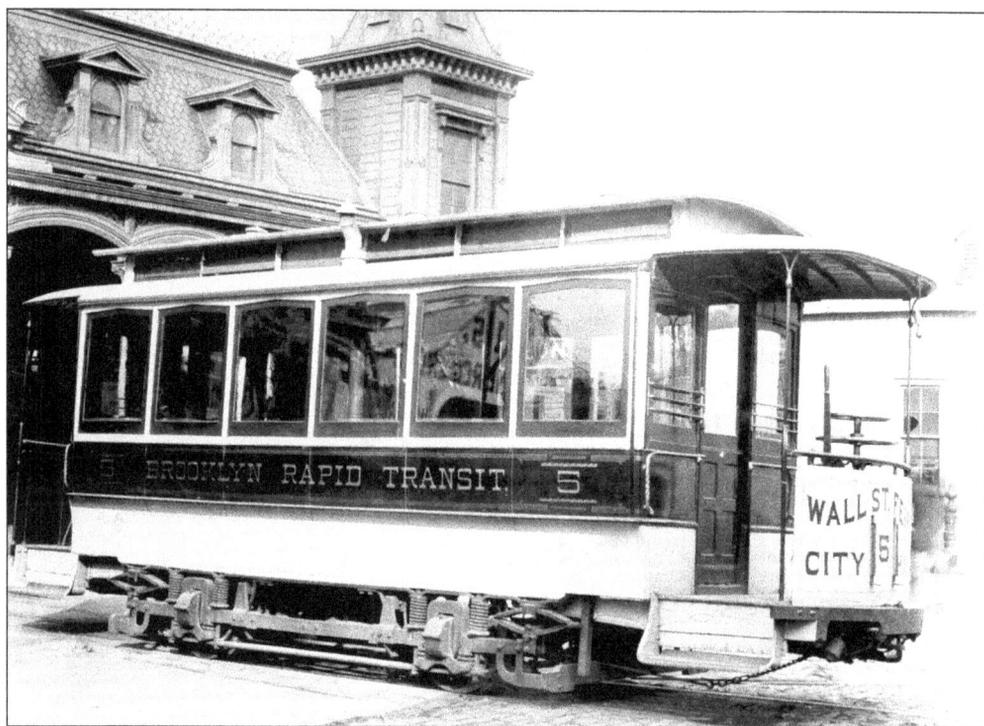

Montague Street cable car No. 5 is at the Wall Street ferry on November 24, 1899. Cars No. 1–5 were built, like most of Brooklyn's early electric cars, by the Lewis and Fowler Manufacturing Company owned by Daniel Lewis, president of the Brooklyn Heights Railroad. Inside were plush seats, a coal stove for heat, and oil lamps for illumination. (EBW/AJL.)

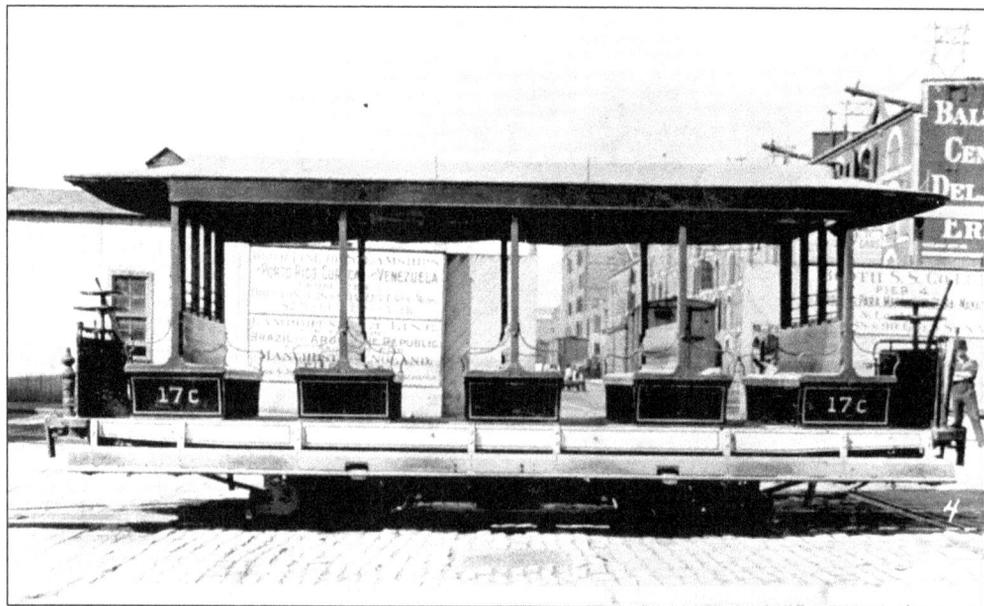

This side view of Montague Street open cable car No. 17C was taken in 1905. The horizontal wheels on the front platform controlled the grip that engaged the wire cable moving through the vault beneath the street. All six open cable cars were scrapped in 1917. (EBW/AJL.)

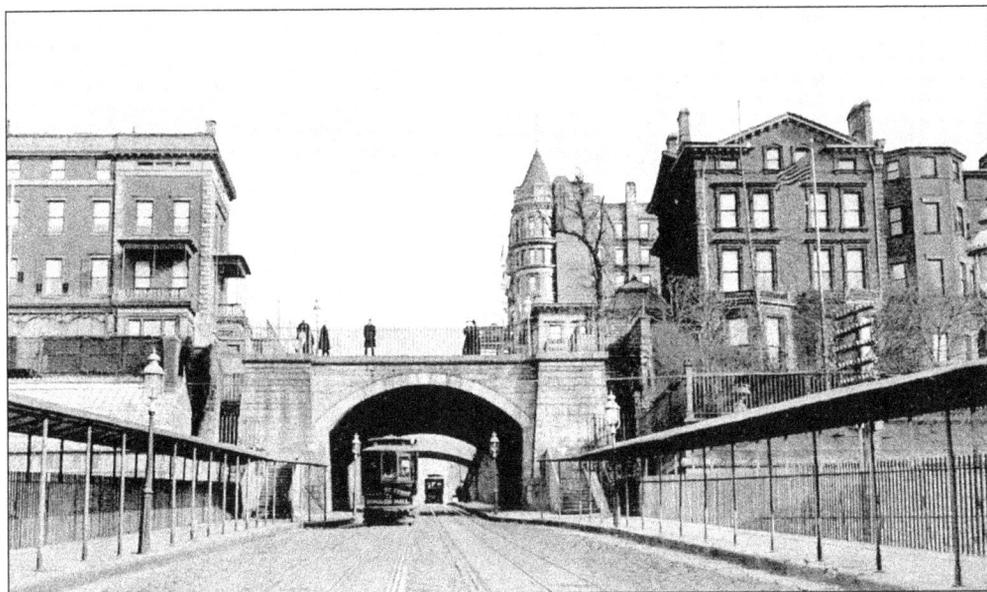

A cable car on Montague Street passes under the Hicks Street arch in 1907. When the Interborough Rapid Transit Company (IRT) subway was extended to Brooklyn in 1908, traffic on the Montague Street line declined by more than 65 percent. Nevertheless, the line was electrified on September 25, 1909. After the Wall Street ferry ceased operation on July 28, 1912, the line was cut back to Hicks Street. Operation continued until May 18, 1924. (EBW/AJL.)

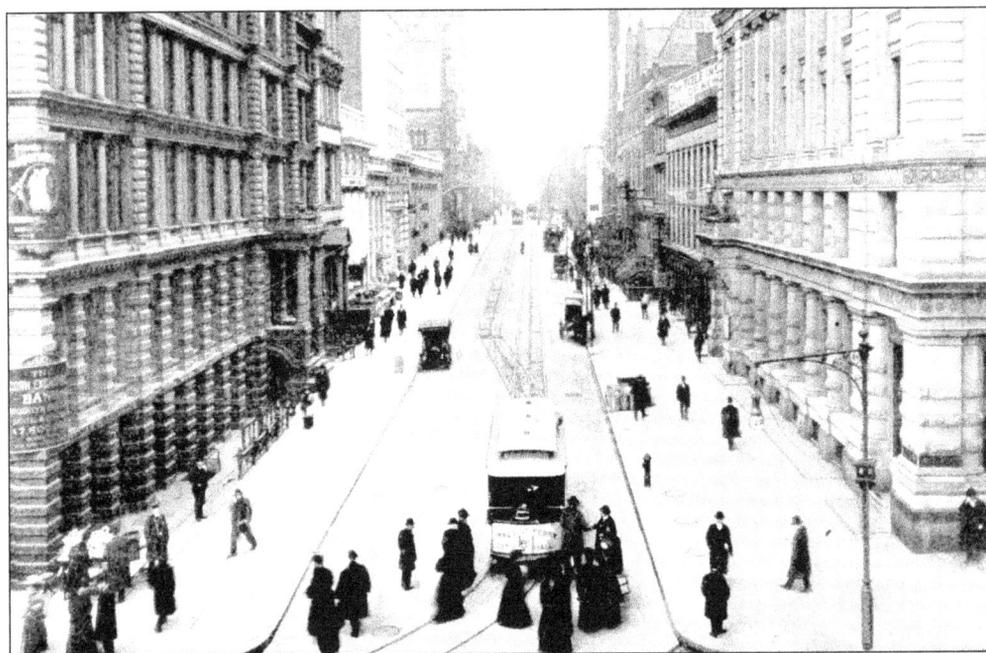

Cable car No. 8C is at the Court Street end of the Montague Street line in 1904. The track in the foreground without a conduit slot was the sole connection between the cable line and the rest of the Brooklyn trolley system. A streetcar towed cable cars with the grip removed to the Fifty-eighth Street depot for repairs and servicing. (EBW/AJL.)

11

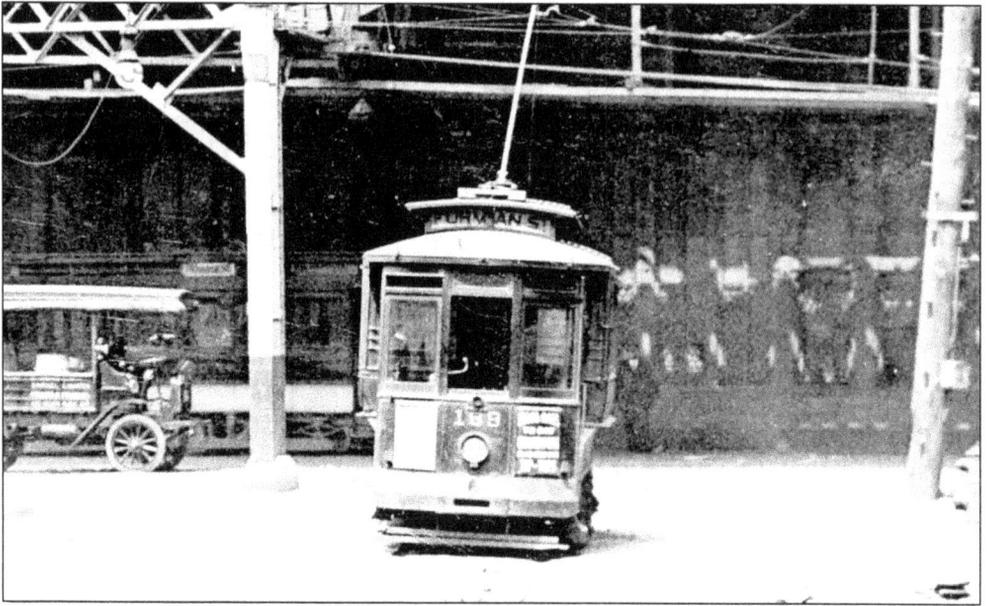

No. 189, built by St. Louis in 1893, emerges from under the elevated at Fulton Ferry on May 20, 1914. Horsecars first used Furman Street in 1860, going to South Ferry at Atlantic Avenue, then down Columbia Street to Hamilton Ferry. Along the way, they passed the Pierpont stores (warehouses) full of sugar and molasses, the Woodruff and Robinson stores holding guano and fish, and the Deforest stores with hides and wool. Electrified in 1894, the little-used line was eliminated in 1899 and revived from May 31, 1912, to April 23, 1915, with similar unprofitable results. (EBW/AJL.)

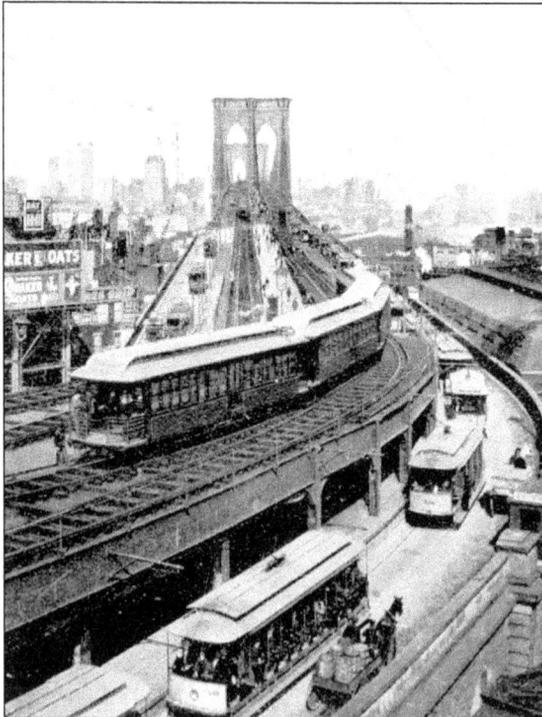

Cable-hauled trains, trolleys, and wagons appeared on the Brooklyn Bridge shortly after streetcars began crossing the span in 1898. Within a few years, the competing Union Ferry Company's passenger traffic declined by over 60 percent. (EBW/AJL.)

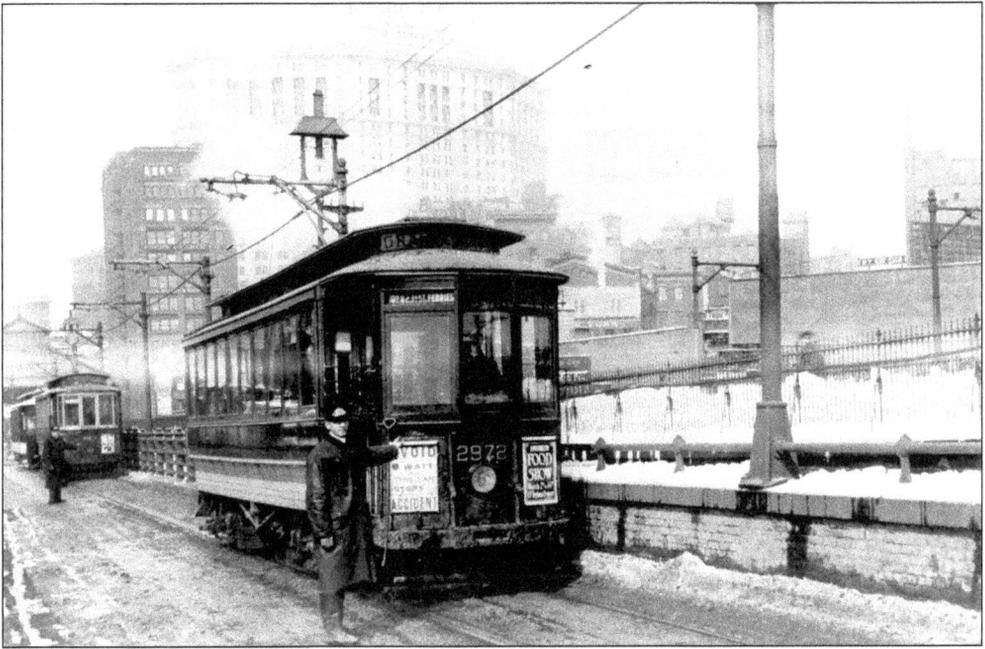

The conductor of Graham Avenue No. 2972 poses at the head end of a line of cars on the Brooklyn Bridge in 1914. The maximum number of trolleys operated on the span was 280 per hour, which meant that in rush hour there was a car every 102 feet moving at 7.8 miles per hour, providing a 13-second headway. (EBW/AJL.)

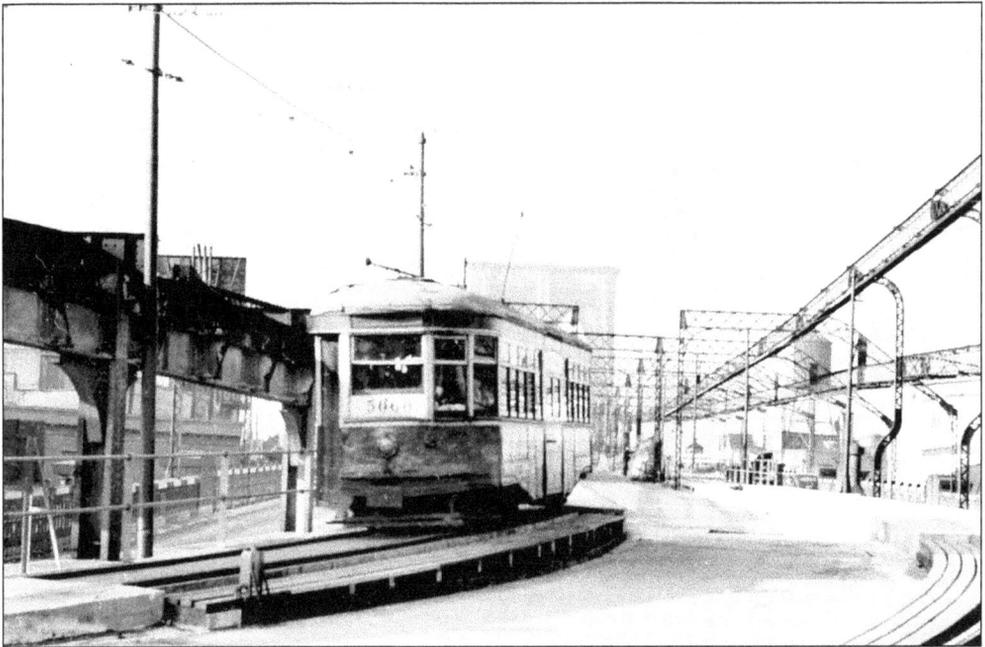

Car No. 5060 is seen coming off the Brooklyn Bridge in 1945. Surface lines using the bridge at various times included Bergen, Court, DeKalb, Erie Basin, Flatbush, Flushing, Flushing-Knickerbocker, Fulton, Gates, Graham, Myrtle, Putnam, Ralph-Myrtle, Seventh, Smith, Third, Vanderbilt, and Wilson Avenue–Brooklyn Bridge. (EBW/AJL.)

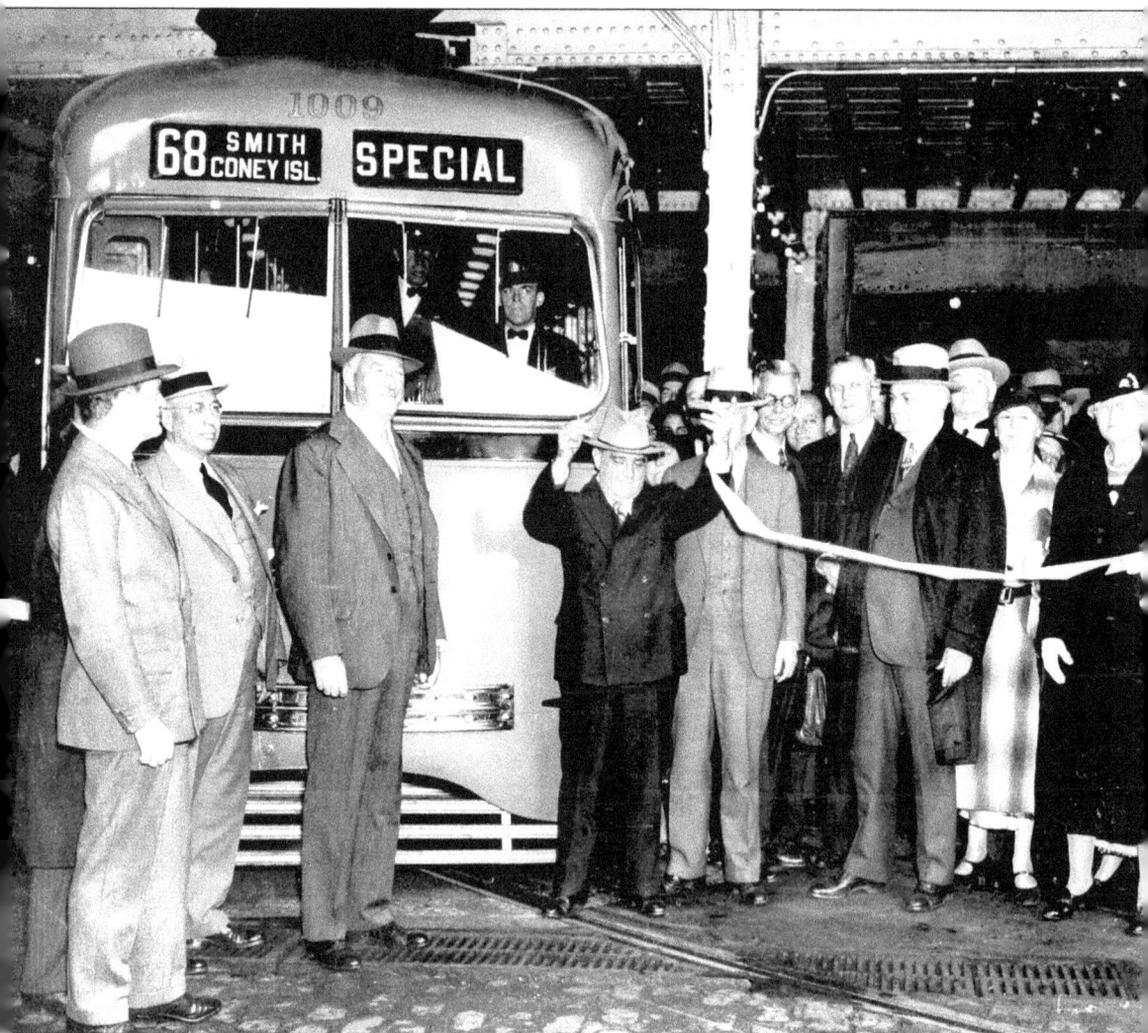

Mayor Fiorello LaGuardia cuts a ribbon on November 1, 1936, to inaugurate Presidents' Conference Committee (PCC) service on the Smith Street–Coney Island Avenue line. PCC was the agency responsible for designing and developing these vastly superior modern streamlined streetcars. Most of the field testing of the equipment for the streamliners was done in Brooklyn. (BERA, World Wide Photos.)

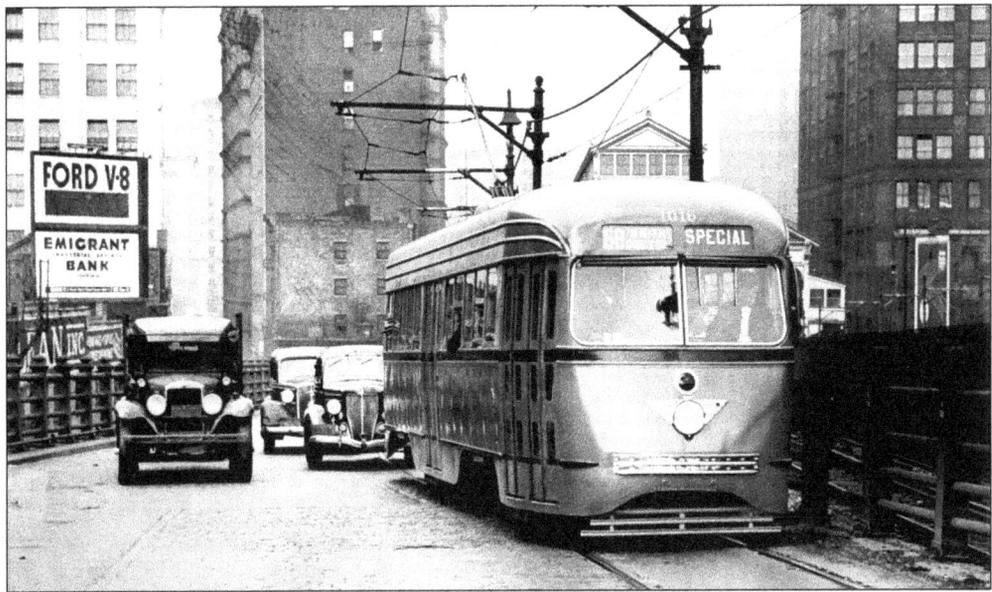

No. 1016, leaving Park Row, Manhattan, shares the road with cars and trucks. Of all the people who crossed the Brooklyn Bridge during the first half of its life, over 90 percent used public transportation. Cable car and train service began on September 24, 1883, and continued until January 27, 1908. Elevated lines ran over the bridge in 1888–1899 and from 1901 to 1944. Streetcars operated over the bridge from January 23, 1898, until February 11, 1951. (BERA, Don Harold collection.)

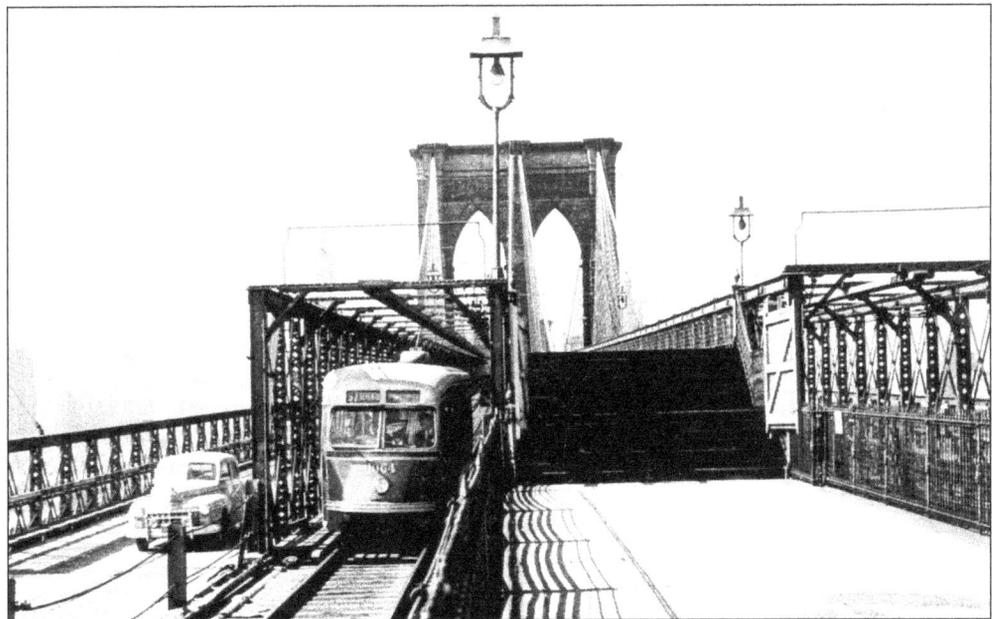

PCC No. 1064 is seen on the Brooklyn Bridge sometime after elevated trains were removed from the bridge and the streetcars were shifted to the reserved tracks on December 16, 1944. At a time when teamsters drove a real team of horses, the animals were regularly overworked, and it was common for horses to collapse and die on the steep grade going up onto the span. Hours could pass until a carcass was removed and the roadway reopened. (BERA.)

15

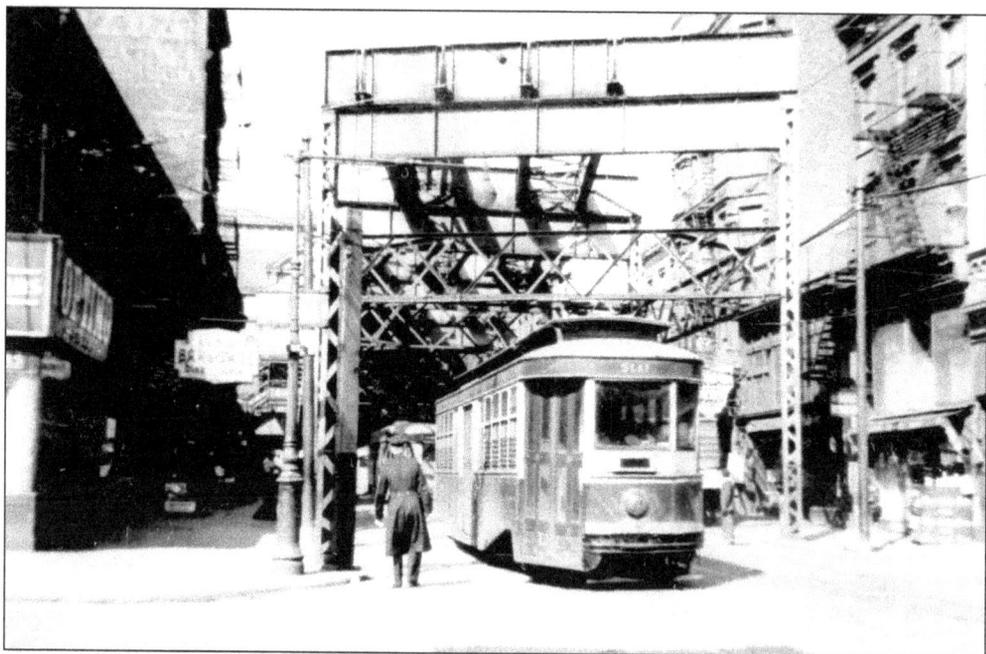

Graham Avenue No. 5141 at Sands and Adams Streets has just come off the Brooklyn Bridge on April 3, 1943. Husted and Kendall's stagecoaches from Fulton Ferry to the Franklin Hotel at Broadway and Myrtle Avenue served most of this route along Flushing Avenue before being replaced by the horsecars of the Brooklyn City Railroad in 1855. (EBW/AJL.)

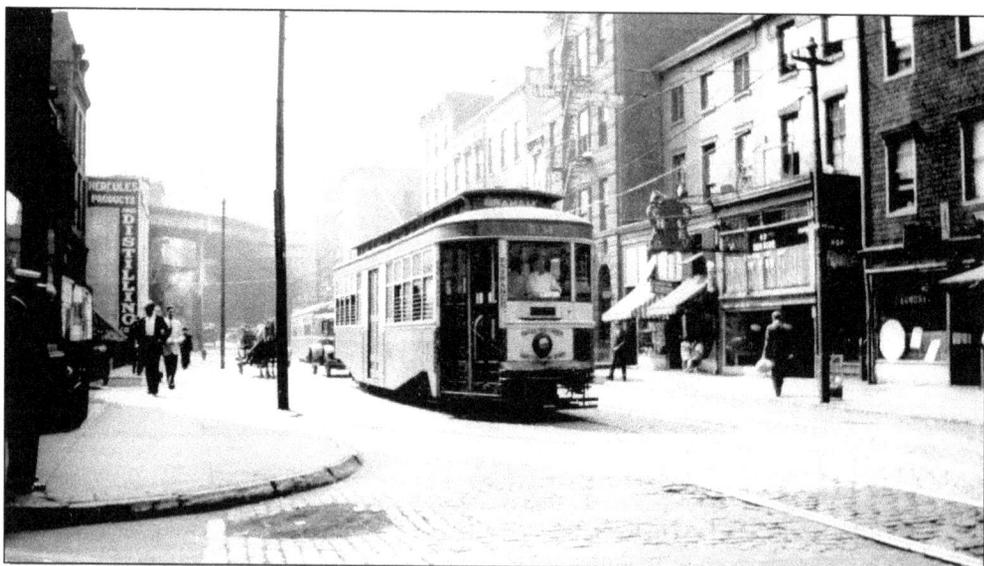

Graham Avenue No. 5134 is seen heading east on Sands Street toward the Brooklyn Navy Yard in August 1935. It runs past the blocks of bars, brothels, boardinghouses, and navy uniform shops that lined the main street of Brooklyn's former red-light district. (EBW/AJL.)

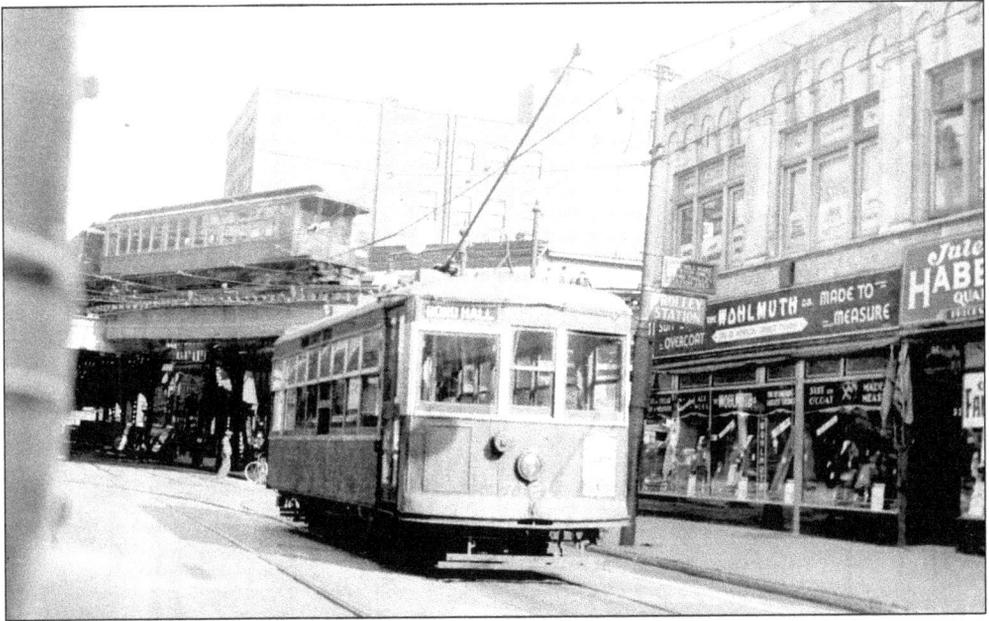

Safety car No. 7121 is on the Greenpoint line at Adams Street and Myrtle Avenue in 1924. One-man cars with interlocking safety features are often called Birney cars after Charles O. Birney, master mechanic of the Stone and Webster Engineering Company. Birneys ran on Brooklyn's lightly used lines until the 1930s. (EBW/AJL.)

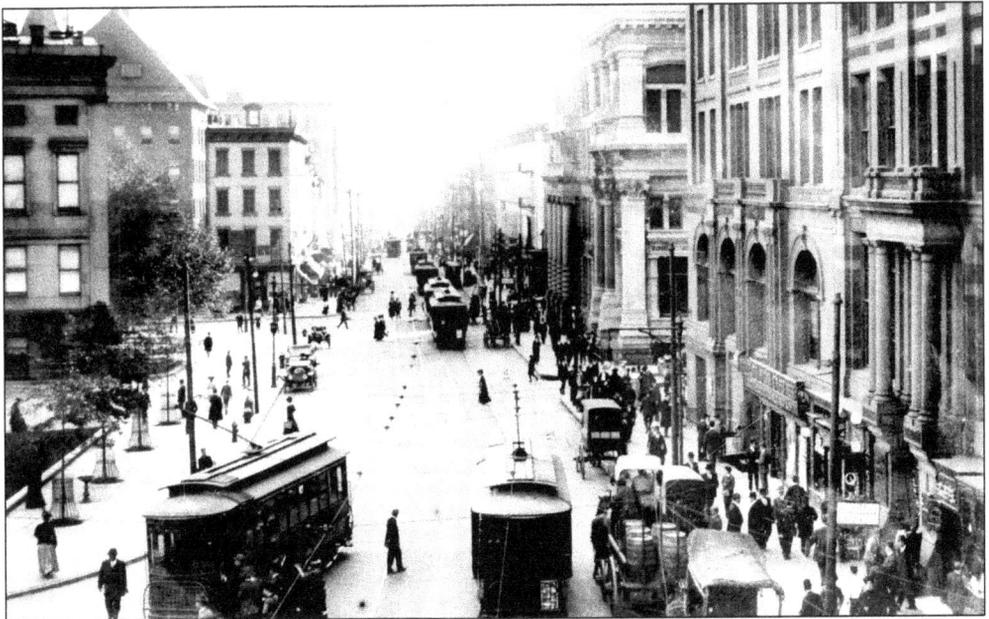

Cars of several lines passed Brooklyn Borough Hall on Court Street. Originally called George Street, its name was changed when the Town of Brooklyn offered a site for a new courthouse to replace the old Colonial courthouse at the county seat in Flatbush. The new courthouse, however, was built around the corner on Joralemon Street. This is a 1908 view with the car on the left coming off the loop around borough hall. (EBW/AJL.)

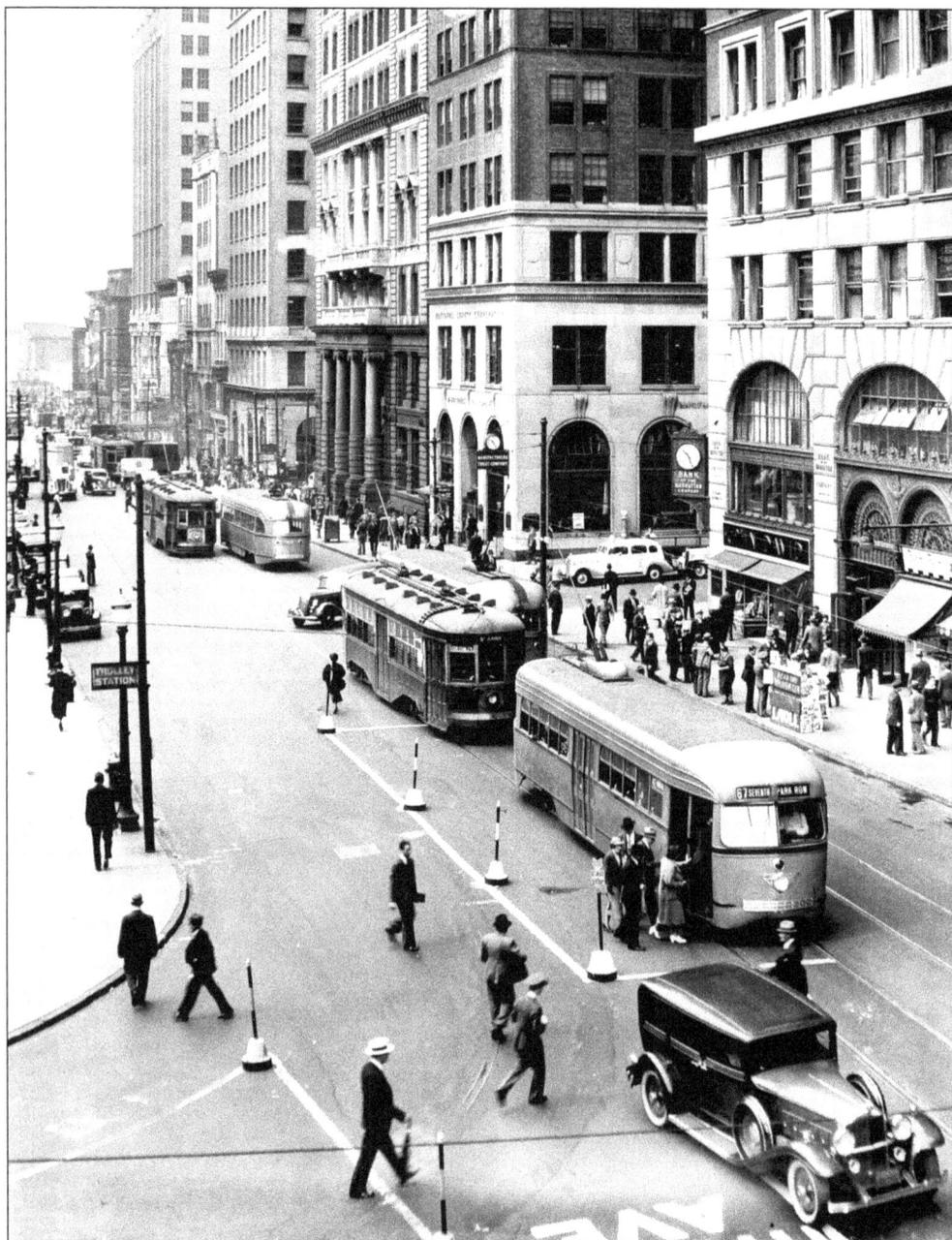

A Manhattan-bound PCC car loads passengers on Court Street near Montague Street followed by a St. Johns car heading for Fulton Ferry. This pre–World War II view is after September 13, 1937, when the St. Johns line was extended to the ferry. Three more streetcars are visible beyond Remsen Street. The out-of-service third track in the foreground looped around borough hall via Fulton Street. (BERA, Don Harold collection.)

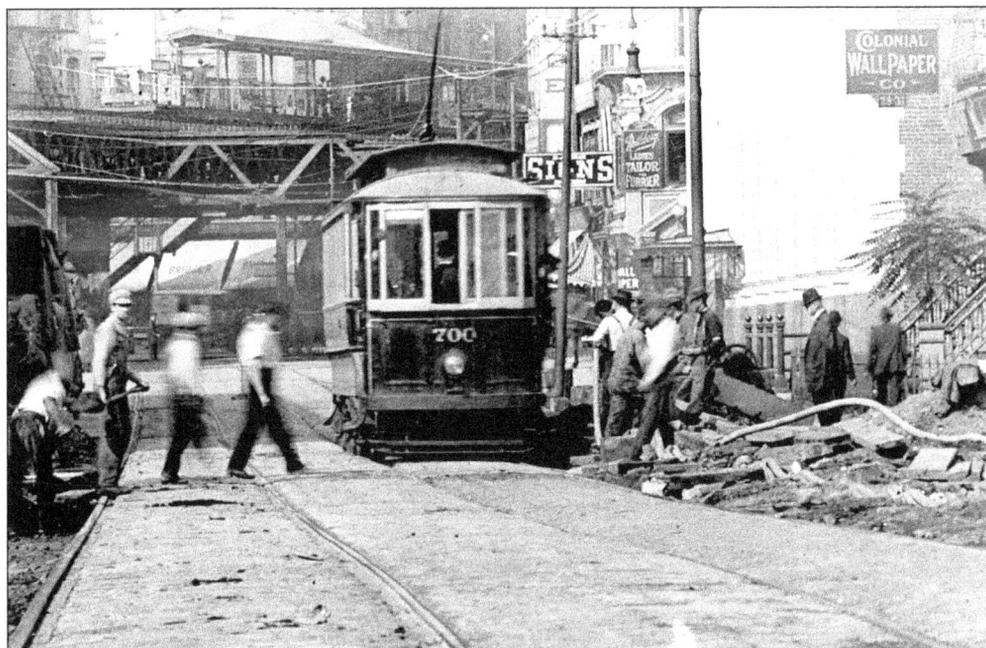

Coney Island and Brooklyn Railroad No. 700 is on DeKalb Avenue at its junction with Fulton, Gold, and Bond Streets on September 28, 1912. During the vaudeville era, Edward Franklin Albee built his namesake theater at this location, which became Albee Square. DeKalb cars continued down Fulton and Washington Streets and either turned onto the Brooklyn Bridge at Sands Street or, until 1925, went to Fulton Ferry via Front Street. (EBW/AJL.)

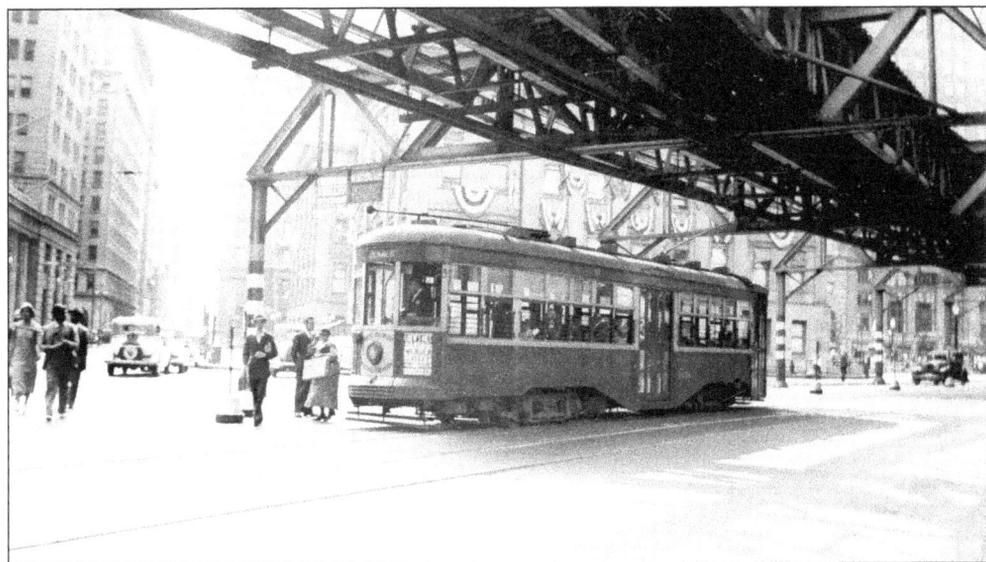

DeKalb Peter Witt car No. 8436 is at Fulton and Joralemon Streets on July 4, 1936. A Peter Witt is a streetcar built under patents held by Peter Witt of the Cleveland Railway. In the beginning, a motorman ran the car, and a conductor moved up and down the aisle or along the running board collecting fares. Witt's system featured front-door entry with fares collected just ahead of the center door. Riders paid as they passed to the rear of the car or as they exited. All of Brooklyn's Witts were rebuilt for one-man operation. (EBW/AJL.)

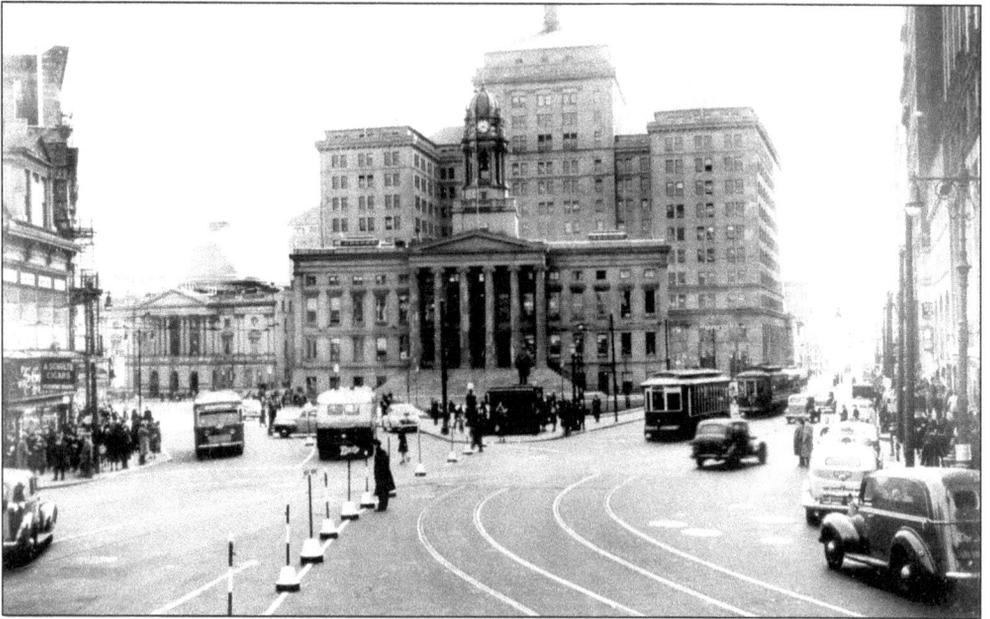

Here is a 1942 view of two Twin Coach buses on Fulton Street and two streetcars on Court Street at Brooklyn Borough Hall shortly after the Fulton Street elevated was torn down. There are few unobstructed views before this of the front of Brooklyn's 1846–1851 city hall/borough hall. To facilitate removal of the elevated, the streetcars running under the structure—the Fulton, Putnam, and Gates lines—were replaced by buses in the fall of 1941. (EBW/AJL.)

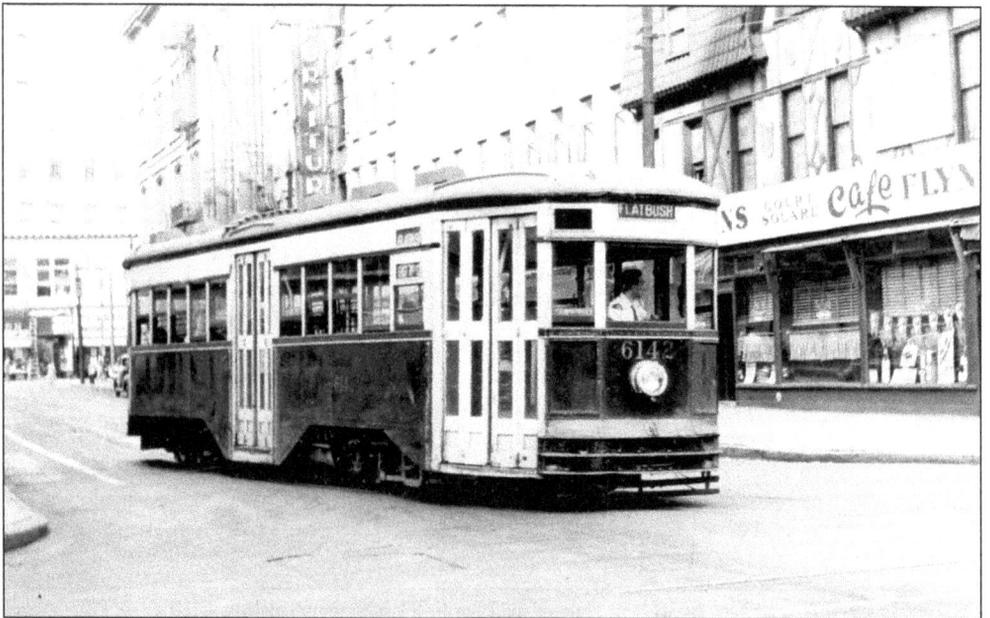

Flatbush Avenue No. 6142 turns from Court Street onto Livingston Street on August 23, 1947. Before 1907, Livingston was a narrow 40-foot-wide lane one block south of Fulton Street, the major thoroughfare going east through downtown Brooklyn. Livingston Street was widened to 80 feet, and two tracks were put in to divert Flatbush Avenue, Third Avenue, and St. Johns cars from congested Fulton Street. (EBW/AJL, E. P. Doyle photograph.)

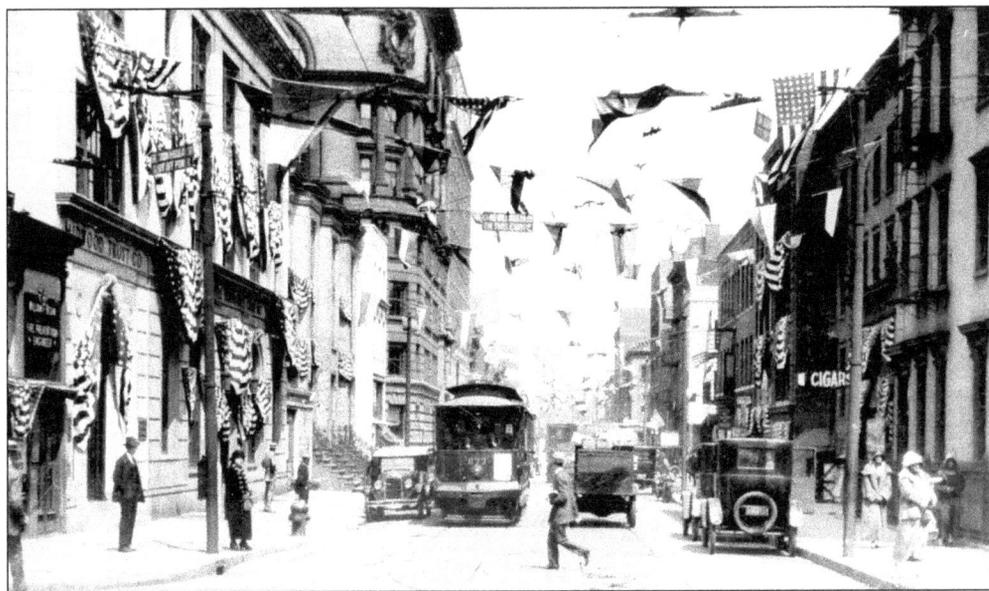

Crosstown open car No. 273 moves along narrow and congested Willoughby Street at Jay Street in 1923. Bunting usually went up for parades, which took place frequently in the days before various forms of electronic entertainment proliferated. The ladies' coats indicate cooler weather, so it might be around Armistice Day on November 11. (EBW/AJL.)

Open car No. 1033 is headed northbound on Jay Street between Willoughby Street and Myrtle Avenue on July 2, 1931. The construction is for the new Independent Subway's Jay Street–borough hall station. (EBW/AJL.)

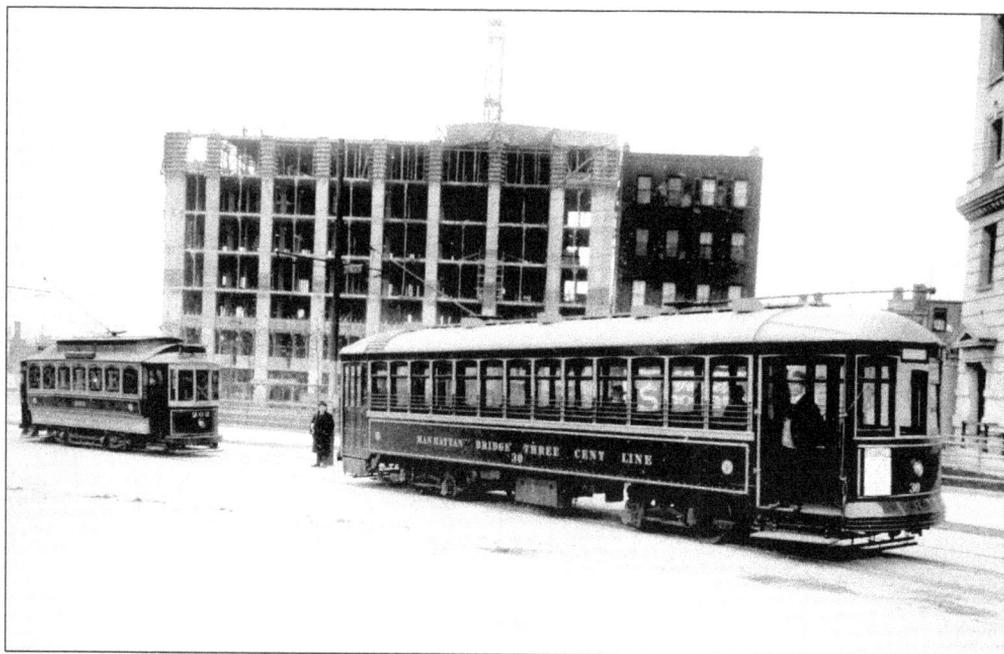

No. 302 and No. 30 are at the plaza at the Brooklyn end of the Manhattan Bridge on November 23, 1915. Thirteen electrified cable cars of 1892 vintage from Third Avenue in Manhattan inaugurated service on September 4, 1912. A dozen modern cars were acquired in 1913–1914, plus four more in 1919–1920. (EBW/AJL.)

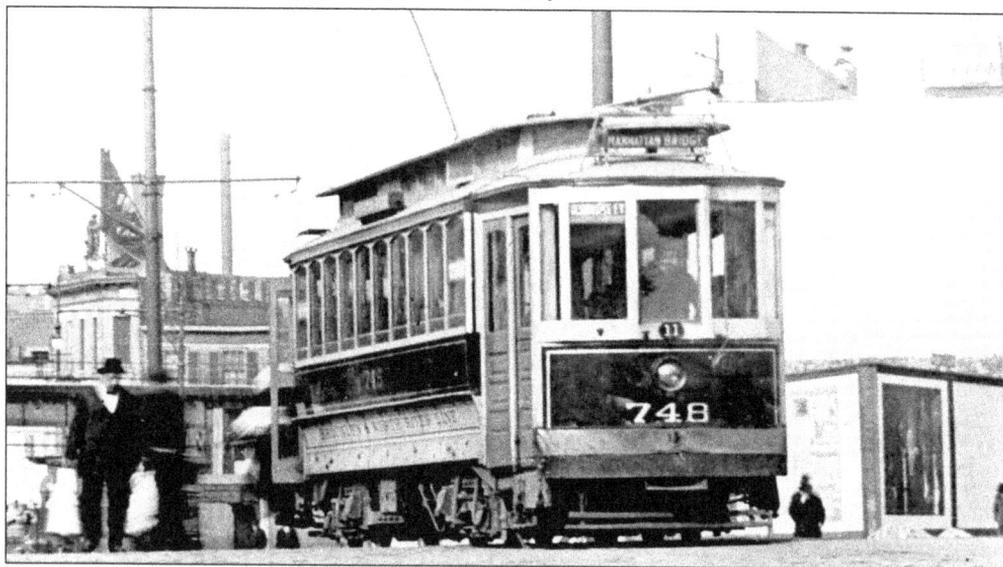

Brooklyn and North River Railroad (B&NR) No. 748 near Willoughby Street in 1915 is a Third Avenue Railway closed car built in 1908. Thirty cars were transferred from Avenue B in Manhattan to the new line in 1913, followed by 20 more in 1917. The B&NR, using the tracks on the north side of the bridge, was jointly owned by the Brooklyn Rapid Transit Company (BRT), the Coney Island and Brooklyn Railroad, New York Railways, and the Dry Dock, East Broadway and Battery Railroad subsidiary of Third Avenue. A 5¢ fare was charged as transfers were exchanged with the lines of the other companies until service ended on October 5, 1919. (EBW/AJL.)

Manhattan Bridge Three Cent Line No. 27 waits beneath an elevated train at the end of the line on Flatbush Avenue Extension at Fulton Street on April, 17, 1927. The blur just above the streetcar is a Fifth Avenue elevated train passing by on the structure over Hudson Avenue. Service over the tracks on the south side of the bridge was provided from 1912 until November 13, 1929. Sixteen steel cars like No. 27 were sold soon thereafter to the Steinway Lines for another nine years of operation in Long Island City. (EBW/AJL.)

No. 4523, seen on DeKalb Avenue passing the Brooklyn Paramount Theater and crossing Flatbush Avenue Extension, in 1933 is still operated by a motorman and conductor. On October 15, 1934, the last two-man streetcar in Brooklyn ran on DeKalb. The workers in the center are removing the tracks of the abandoned Manhattan Bridge Three Cent Line while the Brooklyn Bus Corporation's replacement Route B-15 bus waits on the far side of the street. (EBW/AJL.)

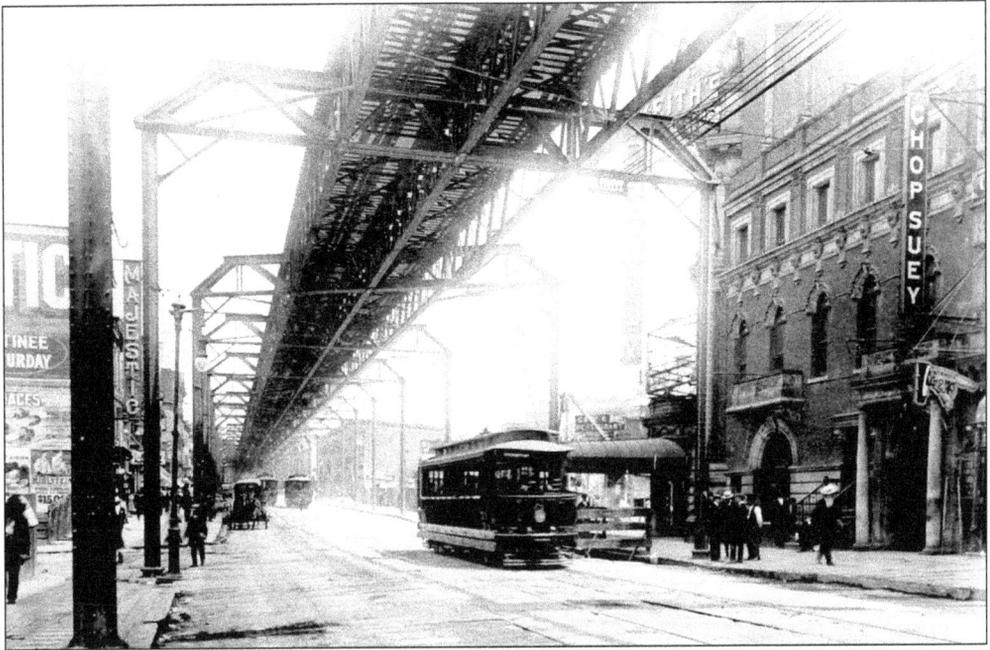

No. 1455 is on Fulton Street at Hudson Avenue on June 6, 1913. Low-rent housing along Fulton Street and Atlantic, Lexington, and Myrtle Avenues beneath the elevated structures was standard by the 1920s. Demolition of the Fulton elevated after 1940 was prompted by an effort to improve real estate values and increase property assessments. (EBW/AJL.)

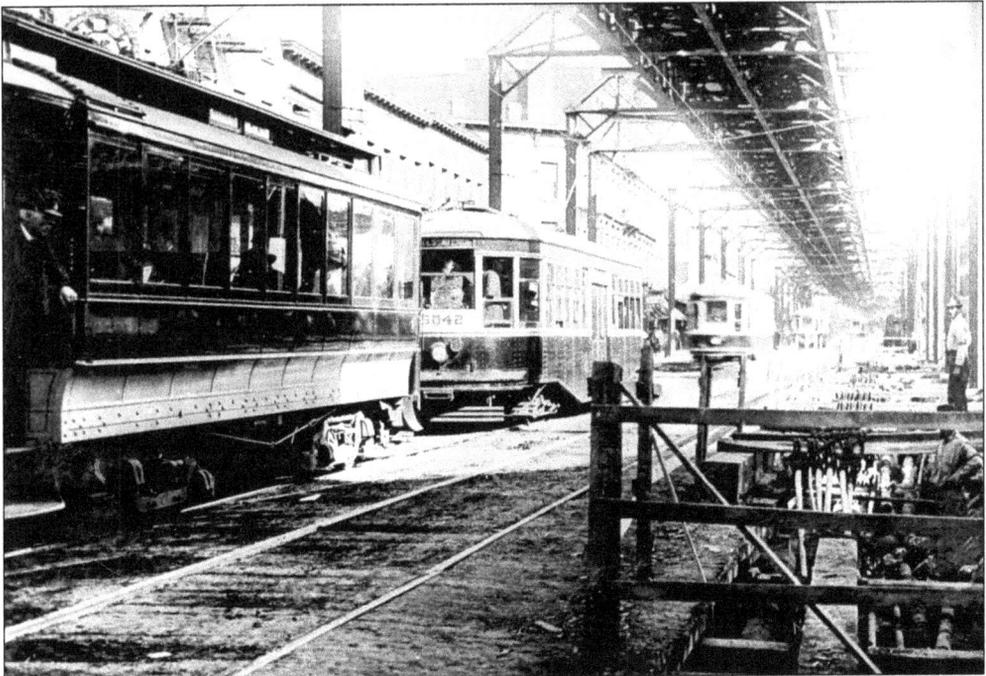

No. 2507 and No. 5042 are under the Fulton Street elevated at Rockwell Place on September 16, 1913. The construction is for the Brighton line subway connection to the Manhattan Bridge and Montague Street tunnel at the DeKalb Avenue station. (EBW/AJL.)

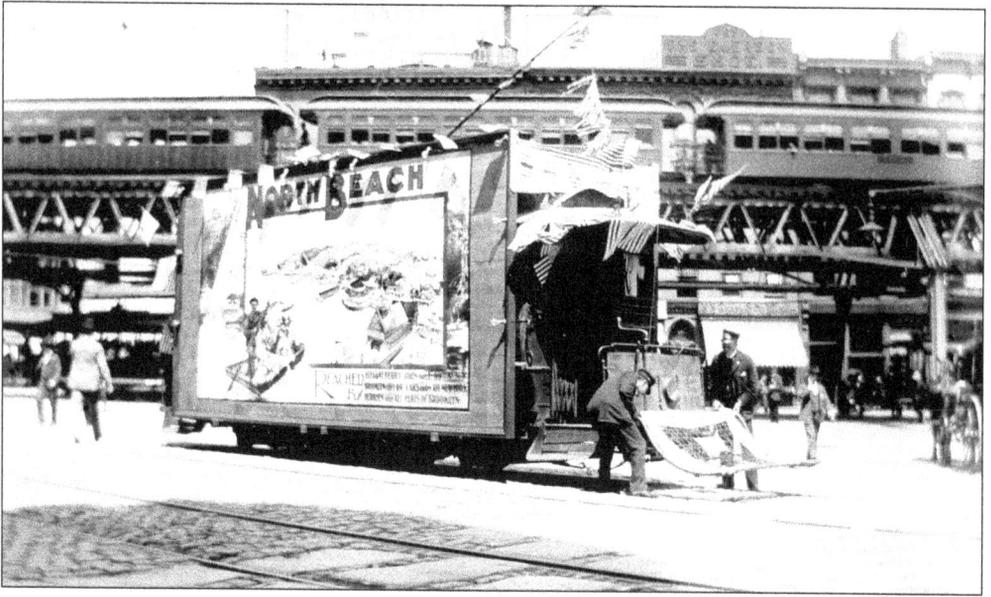

No. 3123, advertising North Beach Amusement Park, is at Court and Fulton Streets changing ends (reversing direction) in 1895 as indicated by the crew moving the fender to the opposite end of the car. Brooklyn cars retained their open platforms until enclosed vestibules were mandated by the Public Utilities Commission in 1905. A total of 1,200 new fenders to supposedly catch anyone falling under the car were ordered at the same time because the old fenders did not clear the new front dash. (EBW/AJL.)

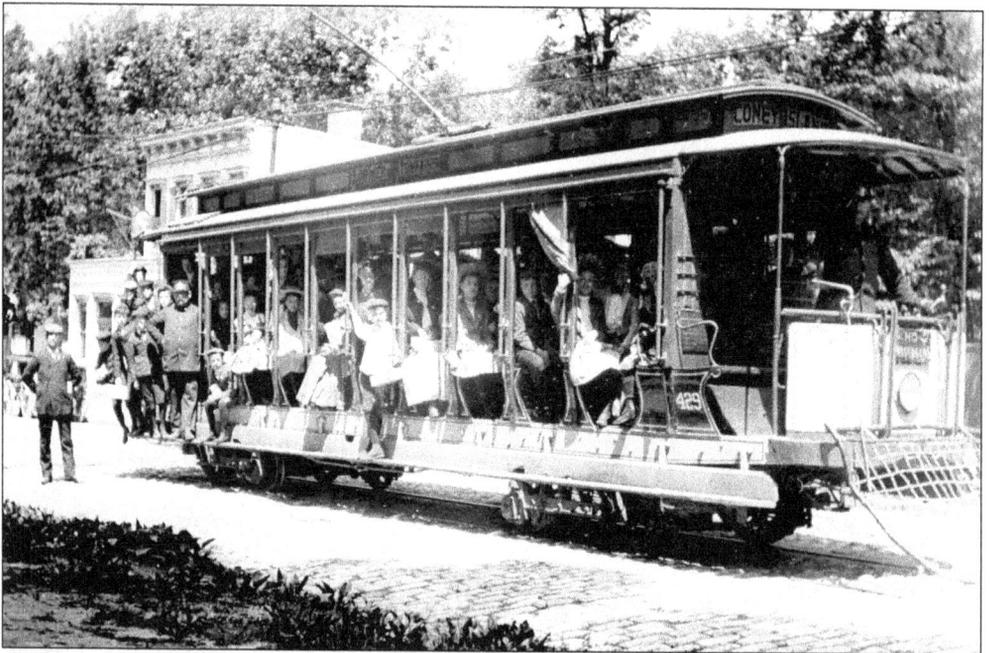

Open car No. 429 transports a Sunday school excursion in 1905. The cost in 1898 for such an outing on a 60-passenger open car was $15 for a round-trip on a chartered car, $12 on regularly scheduled cars, or $20 for an evening trip on an illuminated open car. Excursions went to Bergen Beach, Ulmer Park, Coney Island, Jamaica, Flushing, and North Beach. (EBW/AJL.)

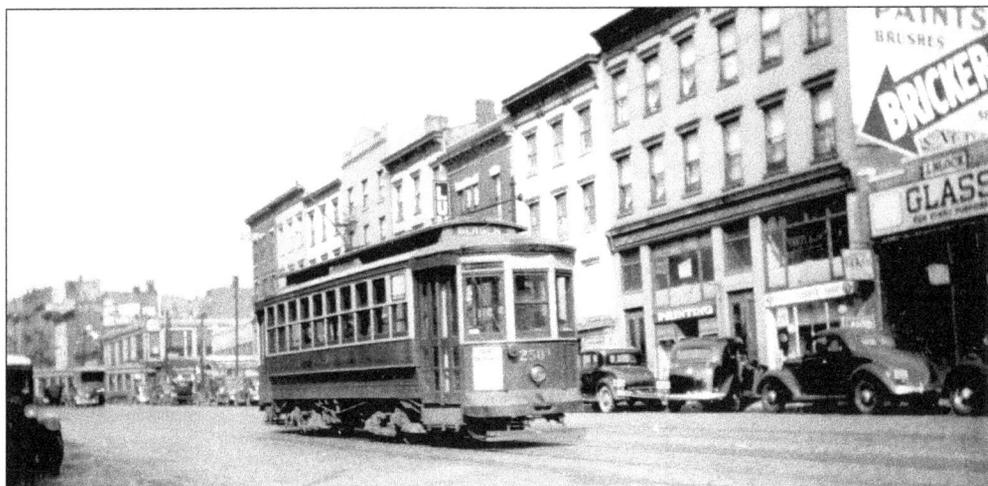

Bergen Street No. 2501 is on Atlantic Avenue at Court Street in February 1937. Before the Civil War, Atlantic Avenue was the main shopping street of South Brooklyn. Rail service on Atlantic Avenue was started in February 1861. By the dawn of the 20th century, a large Swedish population had moved into the area, and Atlantic Avenue acquired the nickname of "Swedish Broadway." (FP, Charles Duncan photograph.)

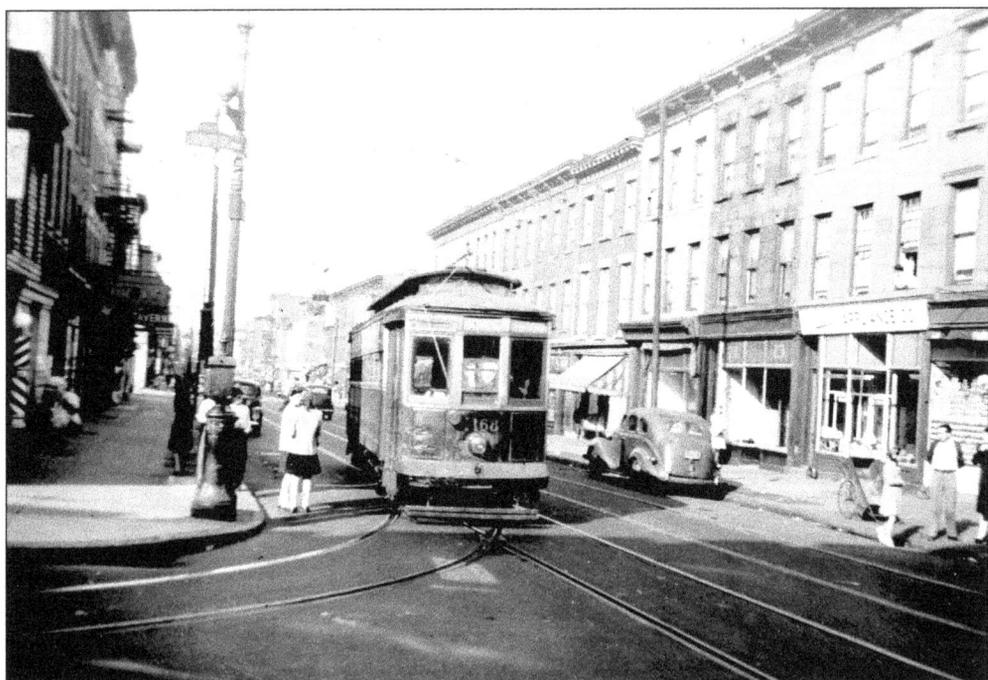

Bergen Street No. 1168 on Smith Street turns onto Sackett Street in 1946. Before World War II, Brooklyn's Little Italy was in this neighborhood along Sackett, Union, and President Streets. (EBW/AJL.)

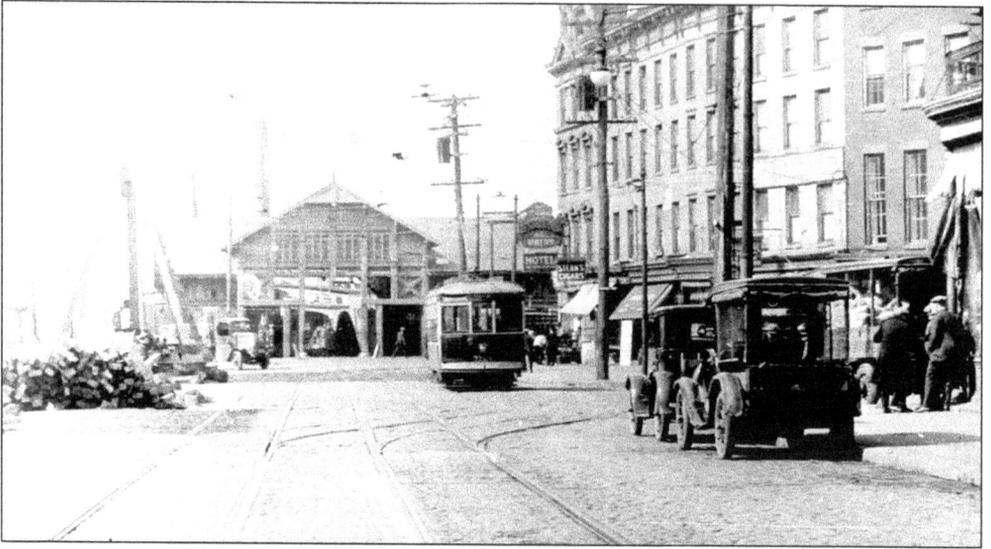

One-man safety car No. 7185 waits on one of the sidings on Hamilton Avenue in front of the Hamilton Ferry terminal building in 1925. (EBW/AJL.)

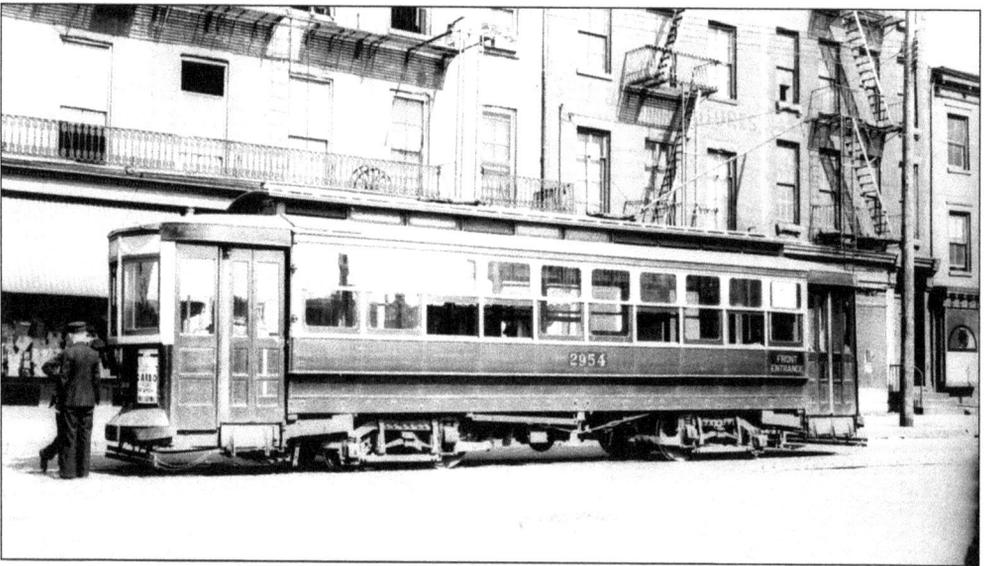

No. 2954 and crew rest on Hamilton Avenue at Union Street in June 1935. By this time, where there had been four through tracks and several sidings at the once bustling ferry, only two tracks and a few switches remained. Hamilton Ferry was one of the last Brooklyn ferries, operating until June 30, 1942. (FP.)

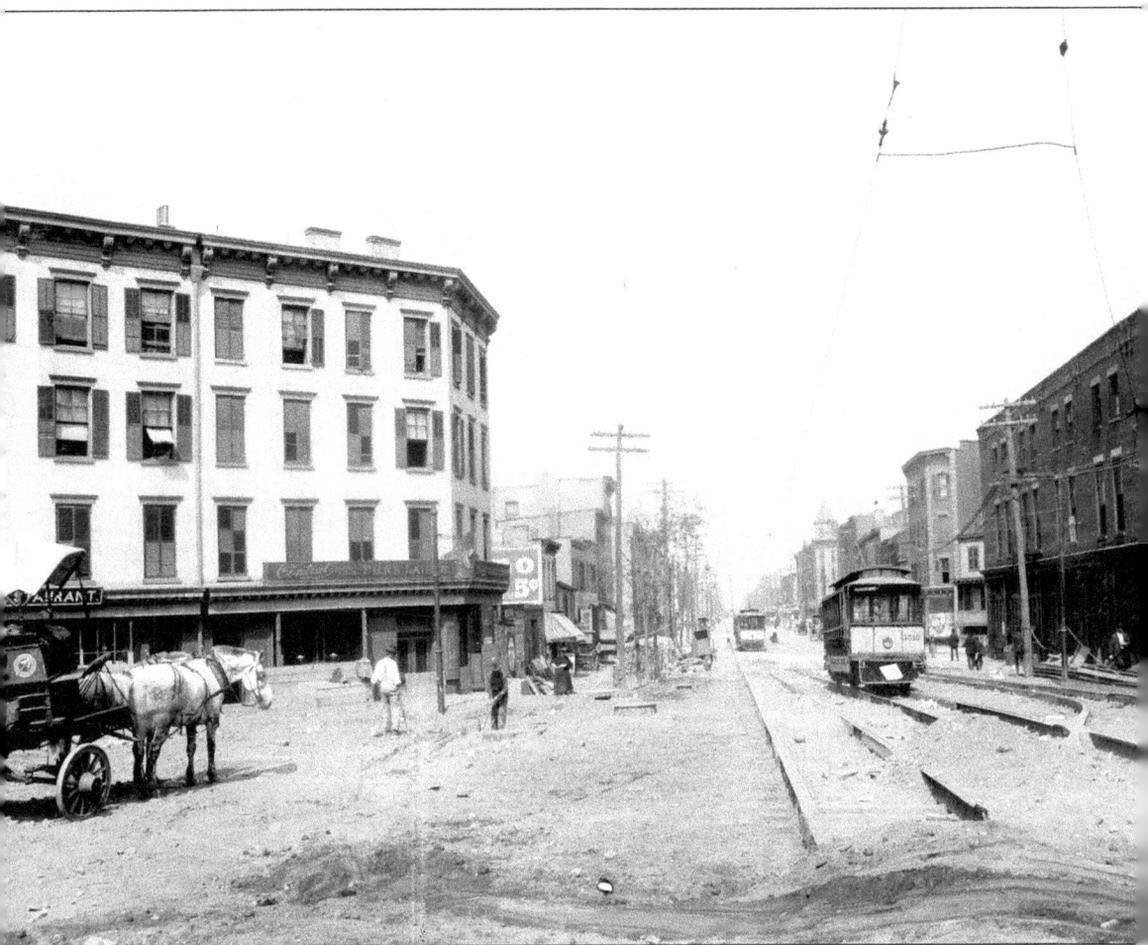

Court Street open car No. 3010 is on Hamilton Avenue near Bush Street in 1905. One of the original Brooklyn City Railroad lines, it began running from Fulton Ferry via Fulton, Court, and Church (West Ninth) Streets and Hamilton Avenue to Hamilton Ferry on August 8, 1854. Known as the Greenwood line for the next 32 years, it was extended via Hamilton and Third Avenues to Thirty-sixth Street in November 1854 and to the Brooklyn city line at Sixtieth Street the following July. This was about as far as anyone cared to travel on a horsecar going five miles an hour, so future extensions had to wait for other means of propulsion to be perfected. (EBW/AJL.)

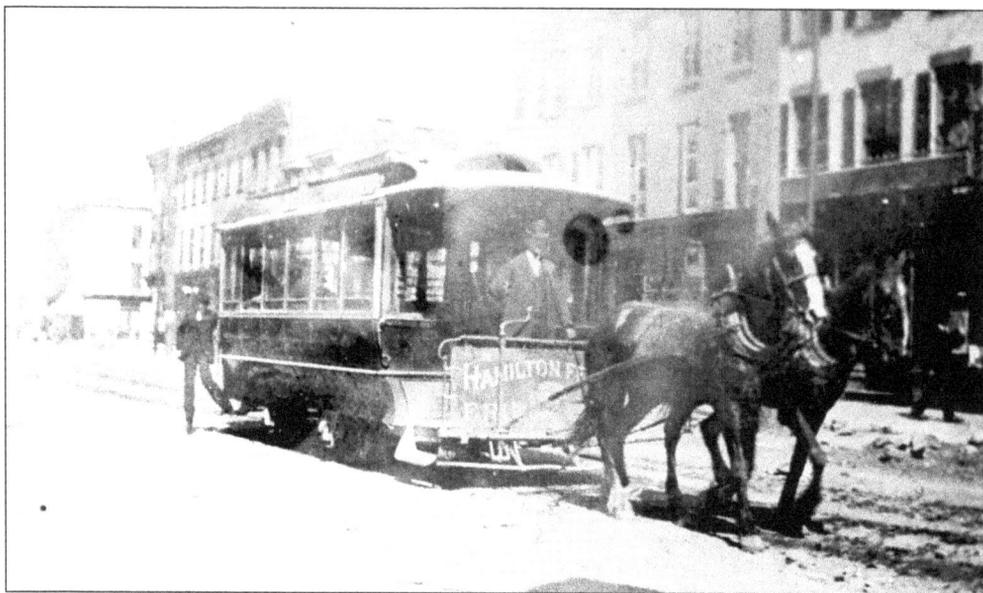

Horsecars of the Van Brunt Street and Erie Basin Railroad began operating on Hamilton Avenue and Van Brunt Street on March 3, 1863. By 1897, the line had been extended via Beard and Halleck Streets to Columbia Street. In 1898, the line was electrified with power purchased from the BRT, which also performed certain maintenance work under contract. Profitable until 1927 on a 3¢ fare, the line went out of business on December 14, 1929. This photograph was taken at the corner of Van Brunt and Van Dyke Streets in 1895. (EBW/AJL.)

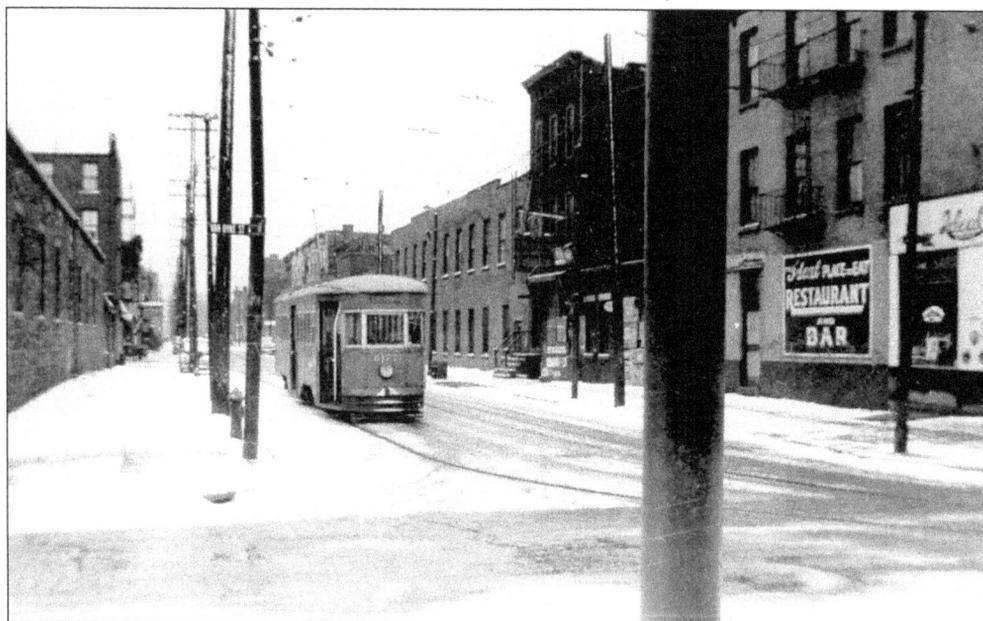

No. 6177 is at Richards and Van Dyke Streets on January 27, 1951, the crosstown line's last day of operation. The line served the Red Hook neighborhood, also called Erie Basin after the maritime facilities just to the south built by William Beard in 1864. Richards Street is named after Col. Daniel Richards, builder of the 1847 Atlantic Docks and Basin just to the west. Beard Street is one block away. (FP, Arthur J. Lonto photograph.)

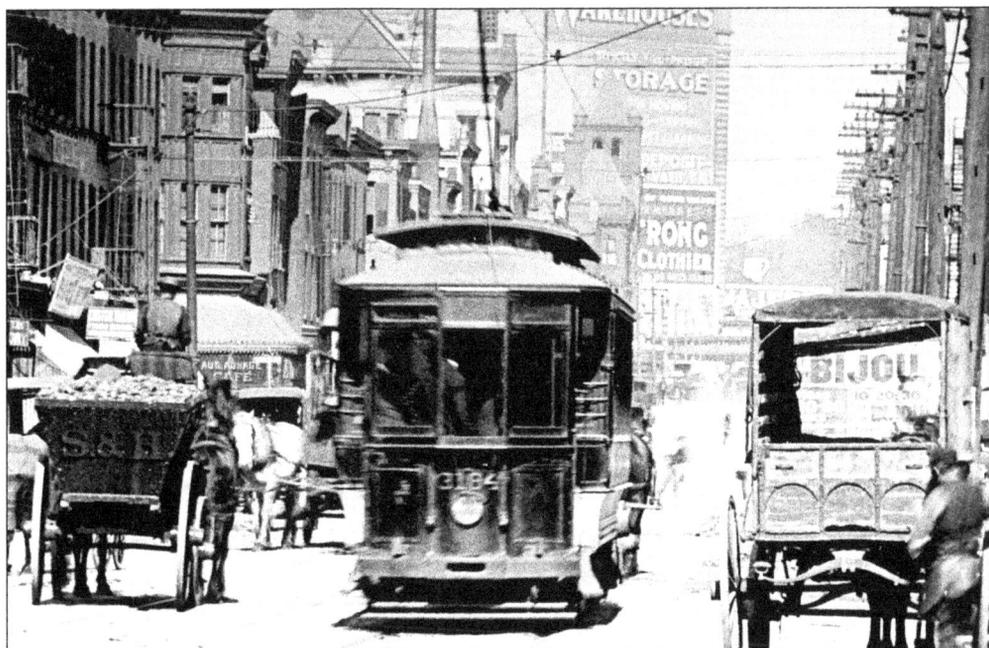

No. 3184 is on Third Avenue at Baltic Street in 1910, eight blocks north of Washington Park, home of the Brooklyn Dodgers at that time. Powers Street (Third Avenue) horsecar service started in 1868 from Fulton Ferry to Wyckoff Street. In 1872, the line was extended down Third Avenue to Twenty-fourth Street and over to Greenwood Cemetery. When the line was electrified on November 7, 1892, it was feasible to continue it all the way to Fort Hamilton. (EBW/AJL.)

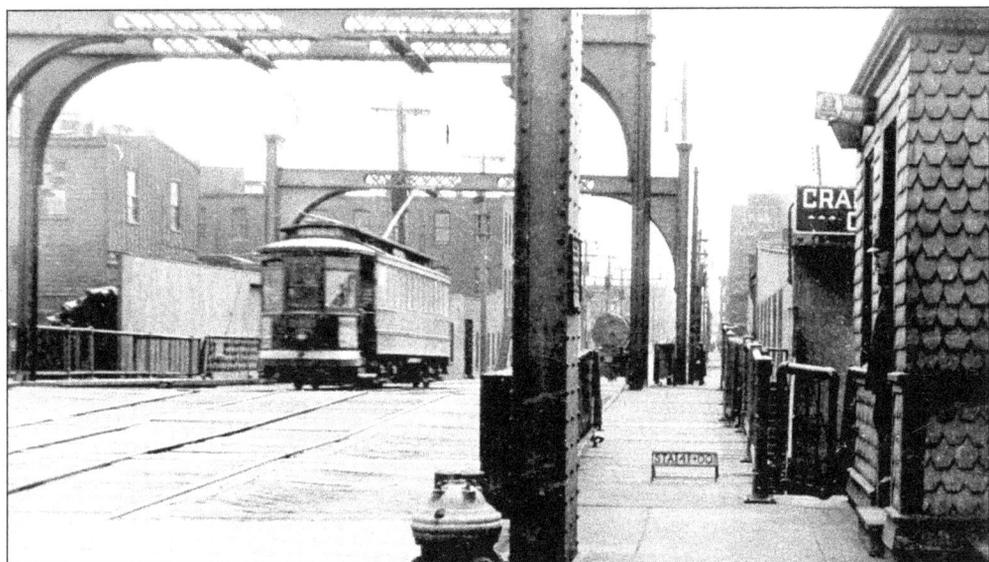

Smith Street No. 3921 crosses the Gowanus Canal on Ninth Street in 1930. In the mid-19th century, Gowanus Creek was the winter storage site for Erie Canal boats. Canalized in 1866, "Lavender Lake" was by the end of that century covered with an oily scum from the gasworks, oil works, brickyards, coal yards, and lumberyards along its banks. Unable to tunnel through the ground around the canal, the Independent Subway viaduct going up above the car had to be high enough to meet canal navigation clearances. (EBW/AJL.)

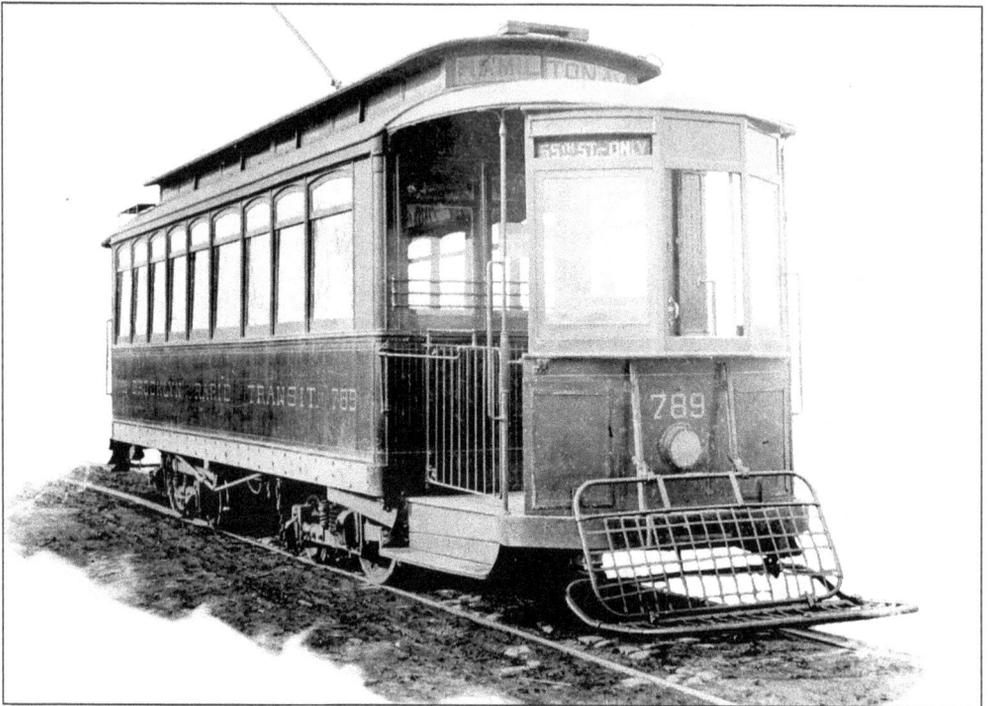

No. 789 (ex–railway post office car No. 1) shows its new fender and the R. W. Bliss "Wood" swing gate on the alighting side of the front platform in 1908. (EBW/AJL.)

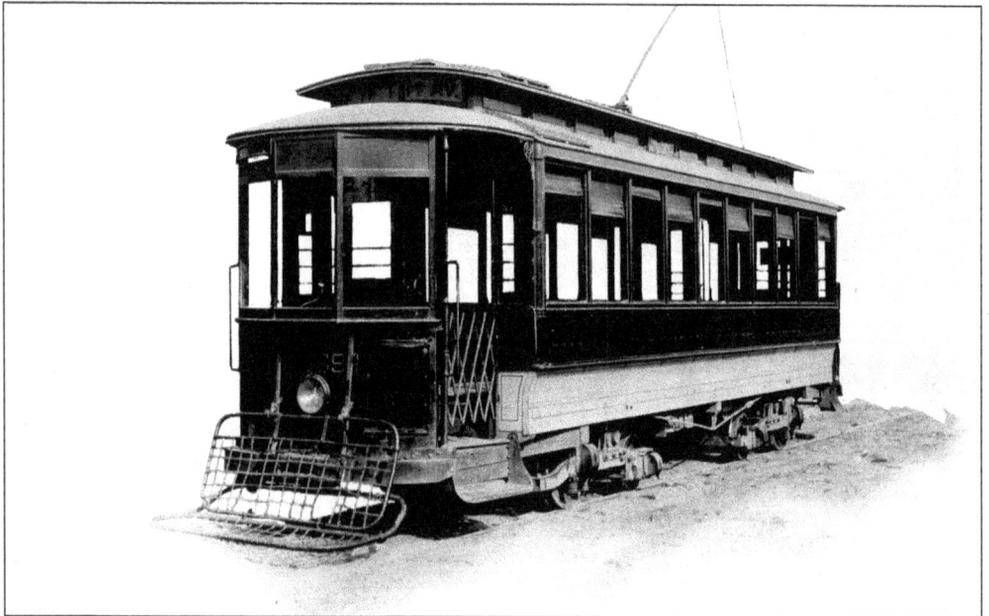

No. 3359 models the BRT pantograph gate on the boarding side of the rear platform in 1908. In early 1910, the Public Utilities Commission ordered the street railways to replace the ineffective fenders with wheel guards. Street railway accidents in Brooklyn occurred daily, especially before air brakes replaced the handbrakes, with many fatalities and serious injuries to passengers, horses, teamsters, and pedestrians. (EBW/AJL.)

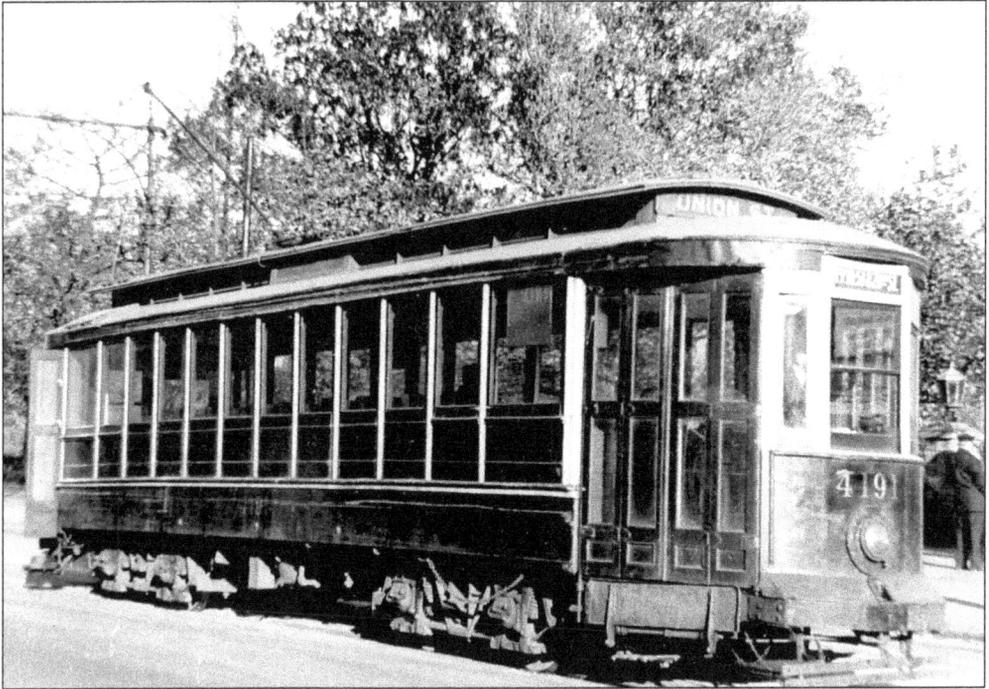

Union Street convertible No. 4191 stops on Ninth Avenue (Prospect Park West) in a neighborhood developed in the 19th century as Prospect Heights. Built in 1901–1902, the Union Street line did not start operating until April 28, 1905, due to public opposition to a trolley line on the strictly residential street. The street was named after the union stores or warehouses near the other end of the line at Hamilton Ferry. (BERA.)

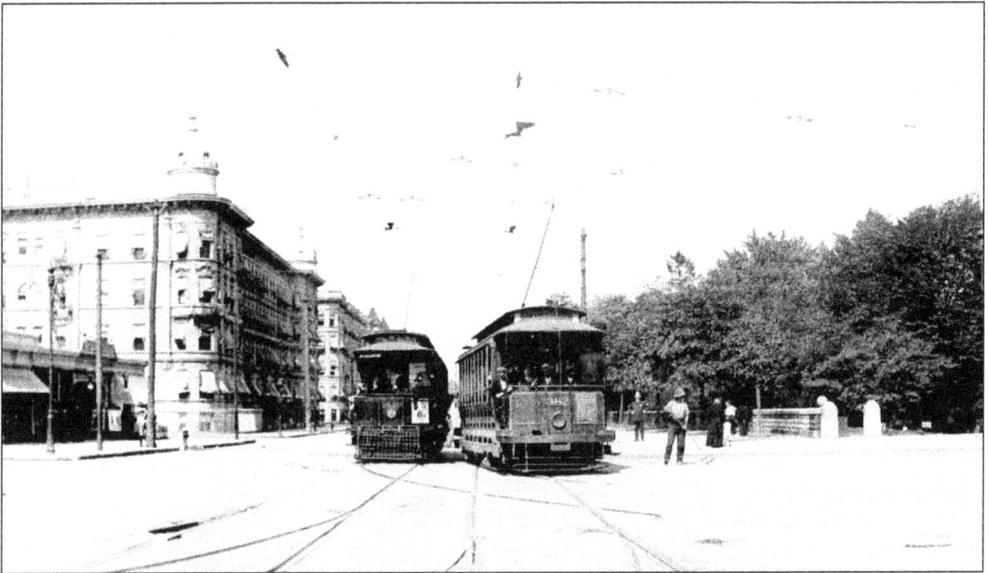

Southbound BRT No. 1435 on the Vanderbilt Avenue line passes northbound Coney Island and Brooklyn Railroad No. 382 (renumbered 1847 after acquisition by the BRT in 1914) on the Smith Street line turning from Fifteenth Street (Prospect Park Southwest) onto Ninth Avenue (Prospect Park West) in 1910. (EBW/AJL.)

This 1910 scene was taken at Fifth Avenue and Fifty-ninth Street, one block from the old Brooklyn city line. When the town of New Utrecht was annexed in 1894, Brooklyn's 1839 grid pattern of streets was extended into the new addition. Fifth Avenue service to Twenty-fifth Street began in 1860 or 1861 from Fulton Ferry via Furman Street and Atlantic and Fifth Avenues. The line was electrified in 1893, extended to Fort Hamilton in 1896, cut back in 1899, and then extended and cut back several more times until 1920, when a permanent route from South Ferry to 101st Street was established with a branch into downtown. Streetcar service ended on February 20, 1949. (EBW/AJL.)

Two

SOUTH TO THE SEA

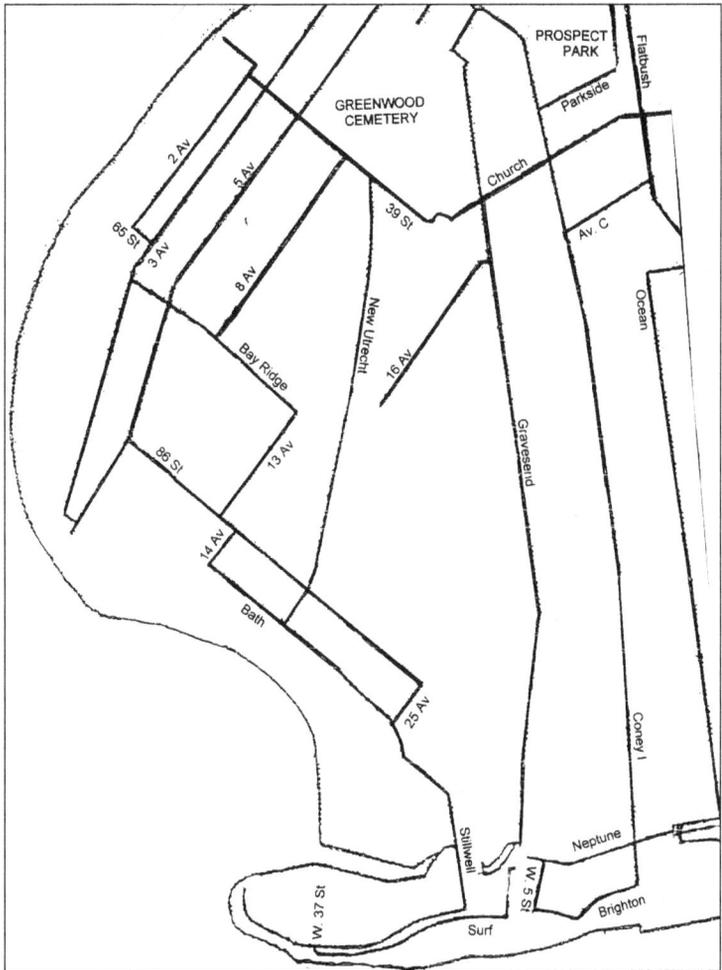

This map showcases the neighborhoods of Sunset Park, Bay Ridge, Fort Hamilton, Bath Beach, Bensonhurst, Boro Park, Kensington, Gravesend, and Coney Island.

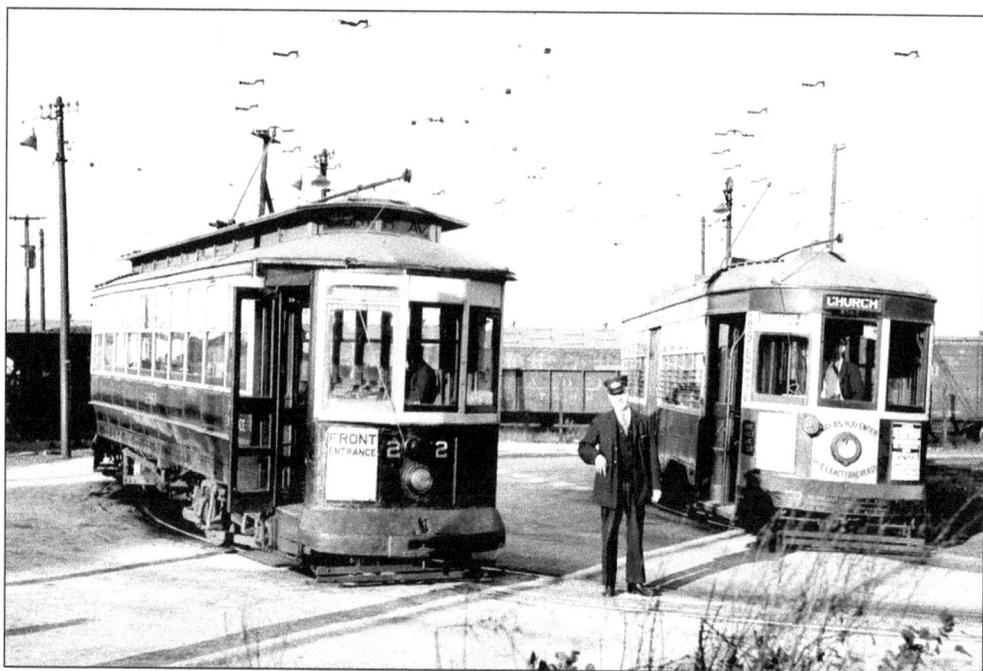

Eighth Avenue No. 2982 and Church Avenue No. 8502 wait at the 1933-built loop at First Avenue on October 13, 1934. Development of the Bush Terminal area was linked to the construction of a complex of piers, redbrick warehouses, and factory lofts built by Irving Bush in 1890 on a site known as Ambrose Park. Eight-story concrete buildings on adjacent land between Twenty-eighth and Fiftieth Streets were erected about 1911. (EBW/AJL.)

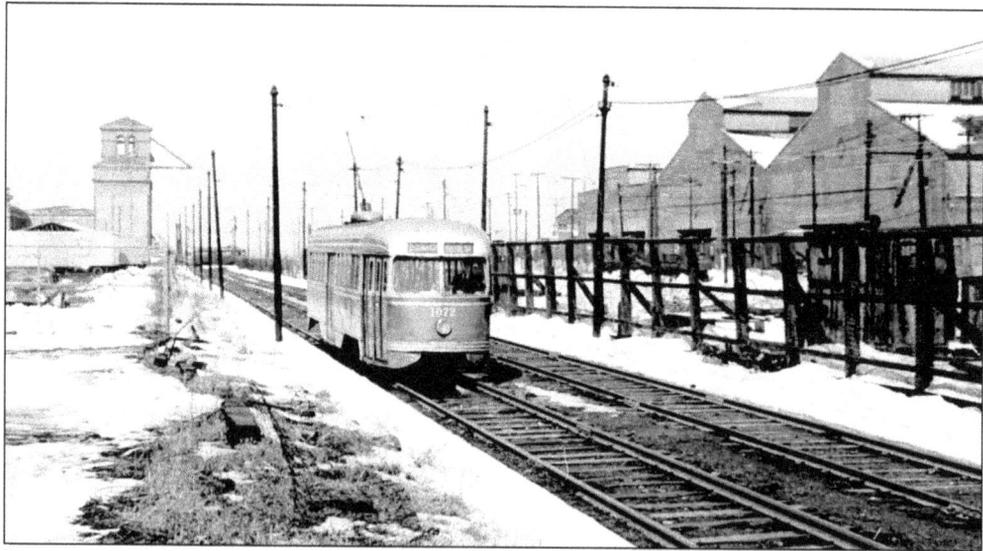

No. 1072 is on the right-of-way from the Thirty-ninth Street ferry to Second Avenue. The Thirty-ninth Street line of the Kings County Electric Railroad began operating from Second Avenue to Church and Rogers Avenues on July 28, 1895. It was extended east to Brownsville on June 1, 1896, and designated the Crosstown line, despite the fact that an important line by that name already ran from South Brooklyn to Greenpoint. The unimportant Crosstown line with its 30-minute headway was renamed Church Avenue in 1899. (FP.)

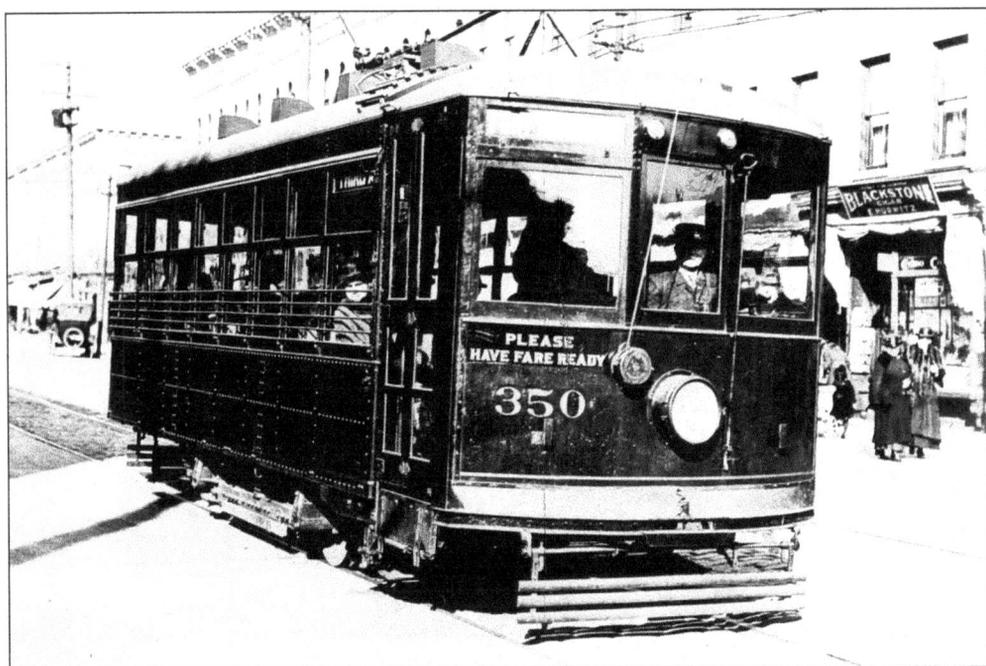

No. 350 was one of six safety cars built in 1919 by the American Car Company for the Brockton and Plymouth Street Railway. Instead of going to Massachusetts, they were shipped to Brooklyn as demonstrators to show the capabilities of the new cars—the first ones in Brooklyn operated by one man. The demonstration was a success, and 206 Birney cars were purchased in 1919. The demonstrators were sold to the Connecticut Company in 1920 and were used in New London. (BERA.)

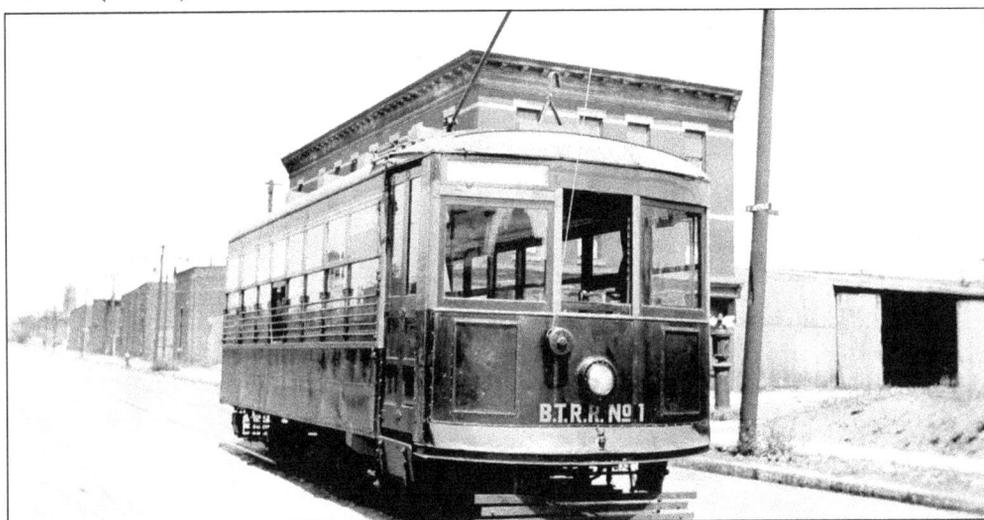

Bush Terminal Railroad No. 1 was originally South Brooklyn Railway No. 7203. With a profitable freight business, the Bush Terminal could afford to subsidize its line from Twenty-eighth Street via Second Avenue, Forty-first Street, and First Avenue to Sixty-first Street. This car was obtained in 1933 to replace a previous safety car acquired from the Danbury and Bethel Street Railway (of Connecticut) in 1927. One car was enough to handle a couple hundred passengers on one of the line's infrequent busy days. (EBW/AJL.)

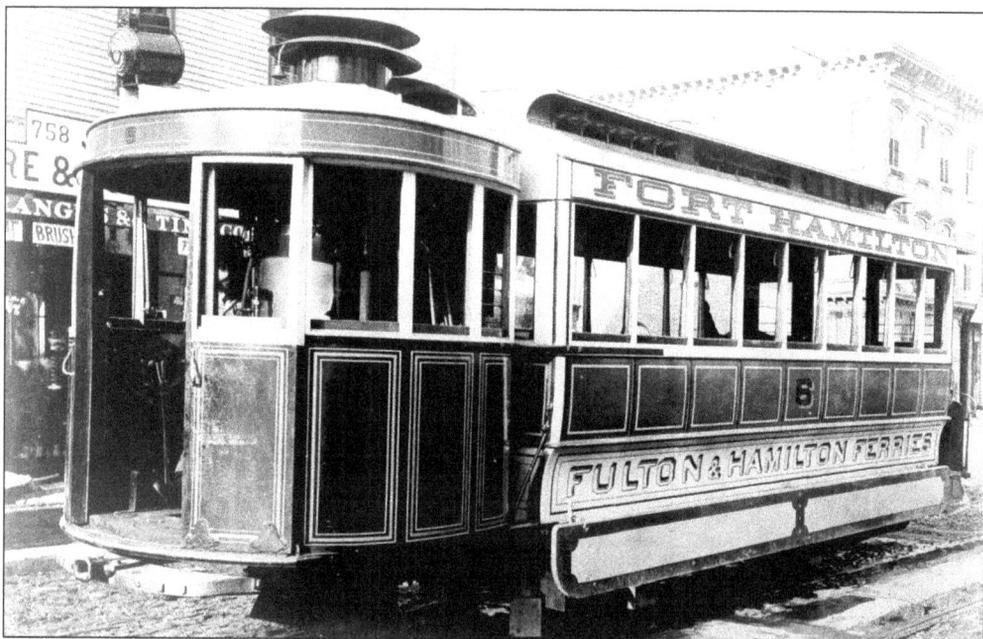

The boiler end of steam car No. 6 is in front of the passenger compartment. Between 1860 and 1877, the Brooklyn City Railroad used this type of equipment to extend the Hamilton Avenue line to Third Avenue and 100th Street. South of Twenty-fifth Street, there was often water over rails at high tide, and ocean spray splattered the cars on windy days. To reach Fulton Ferry as advertised, a transfer to a horsecar was required. (BERA.)

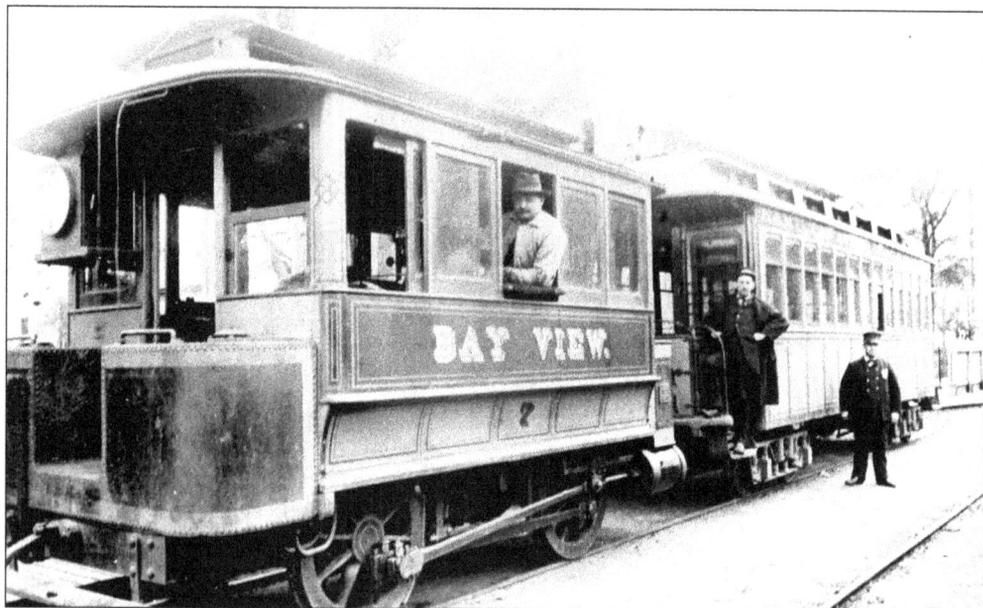

The lettered Bay View steam dummy (locomotive) No. 7 and its coach and crew pose at Fort Hamilton. The trip was made at an exhilarating 10 miles per hour, twice as fast as most urban dwellers of that time had ever traveled before. Before electrification, steam dummies also operated on Broadway, on lines from Ridgewood to Lutheran and Cypress Hills Cemeteries, and to Richmond Hill. (EBW/AJL.)

An incline was constructed at the south end of the elevated at Third Avenue and Sixty-fifth Street about 1903 for a convenient transfer from the surface cars to the rapid transit trains going to the ferry or bridge. Passenger traffic was never very heavy, and, except in rush hour, a single elevated shuttle car to Thirty-sixth Street was sufficient. This car is descending the ramp at Senator Street and Third Avenue in 1910. (EBW/AJL.)

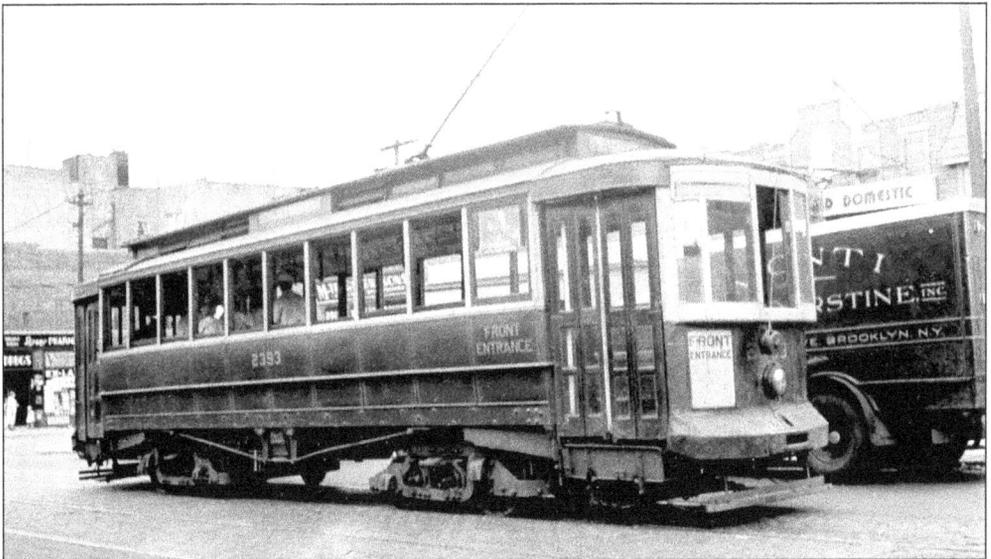

No. 2393 is at the end of the last Brooklyn trolley line built, which opened on December 1, 1916. From this terminal at Bay Ridge Avenue, cars ran up Eighth Avenue through a Scandinavian community (mostly Finnish and Norwegian), which was among the first ethnic groups to establish itself in the neighborhood now called Sunset Park. The principal employers for this community were the industries along the nearby waterfront. (FP.)

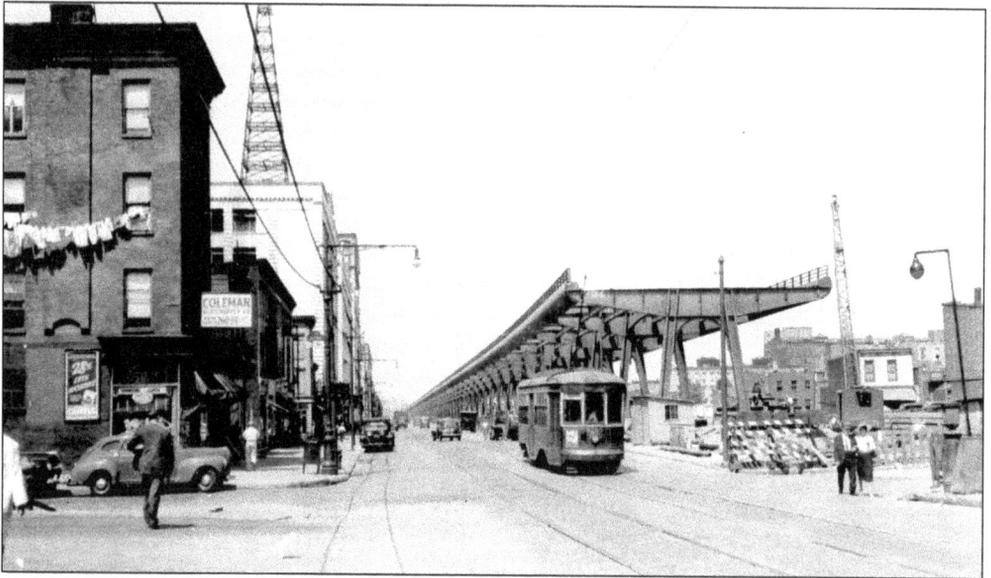

Southbound No. 8265 is on Third Avenue at Thirty-seventh Street on June 25, 1941, with the Gowanus Expressway being built above it. Construction of the highway separated the residential neighborhood from the industrial waterfront where many in the community worked. The east side of commercial Third Avenue was demolished in the process, and Fifth Avenue replaced it as the principal shopping street of the area. (EBW/AJL.)

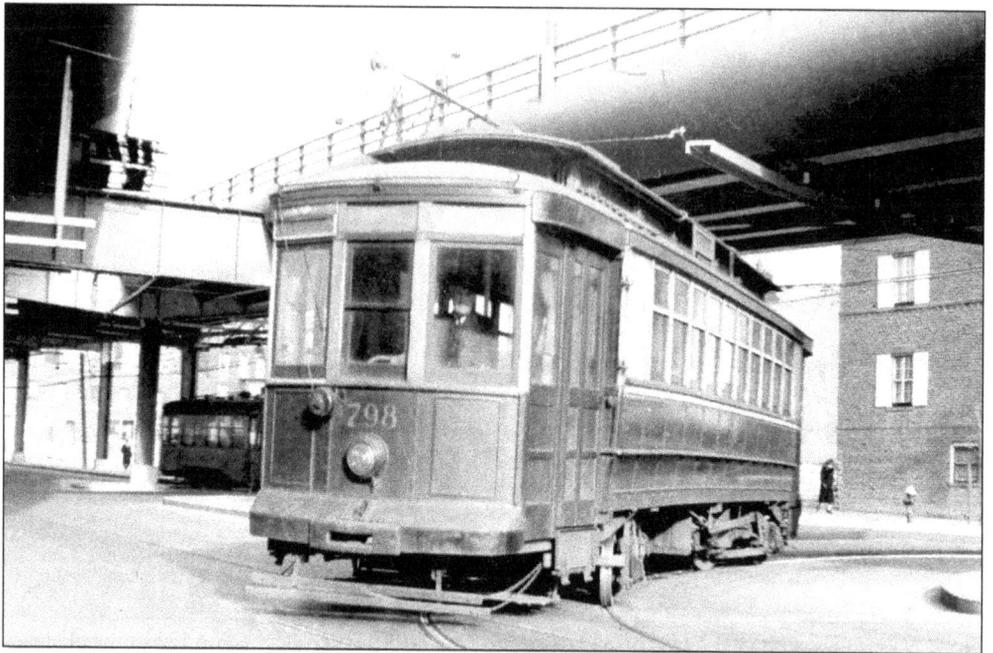

The parlor car Columbia was built by Brill in 1895. It became medical inspection car No. 798 in 1915 and was converted into a one-man passenger car in 1929, remaining in revenue service through World War II. The car was photographed in 1942 at Sixty-fifth Street and Third Avenue with the men above it working on the Gowanus Expressway. (EBW/AJL.)

A loop on the southeast corner of Fifth Avenue and Eighty-sixth Street was used by Fifth Avenue shuttle cars from 1899 to 1906 and from 1916 to 1920 when Fifth Avenue cars were not running all the way to Fort Hamilton. Eighty-sixth Street cars also turned here at times. Within a year of this 1926 picture, a Woolworth's occupied the site of the loop. (EBW/AJL, Brooklyn Edison Company photograph.)

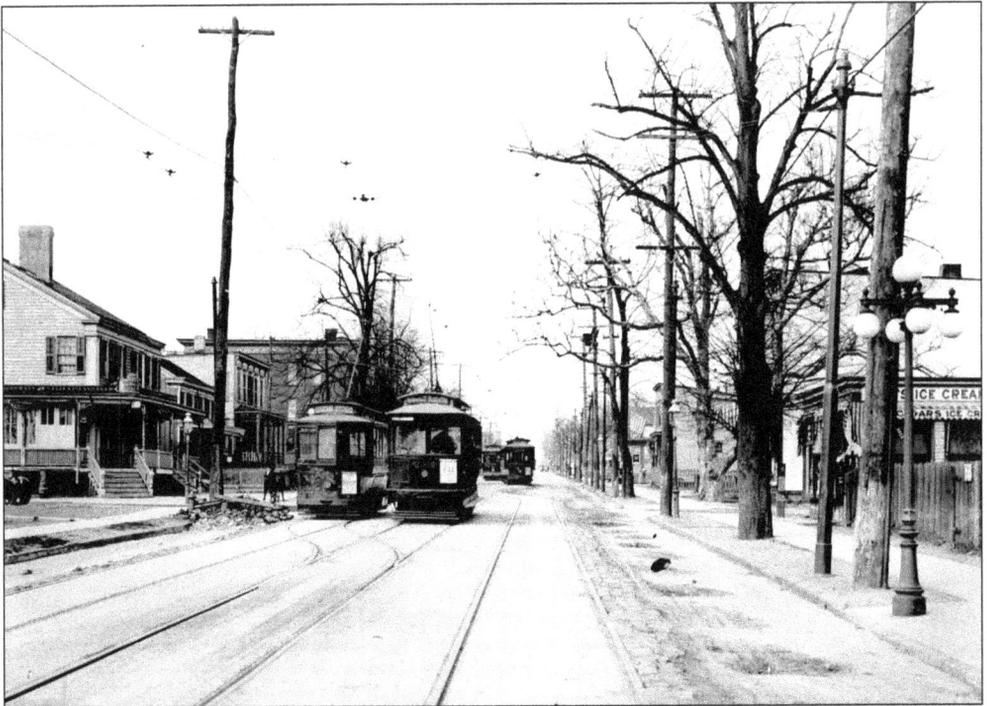

No. 114 on the Thirty-ninth Street ferry–Fort Hamilton line and No. 2055 on the Third Avenue line wait at the end of track at Fourth Avenue and 100th Street in 1916. (EBW/AJL.)

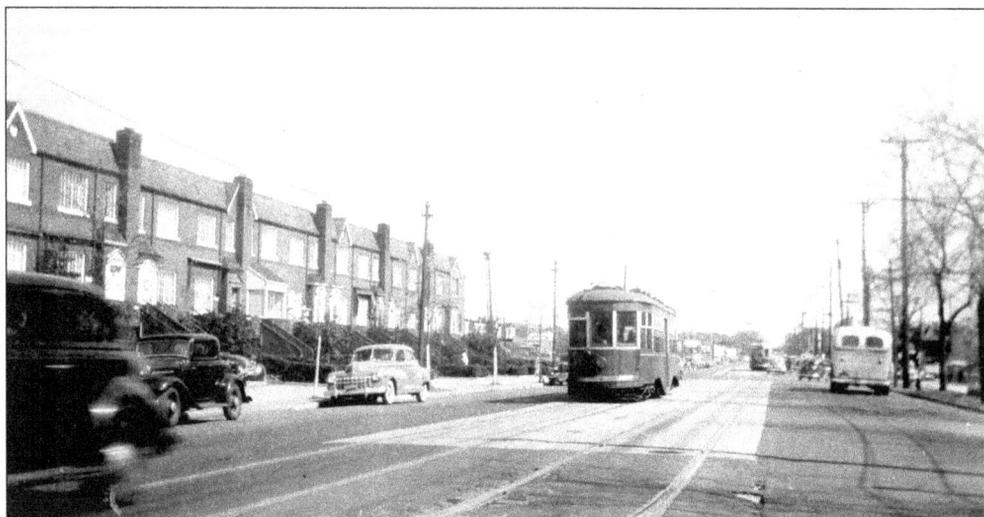

An Eighty-sixth Street GM bus at the curb and Bay Ridge Avenue No. 8284 in the center of Eighty-sixth Street pause near Fourteenth Avenue on April 17, 1949. Sixty-fifth Street–Bay Ridge Avenue was the first Brooklyn car line built as an electric railway, opening on May 22, 1891. Eighty-sixth Street was built by the Nassau Electric Railroad, incorporated on March 19, 1893, specifically to build electric lines into undeveloped areas. P. H. Flynn and Fred C. Cochieu, general manager and secretary of the Bay Ridge Improvement Company, were Nassau Electric's principal officers. Also involved was Daniel Lewis, president of both the Brooklyn City Railroad and the Bay Ridge Improvement Company. (EBW/AJL.)

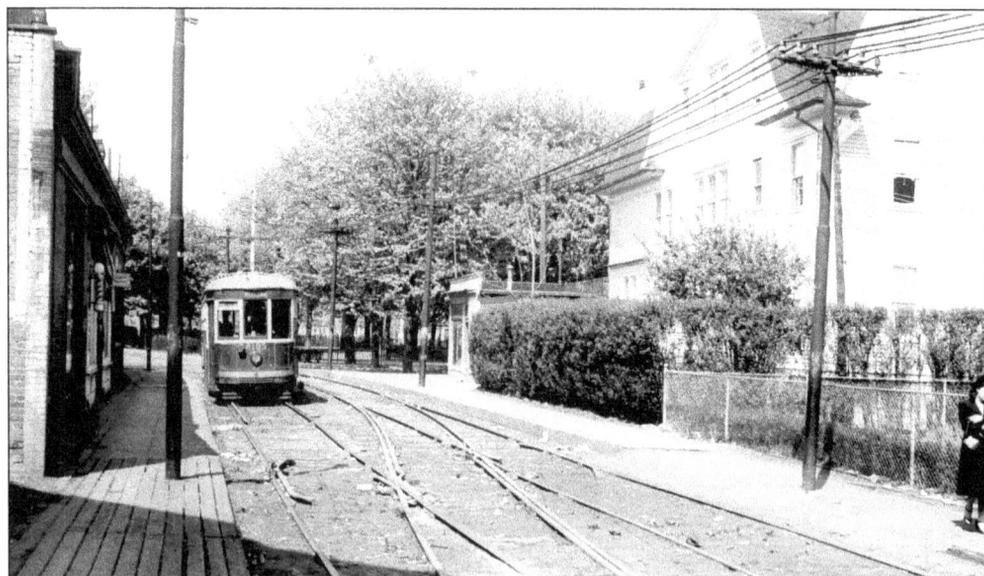

No. 8195 travels along the West End line's short right-of-way at Eighty-third Street in 1940. The elevated portion of the West End subway is just to the west over New Utrecht Avenue. (EBW/AJL.)

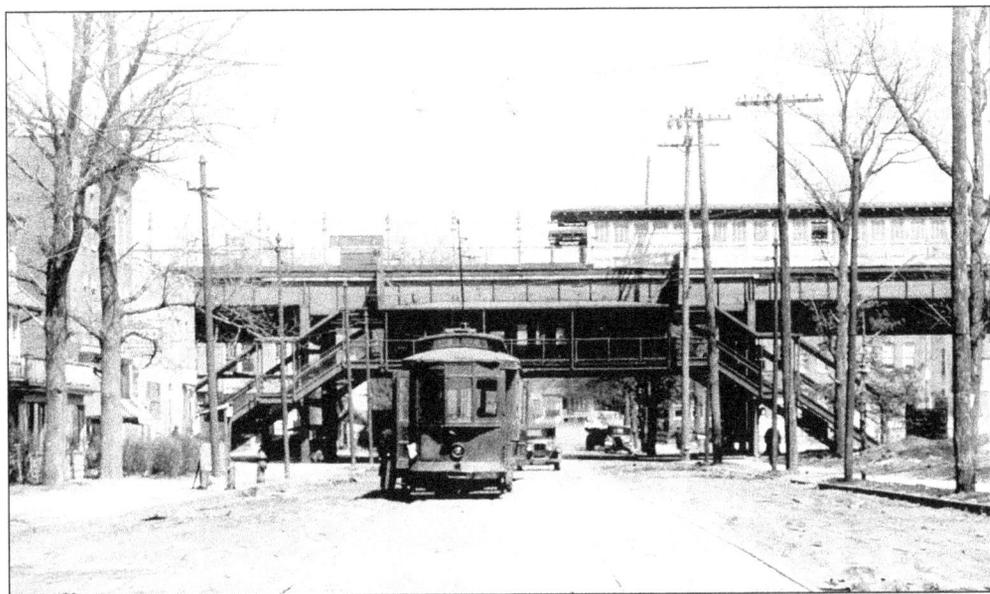

No. 784 is on Twenty-fifth Avenue just south of Eighty-sixth Street in 1928. North of Eighty-sixth Street to Kings Highway were the Benson family farms, which were developed by the Lynch Brothers in 1886–1889 as Bensonhurst-by-the-Sea. After the West End and Sea Beach subways opened in the 1920s, the area filled up with two- and three-family homes. With no trolley lines in the area, some of Brooklyn's first bus routes began operating on Bay Parkway (1924) and Bay Ridge Parkway (1928). (EBW/AJL.)

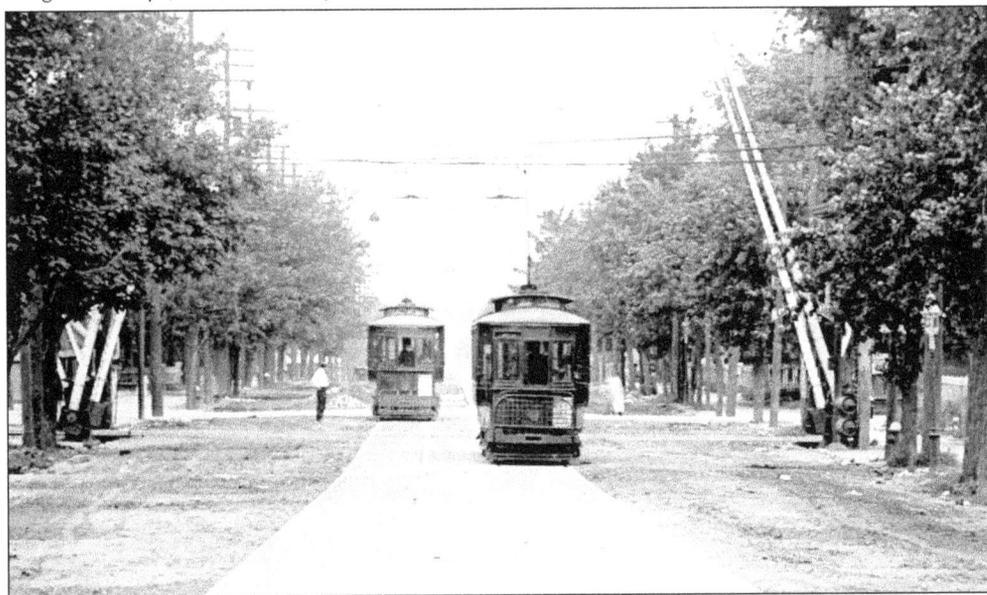

Two cars on Eighty-sixth Street cross the West End line right-of-way at Bay Nineteenth Street in this 1914 view from Eighteenth Avenue. The summer cars passing through Bath Beach carried full loads of noisy passengers until late at night, prompting much local opposition to through cars to Coney Island. As soon as the season was over, trolleys were cut back to Bay Nineteenth Street, leaving only the half-hourly elevated service. This, of course, prompted much local opposition. (EBW/AJL.)

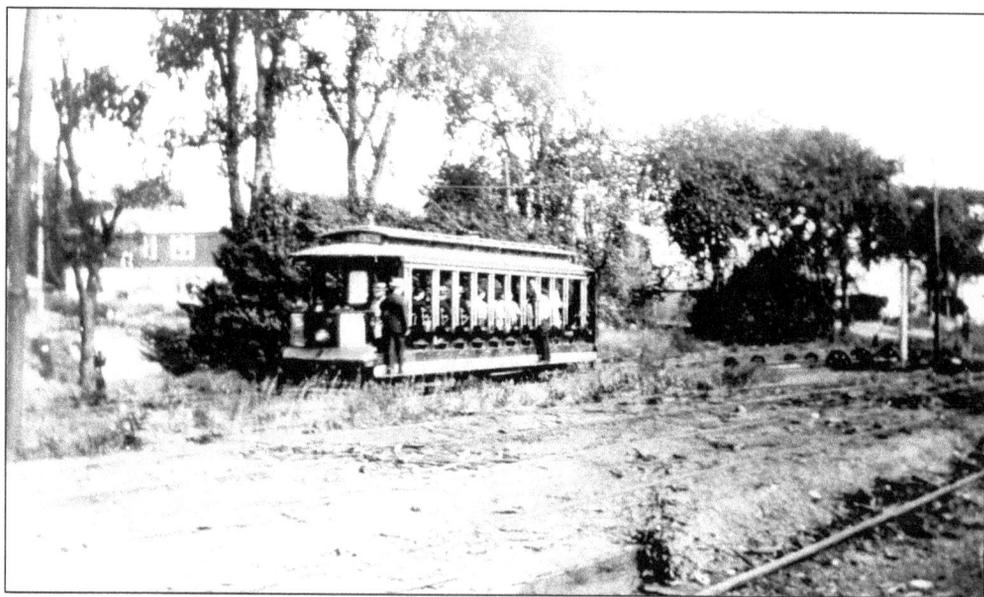

No. 662 passes the site of the Ulmer Park depot south of Bath Avenue and east of Twenty-fifth Avenue on August 30, 1930. Ulmer Park was opened in 1893 by William Ulmer of Vicelius and Ulmer's Continental Lagerbier Brewery on Beaver and Belvidere Streets in Bushwick. A casino at the foot of Twenty-fifth Avenue on the bay was the park's featured attraction. Prohibition, the economic depression, and the widening of Cropsey Avenue in the 1930s put an end to Ulmer Park. (EBW/AJL.)

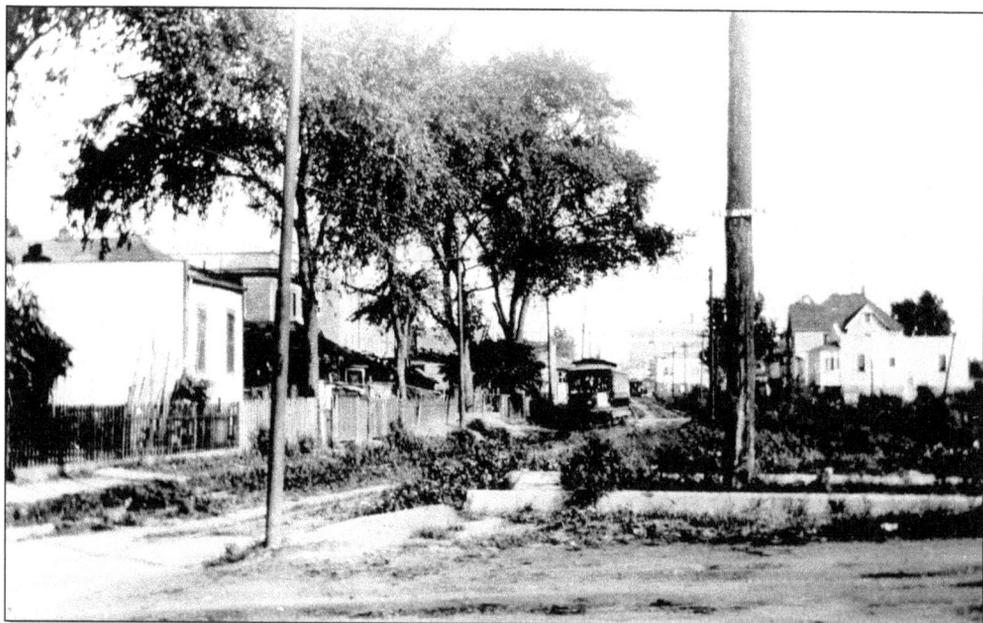

No. 668 rolls west along the West End line right-of-way just south of Bath Avenue at Twenty-sixth Avenue on August 30, 1930. The right-of-way turned northwest at this intersection and ran into Bath Avenue at Bay Thirty-seventh Street. East of Twenty-second Avenue (Bay Parkway) was a settlement of fishermen's and boat makers' shacks known as Unionville or Guntherville. Before the Belt Parkway was built, piers lined the shore of Gravesend Bay. (EBW/AJL.)

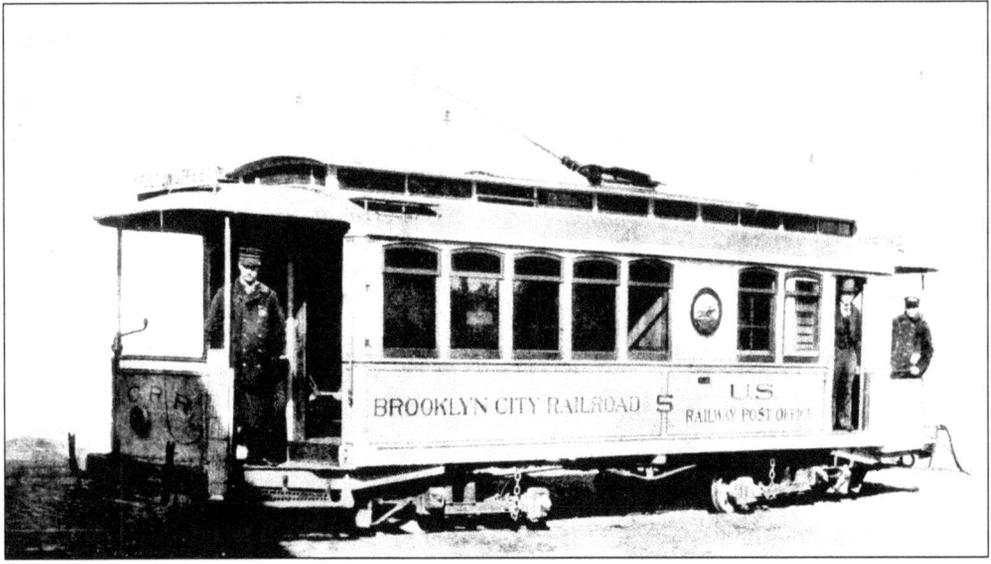

Railway post office car No. 5 and crew pose for the camera. The first Atlantic Avenue Railroad trip on August 12, 1894, from the main downtown post office served West Brooklyn, Blythbourne, Bath Junction, Lesser's Park, Van Pelt Manor, Bath Beach, Bensonhurst, Unionville, and Coney Island. Free mail delivery in New Utrecht, Gravesend, and Flatbush began in 1896. Railway post offices were used until the post office began using its own trucks in 1914. (EBW/AJL.)

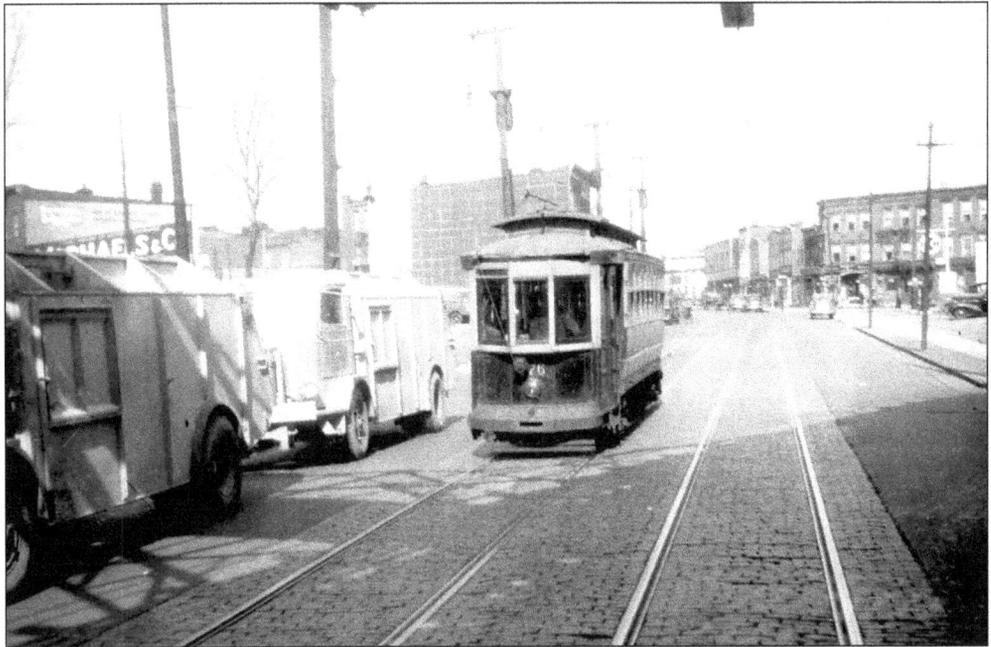

No. 776 is on New Utrecht Avenue at Forty-fifth Street in 1941 next to the typical sanitation trucks of that era. Full garbage cans were passed by the man on the ground up to the man on the deck who dumped the trash into the open-top hopper. Then he threw the empty steel can to the ground. At the time, most homes were heated by coal, and there were many extra cans of ashes to be emptied and dropped. With the elevated overhead, ambulances heading to the hospital on the next block, and trucks delivering coal, this was one noisy place. (EBW/AJL.)

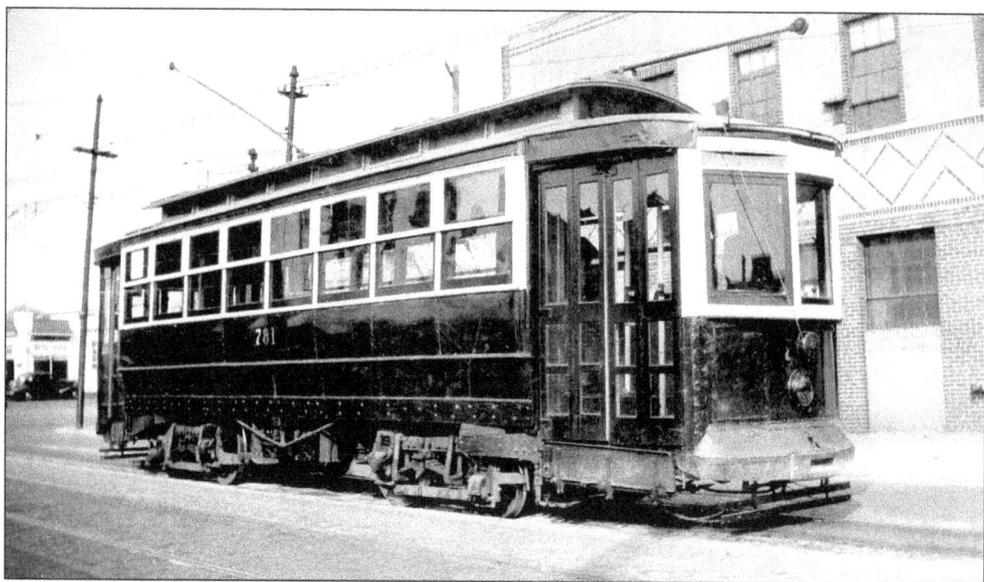

West End line No. 781, an 1898 car inherited from the Coney Island and Brooklyn Railroad in 1914, is on New Utrecht Avenue at Thirty-ninth Street ready to begin its trip to Coney Island. The line started out in 1864 as the Brooklyn, Bath and Coney Island Railroad running from Twenty-fifth Street to New Utrecht along the Brooklyn, Greenwood and Bath Plank Road of 1852; it was extended to Coney Island in 1867. When the West End elevated structure opened on June 24, 1916, streetcars began using the surface tracks and continued to do so until June 28, 1947. (BERA.)

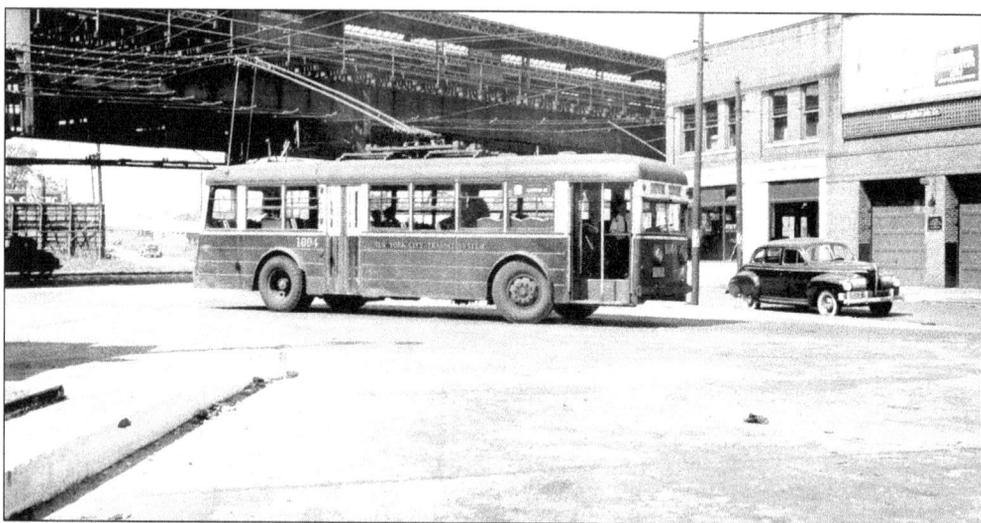

Pullman trackless trolley No. 1003 at Sixty-second Street and New Utrecht Avenue was one of six built for extension of the Avenue C line to New Utrecht over the discontinued Sixteenth Avenue car line in 1932. The extension served Blythbourne at Fifty-seventh Street and Boro Park north of Blythbourne and east of New Utrecht Avenue. (EBW/AJL.)

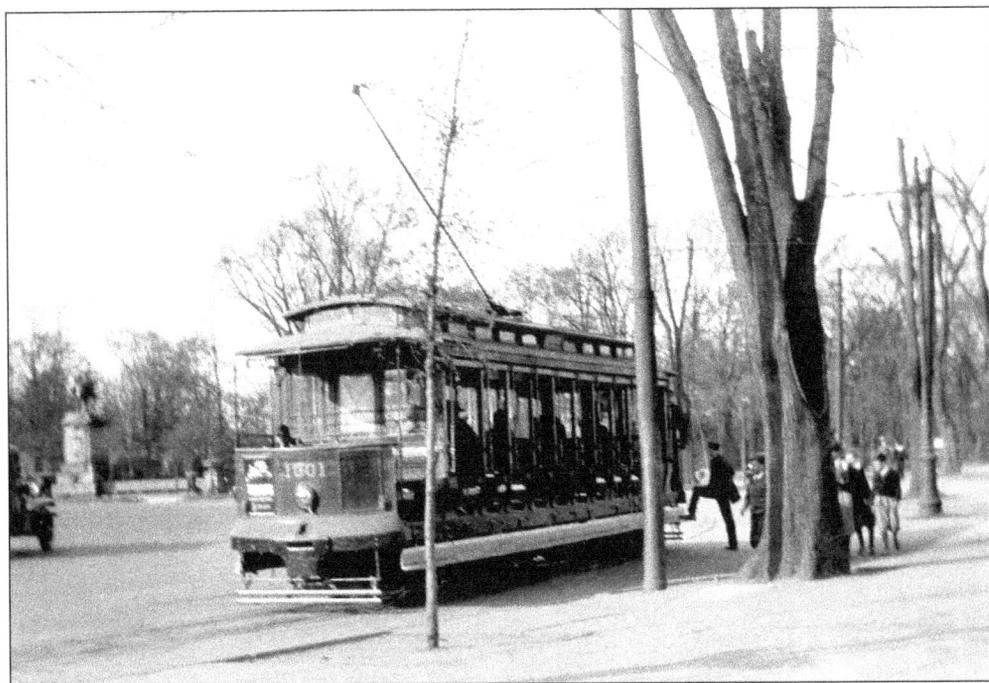

Franklin Avenue open car No. 1001 loads at Park Circle on Saturday, April 5, 1930. It is still early in the season, but the popular open car is already out. It served Prospect Park and Ebbets Field, home of the Brooklyn Dodgers after 1912. (EBW/AJL.)

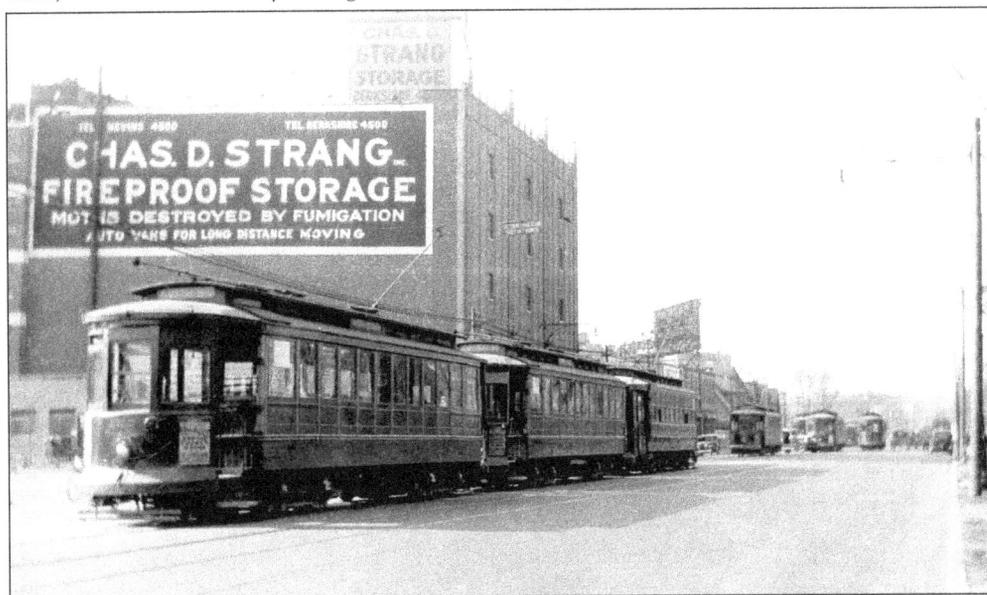

Coney Island Avenue between Caton Avenue and Park Circle is shown on April 5, 1930, with a lineup of cars consisting of No. 3722, No. 3701, No. 2940, No. 3718, No. 4508, No. 3706, and No. 2939. Summer schedules would not go into effect until Decoration Day, but there is obviously a lot of traffic to Prospect Park or Ebbets Field this day. Before city parks existed, people came to nearby Green-Wood Cemetery to spend a day in nature. The busiest day on the horsecars was a summer Sunday when people visited the cemeteries for a graveside picnic. (EBW/AJL.)

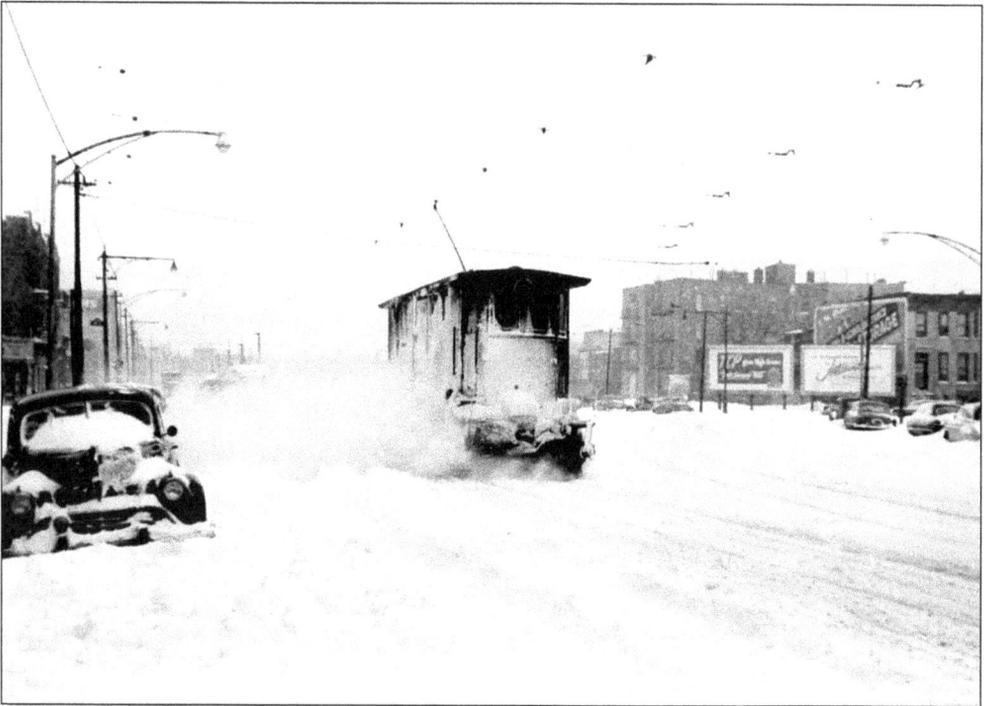

Sixteen sweepers like No. 6 (ex–No. 9831) were obtained in 1915 in response to severe criticism of the BRT's inability to keep its lines open during snowstorms. With more than 400 miles of track, there had previously been only 26 plows and 40 sweepers on the roster. By comparison, the Metropolitan Street Railway in Manhattan had 75 pieces of snow-fighting equipment available for its 130 miles of track. The sweeper is on McDonald Avenue on March 19, 1950, clearing the way for a PCC car. (FP, Russell Jackson photograph.)

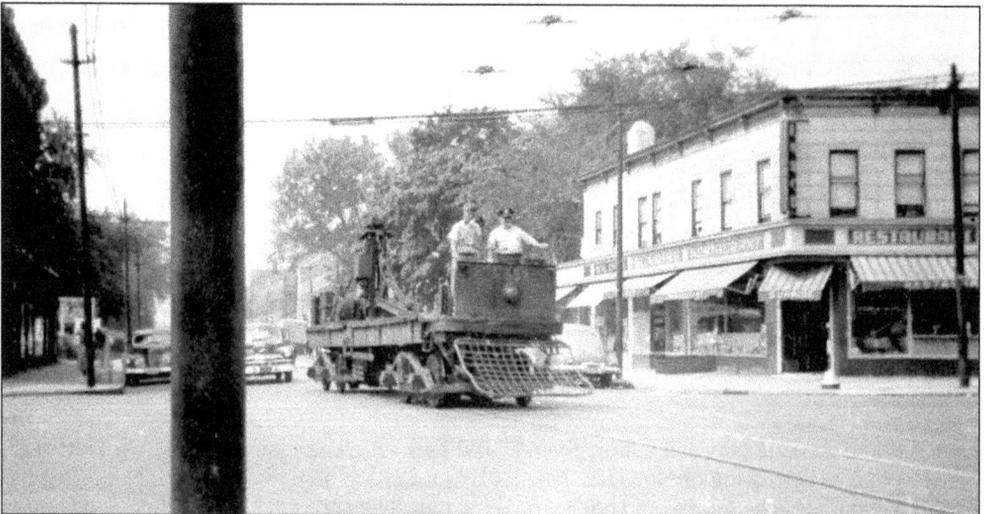

Maintaining a railway requires constant effort and a variety of specialized equipment. Derrick No. 9137 on Church Avenue crossing Coney Island Avenue was used primarily for lifting and transporting rail. (BERA.)

Southbound No. 2126 on the Sixteenth Avenue line is on Gravesend Avenue just south of Cortelyou Road on April 27, 1917. At this time, the line ran to downtown via Vanderbilt, Atlantic, and Flatbush Avenues. Culver rapid transit trains, which shared these tracks, moved upstairs as soon as the elevated was completed. Sixteenth Avenue cars were rerouted to Church and Utica Avenues, and a new Park Slope line ran to downtown. (EBW/AJL.)

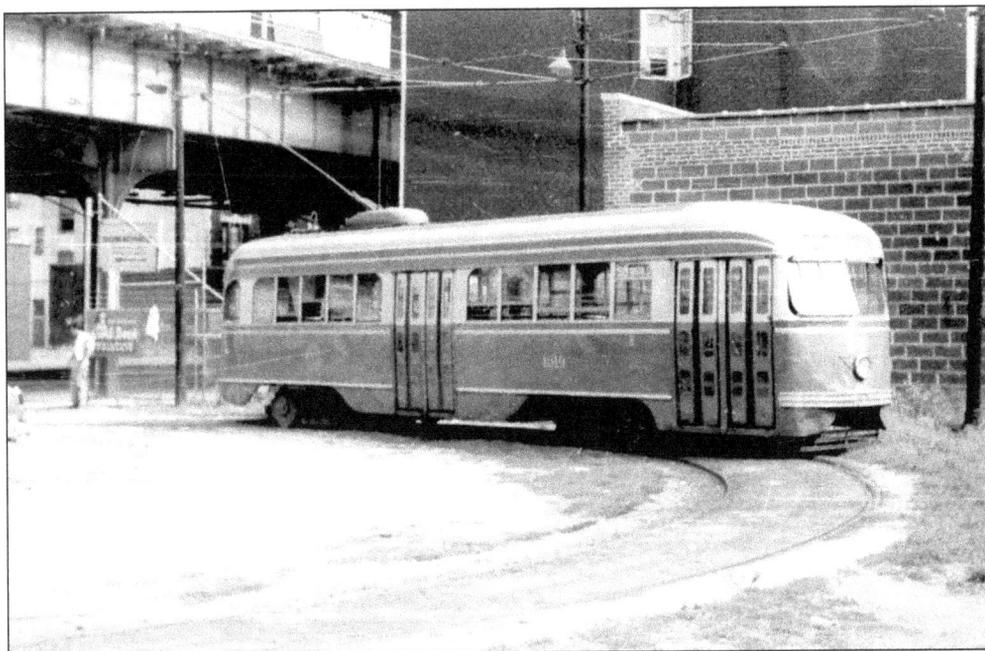

A PCC car waits at Kensington Loop, opened in April 1933 to allow single-ended cars to turn around. It was built on the one-block right-of-way west of McDonald Avenue where Sixteenth Avenue cars once turned off Gravesend Avenue. The avenue was renamed for John R. McDonald, chief clerk of the Brooklyn Surrogate Court, after his death in 1932. (FP.)

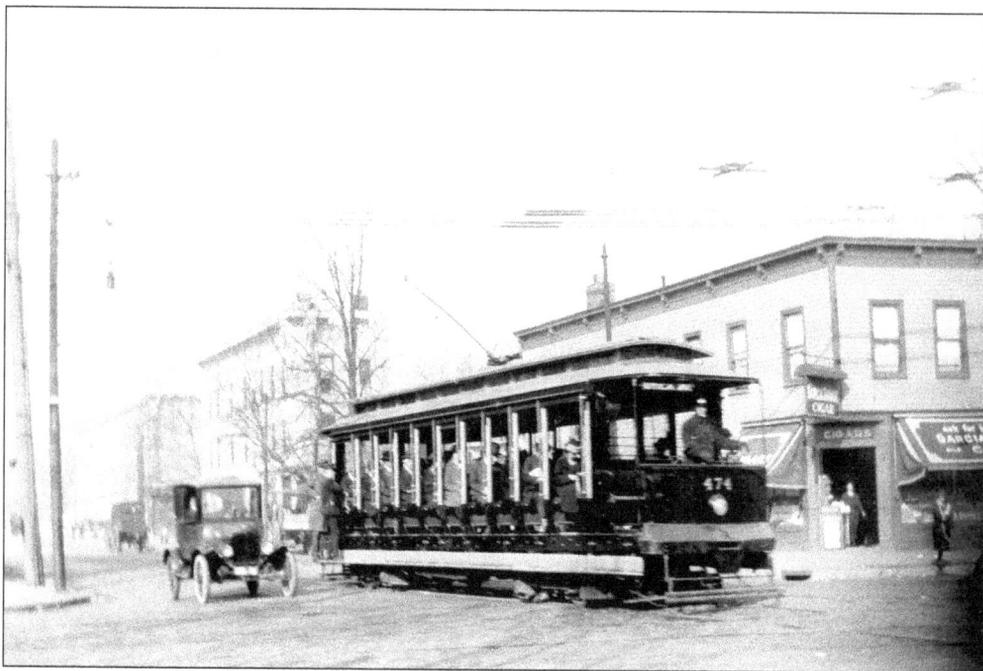

Thirteen-bench open car No. 474 stops on Church Avenue at Coney Island Avenue on April 5, 1922. (EBW/AJL.)

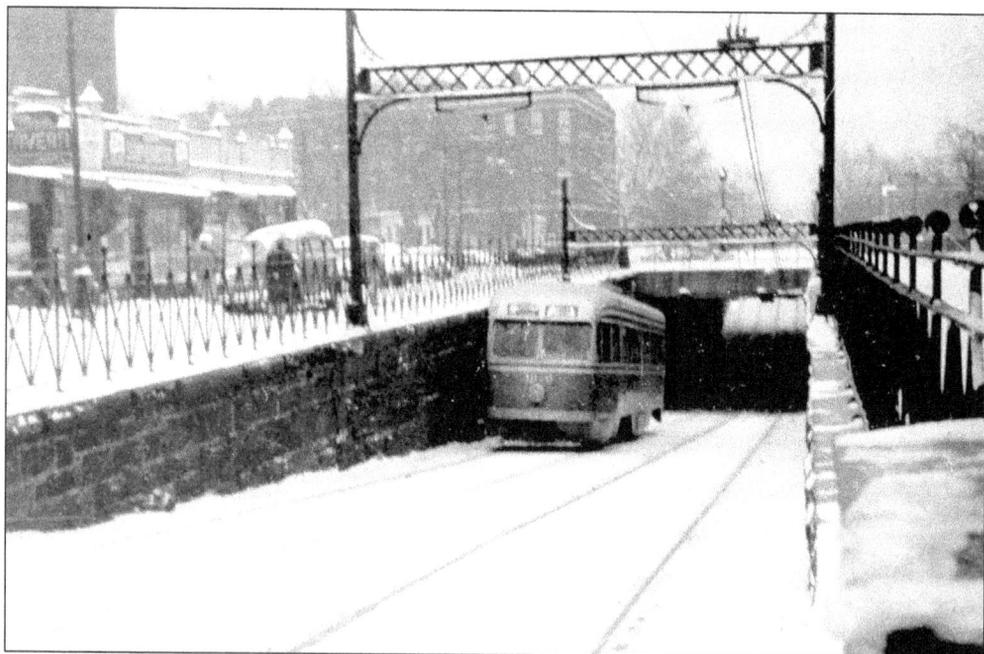

Church Avenue PCC No. 1070 is coming out of the Ocean Parkway underpass. Grade crossings of Ocean Parkway, which opened in 1876, were prohibited, so both the Long Island Rail Road and the street railway each built an underpass. Eastern Parkway, opened just a few years earlier, had a half-dozen streetcar grade crossings. The single-track underpass was widened for two tracks in 1912. (FP.)

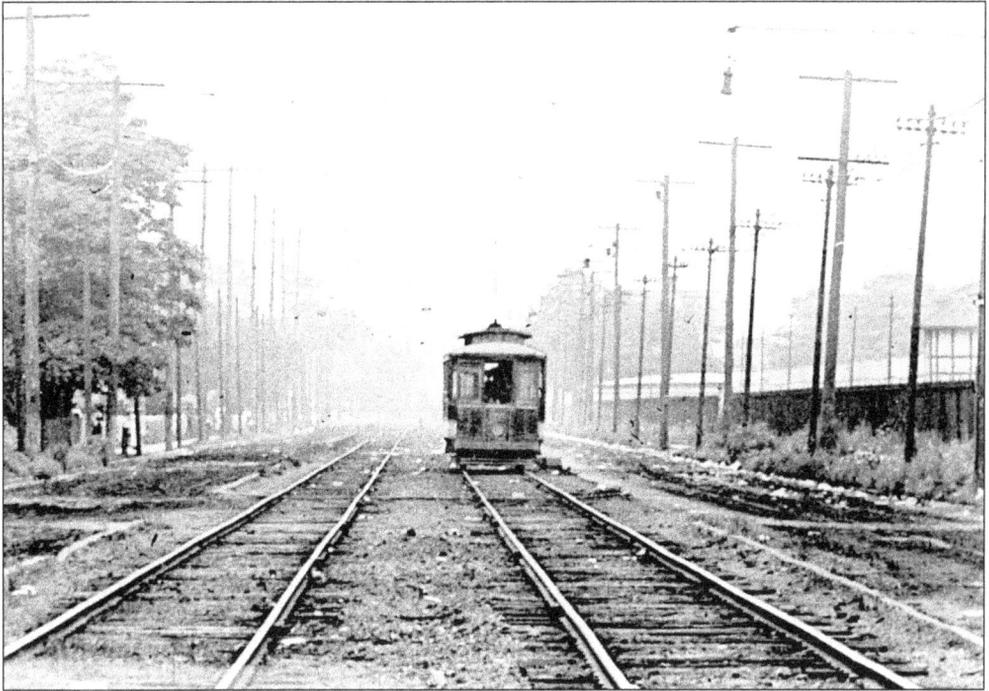

This car on Gravesend Avenue in 1915 is stopped next to the racetrack of the Brooklyn Jockey Club. The Gravesend racetrack covered the area south of Kings Highway and west of Ocean Parkway. The BRT also provided service to the Coney Island Jockey Club's Sheepshead Bay racetrack east of Ocean Avenue between Avenues W and Z and to the Brighton Beach racetrack east of Ocean Parkway and south of Neptune Avenue. (EBW/AJL.)

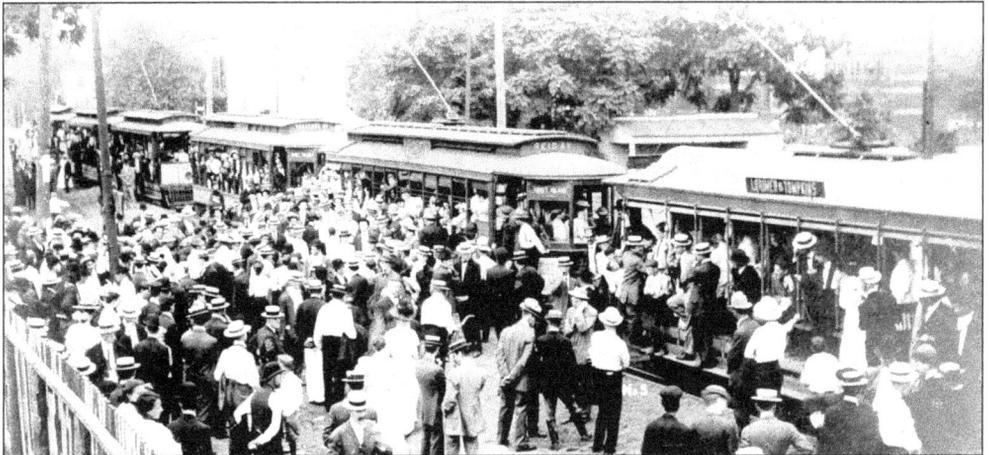

Open cars and crowds block Gravesend Avenue at Neck Road on August 12, 1906. When the railway company began collecting 10¢ for the trip to Coney Island based upon the original railroad franchises of the steam roads authorizing fares of 3¢ per mile, many riders refused to pay a second fare. Company employees tried to evict them from the cars, riots ensued, and nothing moved for over 12 hours. Ten years later, the legality of the second fare was still being discussed in Brooklyn courtrooms. (EBW/AJL.)

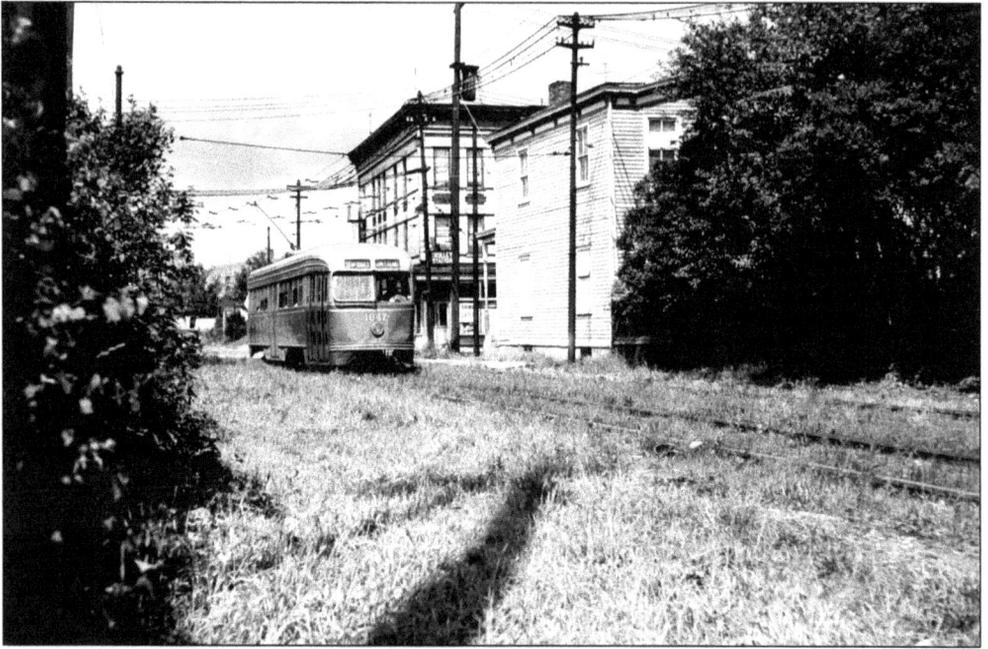

PCC No. 1047 is on the private right-of-way just east of Shell Road from Avenue X to the Culver terminal in Coney Island. Streetcars were rerouted to Shell Road in April and May 1940, and the right-of-way was abandoned on May 5, 1940, to facilitate construction of the Belt Parkway. (FP.)

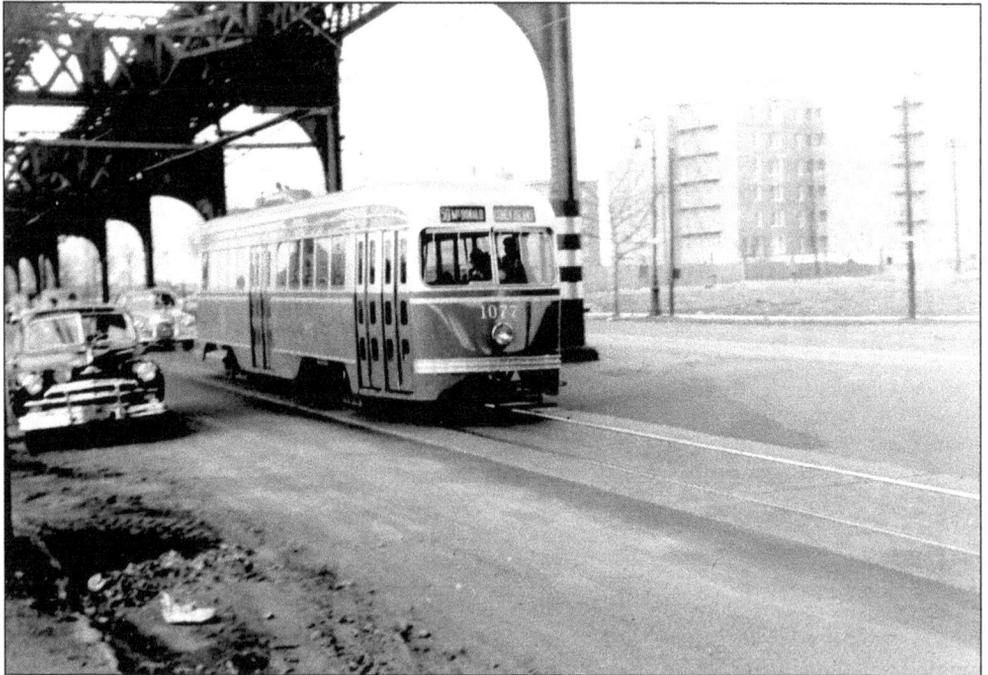

PCC No. 1077 is southbound on Shell Road just north of Shore Parkway. The Coney Island Causeway, opened in 1824, acquired the name of Shell Road because it was paved with crushed oyster and clam shells. (BERA, Walter J. Brunke photograph.)

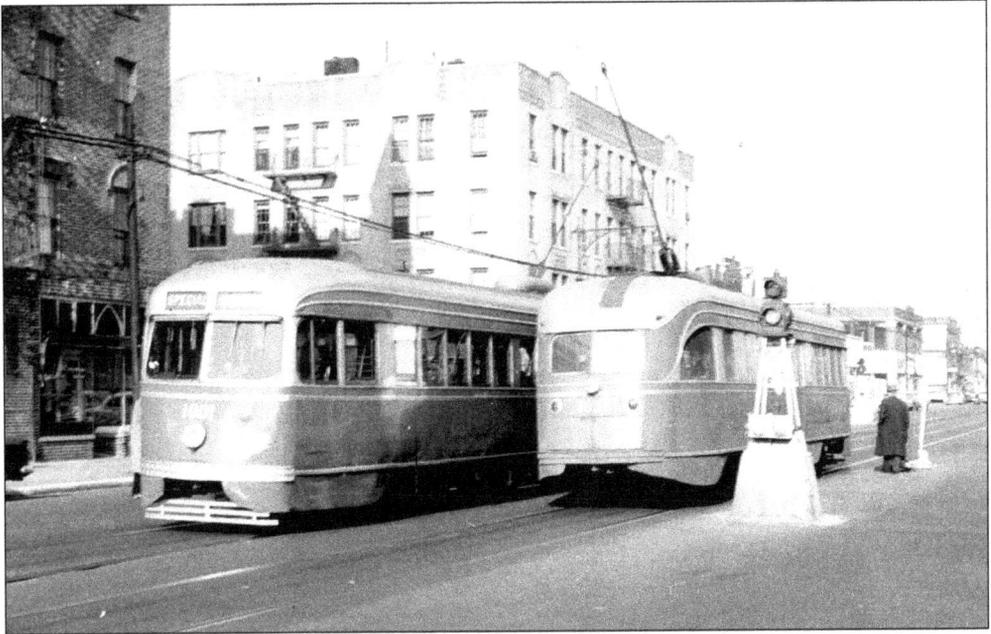

The second electric line to start operating in Kings County was also one of the last trolley lines to be discontinued. Coney Island and Brooklyn Railroad horsecars began operating in 1862 along the west side of the Coney Island Plank Road, which opened in 1850. On April 1, 1890, 12 bright yellow and orange electric cars began running from Park Circle south to Coney Island. By the time streetcars stopped running on November 30, 1955, service was provided by green and silver PCC cars like these passing at the Avenue N safety island. (FP.)

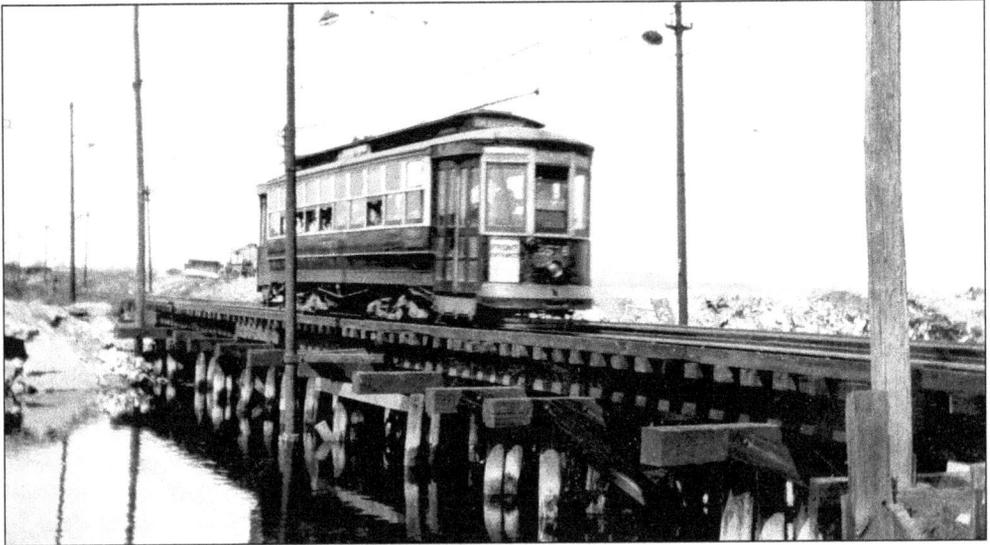

Semiconvertible (a car with windows lifting into roof pockets) No. 2578 is on the trestle over Coney Island Creek in 1933. In addition to the regular Gravesend/Culver service, cars from Court Street, Fifteenth Street, Myrtle Avenue (via Vanderbilt Avenue), Reid Avenue (via Church Avenue), and Tompkins Avenue (from Greenpoint via Lorimer Street, Bergen Street, Rogers Avenue, and Church Avenue) passed this way in summer carrying the crowds to Coney Island. (EBW/AJL.)

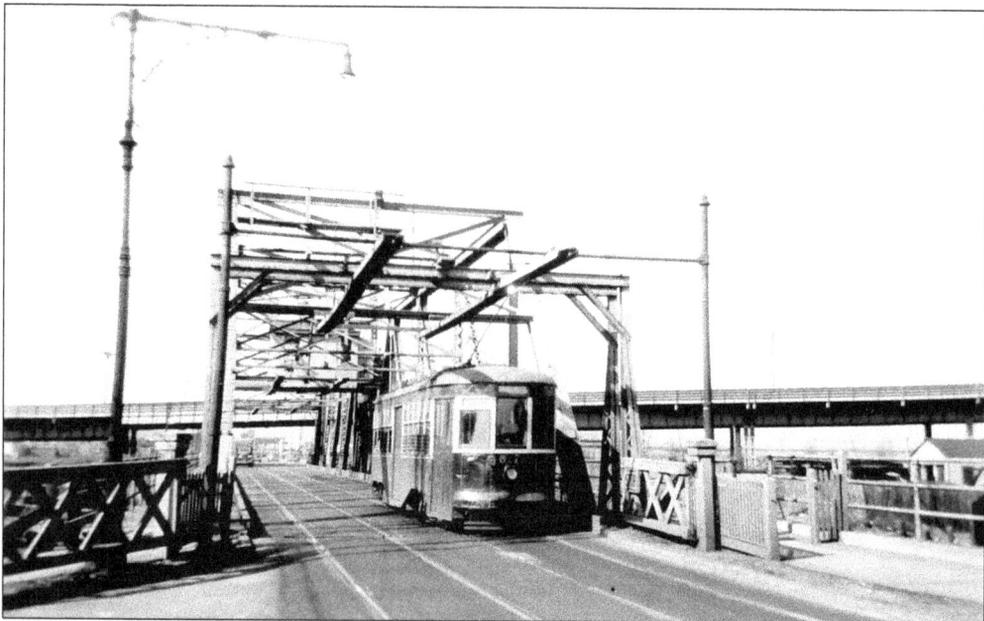

Car No. 8172 on the Eighty-sixth Street line crosses the Stillwell Avenue bridge on August 4, 1948. (EBW/AJL.)

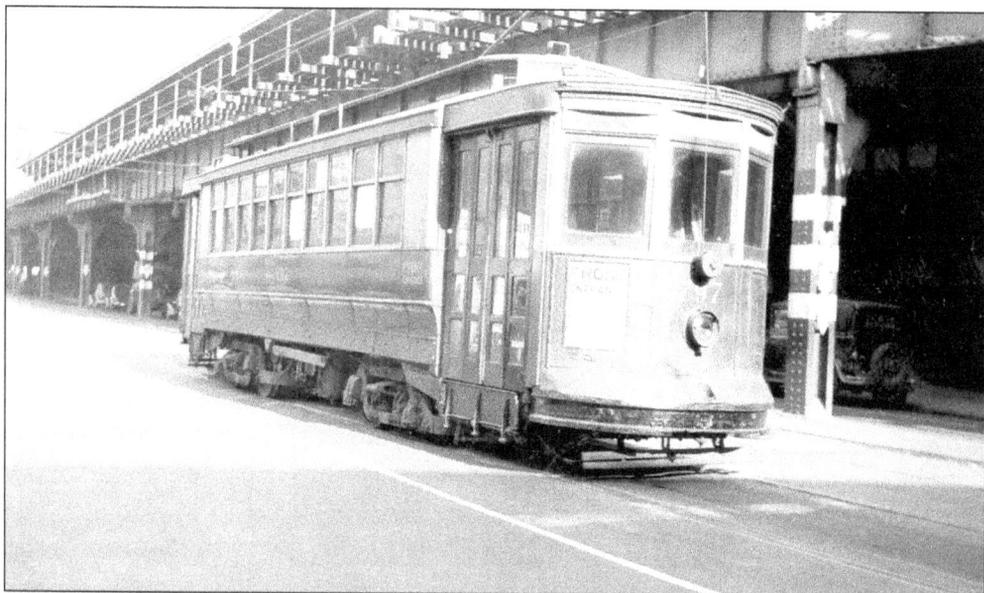

Two parlor cars, the *Amphion* and the *Montauk*, were built by Barney and Smith in 1894 for excursions to places like Coney Island. The cars were rebuilt as passenger cars to test the pay-as-you-enter method of fare collection. Both lasted long enough to be put back into revenue service during World War II. No. 797 (ex-*Amphion*) sits on Stillwell Avenue next to the Coney Island subway station. (EBW/AJL.)

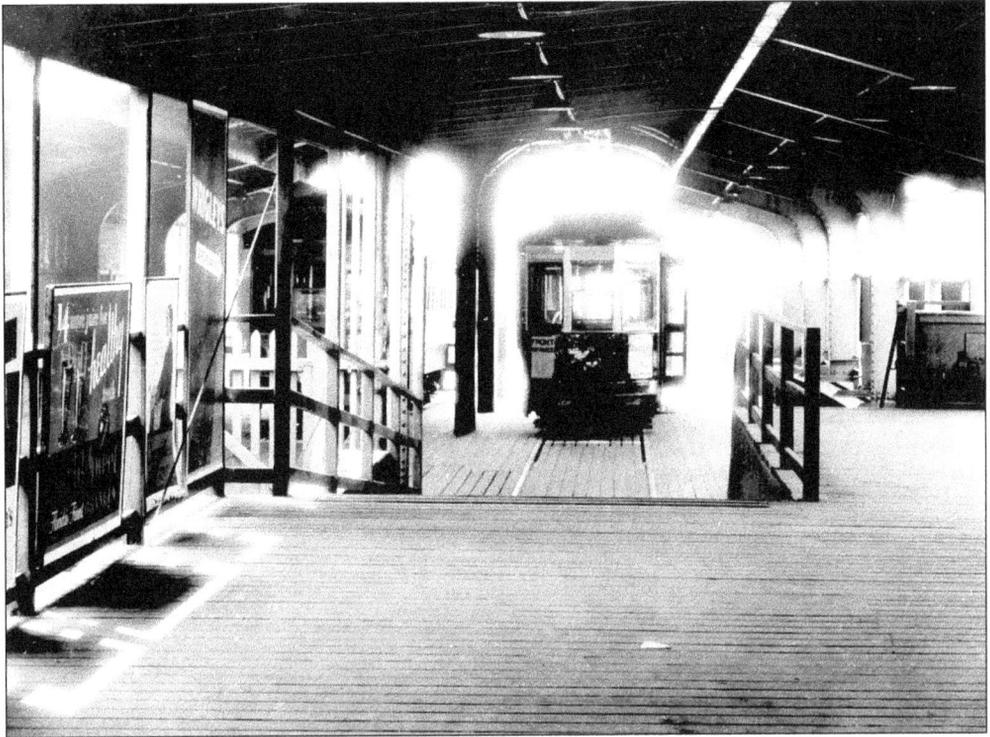

Norton's Point No. 2599 is at that line's terminal platform at the south end of the upper level of the Stillwell Avenue station in 1931. (EBW/AJL.)

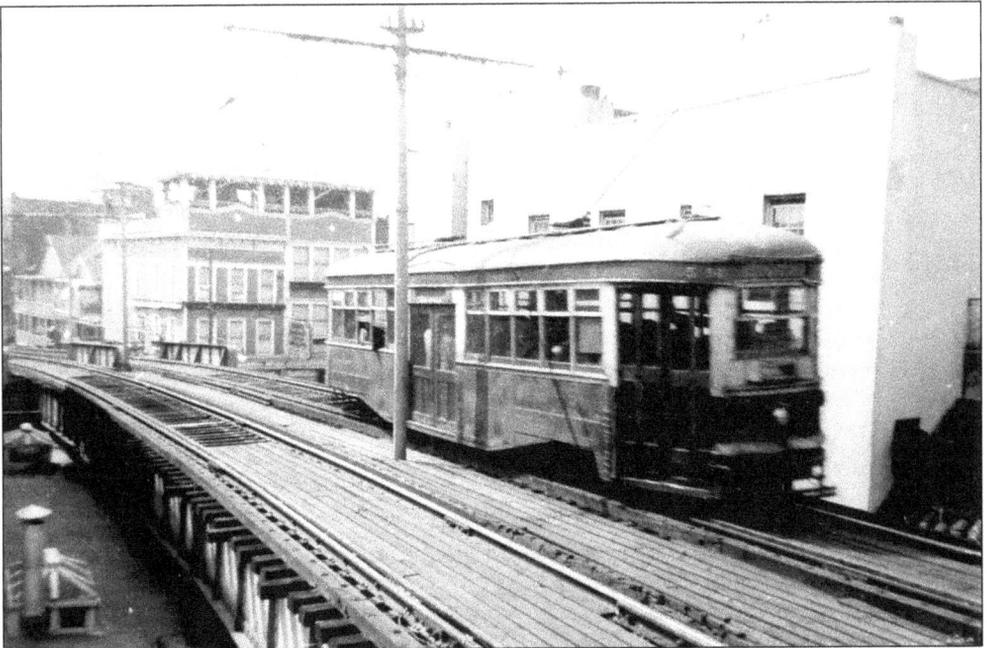

No. 5084 heads down the ramp from the upper level of the Stillwell Avenue station. The ramp went into service when the new subway station opened in 1918 and remained in use until the Norton's Point line was replaced by buses on Mermaid Avenue on August 7, 1948. (EBW/AJL.)

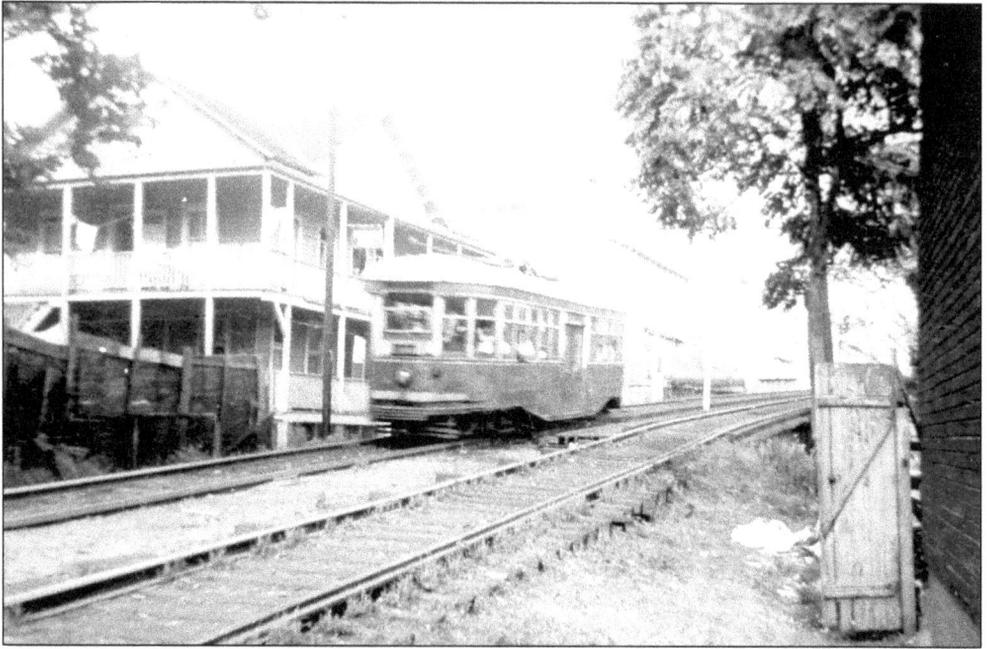

Originally operated as an extension of the steam railroads running to Coney Island, streetcars on the Norton's Point line did not replace the elevated trains running on the surface until July 3, 1910. No. 5096 is one of 20 rebuilt center-entrance cars that remained double ended specifically for use on this line. It is seen here in 1946 on the private right-of-way midway between Mermaid and Surf Avenues. (EBW/AJL.)

Mike Norton opened an entertainment pavilion in the 1840s at the west end of Coney Island that became notorious for various socially unacceptable activities. In 1892, the land was acquired by the Norton's Point Land Company, then sold to the Sea Gate Association in 1899. Nine hundred homes but no stores were built on Sea Gate's 43 blocks. A shuttle car ran within the gated community from May 25, 1918, until replaced by a bus on March 20, 1933. During World War II, No. 5099 returned to the Norton's Point shuttle from June to October 1943. (EBW/AJL.)

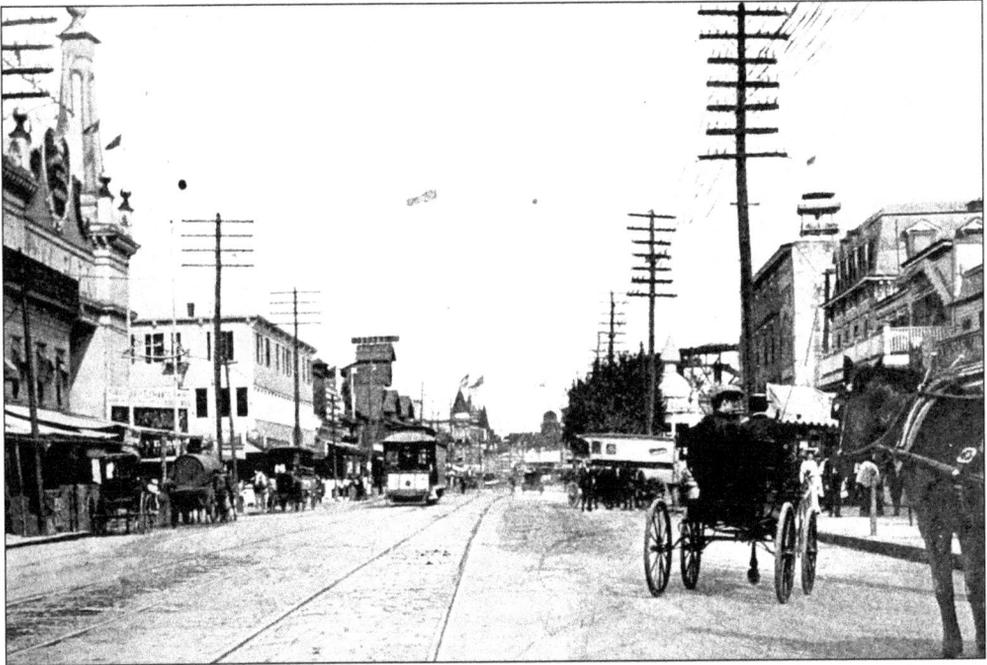

The car line from West Thirty-seventh Street to Sheepshead Bay via Surf and Neptune Avenues was built by the Coney Island and Gravesend Railway in 1897. No. 792 is on Surf Avenue in mid-1905 when there was decent patronage and extra service to Brighton Beach and Manhattan Beach. During the off-season, there was little need for the Sea Gate line as most riders from the west end of Coney Island used the Norton's Point cars less than a block away. In 1901, one car running every 40 minutes was all that was needed in winter. (EBW/AJL.)

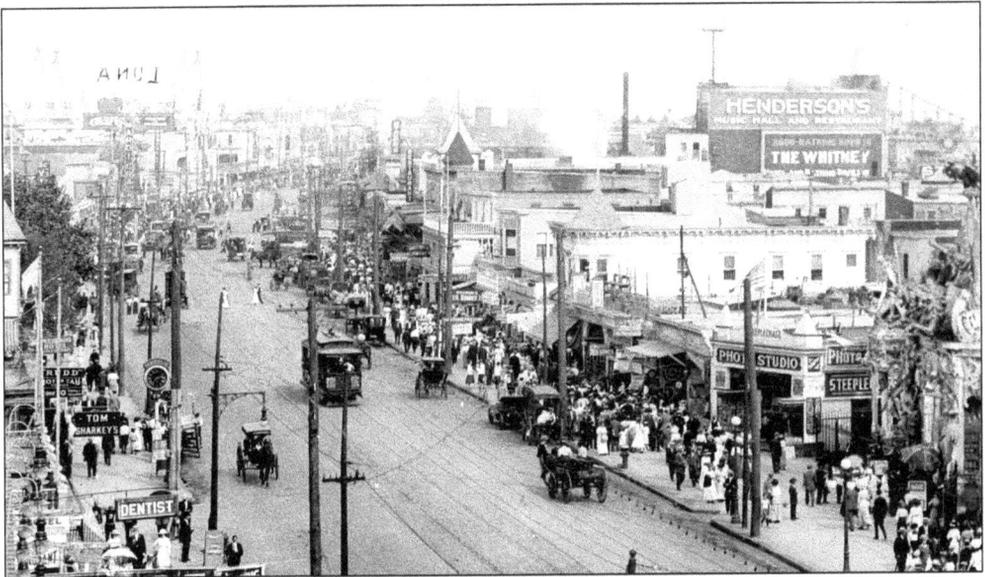

This Surf Avenue scene from about 1914 features Luna Park (opened in 1903) at West Tenth Street with 90,000 daily visitors, Dreamland (opened in 1904) at West Eighth Street, George C. Tilyou's Steeplechase at West Sixteenth Street, the ocean, and the beach. In 1915, 50 men were arrested in Coney Island for topless bathing. (EBW/AJL.)

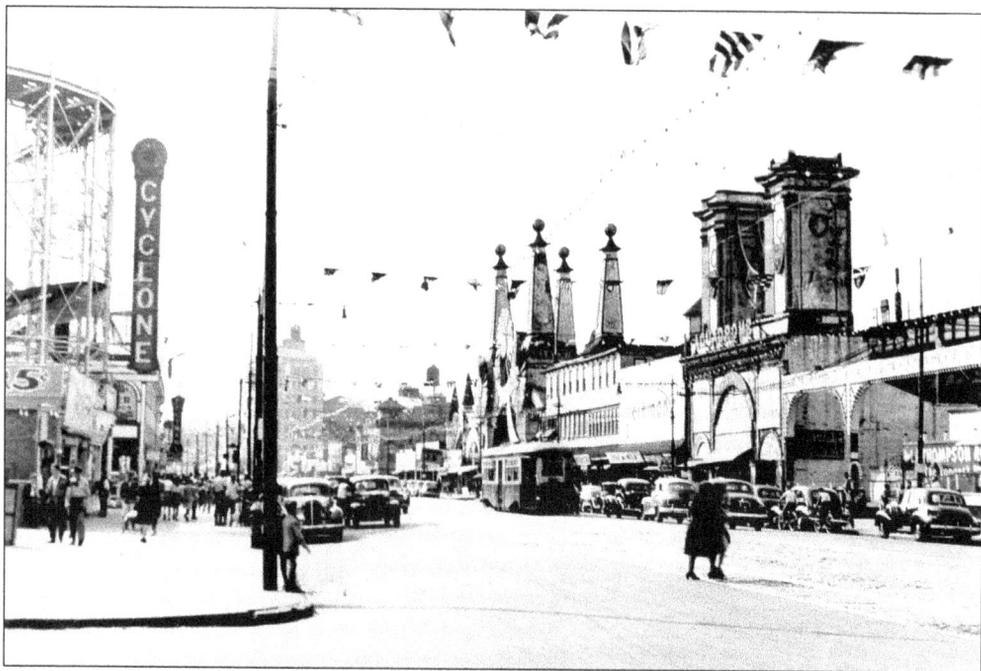

This view of Surf Avenue on September 11, 1946, shows Coney Island's still evolving entertainment area. The Parachute Jump arrived from the world's fair in time for the 1941 season. Luna Park, Coney Island's premier amusement venue, burned and closed in 1949. Sea Gate trolleys on Surf Avenue were replaced by buses on December 1, 1946. (EBW/AJL.)

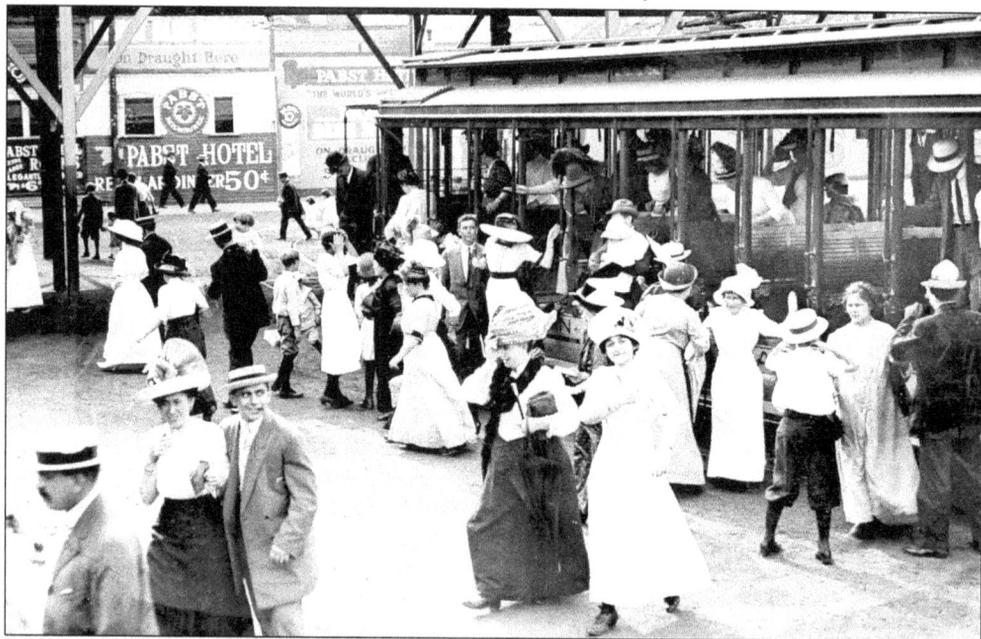

Union Street open car No. 1010 is at the Culver terminal in 1913. With all the existing entertainment facilities in place at Coney Island, Bergen Beach, Canarsie, and North Beach, the BRT did not incur major expenses in building and maintaining its own amusement parks. It may have been the only street railway in America in such a fortunate position. (EBW/AJL.)

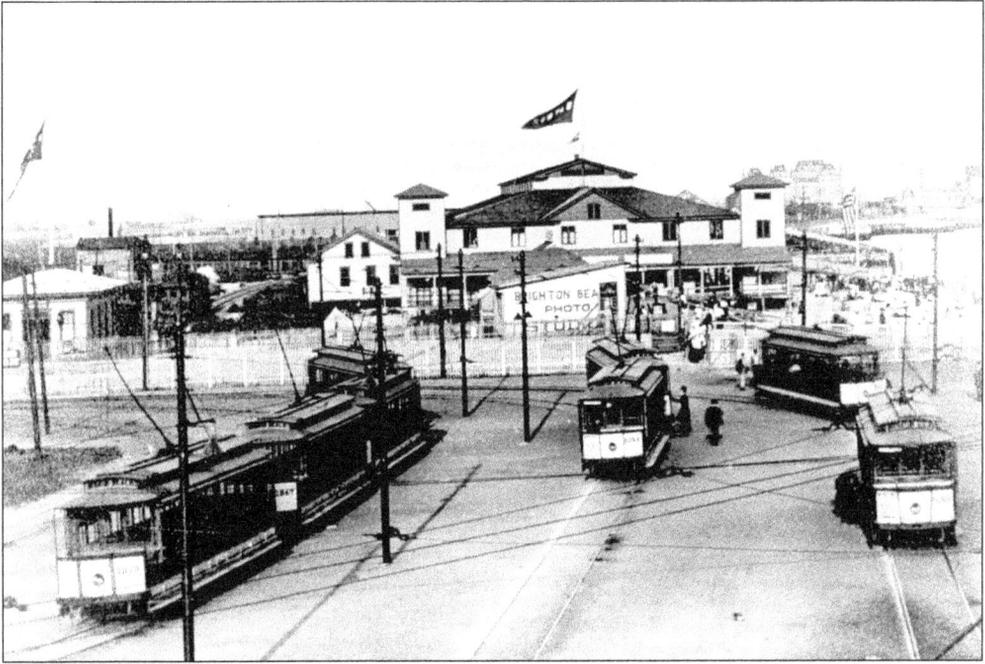

Eight open cars loop at the Brighton Beach trolley terminal in 1901. The Marine Railway car and locomotive at the left ran a half mile eastward to a connection with the Long Island Rail Road's Manhattan Beach branch. A single open trolley served this line after 1905. (EBW/AJL.)

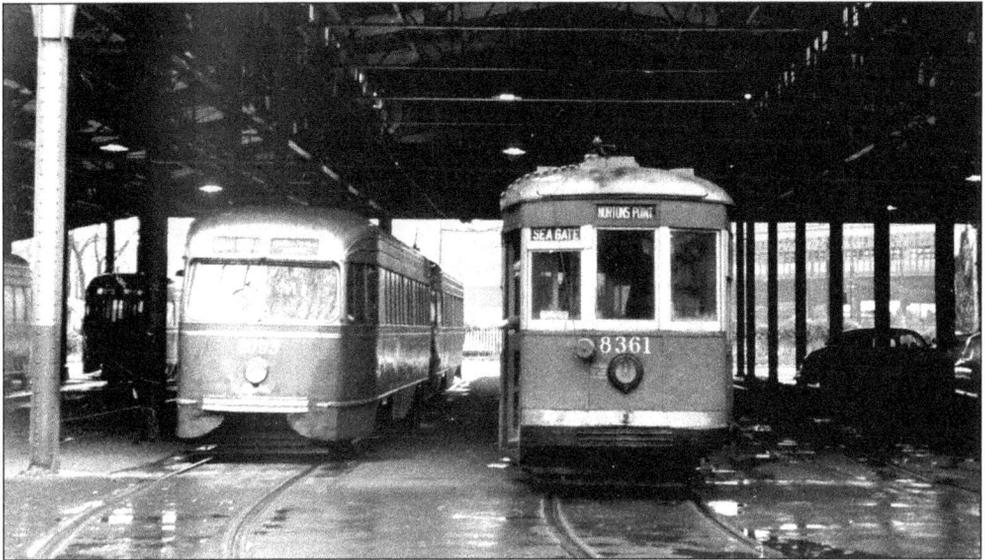

No. 1093 and No. 8361 are at the Coney Island and Brooklyn Railroad terminal on West Fifth Street. The terminal was built in 1912 with seven loop tracks. Inside was the largest merry-go-round in Coney Island, a waiting room, an incline to a rooftop restaurant, and a lunch room–kitchen "so employees do not have to pay exorbitant resort food prices." Just north of the site was a 17-track barn for winter storage of open cars. A concrete floor allowed the barn to be used as a parking garage in summer, which made it easy to convert it into the Neptune Avenue bus garage in 1946. (FP.)

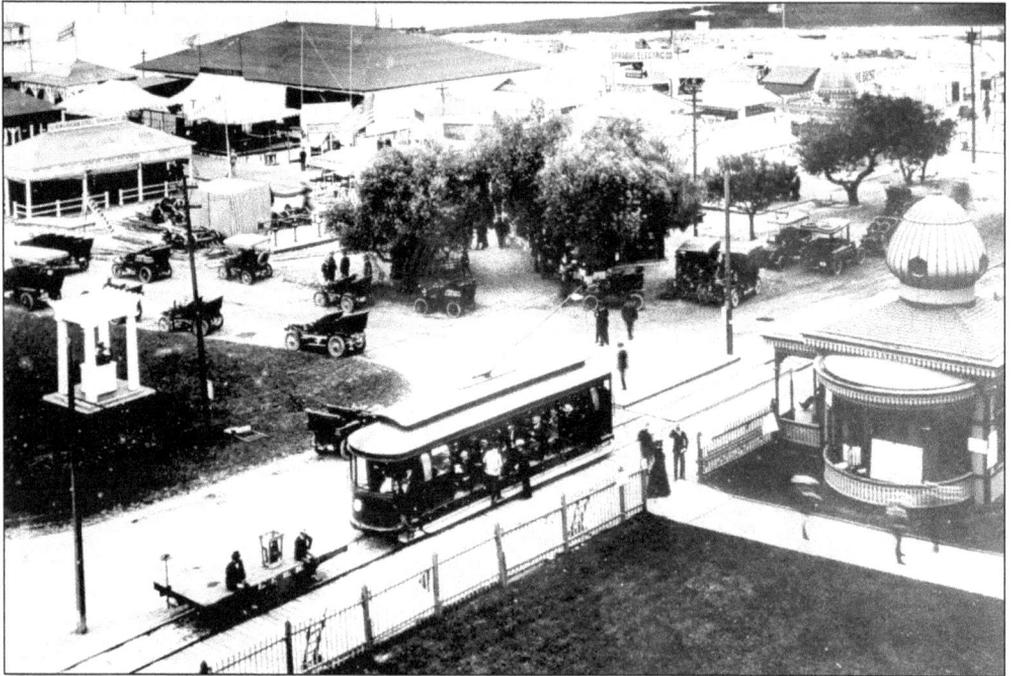

The Long Island Rail Road operated a steam railroad into Manhattan Beach. In 1906, streetcars were put in service from Langham Street via Oriental Boulevard and West End Avenue to the Sheepshead Bay station of the Brighton line at Voorhies Avenue. Sheepshead Bay is beyond the trade fair in the foreground. (EBW/AJL.)

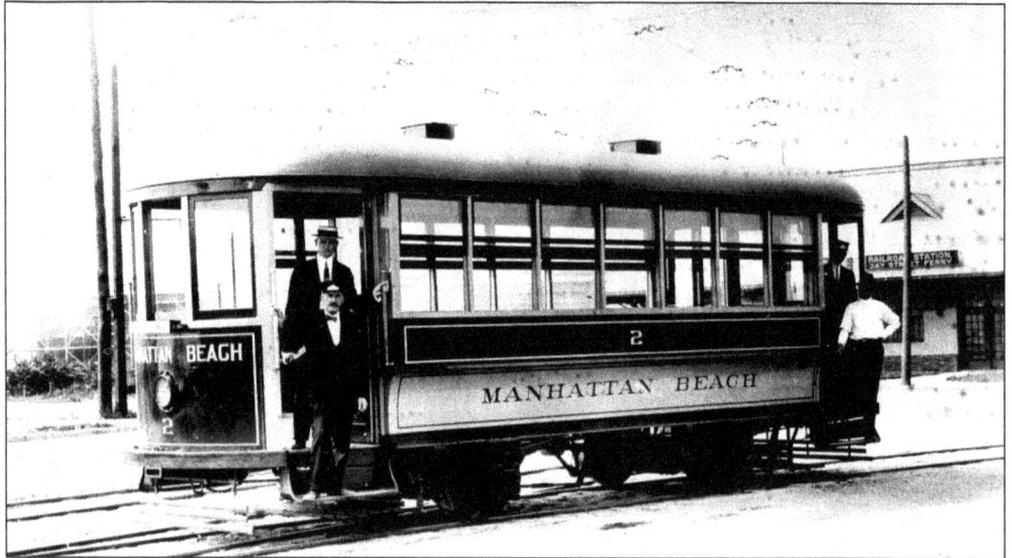

Not wanting its elite community defaced by unsightly overhead wires, Manhattan Beach Park Inc. replaced the trolleys on August 7, 1913, with battery cars. The line was rerouted on April 7, 1921, via Oriental Boulevard, Corbin Place, and Brighton Beach Avenue to Coney Island Avenue and the Brighton Beach subway station. On June 10, 1923, the railway quit, yielding to the competing Plumb Beach Auto Stage (established in 1919) running to the Sheepshead Bay station. (EBW/AJL.)

Three

UP FROM THE BAY

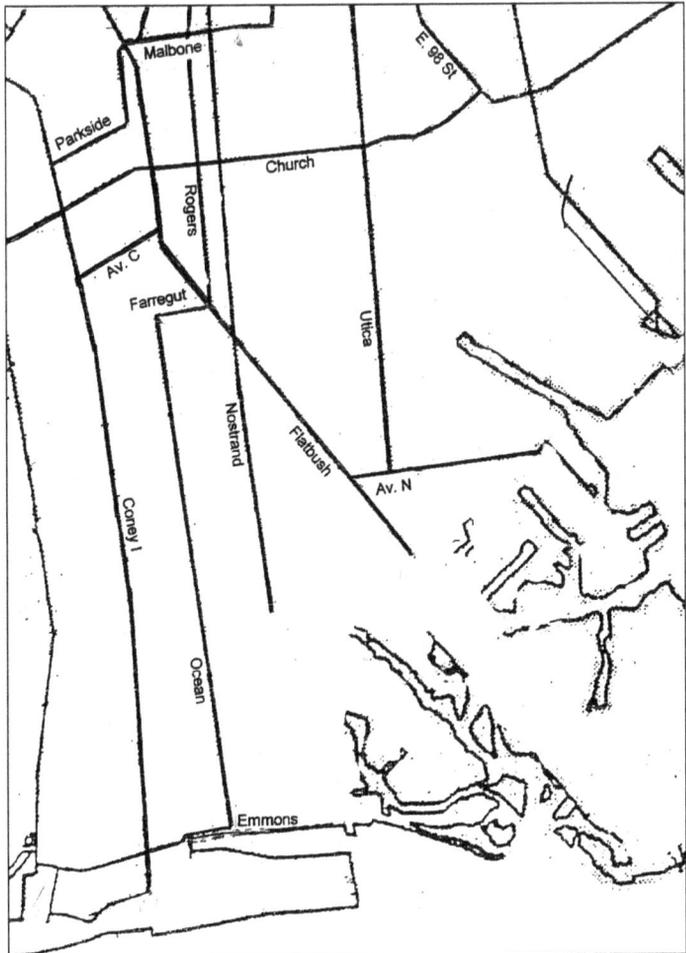

This map shows
the communities of
Manhattan Beach,
Sheepshead Bay,
Midwood, Flatlands,
and Flatbush.

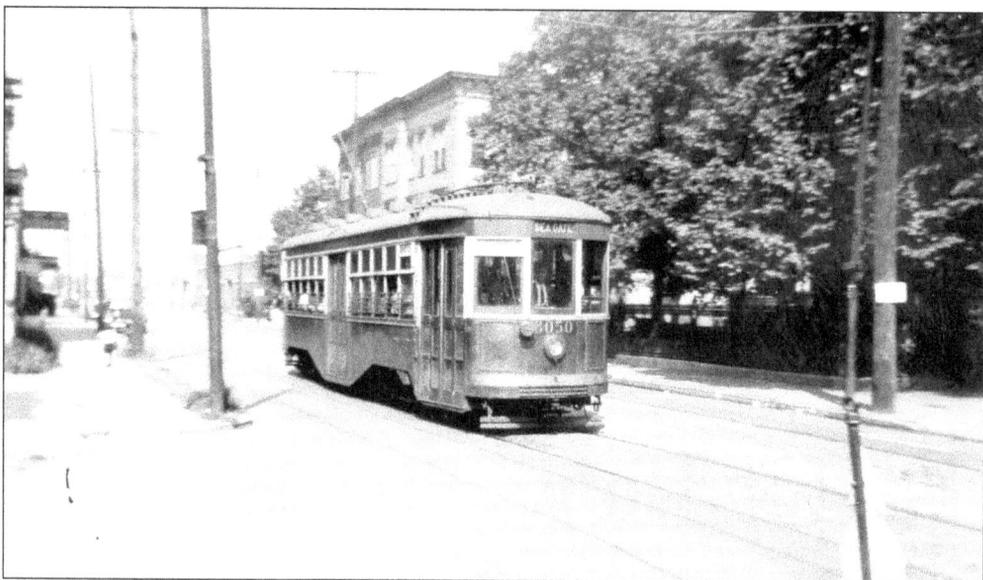

No. 8050 travels along Neptune Avenue between Coney Island and Sheepshead Bay. Marcy Avenue cars originating in Williamsburg ran through here as the Manhattan Beach line in 1896 and the Broadway ferry–Coney Island line in 1897–1899. (BERA, Karl F. Groh Jr. photograph.)

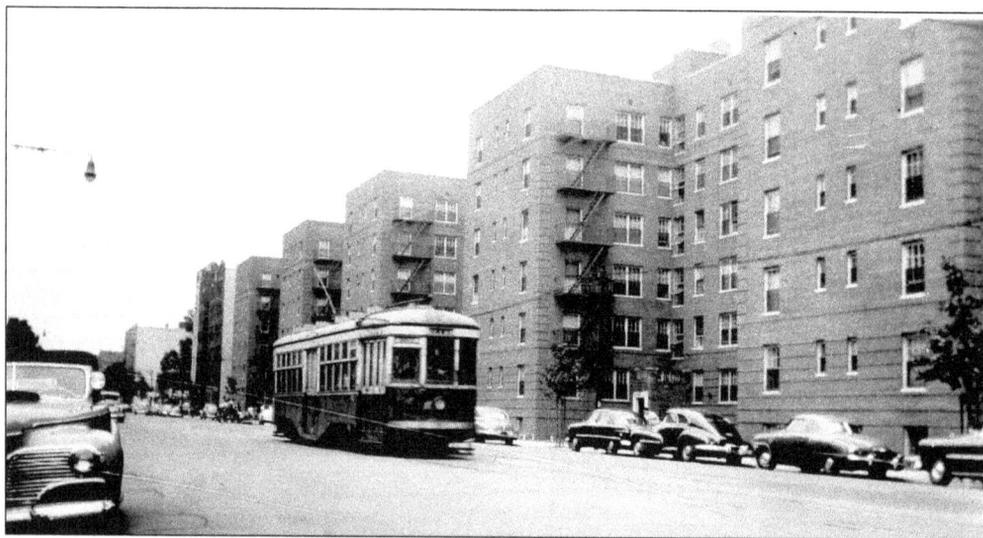

No. 8346 passes through a canyon of apartment buildings on Ocean Avenue at Avenue T on August 24, 1950. Streetcars arrived on this street on July 28, 1895, when the Nassau Electric Railroad opened its Marcy Avenue line running from the Broadway ferry to Sheepshead Bay. Cars went to Coney Island until 1899, when the line was renamed Ocean Avenue and cut back to Emmons and Ocean Avenues. This remained the terminus until buses replaced the trolleys on April 29, 1951. (EBW/AJL.)

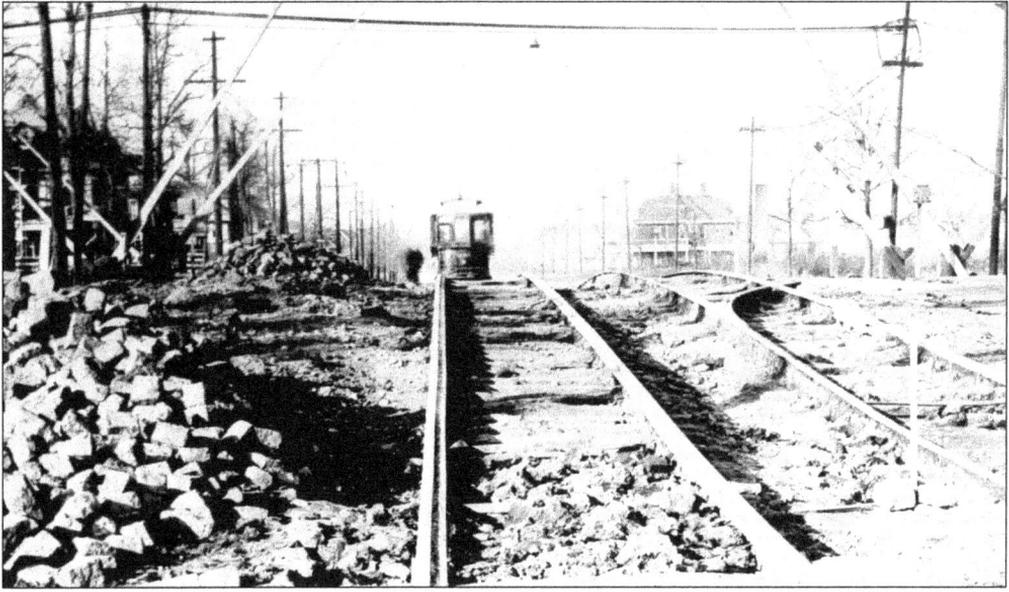

No. 1195 is on Ocean Avenue at the Long Island Rail Road on December 26, 1906, as work to eliminate the grade crossing begins. The street was opened in 1876, but the area south of Avenue C remained vacant for another three decades. Many accidents occurred at Ocean Avenue and Avenue I, as motormen always operated fast to make up schedule time. W. E. Harman began the development of the neighborhood in 1913 with the opening of East Midwood around Avenue J. (EBW/AJL.)

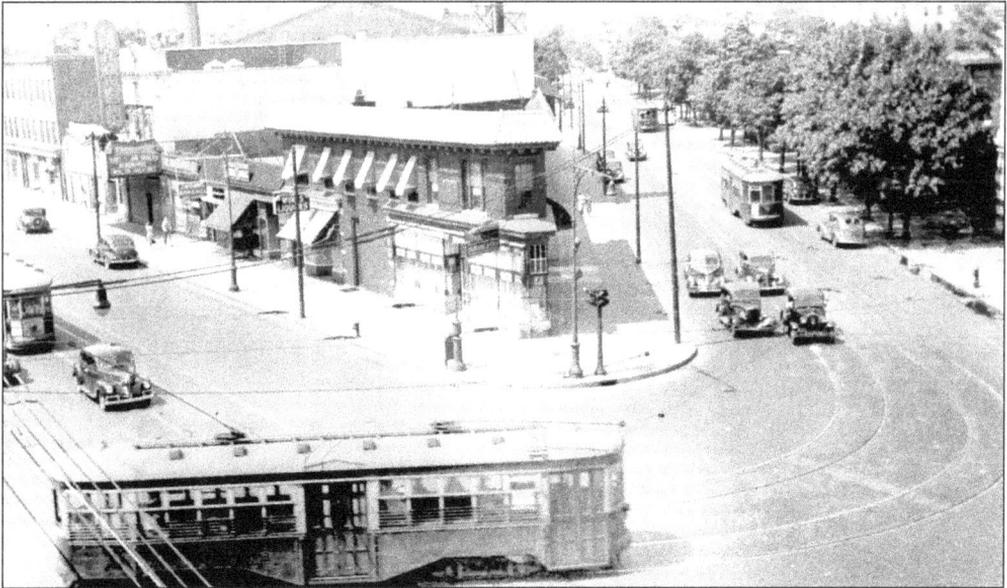

Ocean Avenue car No. 8114 on Farregut Road crosses Flatbush Avenue and follows two other cars up Rogers Avenue on Sunday, July 14, 1940. Heavy passenger traffic to Sheepshead Bay was normal on summer weekends, and many riders walked over the footbridge across the bay to Manhattan Beach. Between 1914 and 1920, a separate Rogers Avenue service operated from this intersection to downtown via Sterling Street, Washington Avenue, and Atlantic Avenue. (EBW/AJL.)

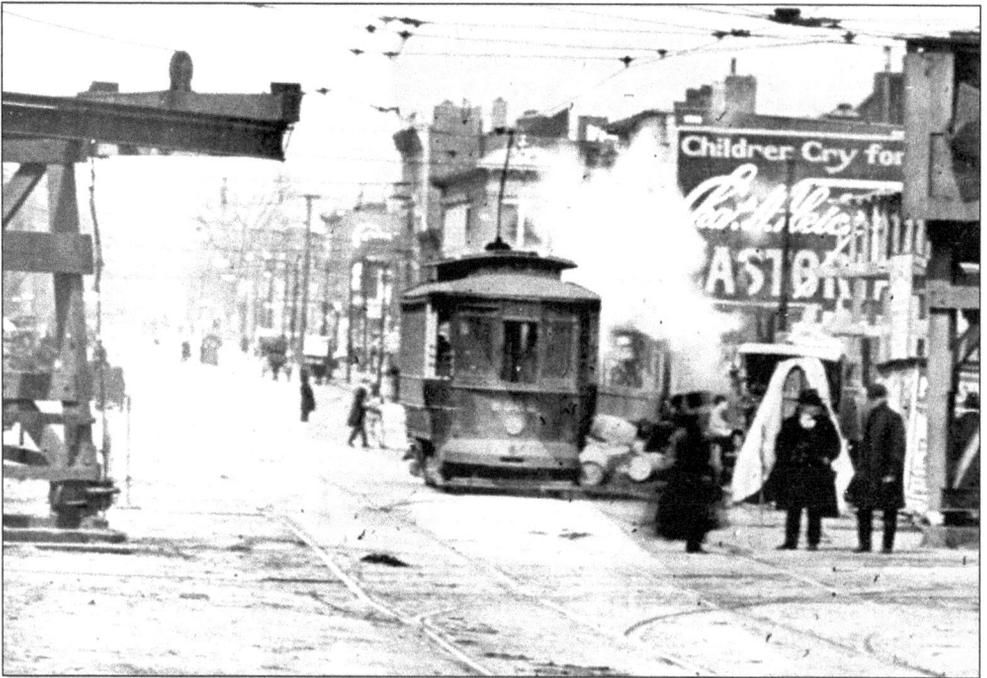

No. 2925 is at Flatbush and Nostrand Avenues in 1917. Until the IRT subway opened in 1920 and spurred development of the neighborhood, the surrounding area was mostly truck farms growing produce for the city's markets. (EBW/AJL.)

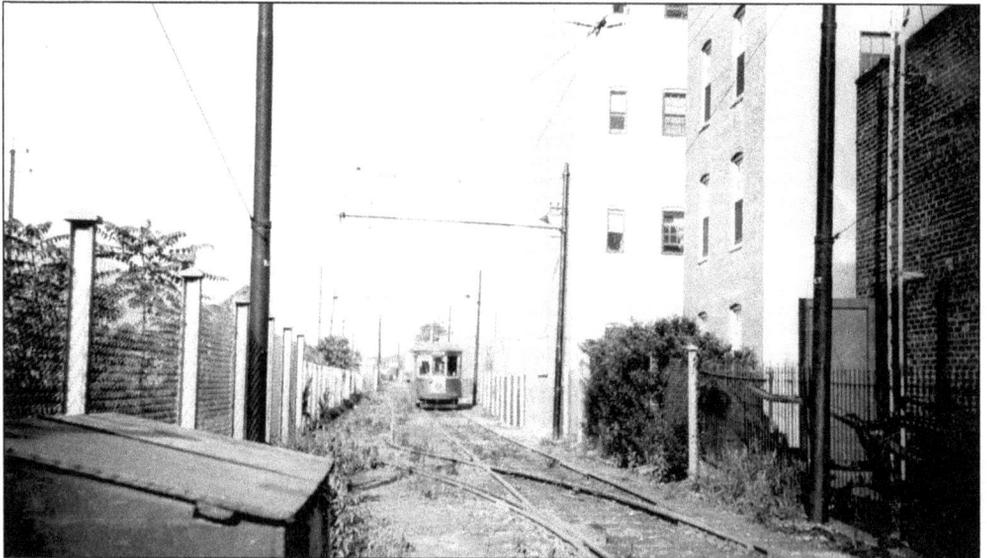

Nostrand Avenue shuttle No. 8003 is on the right-of-way on the south side of the Long Island Rail Road between Flatbush and Nostrand Avenues in 1938. This piece of track was one side of a triangular loop built in 1936 for cars terminating at "the Junction." (EBW/AJL.)

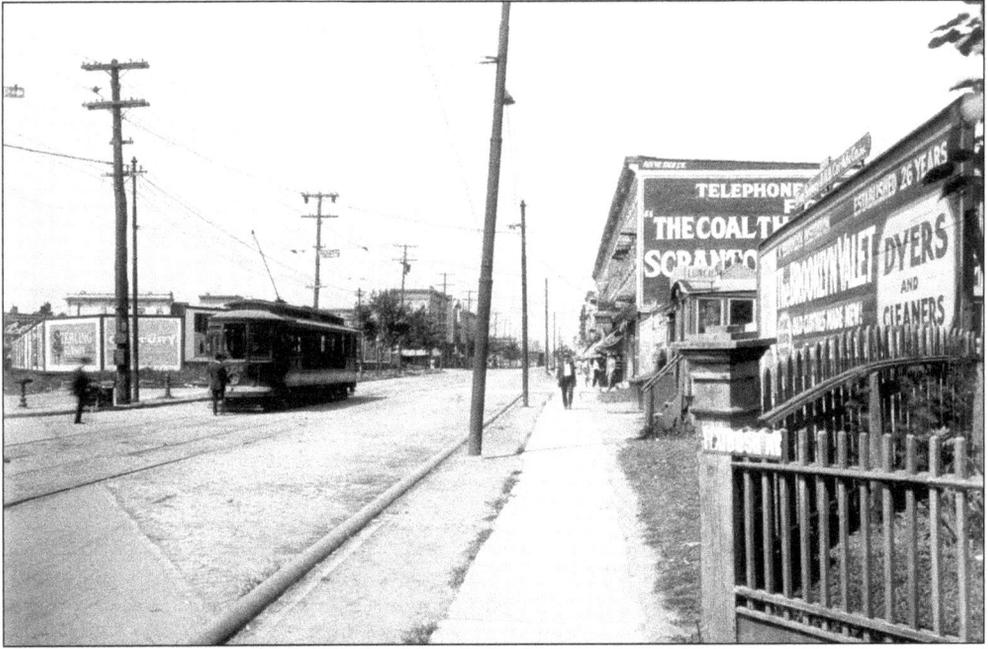

Nostrand Avenue convertible No. 4336 changes ends at Flatbush Avenue in 1916. Nostrand north of Malbone Street (Empire Boulevard) was electrified in 1894 and extended to Flatbush Avenue on July 15, 1895. Extensions opened to Kings Highway in 1909 and Avenue U in 1917 but operated as a separate line until October 28, 1945. (EBW/AJL.)

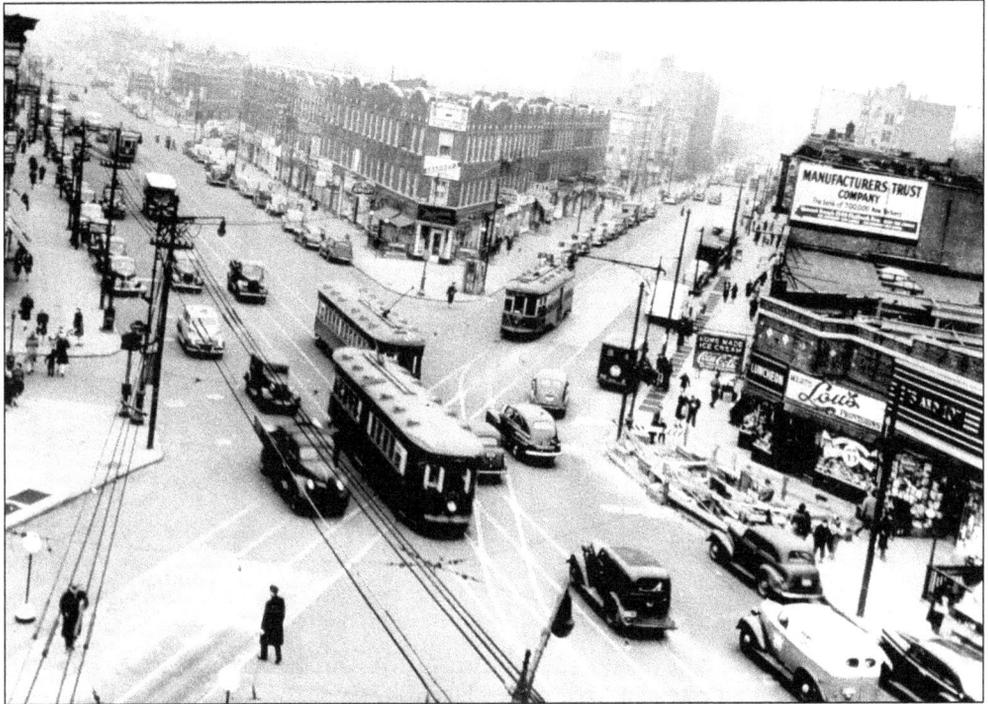

Two Flatbush Avenue 6000-series cars of 1930 vintage pass in front of No. 8248 on Nostrand Avenue at "the Junction" in 1949. (EBW/AJL.)

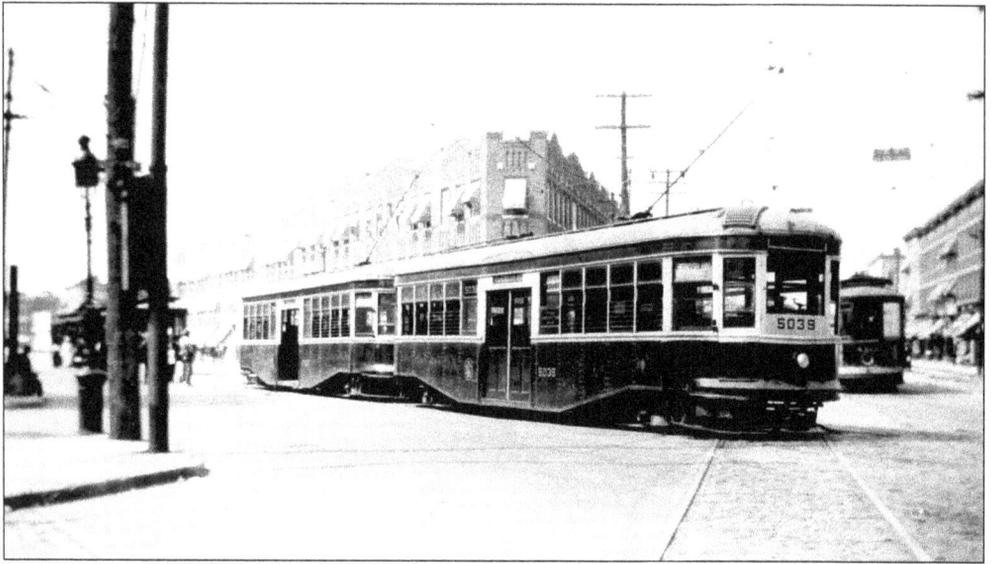

A northbound two-car train of 1913 center-entrance cars is on Flatbush Avenue at Nostrand Avenue in 1920, one year after being modified for multiple-unit operation. These cars were three feet longer and five inches wider than any of the older cars in Brooklyn and had wider aisles and seats. Electrically operated fare registers could ring up 200 fares per minute, even though the cars could load only 22 passengers in that time. There were fewer accidents with these cars as the door was always watched by the conductor and had to be closed for the car to move. (EBW/AJL.)

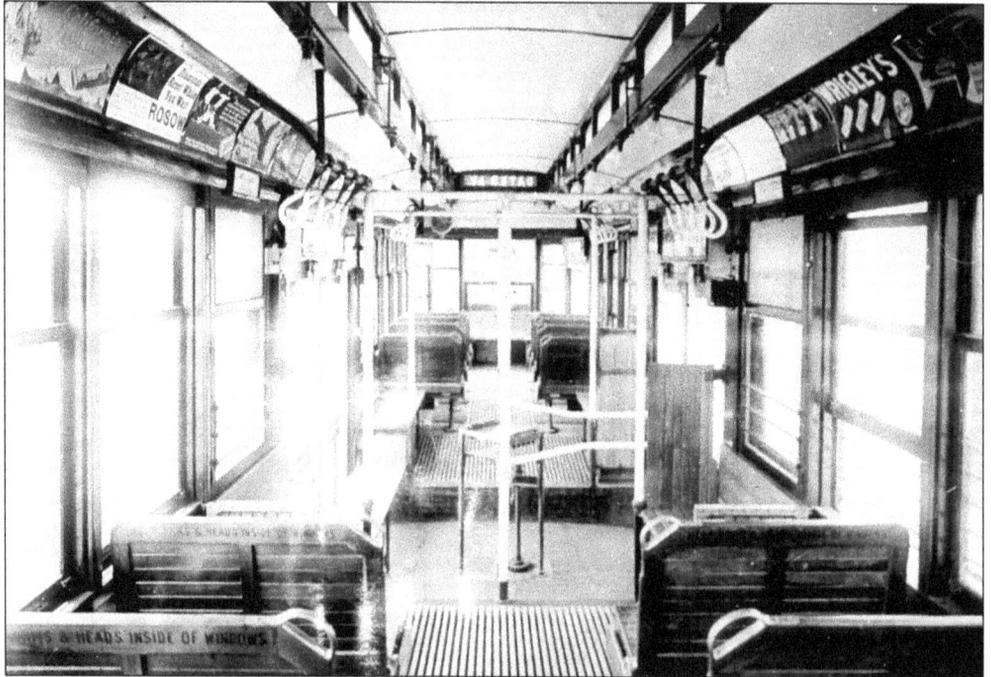

This is the interior of a center-entrance trailer. Flatbush Avenue was also served by two-car trains of one trailer like this towed by a convertible. During rush hour, Flatbush cars ran on a 40-second headway. (BERA.)

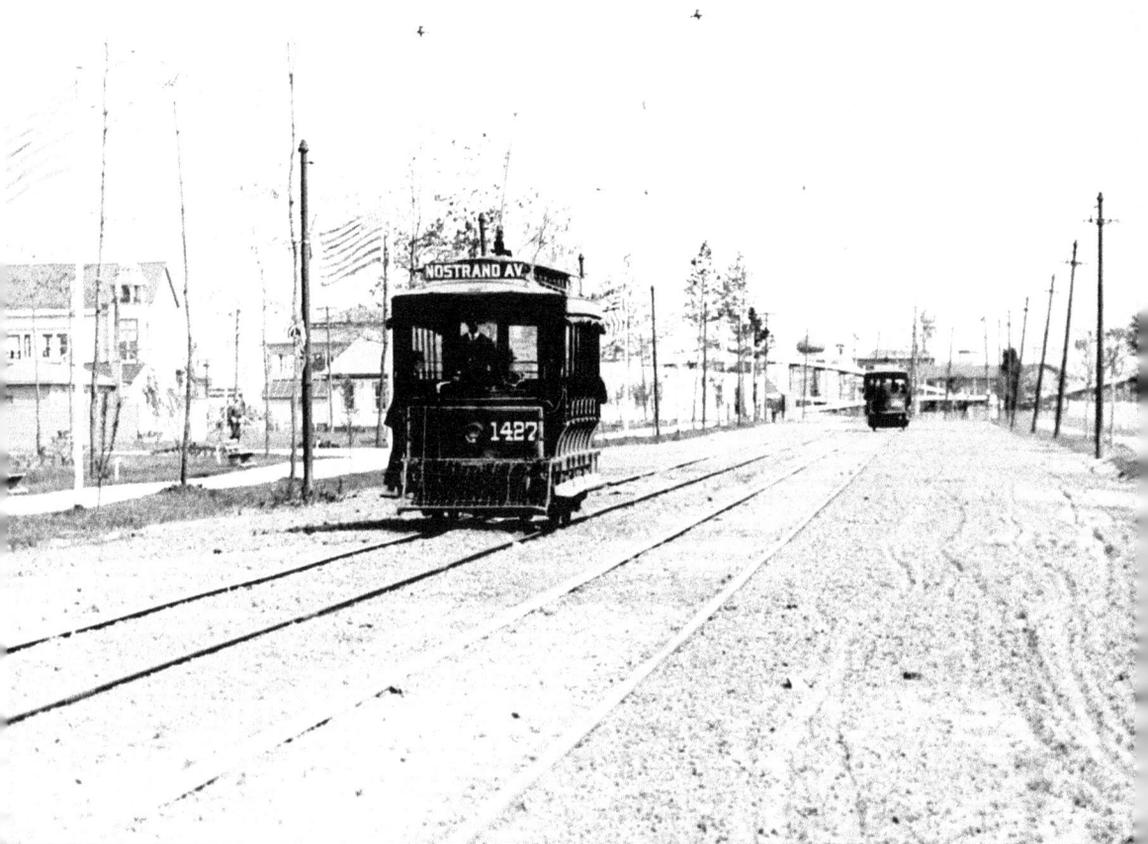

Nostrand Avenue open car No. 1427 is at Bergen Beach in 1898 with No. 1425 in the distance. The amusement park here was built by Percy Williams and Thomas Adams (of Chicklets gum fame) with the understanding that the Flatbush Avenue car line would be extended from Kings Highway to the park. In 1896, Bergen Beach featured a glass-enclosed pier, a casino, a children's theater, free vaudeville, puppets, a maze, bands, a Ferris wheel, and a saltwater pool. Five lines provided trolley service every three minutes on summer Sundays. (EBW/AJL.)

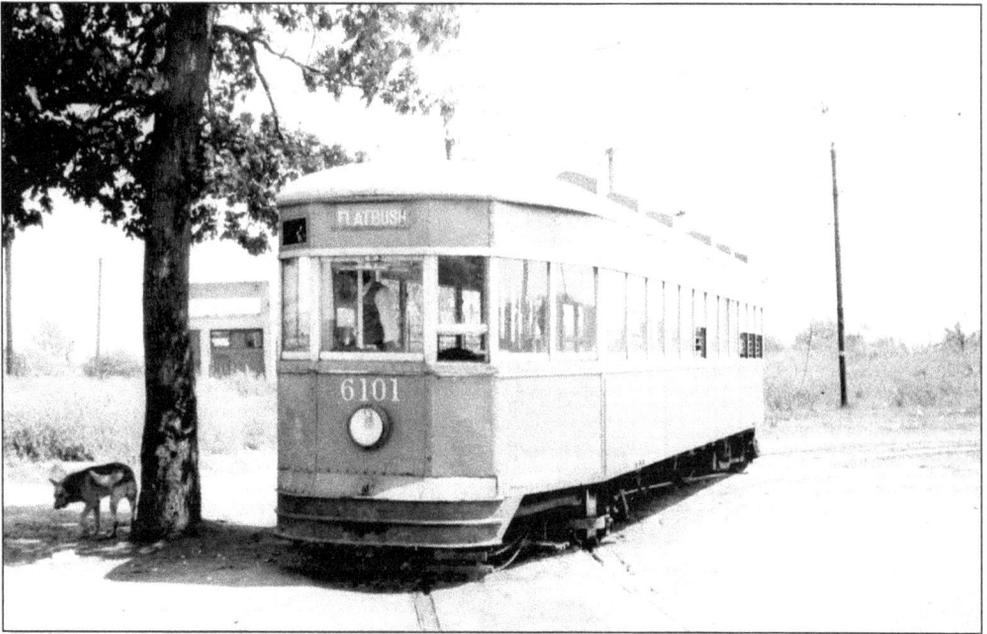

The Brooklyn City Railroad began operating horsecars from Fulton Ferry to Vernon (Tilden) Avenue in the town of Flatbush on July 1, 1860. Extensions were opened to Foster Avenue in 1891, Nostrand Avenue in 1892, and Kings Highway when the line was electrified on March 13, 1893. Trolleys ran to Bergen Beach at East Seventy-sixth Street and Avenue X between 1896 and 1920, and service was provided to the National Lead Company smelting plant on Mill Island from 1916 to 1929. When new single-ended cars were ordered in 1930, a loop was built at East Seventy-first Street, Avenue U, and Island (Veterans) Avenue where No. 6101 is turning on August 22, 1948. (EBW/AJL.)

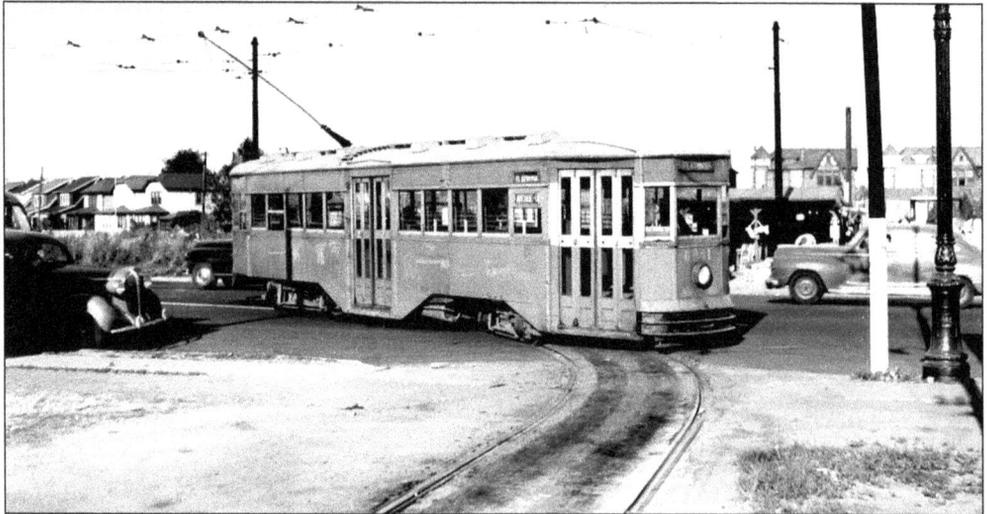

No. 6041 enters the 1938-built loop at Flatbush Avenue and Avenue U in 1950. The outer ends of the Flatbush Avenue line were first served by shuttle cars. Bergen Beach cars ran east from the depot on Avenue N at East Forty-ninth Street. Another Flatbush shuttle started running on March 23, 1917, from Avenue N to Avenue U. Shuttle cars were extended to Nostrand Avenue in 1919 and through-routed to downtown in 1925. (EBW/AJL.)

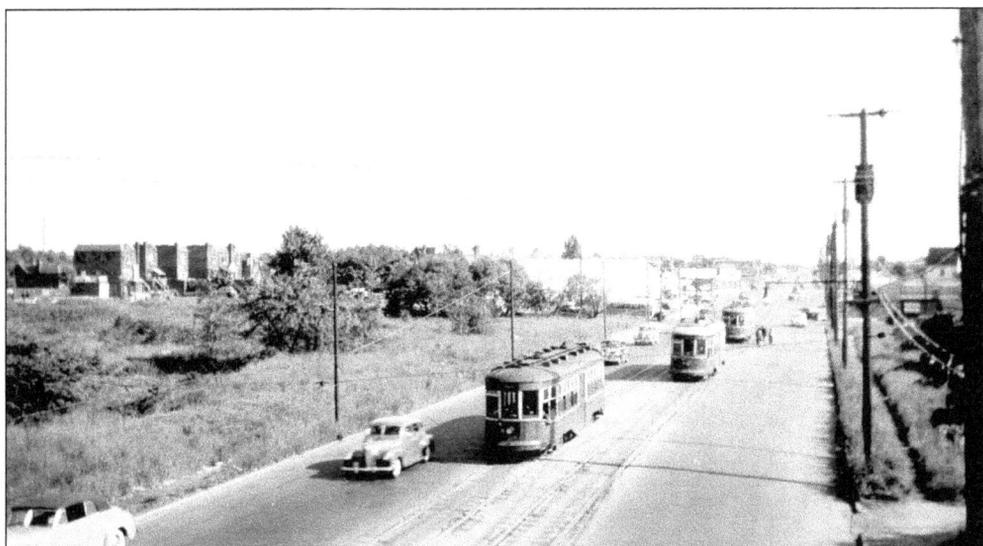

In 1898, Utica Avenue was extended south 7,996 feet from the old Flatbush-Flatlands town line. Half a century later on May 21, 1949, three Utica-Reid Peter Witt cars can be seen in the same area from the Long Island Rail Road overpass near Kings Highway. (EBW/AJL.)

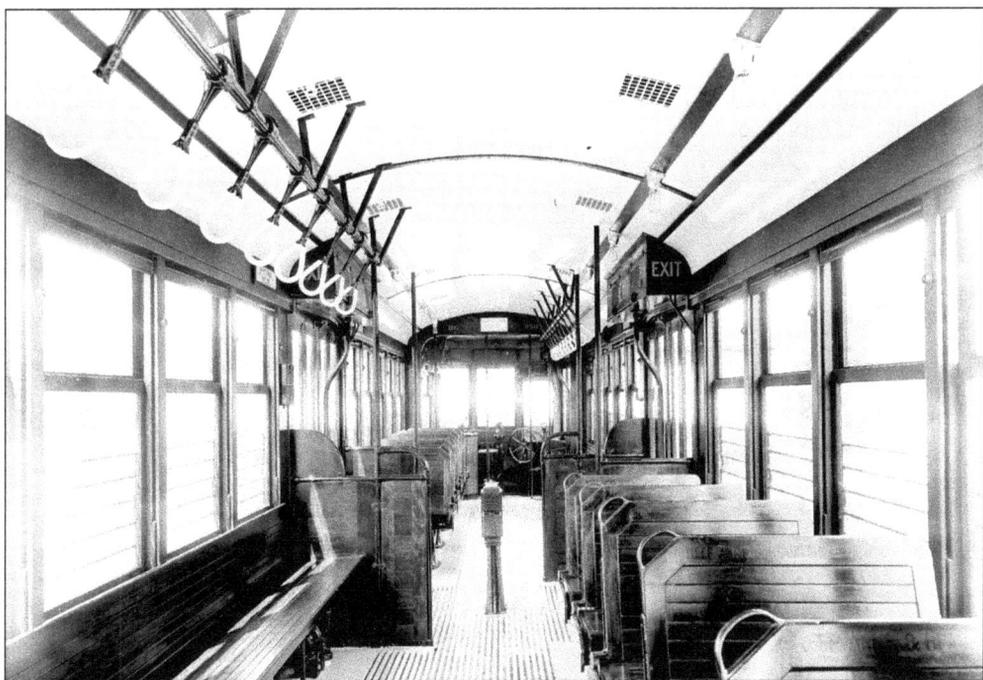

This is the interior of Peter Witt car No. 8505 before conversion for one-man operation. The conductor was stationed at the fare box between the center doors. Double-ended one-man cars had a fare box pedestal installed at each end behind the operator's positions. (EBW/AJL.)

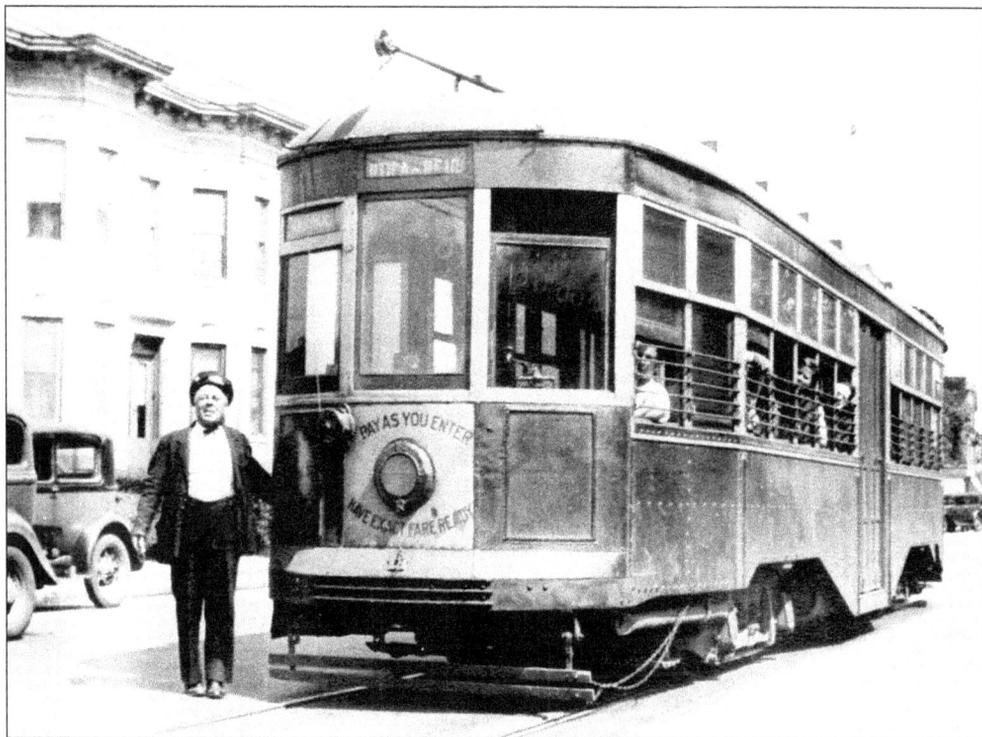

Operator Michael Trotta poses with his car in front of 936 Utica Avenue near Snyder Avenue. Wood Harmon and Company developed the Rugby neighborhood and guaranteed construction of 50 homes within one year if the BRT built a trolley line through the area. Reid Avenue cars were extended to Church Avenue in 1900. Utica Avenue shuttle cars ran south from Church Avenue to Avenue N after 1910. Some rush hour shuttles ran to St. Johns Place until 1927, when full-time service north of Church Avenue began. Utica-Reid became one line on July 15, 1936. (BERA.)

The bodies of old cars retired from passenger service were often set up at transfer points in undeveloped areas to be used as shelters by waiting passengers. This one is on the northeast corner of Church and Utica Avenues. Reid Avenue No. 3968 is arriving in 1907, four years after a second track was installed on Utica Avenue. (EBW/AJL.)

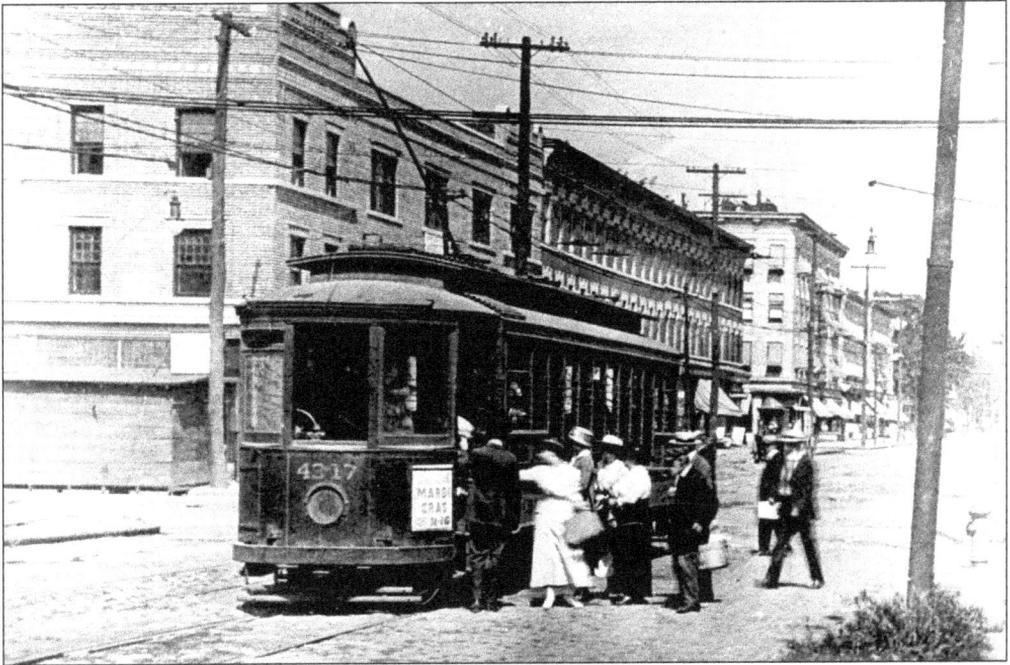

Passengers board No. 4317 on Nostrand Avenue at Church Avenue in 1916. Deep puddles of water around Newkirk Avenue often shut down the Nostrand Avenue line south of Malbone Street. Trenches from the street onto private property frequently had to be dug to drain the roadway. Excessive groundwater also plagued the subway under Nostrand Avenue. (EBW/AJL.)

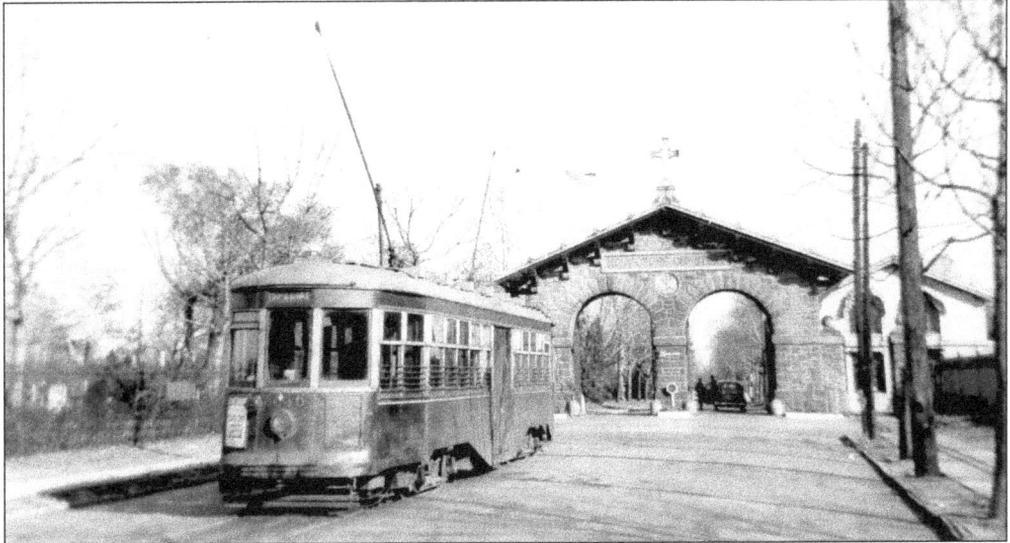

Holy Cross shuttle No. 8045 ends its six-block run at Canarsie Lane in front of the Holy Cross Cemetery gate in 1944. Prospect Park and Holy Cross Cemetery cars started running in September 1883 via Malbone Street, Clove Road, Clarkson Avenue, and Canarsie Lane to Canarsie (Cortelyou) Road. When the line was electrified on July 15, 1895, Nostrand and Vernon (Tilden) Avenues replaced Clove Road and Canarsie Lane. Reduced to a shuttle by 1903, Birney cars were used from 1919 to 1936, longer than any other line. Service ended on April 1, 1951. (EBW/AJL.)

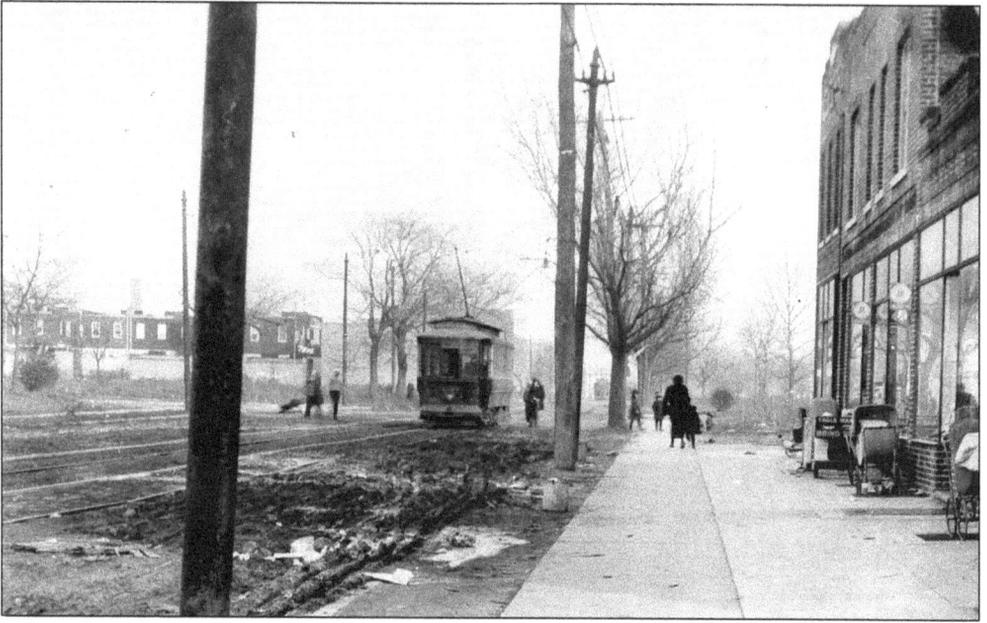

When the BRT went into receivership in 1919, it became necessary to reduce operating expenses. Several lines served by other routes or with low ridership were terminated. Church Avenue cars did not run from August 29, 1920, to April 26, 1921. No. 3155 is seen passing East Fortieth Street on unpaved Church Avenue on December 8, 1923, shortly after the BRT was reorganized as the Brooklyn-Manhattan Transit Corporation. (EBW/AJL.)

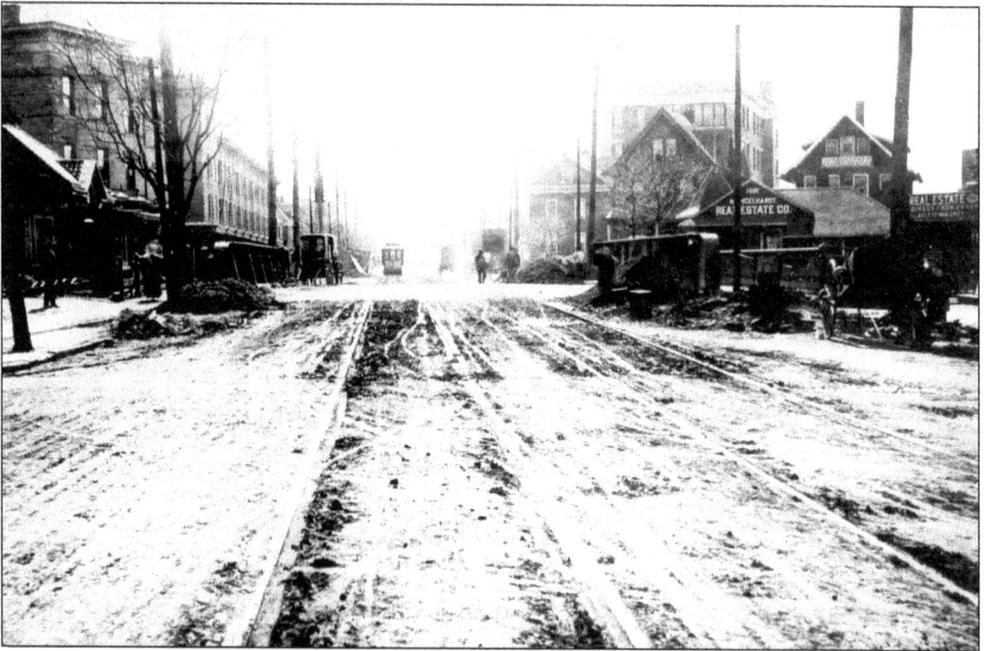

No. 141 is on Avenue C west of East Sixteenth Street on April 9, 1908. This three-quarter-mile line served Beverly Square, T. B. Ackerson's 1898–1901 real estate development between Cortelyou and Beverly Roads that offered individually built to order houses. Avenue C was renamed Cortelyou Road in honor of Colonial surveyor and mapmaker Jaques Cortelyou. (EBW/AJL.)

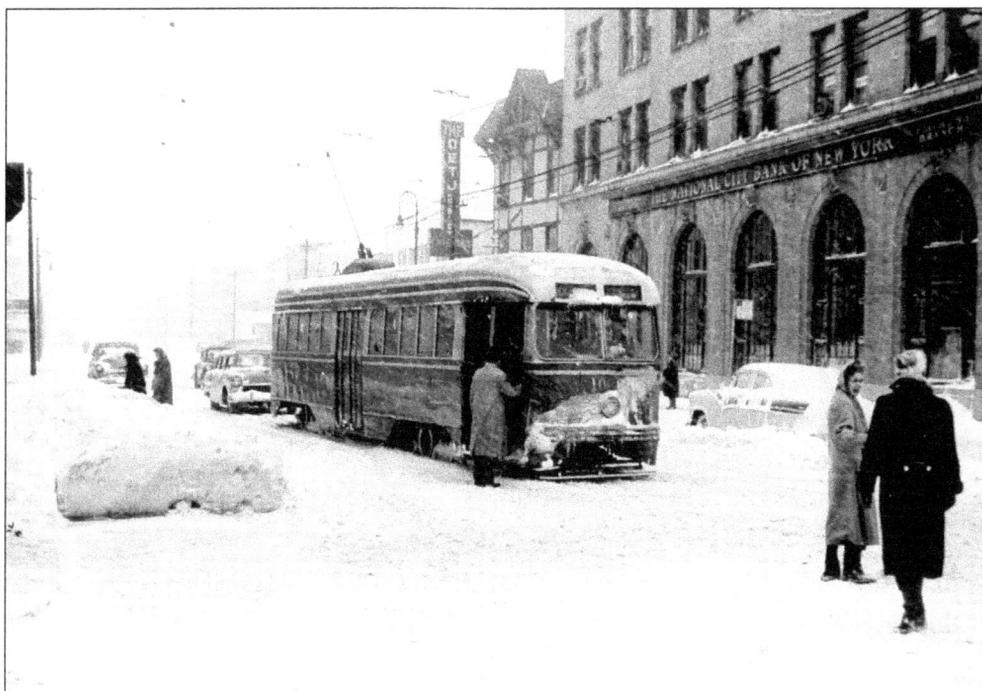

PCC No. 1086 passes Oetgen's Restaurant at 2210 Church Avenue. Oetgen's, whose advertisements appeared on the front dash of many Brooklyn streetcars, was a well-known speakeasy during Prohibition. (FP.)

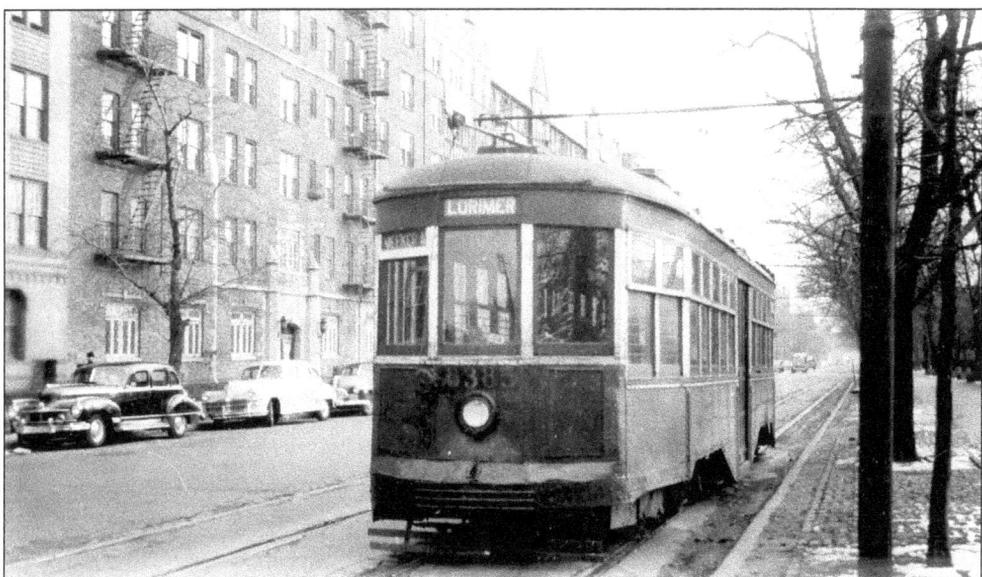

Lorimer Street No. 8385 changes ends on Ocean Avenue west of Flatbush Avenue on December 13, 1947. Movie stars Douglas Fairbanks Jr. and Mary Pickford lived here on Ocean Avenue facing Prospect Park. Universal Studios built an apartment house just for them so they would have easy access to its studio on East Fourteenth Street near Avenue M. (EBW/AJL.)

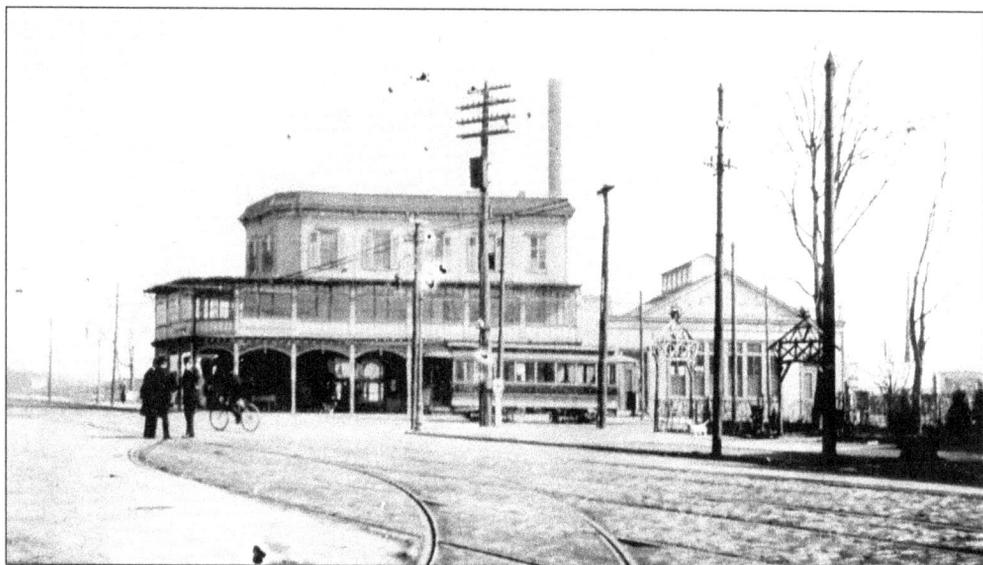

Lorimer Street No. 2187 poses in front of Peter Sutter's Saloon and Summer Garden on the northeast corner of Flatbush Avenue and Malbone Street in 1905. This was the domain of police precinct No. 51, which covered the area around the Willink entrance of Prospect Park. There were frequent complaints about the resorts here serving drinks on Sunday mornings and of passengers on Franklin Avenue cars being bothered. The police of the 67th (Flatbush) and 72nd (Parkville) precincts, however, managed to keep the establishments and their patrons around the two Parkside Avenue entrances within the limits of the law. (EBW/AJL.)

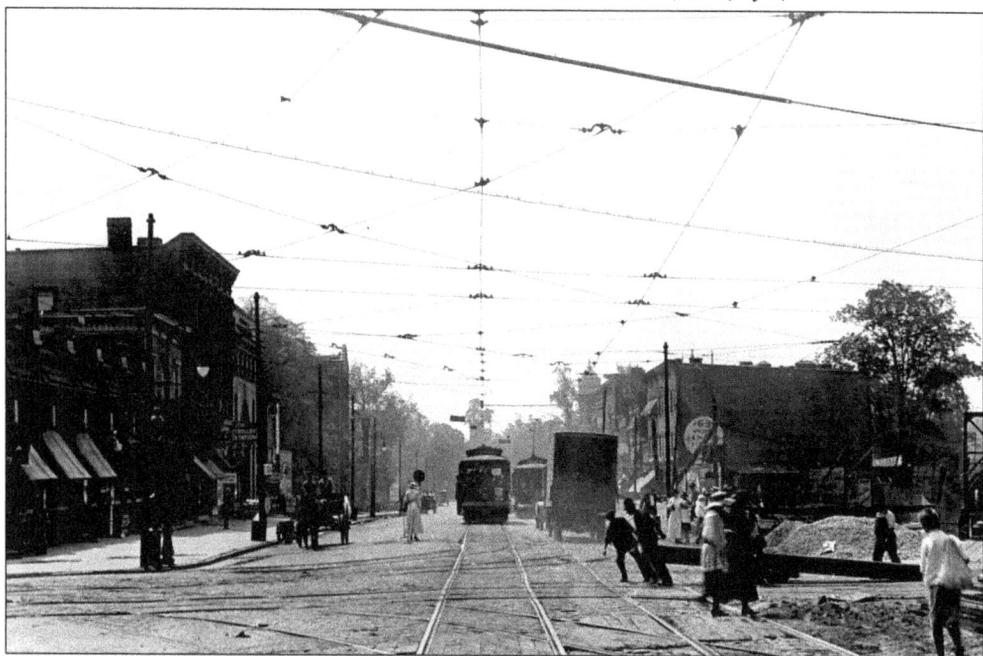

Open car No. 1212 and convertible No. 4569 are on Flatbush Avenue just south of Malbone Street in 1918. A connection to the Brighton line to the right of the car was replaced with a streetcar loop above the rapid transit line in 1906. The street was named after Ralph Malbone, developer of Malboneville along Clove Road in the 1830s. (EBW/AJL.)

Four

CENTRAL BROOKLYN

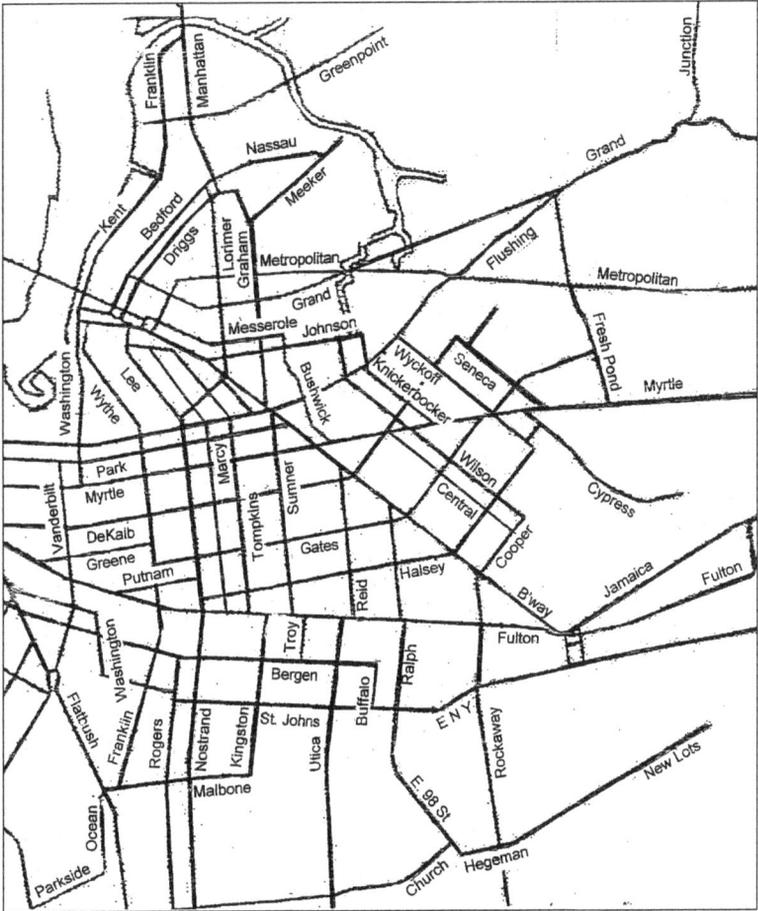

This map shows the communities of central Brooklyn, including Crown Heights, Grand Army Plaza, East Brooklyn, Williamsburg, Greenpoint, Bushwick, and Ocean Hill.

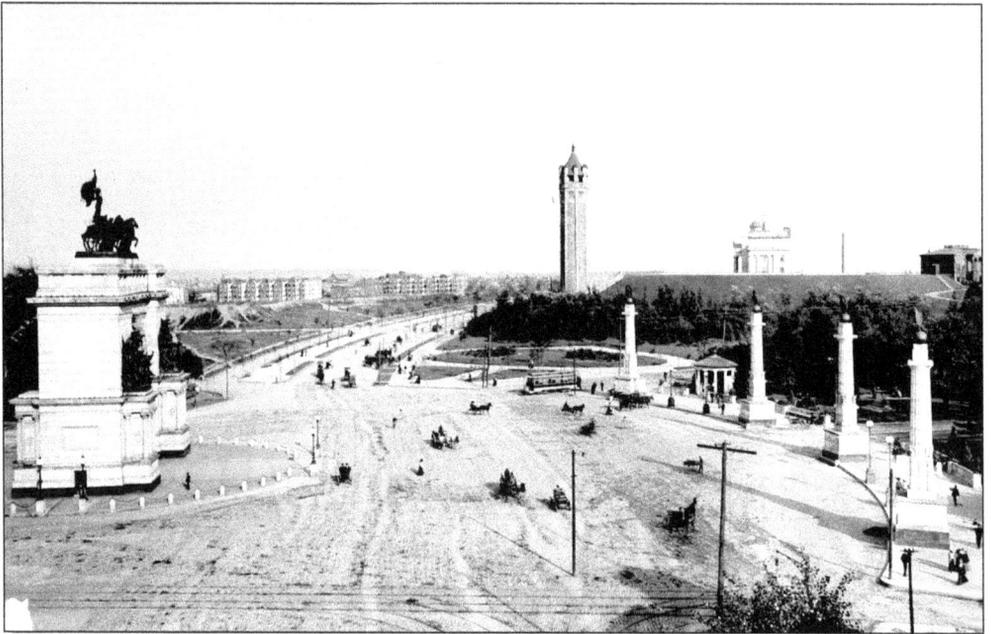

This 1906 view shows Eastern Parkway, the first six-lane road in the United States, running eastward from Grand Army Plaza along the top of the glacial ridge that forms Long Island. The boulevard, designed in 1869–1870 by Frederick Law Olmsted and Calvert Vaux along with the plaza and Prospect Park, cut through the existing street grid of an African American neighborhood variously called Crow Hill, Carrville, Crown Hill, or, after 1906, Crown Heights. Flatbush Avenue No. 2955 has just passed Prospect Park, named after Mount Prospect, the second-highest point in Kings County before it was cut down in the 1850s to build the reservoir shown in this picture. In the 20th century, the Brooklyn Museum, the public library, and the botanical gardens were built on the site of the reservoir. (EBW/AJL, Library of Congress collection.)

GRAND ARMY PLAZA and P. C. C. CAR, Brooklyn, N. Y.

Vanderbilt Avenue PCC No. 1061 runs through Grand Army Plaza and heads for Prospect Park West. (BERA.)

Southbound Flatbush Avenue No. 6021 travels around the eastern side of Grand Army Plaza "against traffic" in 1936. Vanderbilt Avenue cars traveled against traffic on the western side of the plaza. (EBW/AJL.)

No. 2134 and No. 2148 pass on Vanderbilt Avenue north of Plaza Street on October 6, 1921. Park and Vanderbilt horsecars started operating from the Catherine Street ferry at the foot of Main Street to Flatbush Avenue on May 18, 1870, and were extended to Twentieth Street and Ninth Avenue on May 8, 1871. (EBW/AJL.)

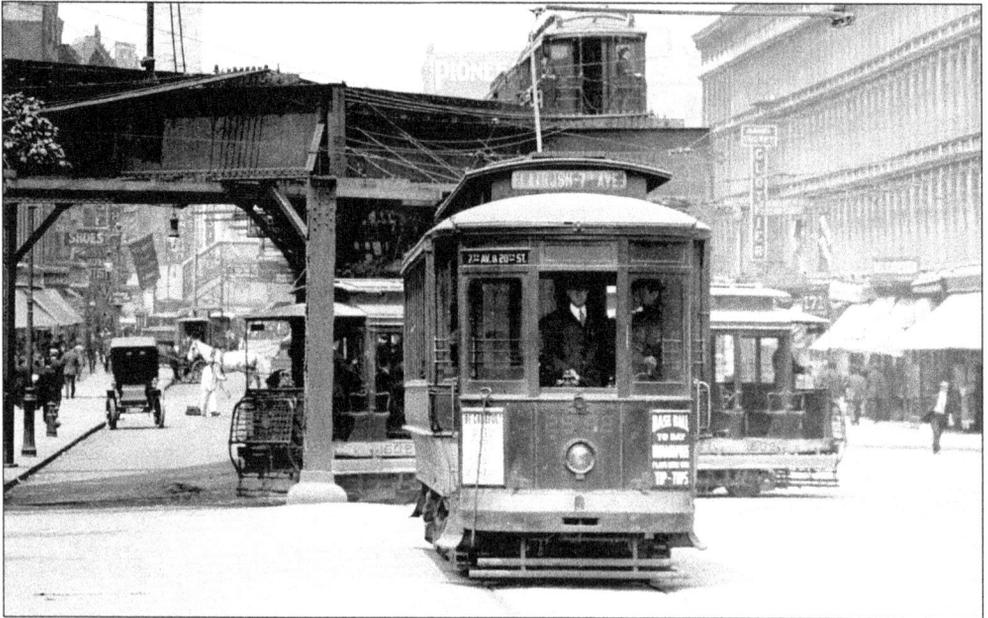

No. 2592 on the Flatbush–Seventh Avenue line emerges from under the Fifth Avenue elevated at Bergen Street as open car No. 1609 crosses behind it on May 18, 1914. The wood block destination signs above the front corner window were introduced in 1899 to replace metal dash signs costing twice as much. This also doubled the room available for revenue-producing advertisements on the front dash. (EBW/AJL.)

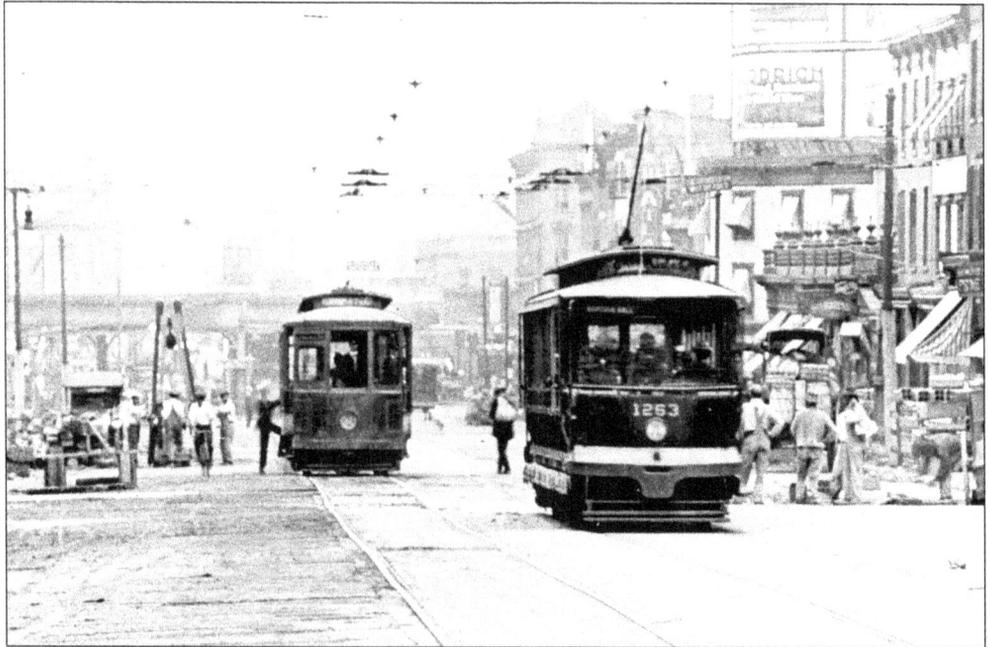

Flatbush–Seventh Avenue convertible No. 4107 and Flatbush Avenue open car No. 1263 are about to pass at Flatbush Avenue and Bergen Street on July 17, 1916. Bergen Street is named for Brooklyn's first Norwegian settler, Hans Hansen from Bergen, Norway. (EBW/AJL, Bob Presby photograph.)

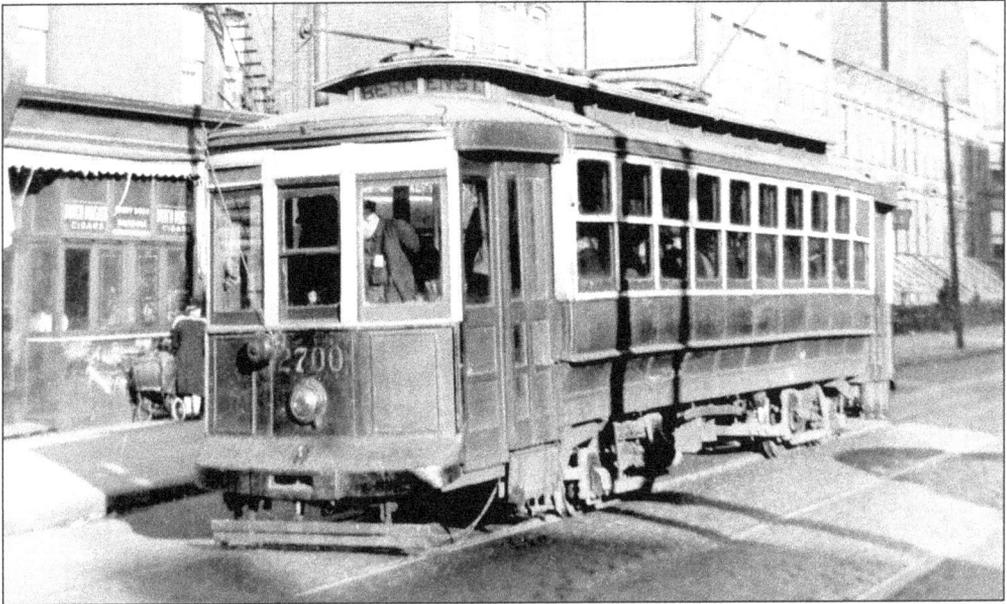

No. 2700, signed Bergen, was one of five prototype semiconvertibles manufactured by the Brooklyn Heights Railroad in 1900. The trial was obviously successful as 744 more cars of this type were eventually acquired. One theory advanced as to why the older cars were always assigned to Bergen Street was that these trolleys were several inches narrower than the later additions to the fleet and could clear obstructions with less difficulty. (BERA.)

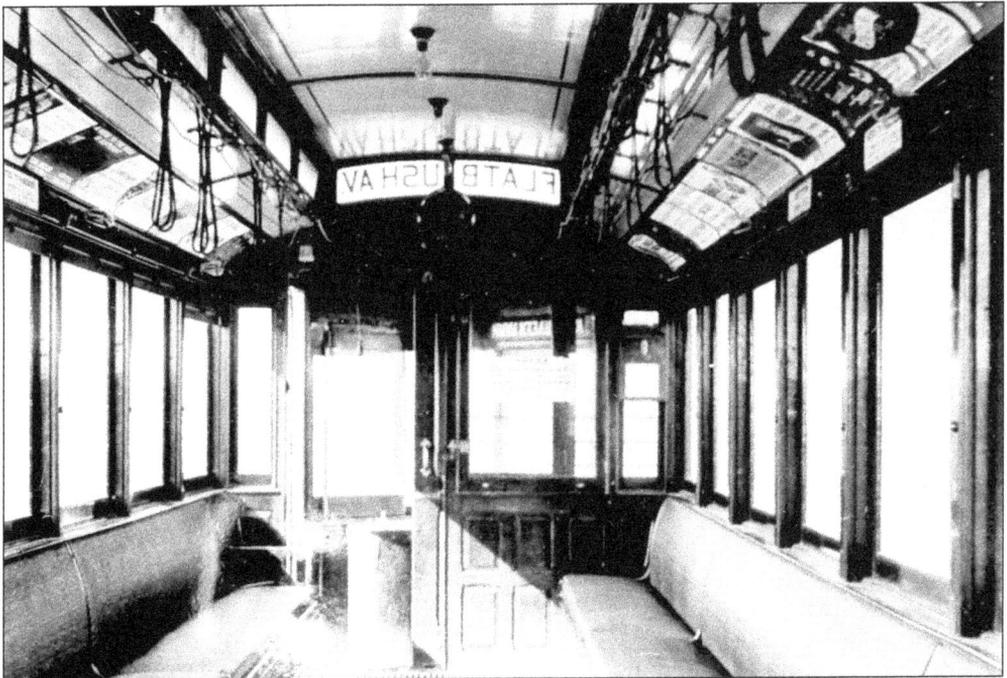

This is the interior of a typical Brooklyn closed car or semiconvertible with wooden benches along the side walls and a wide aisle. Offset bulkhead doors were supposed to prevent platform crowding by placing exiting passengers close to the steps. (BERA.)

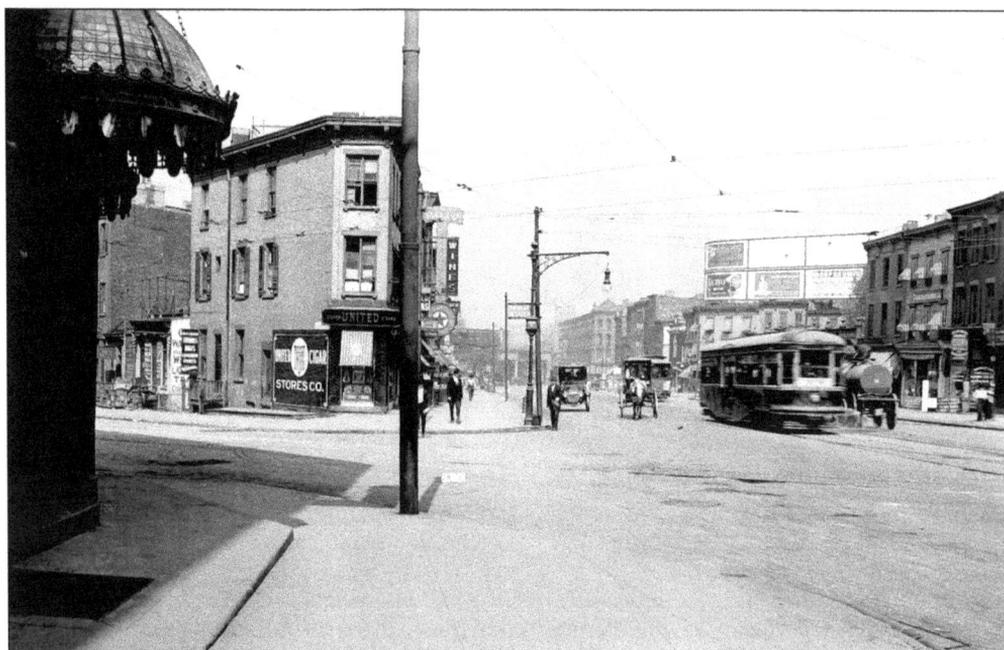

One of the BRT's 100 new center-entrance cars rolls south in unusually light automobile, horse, trolley, and truck traffic on Flatbush Avenue at Bergen Street on September 23, 1914. The new cars were the first in Brooklyn with steel bodies. As of December 1913, 50 were assigned to Gates, 30 to Flatbush, and 20 to St. Johns. (EBW/AJL.)

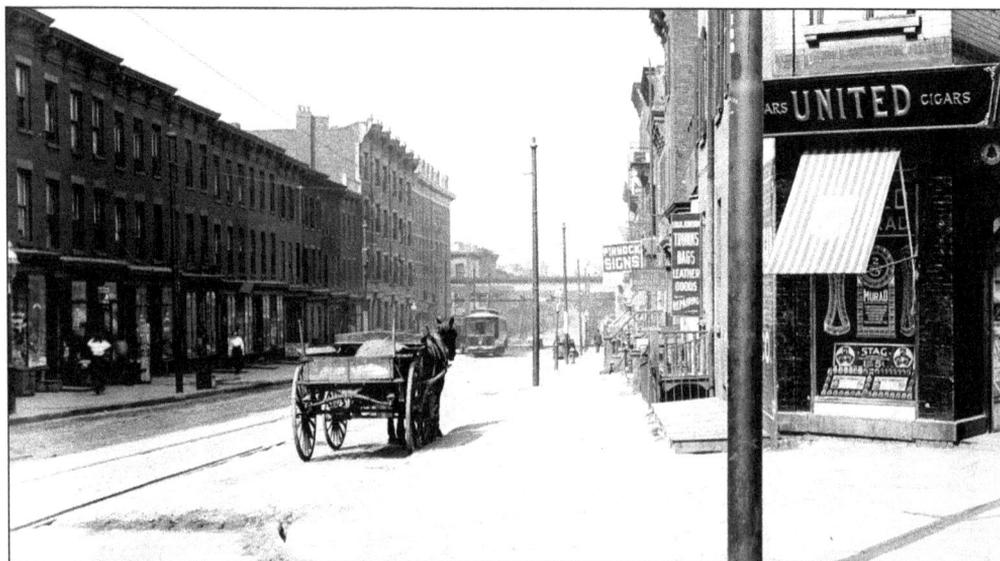

Hoyt-Sackett No. 179 moves along Bergen Street between Flatbush and Fifth Avenues on September 28, 1914. Not only the cars moved, for the lines themselves frequently moved too. Hoyt Street crosstown cars inaugurated service in 1865 on Bergen, Hoyt, and Sackett Streets. By 1885, this was one of three branches of the Bergen Street line serving Fulton, South, and Hamilton Ferries. Marcy Avenue absorbed the Hoyt-Sackett line in 1899, and these two lines were split and combined several times over the next dozen years. Sumner–Sackett took over in 1934, giving way, in turn, to Bergen Street cars in 1943. Most lines have similar histories. (EBW/AJL.)

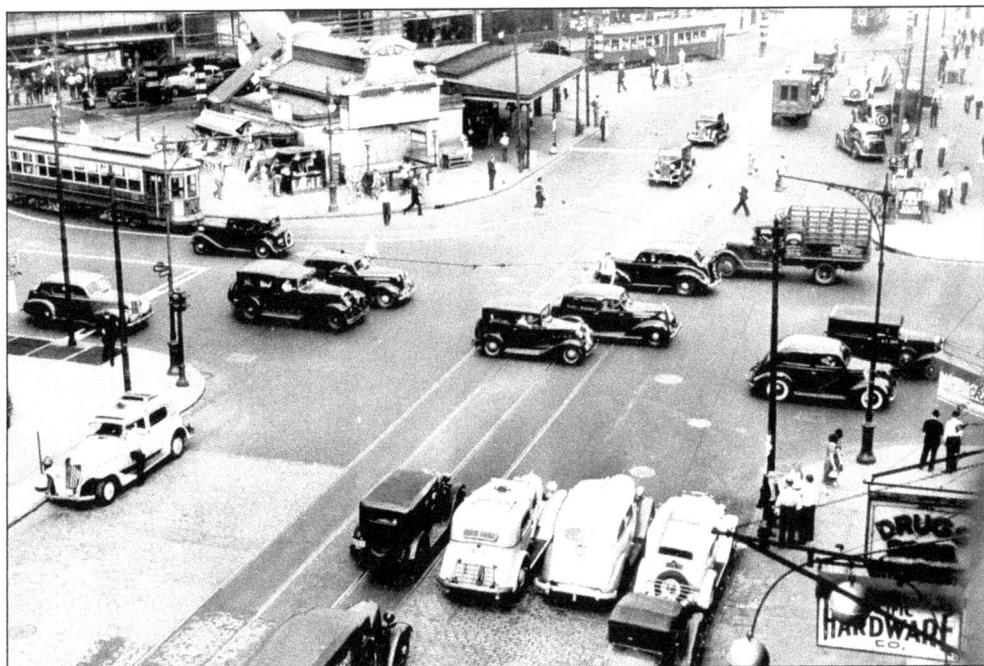

No. 2513 is on Fourth Avenue looping around the subway entrance/exit building at Times Plaza in 1938. When the IRT subway opened in 1908, patronage on the Brooklyn Bridge lines decreased by 12 to 15 percent. Many of the lost riders who had formerly crossed into Manhattan on streetcars now transferred to the new subway. BRT service was modified accordingly with new trolley routes and turnbacks at Atlantic Avenue. To expedite turning the cars, a new loop was installed here in 1911. (EBW/AJL.)

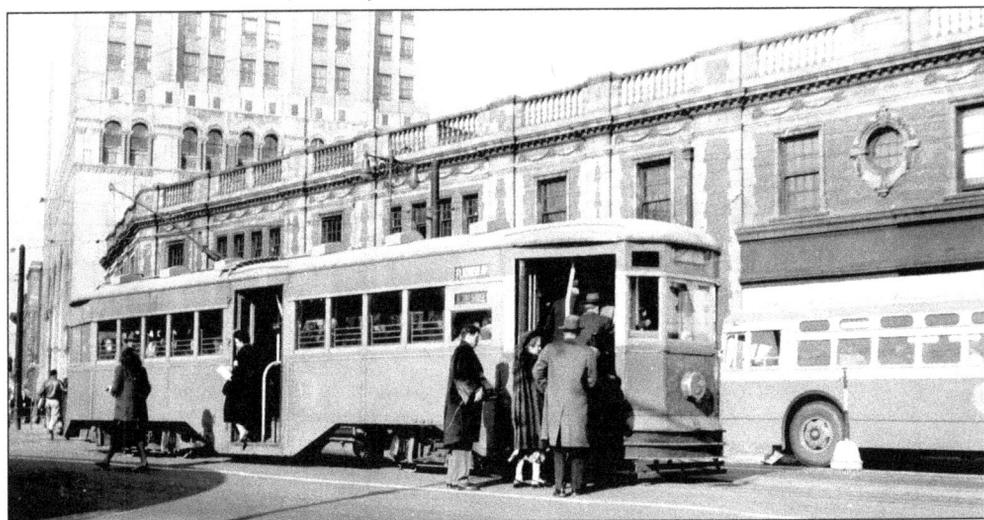

Passengers board No. 6122 on Flatbush Avenue at Atlantic Avenue. St. Johns trackless trolley No. 3019 is across the street next to the Long Island Rail Road station. Two hundred St. Louis trolley buses arrived in 1948 to replace certain streetcar lines. St. Johns started the process on September 16, 1948, with Bergen Street, Tompkins Avenue, Lorimer Street, Flushing Avenue, and Graham Avenue converted later in 1948 and 1949. St. Johns became a diesel bus line on March 25, 1959, and the other five lines followed on July 27, 1960. (FP.)

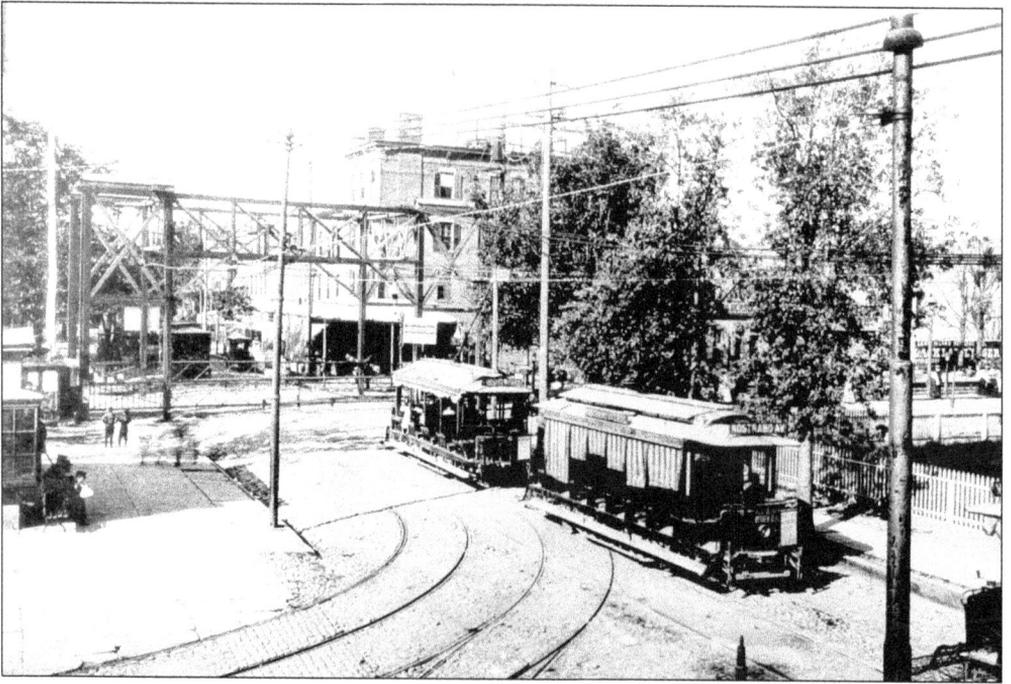

Open cars No. 409 and No. 253 wait on Nostrand Avenue at the Atlantic Avenue grade crossing in 1896. Electrification of the Long Island Rail Road and elimination of the grade crossings began in 1903. (EBW/AJL.)

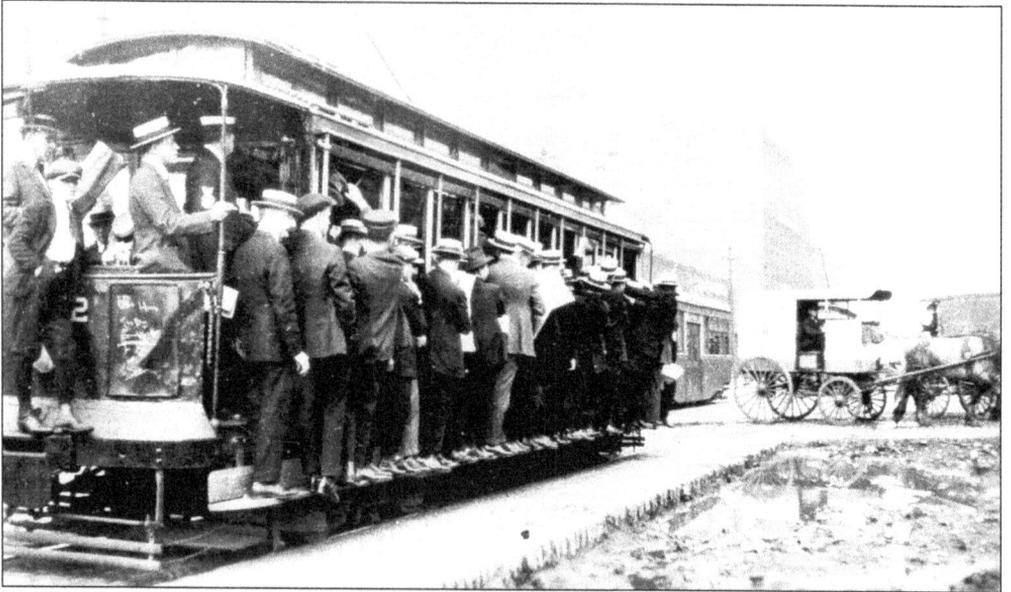

Crowded St. Johns open car No. 1642 is on Atlantic Avenue in 1920. In 1834, the Brooklyn and Jamaica Railroad built its line from the East River to Jamaica on a private right-of-way on the north side of Atlantic Avenue. Horsecars began operating on the street in 1861 after railroad trains were banned. Steam trains returned to Atlantic Avenue east of Flatbush Avenue in 1877 on a new right-of-way in the center of a widened road, but the street railway tracks remained in use on the south side of the widened street until 1949. (EBW/AJL.)

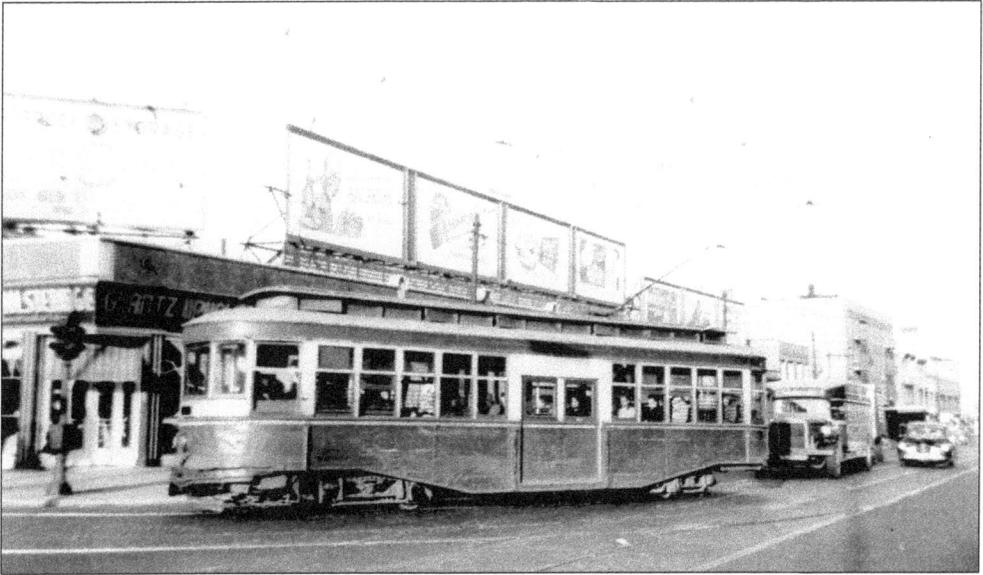

Sumner Avenue No. 5152 turns from St. Johns Place onto Buffalo Avenue in 1945. The car was built in 1919 as a trailer to be towed by a 4100-series convertible. Two-car train operation on the streets of Brooklyn ended in 1924, and 54 of the 100 trailers were rebuilt into motor cars. (EBW/AJL.)

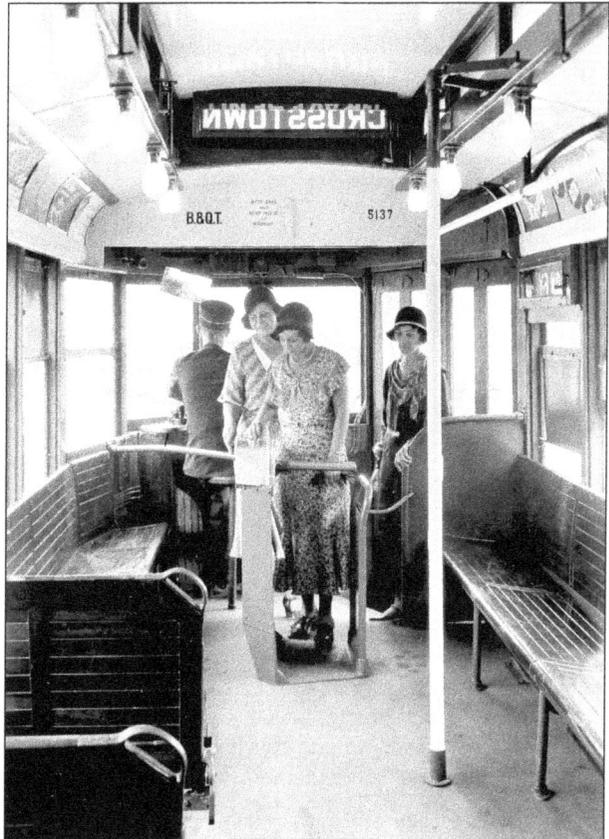

Seen here is an interior view of No. 5137 after being converted from a center-door trailer into a motor car. Long after a roof with a raised clerestory went out of style, these trailers were built so that their roofline matched that of the deck-roof convertibles towing them. (EBW/AJL.)

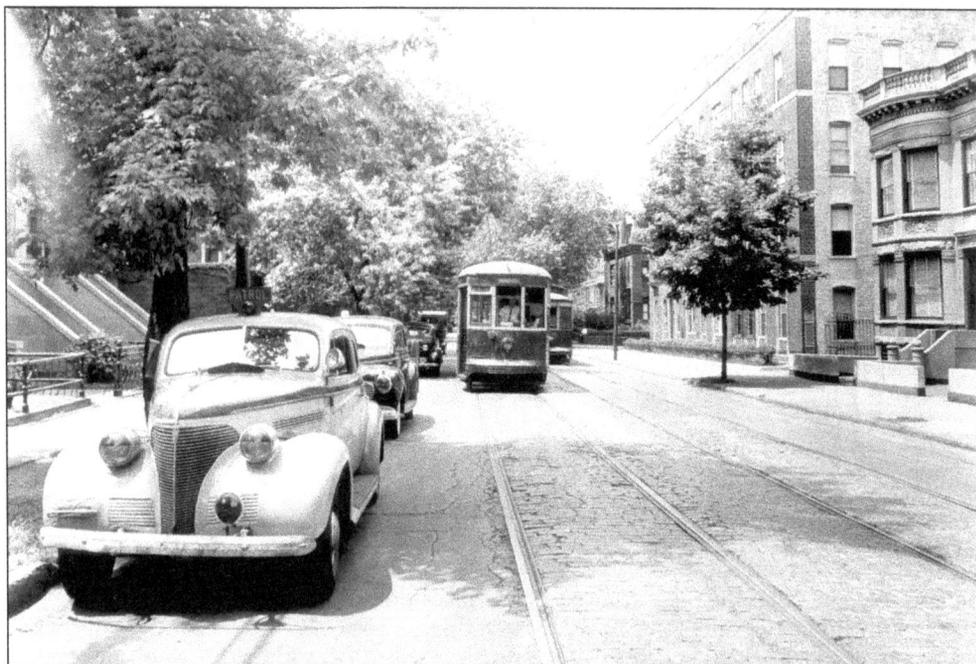

No. 8303 and No. 1159 pass on Sumner Avenue (Marcus Garvey Boulevard) in 1943. This locality went by the name of Stuyvesant Heights until a Brooklyn Edison Company survey done in the 1930s coined the name *Bedford-Stuyvesant* for the entire area between Bedford and Stuyvesant Avenues. (EBW/AJL.)

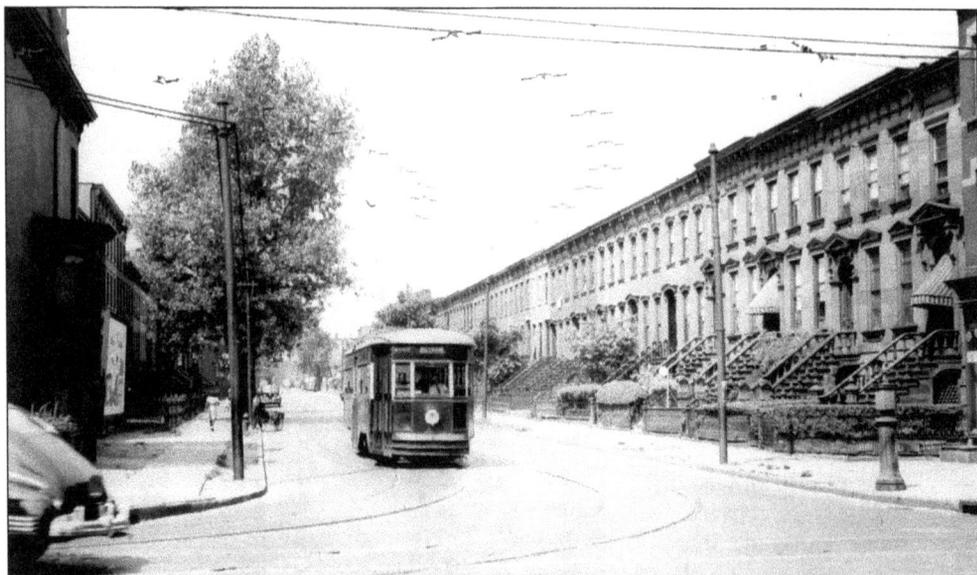

No. 6060 heads west on Putnam Avenue on March 6, 1941. Bedford Village, centered four blocks to the south, grew up around the important crossroads formed by Ferry Road (Fulton Street) going to Jamaica and Cripplebush Road leading to Bushwick. Cripplebush Road became the Brooklyn and Newton Turnpike in 1805 and followed Nostrand, DeKalb, and Bedford Avenues from Flushing Avenue to Bedford Village. (EBW/AJL.)

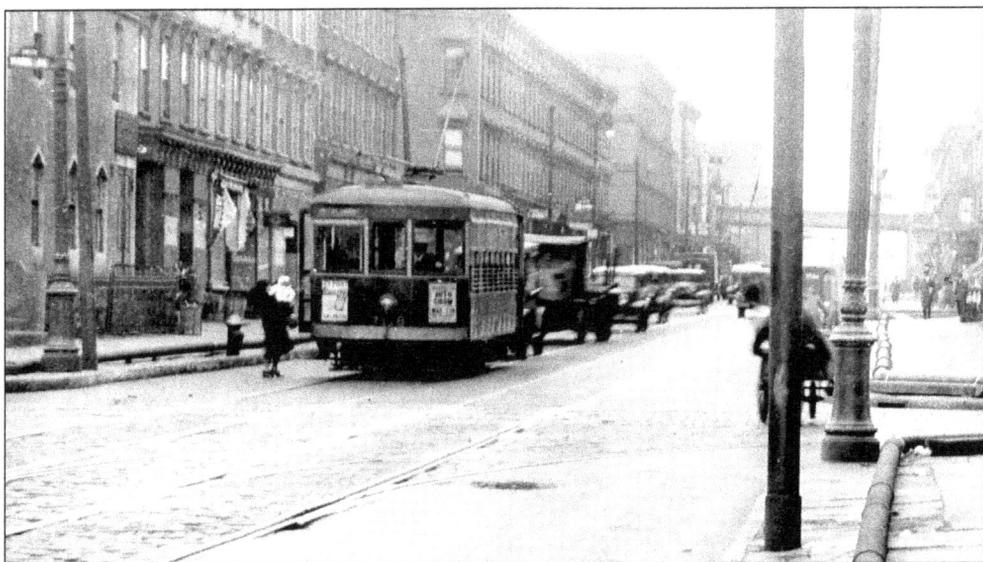

Safety car No. 7118 is pictured on the frequently modified Marcy Avenue line at Marcy and Park Avenues in March 1931. Sometimes the cars ran downtown via Park Avenue and sometimes via Myrtle Avenue. Sometimes they terminated at Classon and Park Avenues. Going in the other direction, they wound up at various times at the Broadway ferry, Calvary Cemetery, or the Grand Avenue bridge. (EBW/AJL.)

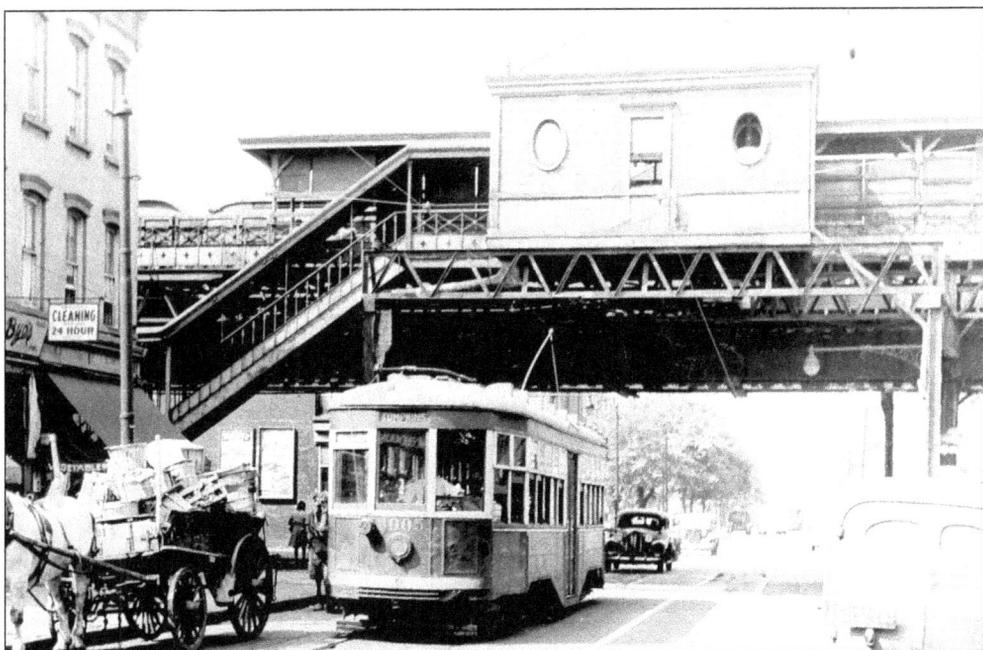

No. 8005 is on Tompkins Avenue at Lexington Avenue on August 22, 1947. The street was named after Daniel D. Tompkins (1774–1825), who served as assemblyman, congressman, judge, governor, and vice president from 1817 to 1825 under James Monroe. (EBW/AJL.)

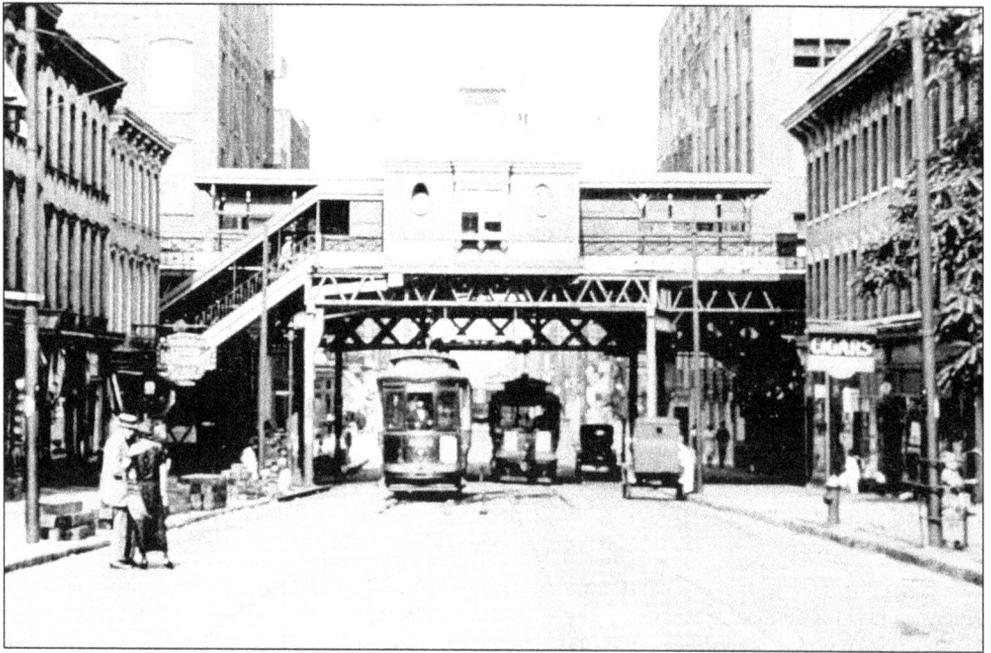

No. 2500 on DeKalb Avenue at Grand Avenue passes under the Lexington Avenue elevated in 1923. Lexington was Brooklyn's original elevated main line, opening on May 13, 1885. The elevated stopped operating on October 13, 1950, over a year after the DeKalb streetcars were replaced on January 30, 1949. (EBW/AJL.)

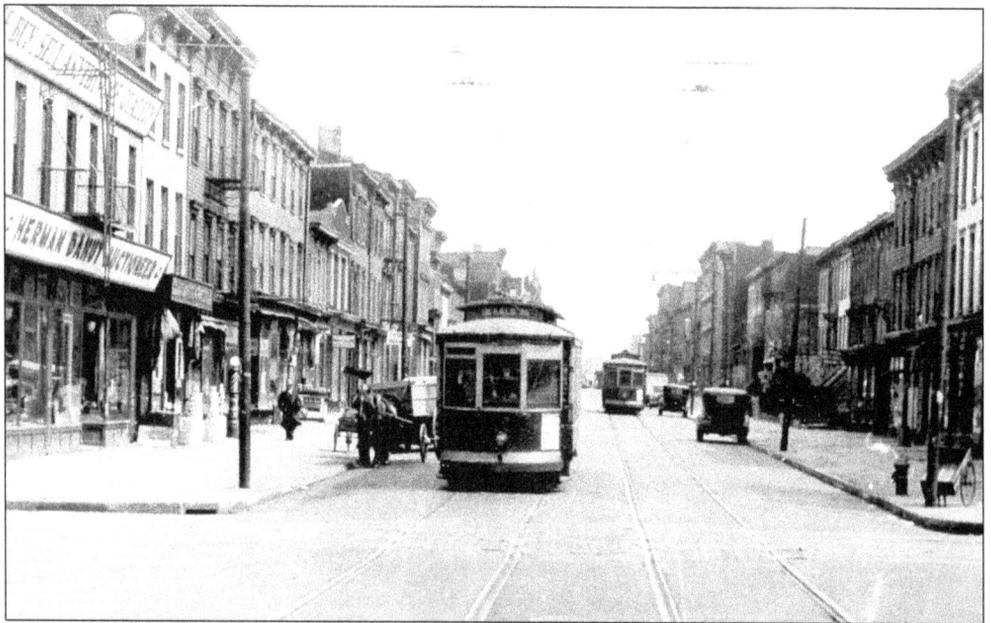

Westbound No. 4525 on DeKalb Avenue crosses Nostrand Avenue in 1933. Brooklyn City and Newtown Railroad horsecars started running on DeKalb on January 28, 1862. The Brooklyn City and Newtown Railroad was leased to the Coney Island and Brooklyn Railroad in 1897 and became part of the BRT in 1914—the BRT's last acquisition of an existing railway. (EBW/AJL.)

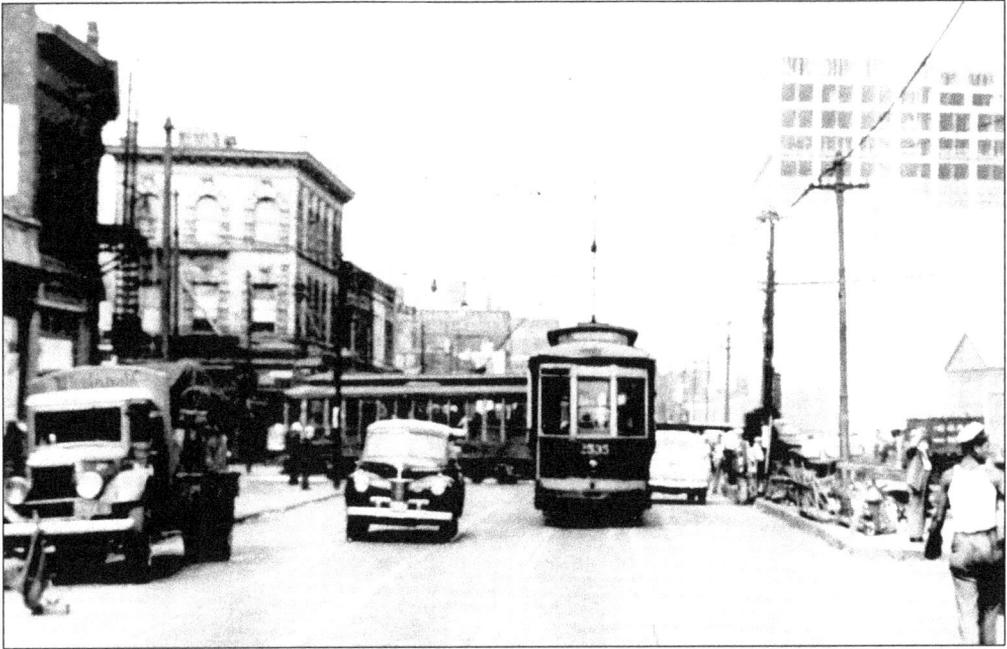

In 1805, the Wallabout and Brooklyn toll bridge connected Sands Street with the Wallabout and Newtown Turnpike running around the edge of the marsh bordering Wallabout Bay. The road ending at Flushing and Nostrand Avenues was purchased by the town of Brooklyn in 1833 and extended to Broadway in 1850. Johnson and Hudson's Knickerbocker stage was using the road by 1851, giving way to the Greenpoint horsecars of the Brooklyn City Railroad on October 1, 1854. No. 2535 is shown at Flushing and Vanderbilt Avenues on the Greenpoint line in 1941. (EBW/AJL.)

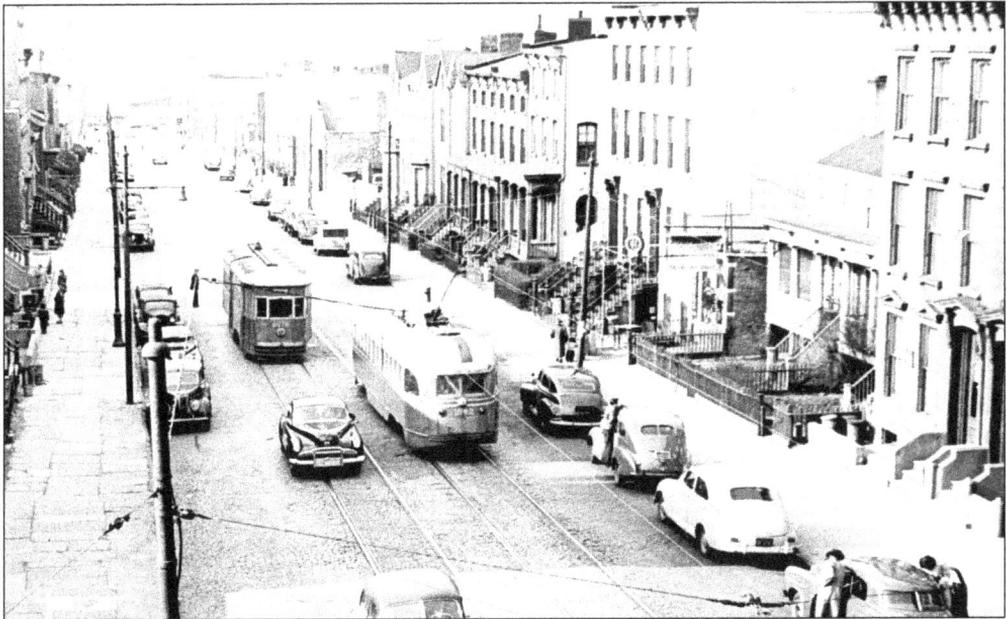

Southbound Crosstown No. 6070 and northbound Vanderbilt PCC No. 1082 were photographed from the Vanderbilt Avenue station of the Myrtle Avenue elevated in 1950. (EBW/AJL.)

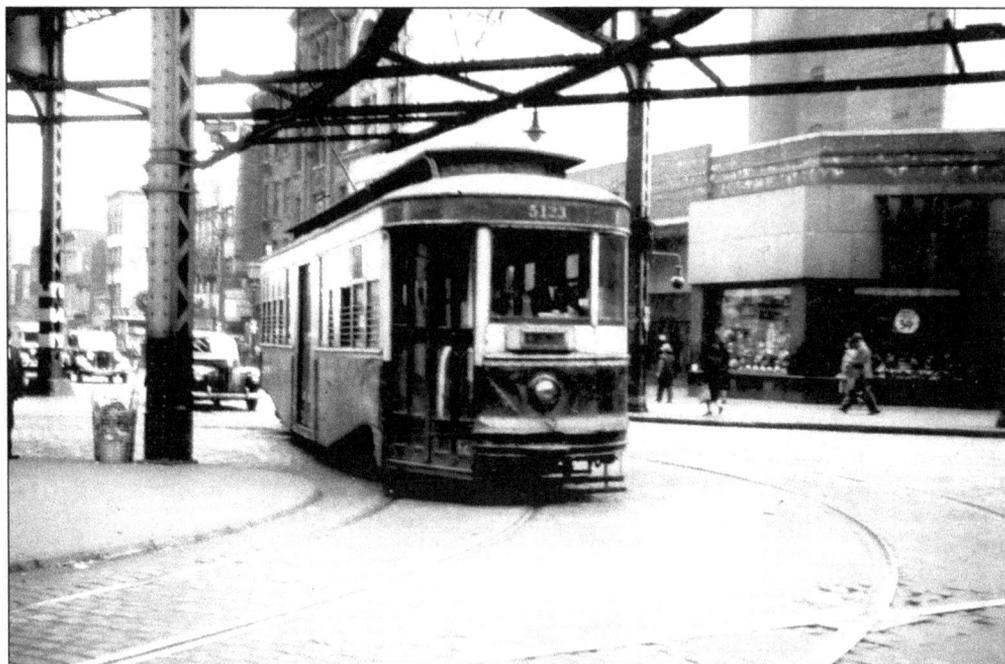

No. 5123 turns from Graham Avenue onto Flushing Avenue in 1941 at the busy intersection of those two streets with Broadway. (EBW/AJL.)

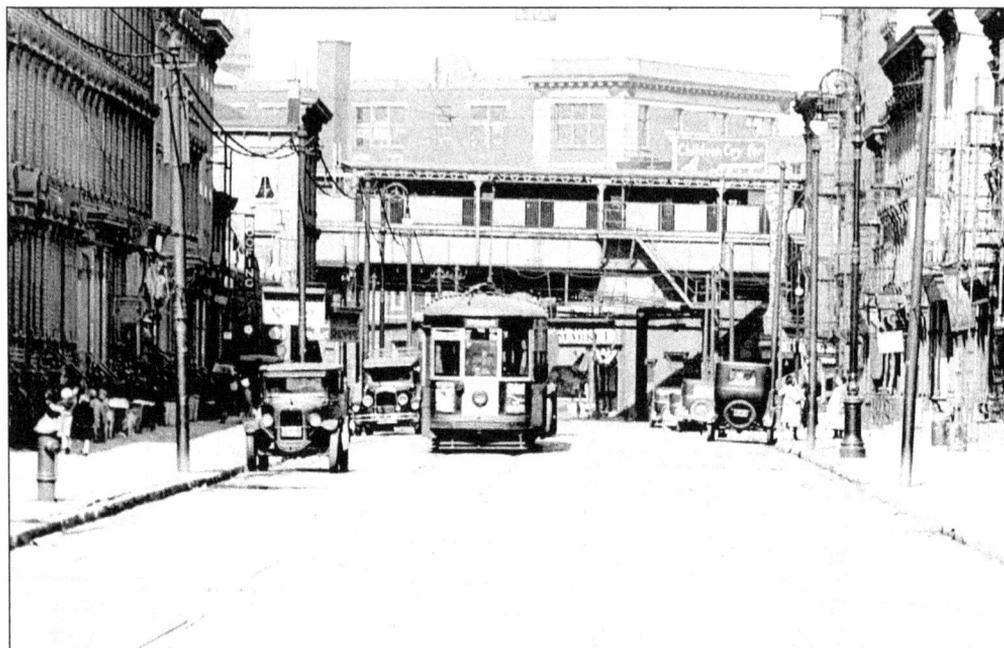

A typical Brooklyn street scene surrounds a Lorimer Street car near Throop Avenue on April 8, 1931. The Broadway elevated is in the background. (EBW/AJL.)

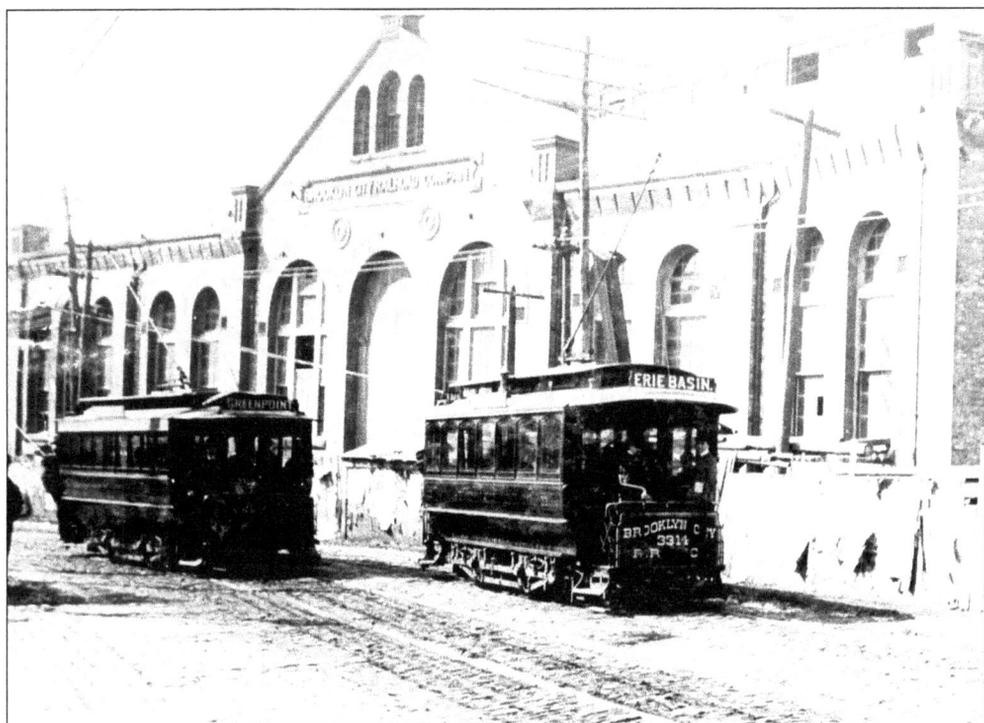

No. 3118 and No. 3314 are on Kent Avenue near the Broadway ferry in 1895. Clearance of Lower East Side tenements for the Williamsburg Bridge approach forced more than 10,000 people to relocate in Brooklyn's Eastern District between 1897 and 1903. By 1902, every rush hour car on each of the nine lines serving the Broadway ferry left with a full standing load. Riders seeking to get on east of the ferry had no chance of boarding. (EBW/AJL.)

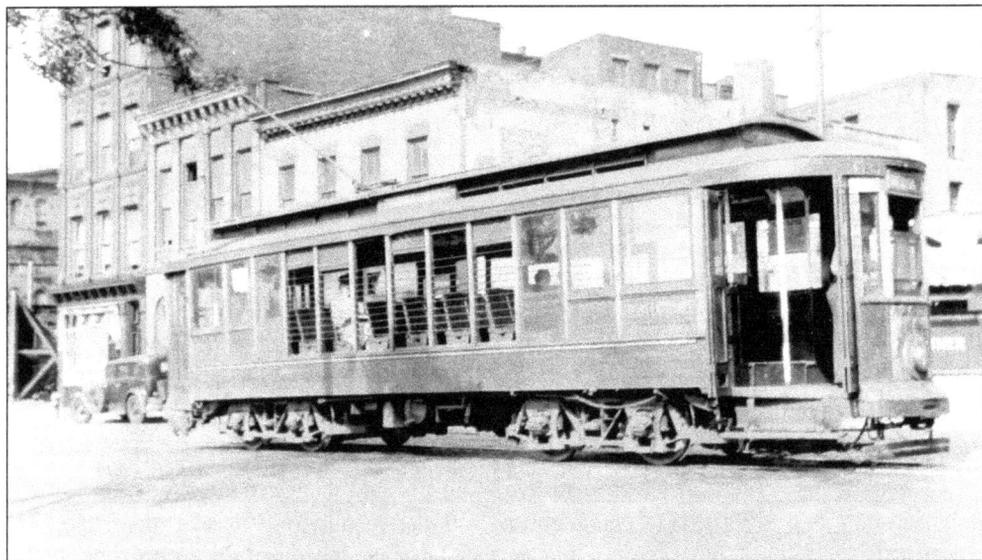

A convertible waits at Kent Avenue and South Eighth Street with some side panels removed on August 16, 1941. This was the typical summer configuration of these cars during their last two decades of service. (FP.)

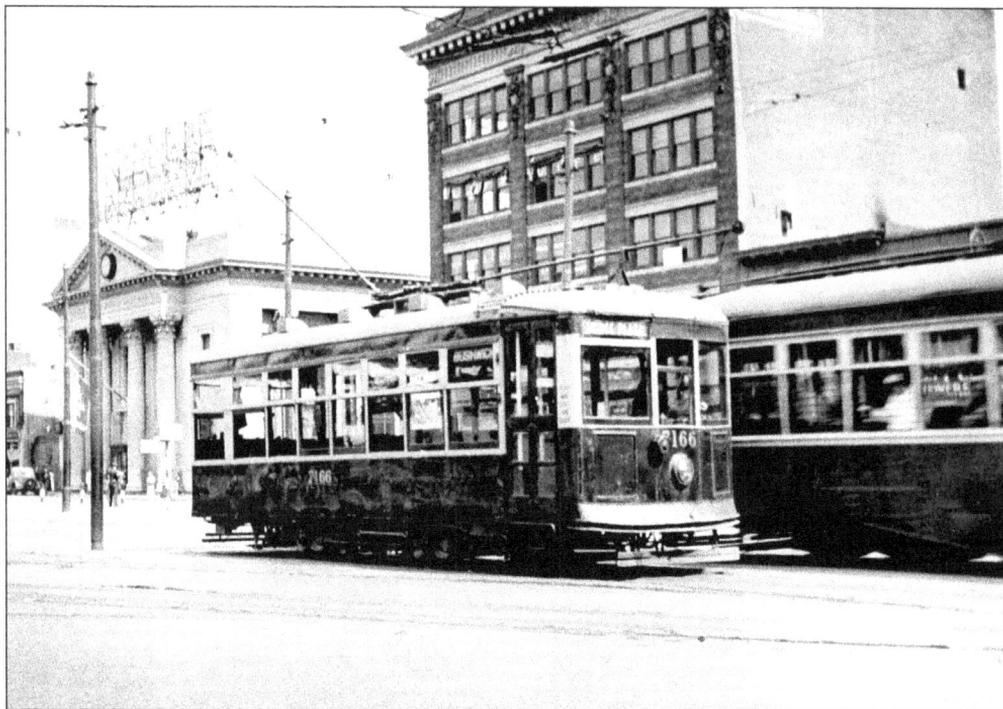

Bushwick Avenue safety car No. 7166 passes Washington Plaza on Broadway in 1936 en route to its terminal at Kent Avenue. (EBW/AJL, S. Maguire photograph.)

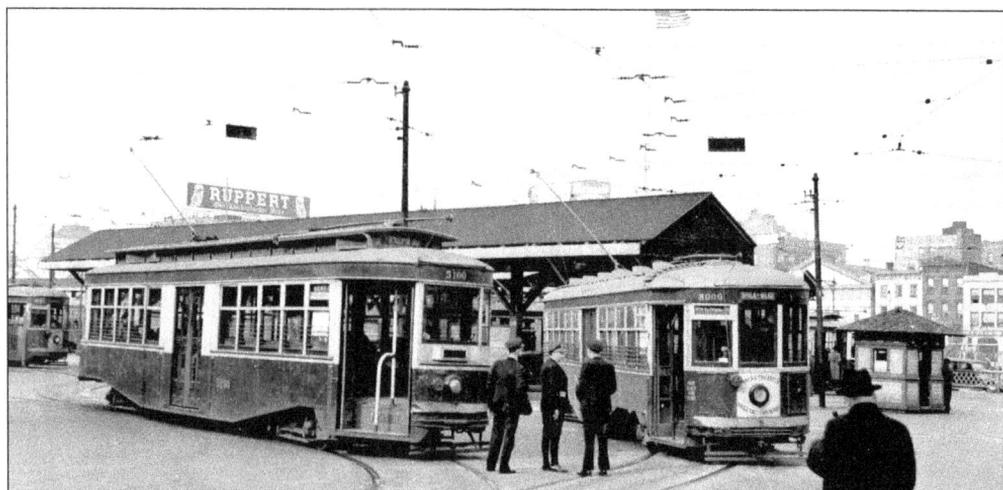

Ralph Avenue No. 5100, a 1919 center-entrance trailer rebuilt in 1925 as a motor car, and Utica-Reid No. 8000, a 1923 Peter Witt car, wait for their scheduled departure time at the Williamsburg Bridge plaza. Both cars were converted for one-man operation about 1932. Both lines also ran over the Williamsburg Bridge. Ralph Avenue was the heaviest bridge line before World War I. (BERA, Charles Duncan photograph.)

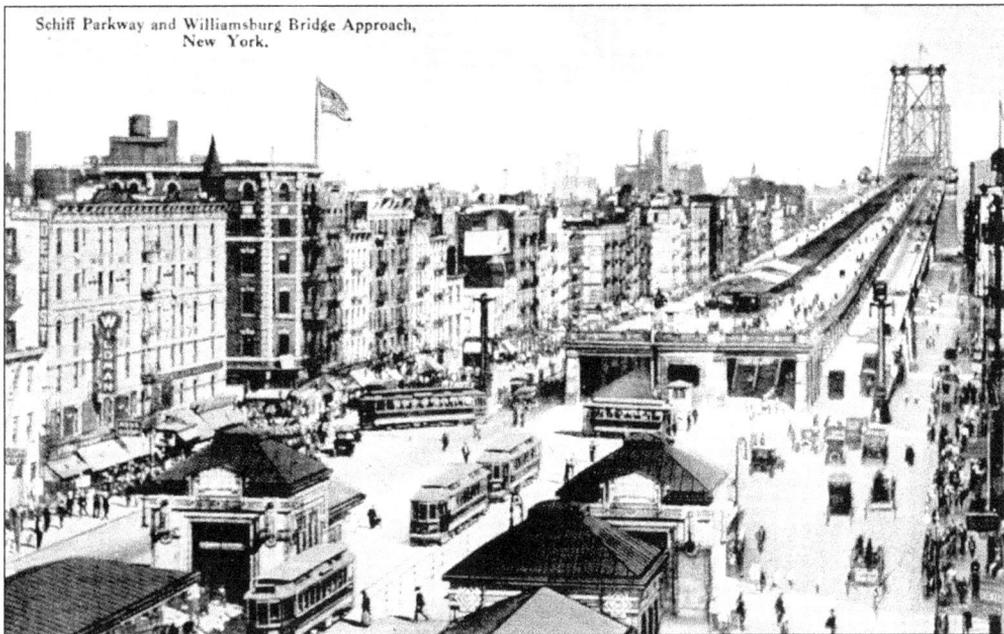

Delancey and Columbia Streets in Manhattan and the Williamsburg Bridge approach are seen here. As built, the bridge was supposed to accommodate 450 cars per hour on its four streetcars tracks. In 1905, the BRT was running 145–166 streetcars per hour over its two tracks on the south side of the span. Several Manhattan car lines using an underground third rail for power ran on the two north side tracks to cross into Brooklyn. (BERA.)

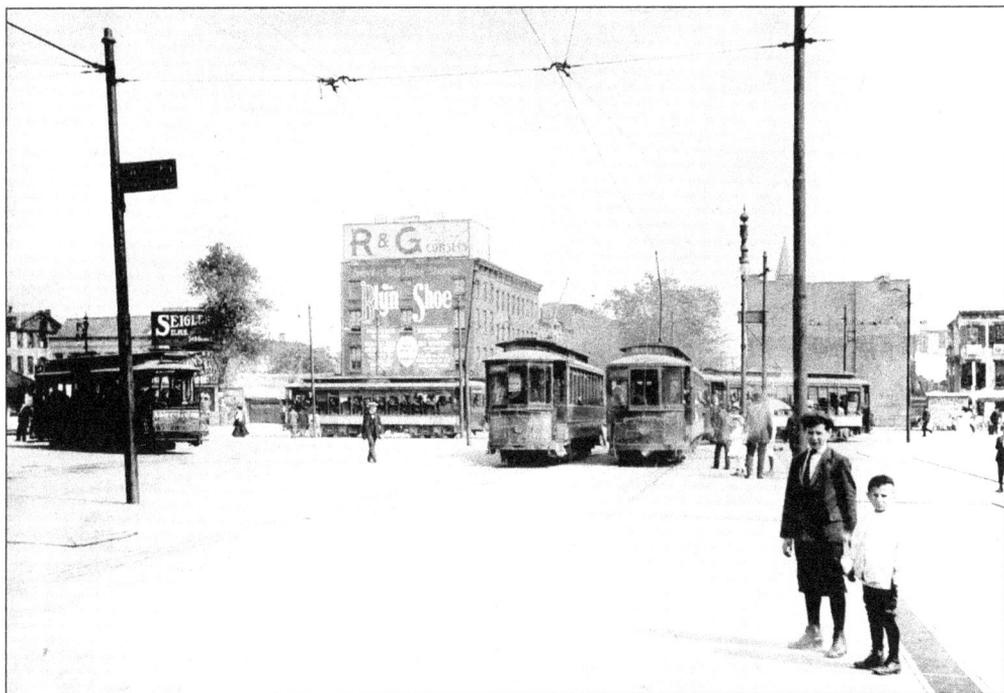

Metropolitan Street Railway conduit car No. 1697 and BRT cars No. 4134, No. 3313, No. 3917, and No. 3786 lay over at Washington Plaza in 1907. (EBW/AJL.)

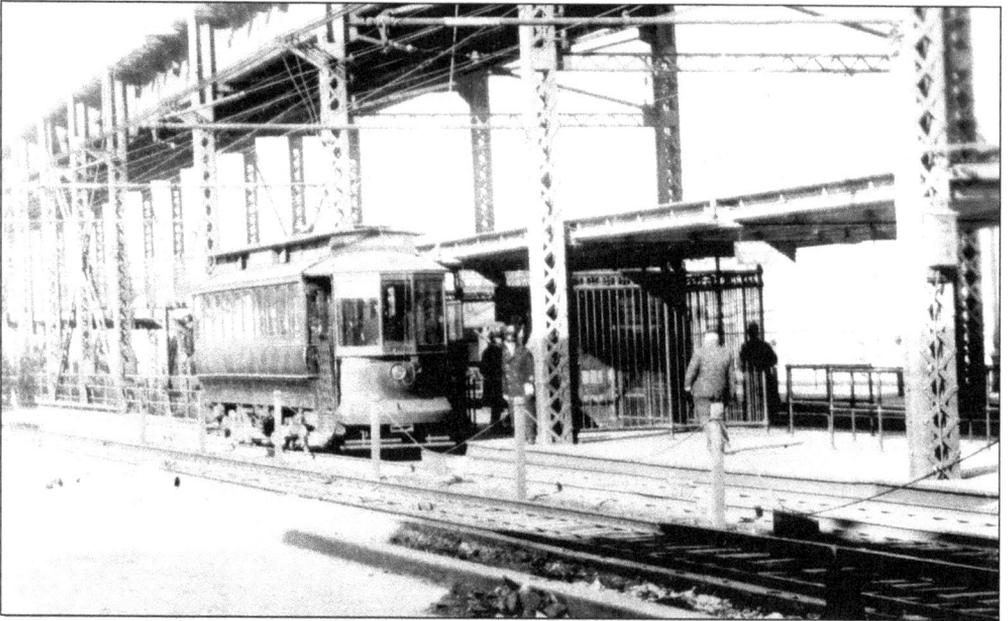

Williamsburg Bridge streetcars began running in 1904 under the auspices of the New York City Department of Plants and Structures. The city contracted with the Bridge Operating Company, formed in July 1904 and jointly owned by the BRT and Metropolitan Street Railway, to operate the service. Car No. 10 is at the station on the bridge approach between Bedford and Driggs Avenues where passengers could transfer to the Crosstown line. (EBW/AJL.)

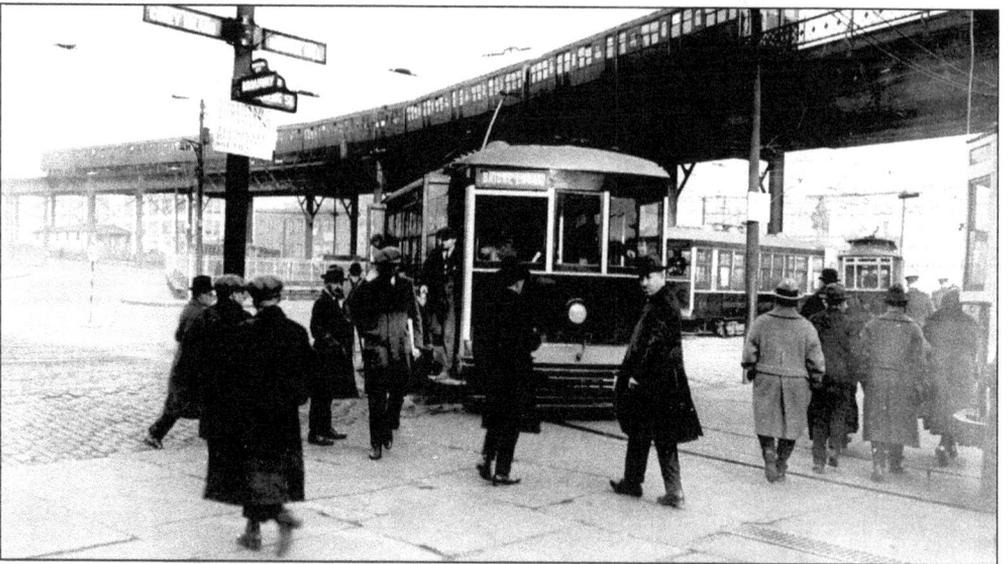

After the BRT entered receivership in 1919, the city took over the Bridge Operating Company. Brooklyn cars were terminated at Washington Plaza, and 33 Brill safety cars arrived in 1921 for bridge local service. New York City Department of Plants and Structures Birneys No. 212 and No. 220 are shown taking over the line on December 12, 1923. They were in service until February 1931, when the Brooklyn-Queens Transit Corporation resumed through service to Manhattan. After that, the cars were sold to Louisville, Kentucky, Beacon, New York, and Sherbrooke, Quebec. (EBW/AJL.)

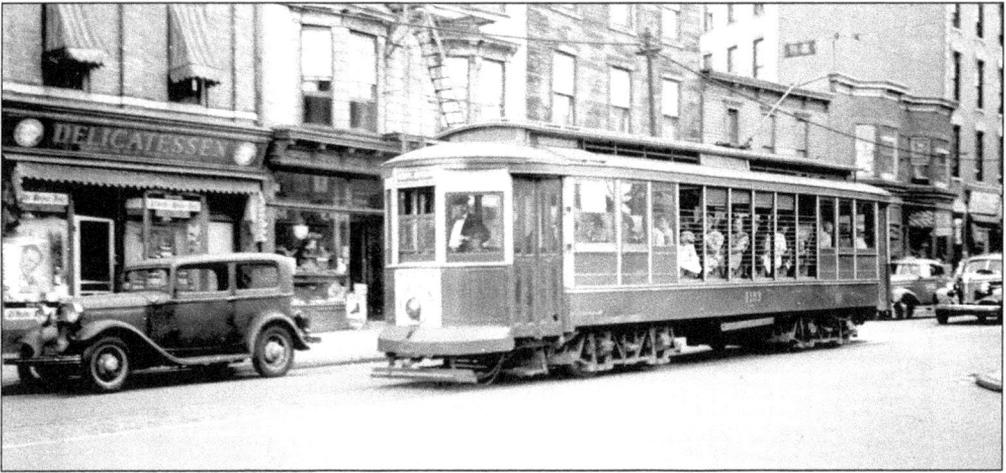

Convertible No. 4183, with most of its side window panels replaced by open grates, is on the Crosstown line traveling down Bedford Avenue toward downtown and Erie Basin on August 8, 1938. Fourth Street, Williamsburg, was laid out at the top of the bluff above the East River. The bluff was leveled about 1853, and the street name was changed to Bedford Avenue about 1890. (FP.)

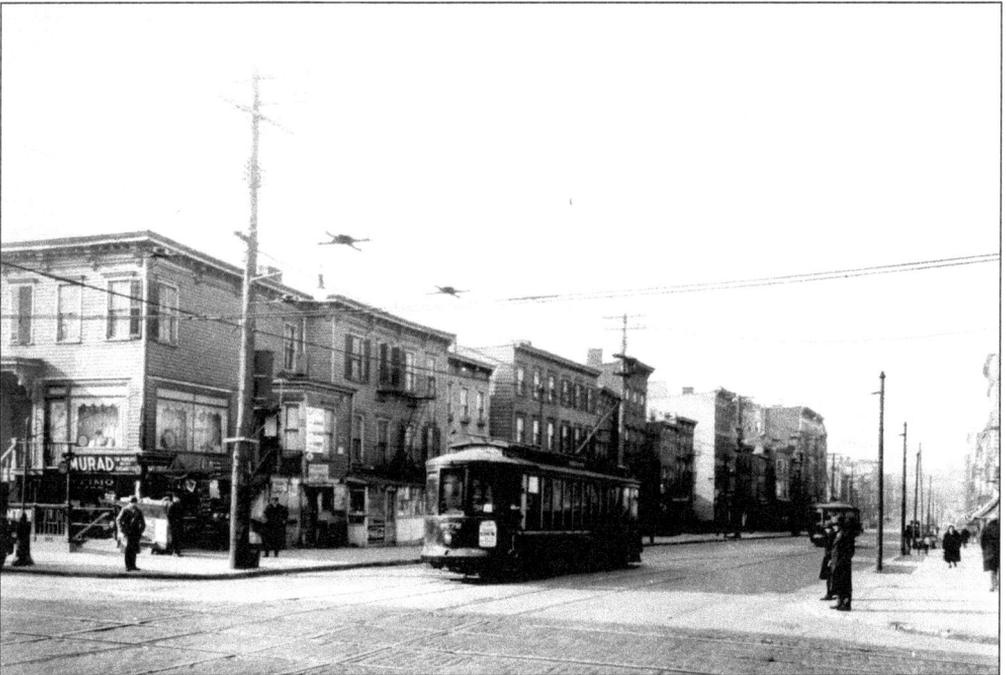

No. 4578 is on Metropolitan Avenue at Lorimer Street on January 27, 1928. In 1905, it was one of the last Brooklyn convertibles built but one of the first cars to be constructed with a platform windscreen. All cars eventually received windscreens in the first decade of the century by order of the Public Service Commission, but the platform gates were not replaced with doors until the cars were rebuilt for one-man operation in the 1930s. Farther east up the street is a one-man safety car on the lightly traveled Meeker Avenue line. (EBW/AJL.)

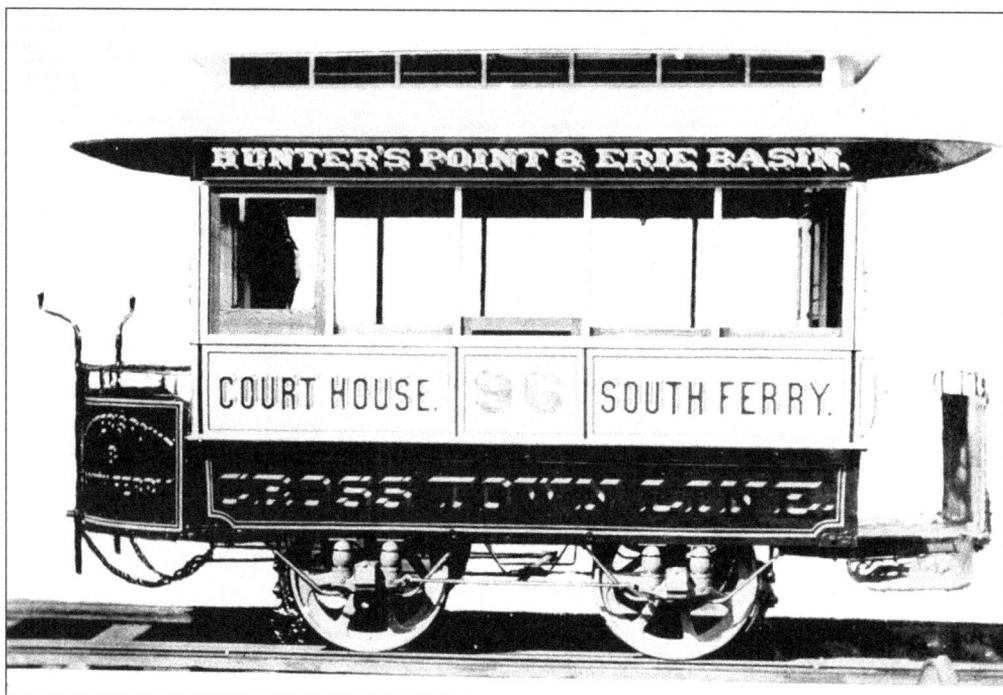

Horsecar service over the bridge between Greenpoint and Long Island City started on October 1, 1868. Hunters Point and Erie Basin horsecar No. 96 went to the Long Island Rail Road ferry via Borden Avenue. The Hunters Point shuttle was Brooklyn's last horsecar line, lasting until May 28, 1900. (BERA.)

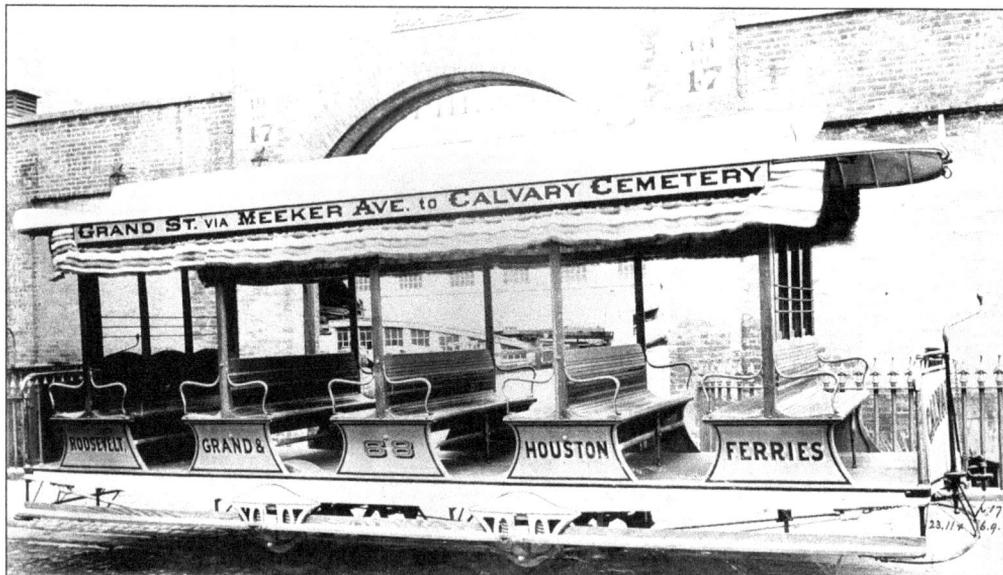

A branch of the Grand Street horsecar line started running up Smith (Humboldt) Street and Meeker Avenue in 1861 to Penny Bridge. The name was derived from the 1¢ toll pedestrians were charged to cross the bridge to reach Calvary Cemetery. Horsecar No. 68 was photographed at the John Stephenson factory on Twenty-third Street in Manhattan. (EBW/AJL, Museum of the City of New York collection.)

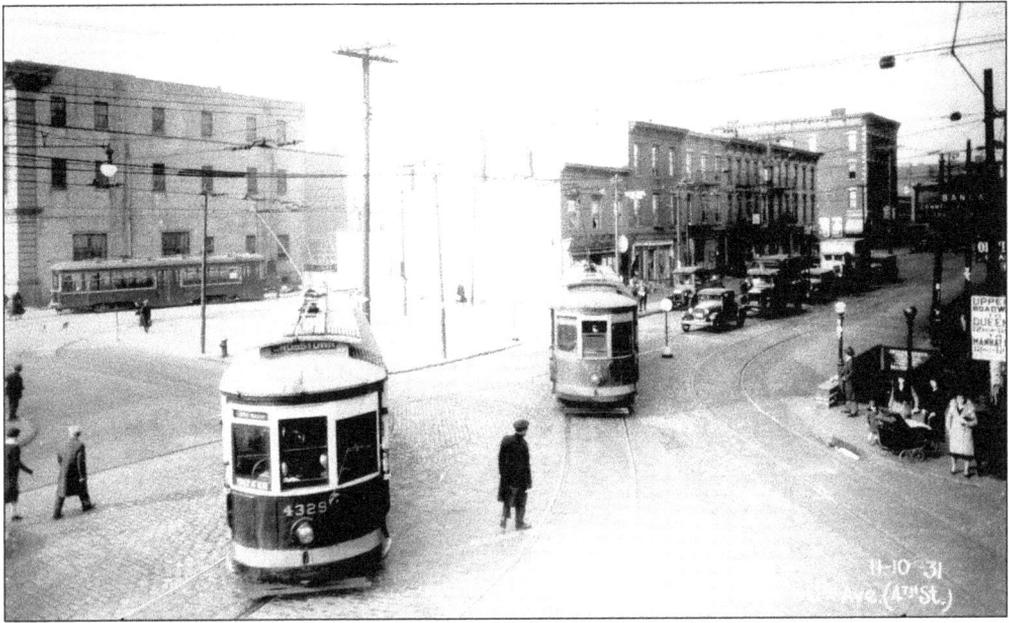

Crosstown cars are at the busy Long Island City loop at Fiftieth Avenue (formerly Fourth Street) in 1931 with No. 4329 departing southbound in the foreground, No. 4347 arriving, and No. 8330 on the loop. (EBW/AJL.)

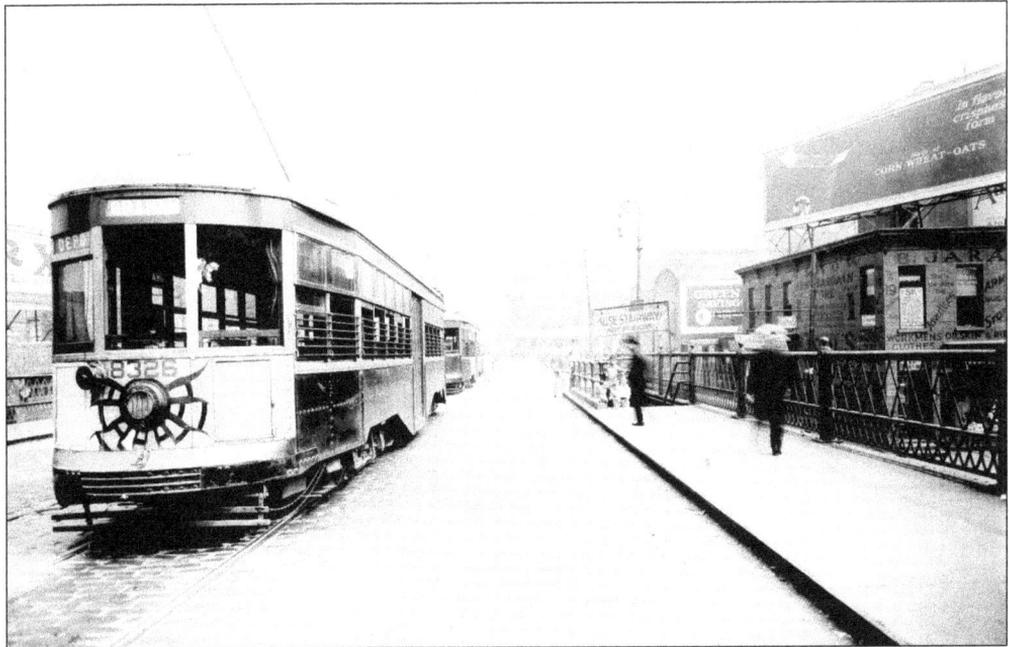

No. 8326 is on the swing bridge connecting Manhattan Avenue in Greenpoint with Vernon Avenue in Long Island City in 1930. The elaborate sunburst paint scheme on the front dash was applied to the new Peter Witt cars in 1923–1924 to indicate a front-entrance car. (EBW/AJL.)

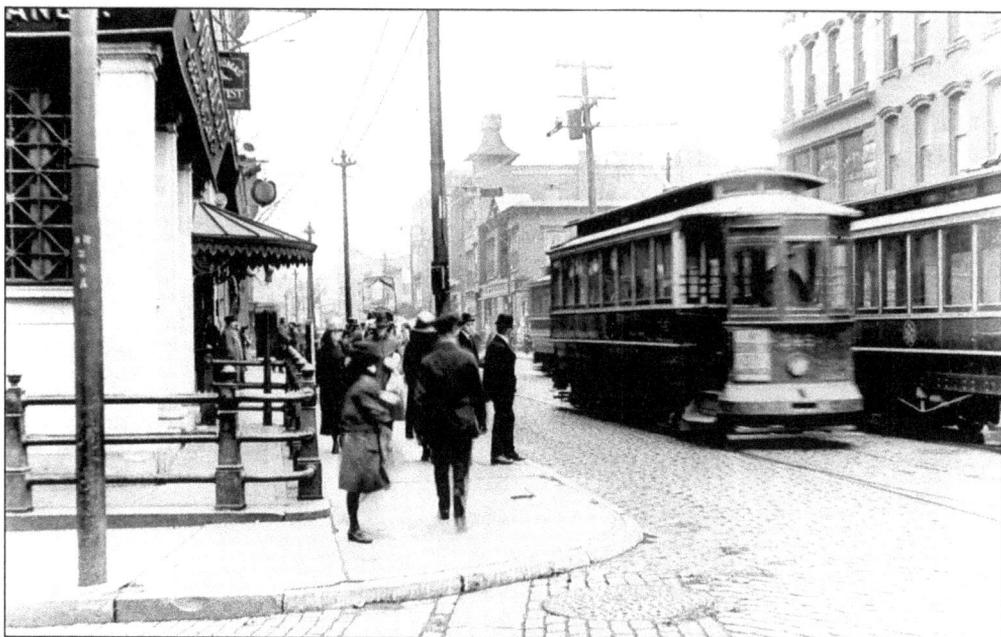

Northbound Lorimer Street No. 345 is on Manhattan Avenue at Greenpoint Avenue on April 13, 1920. An 1852 law banning cemeteries in Manhattan caused morticians and others to look eastward. The Greenpoint and Flushing Plank Road was built to connect the Greenpoint ferry (1853–1933) to Calvary Cemetery. The car lines on Manhattan Avenue all ran to the Greenpoint ferry at one time. (EBW/AJL.)

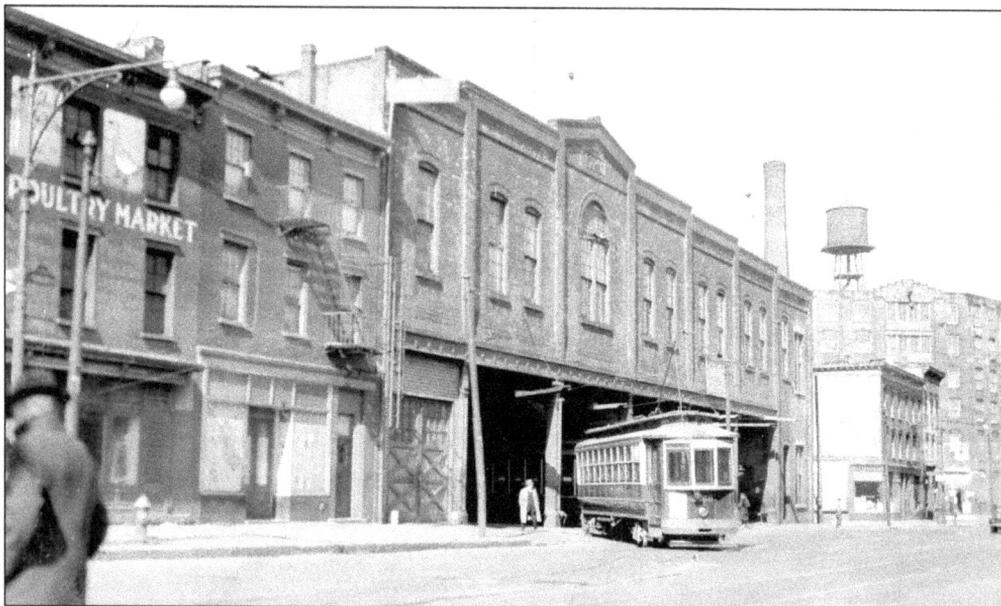

No. 2988 pulls out of the depot onto Manhattan Avenue in 1937. This building at Box Street was home to the Greenpoint, Crosstown, Union Avenue, Nassau Avenue, Lorimer Street, Graham Avenue, Meeker Avenue, and Calvary Cemetery lines. The structure was destroyed in a spectacular multiple-alarm fire on June 13, 1952, in which the entire front facade literally fell off into the street. (EBW/AJL.)

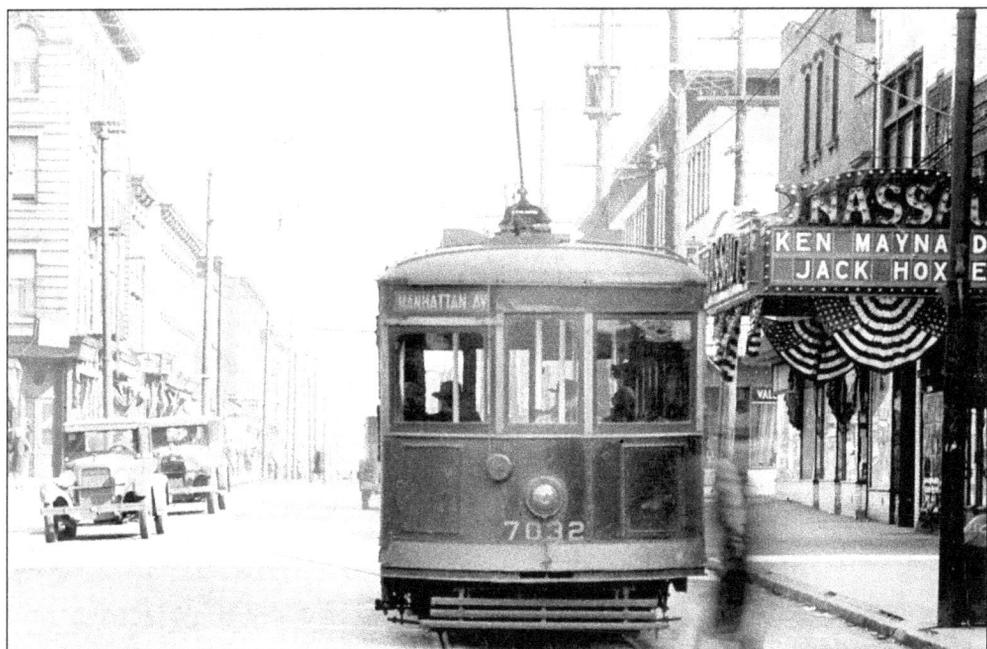

Nassau Avenue Birney No. 7032 is seen at its Manhattan Avenue terminal on February 26, 1928. Nassau was the Colonial Dutch name for Long Island. The rough-riding little safety cars remained in service into the mid-1930s until the rest of the fleet had been converted for one-man operation. Thirty cars were sold to other transit systems, and the remainders were scrapped. (EBW/AJL.)

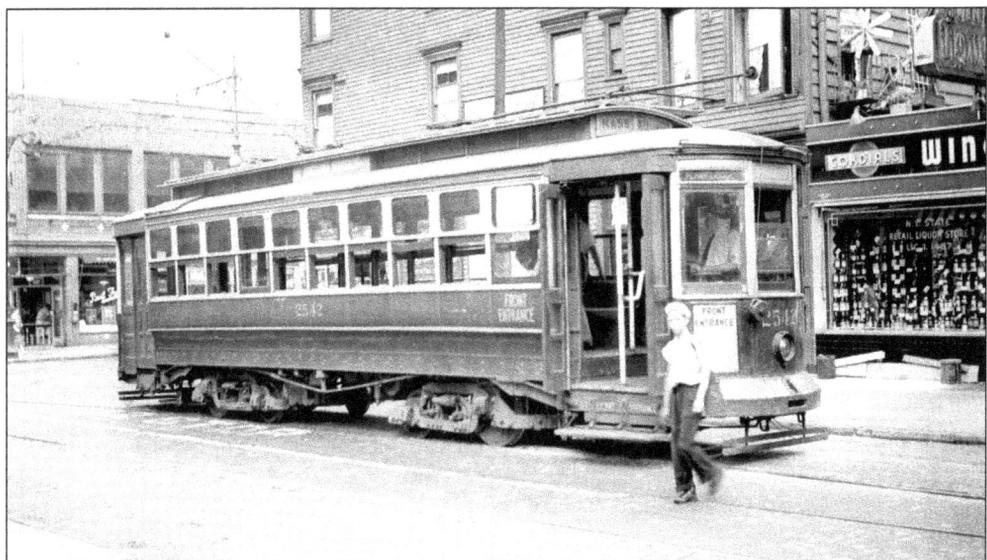

No. 2542, built in 1907, is at the west end of Nassau Avenue at Manhattan Avenue. After a couple of years of bragging about the qualities of its 1905–1906 convertibles, the BRT decided to get cars of the same design as its old 1903–1904 semiconvertibles. Narrow aisles in the convertibles prevented conductors from collecting fares and hindered passenger movement, so the 1907 cars reverted to a wide aisle with seats along the sides. (FP.)

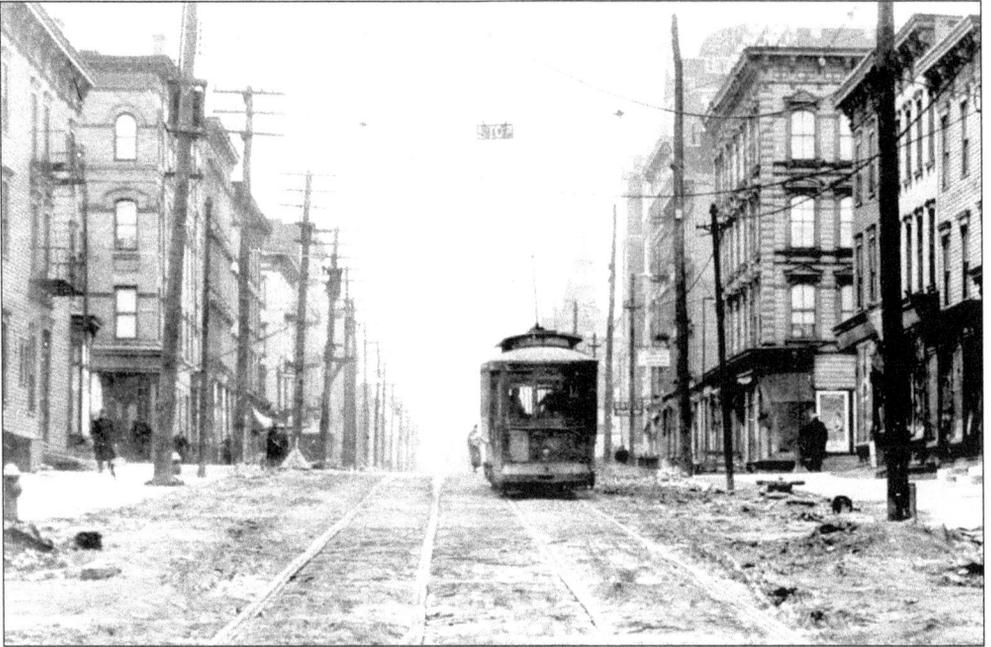

R. G. Thursby's stage ran between Bushwick and Williamsburg in 1832. M. B. Whittlesey's stage ran a similar route from the Bushwick crossroads at Bushwick and Flushing Avenues to the Greenpoint and Broadway ferries. Whittlesey and Company became the Bushwick Railroad on March 20, 1867, and opened its horsecar line on June 1, 1868, on South Fourth and Messerole Streets and Bushwick and Myrtle Avenues to Myrtle Park at Himrod Street. No. 2750 is at Bushwick and Johnson Avenues on February 26, 1925, where it crosses the Wilson Avenue line. (EBW/AJL.)

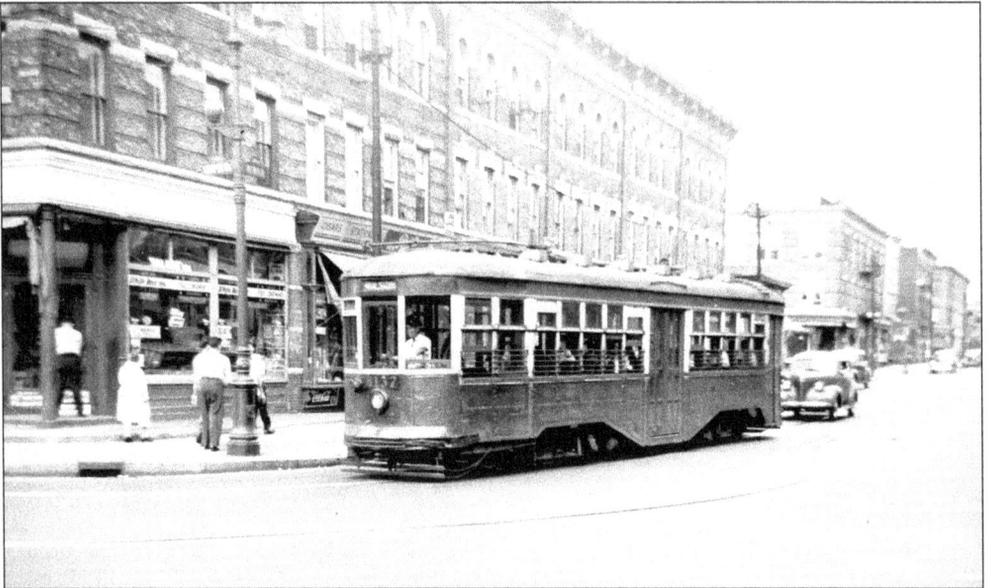

No. 8137 turns from Wilson Avenue onto Cooper Street in 1947. Hamburg Avenue, running through the predominantly German neighborhood of Bushwick, was renamed Wilson Avenue in 1918 in response to the anti-German hysteria that prevailed during World War I. (EBW/AJL.)

The Broadway Railroad opened its East New York line from the Broadway ferry to Alabama and Atlantic Avenues in April 1859. Open cars were introduced to Brooklyn by the Broadway Railroad in 1866, and steam cars ran from Broadway and Ellery Street to Cypress Hills between 1878 and 1882. Horsecar No. 68 was photographed at the John Stephenson factory. (EBW/AJL, Museum of the City of New York collection.)

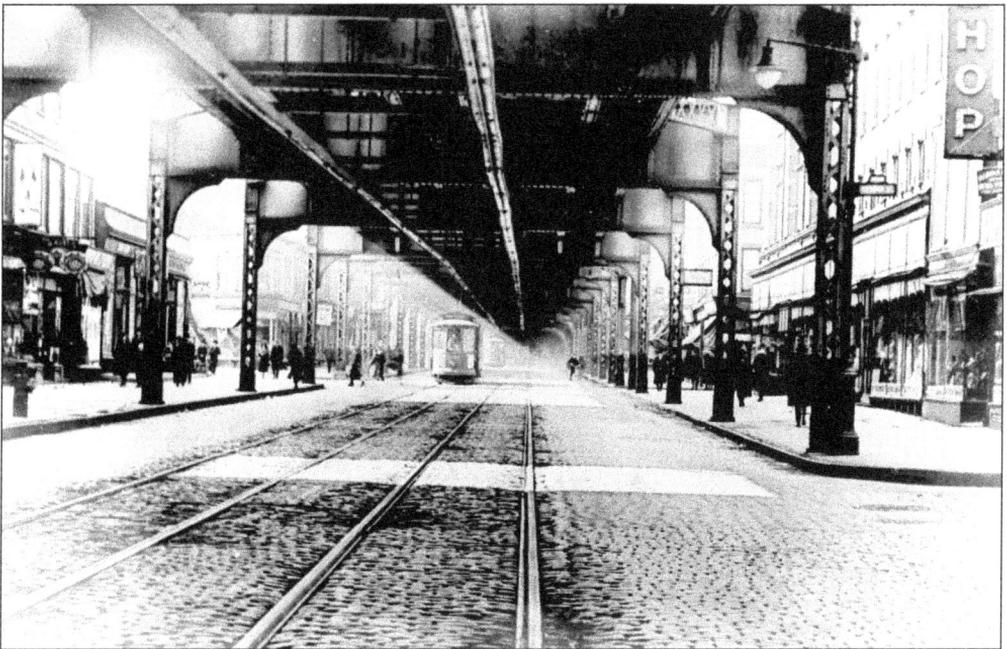

Convertible No. 3961 travels down Broadway at Suydam Street in 1922. Electric cars arrived on July 31, 1894, and continued to run beneath the elevated until January 15, 1950. (EBW/AJL.)

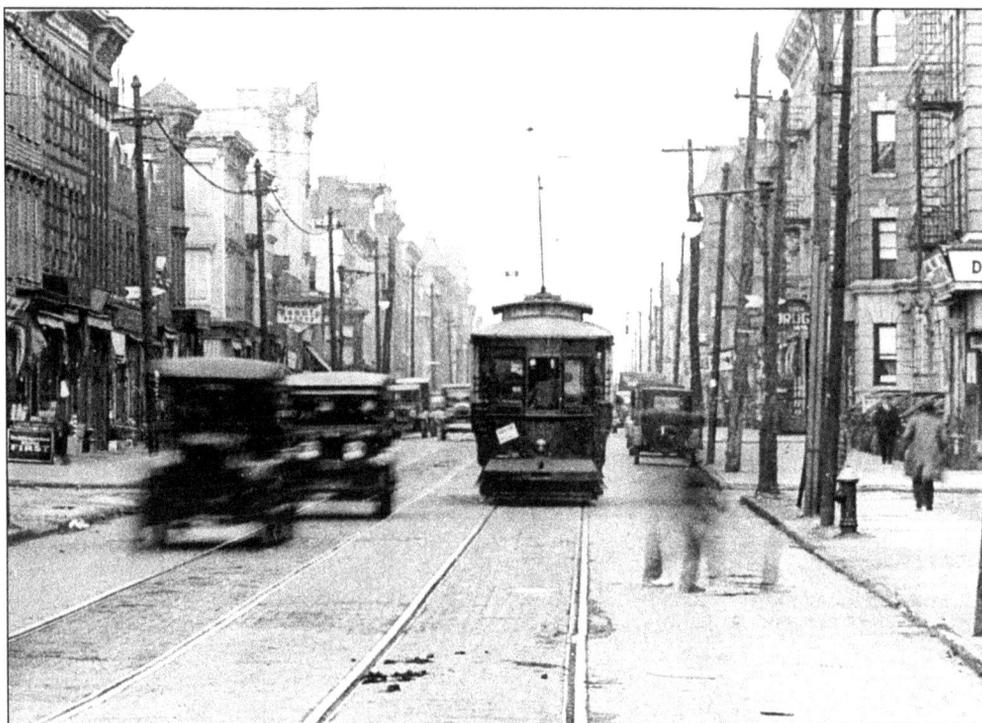

No. 333 is on Reid Avenue on April 7, 1930, near the old Chauncey Street horsecar barn. The Broadway Railroad opened this line from the Broadway ferry to Reid Avenue and Fulton Street on October 27, 1873, and extended it to Atlantic and Utica Avenues in 1885. After electrification in December 1894, it was feasible to further extend the line to Eastern Parkway in 1897, Carroll Street in 1899, and a single track to Church Avenue in 1900. (EBW/AJL.)

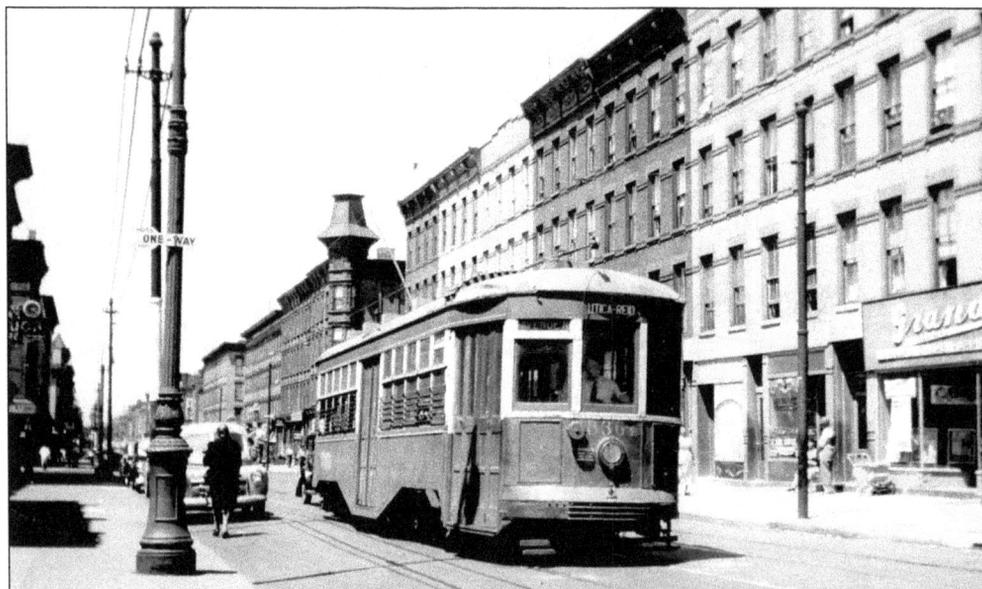

Utica-Reid No. 8361 is on Reid Avenue at Decatur Street on June 4, 1949, two blocks up the street from the horsecar barn. (EBW/AJL.)

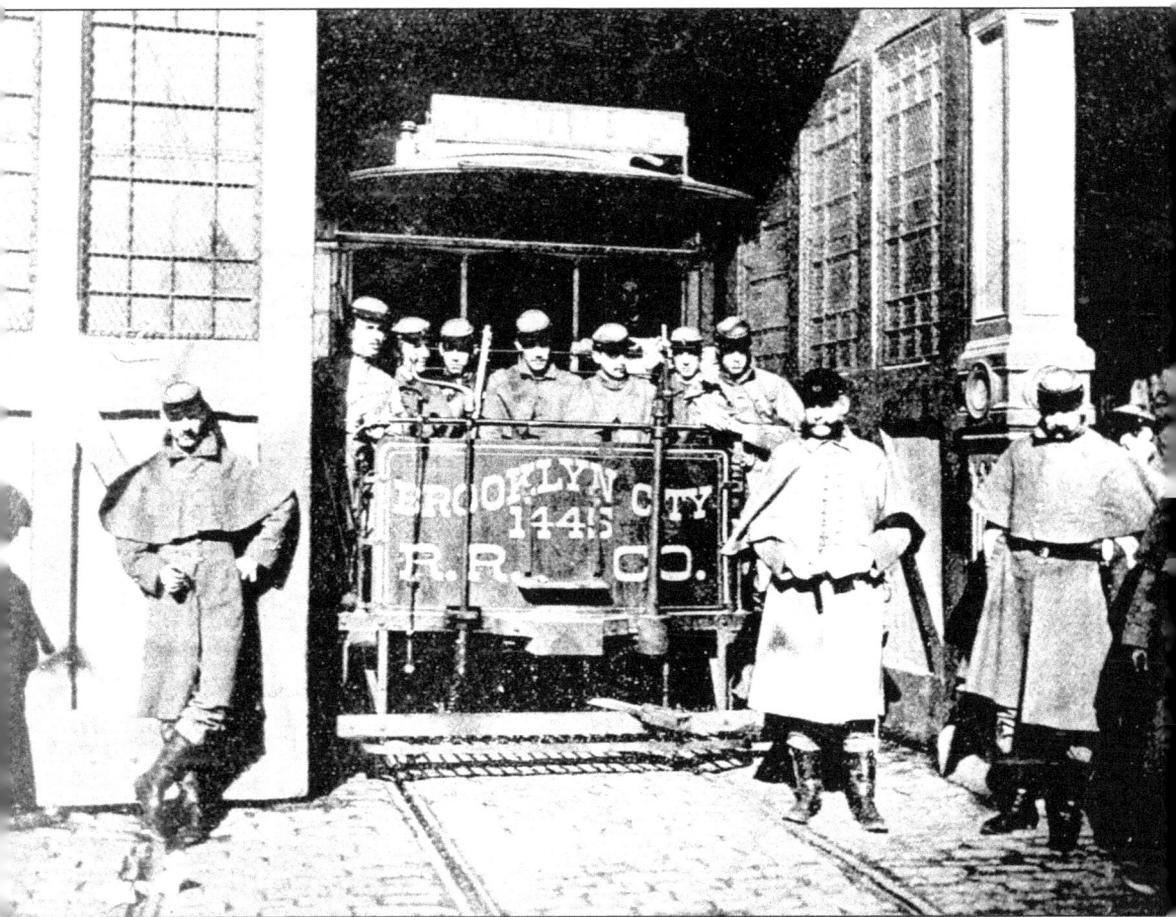

Militiamen gather around open car No. 1445 at the depot on the north side of Halsey Street west of Broadway in February 1895. The Brooklyn City Railroad and the Knights of Labor established collective bargaining relations in 1886 and renewed the agreement each year. Negotiations broke down in 1895, 5,500 employees went on strike, and the company turned to professional strikebreakers to provide trolley service. These experienced professionals traveled to various cities where a strike was in progress and worked for premium wages until the strikers returned to work or new crews were hired and trained. Often these strikebreakers were former railway employees who had been fired or had once gone out on strike and had never been rehired. When the striking Brooklyn workers interfered with railway operations, the mayor called for help from the state, and the governor sent 7,500 troops to the city. Trolleys began operating under military protection on January 22, 1895, with two soldiers on each car. By the time the Brooklyn strike ended, one man had been killed and a sizeable number injured. (EBW/AJL.)

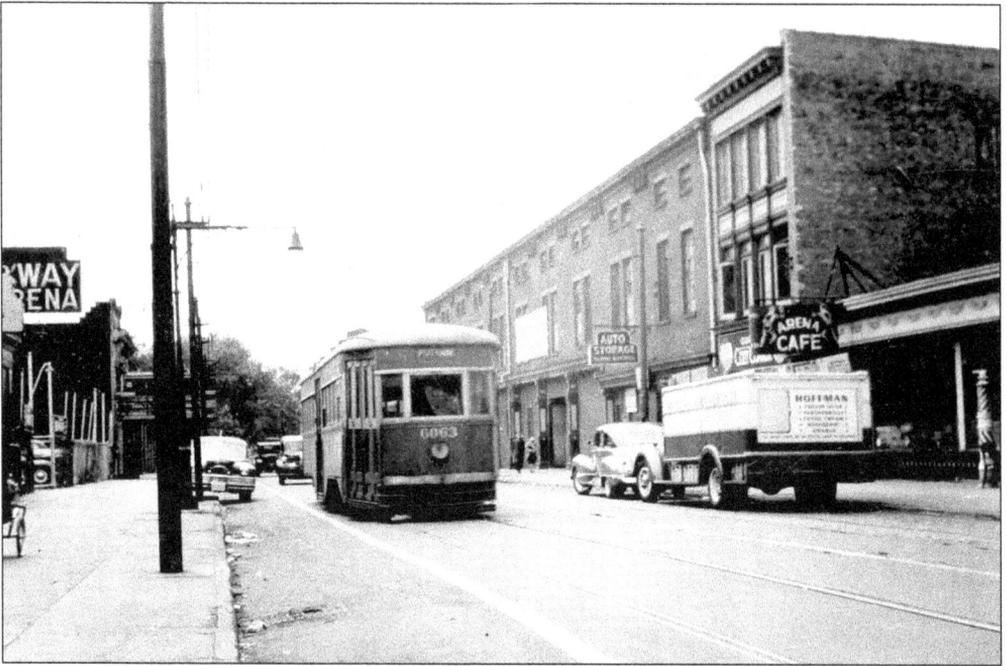

Buses replaced Putnam Avenue cars on September 21, 1941, but World War II rubber and fuel shortages led to the return of the streetcars on November 29, 1942. No. 6063 passes the site of the old depot on Halsey Street near Broadway in 1948. It continued to use these rails until February 5, 1950. (EBW/AJL.)

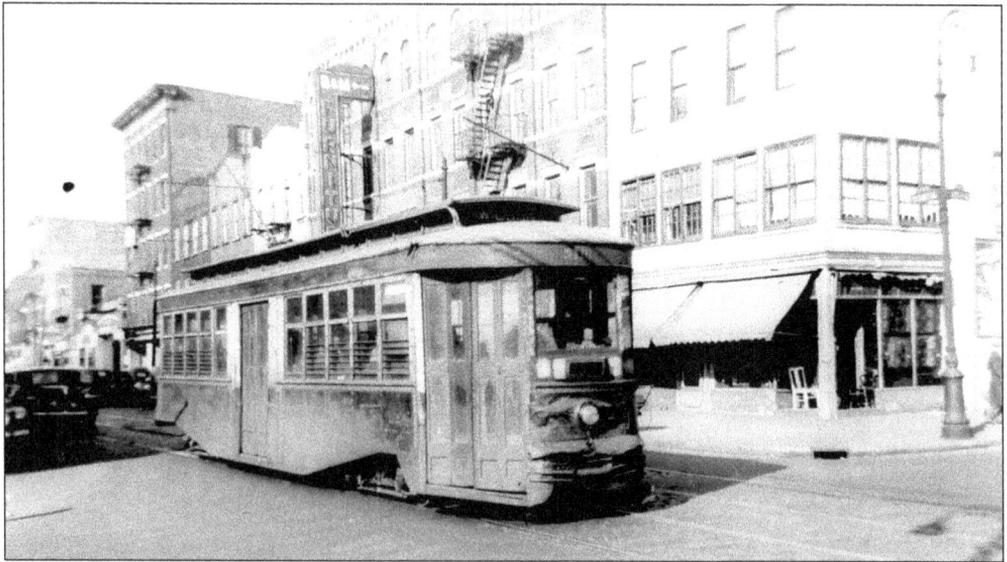

Wilson Avenue No. 5116 travels down Rockaway Avenue in 1945. (EBW/AJL.)

Five

INTO QUEENS AND BACK TO BROOKLYN

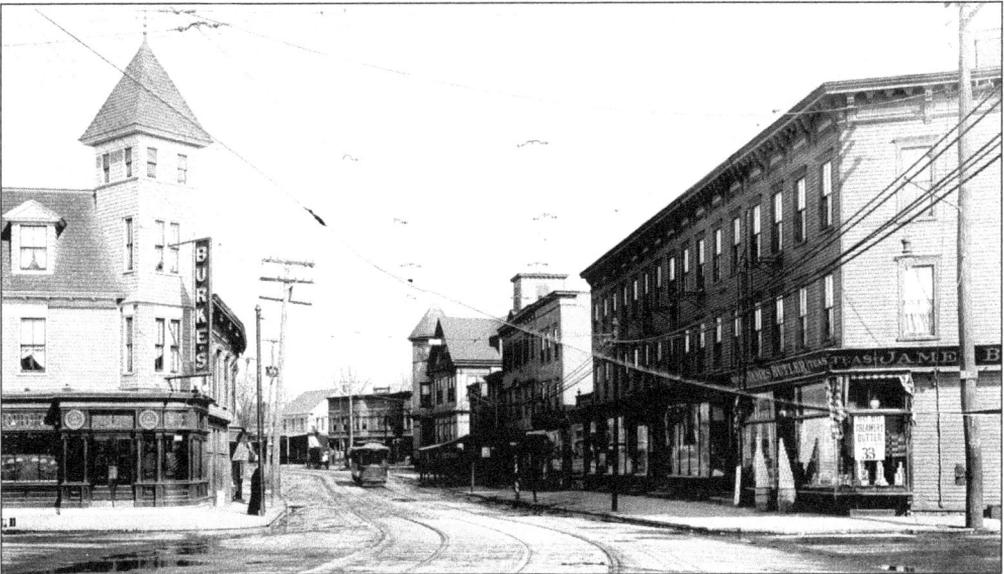

Grand Avenue becomes Broadway north of Queens Boulevard. The Newtown area was developed by Cord Meyer in the 1890s. With the tarnished reputation of polluted Newtown Creek known far and wide, Meyer lobbied for a higher-class name for the district and his real estate venture. Elmhurst was the name applied in 1896. It still had the appearance of a small town in 1912. (EBW/AJL.)

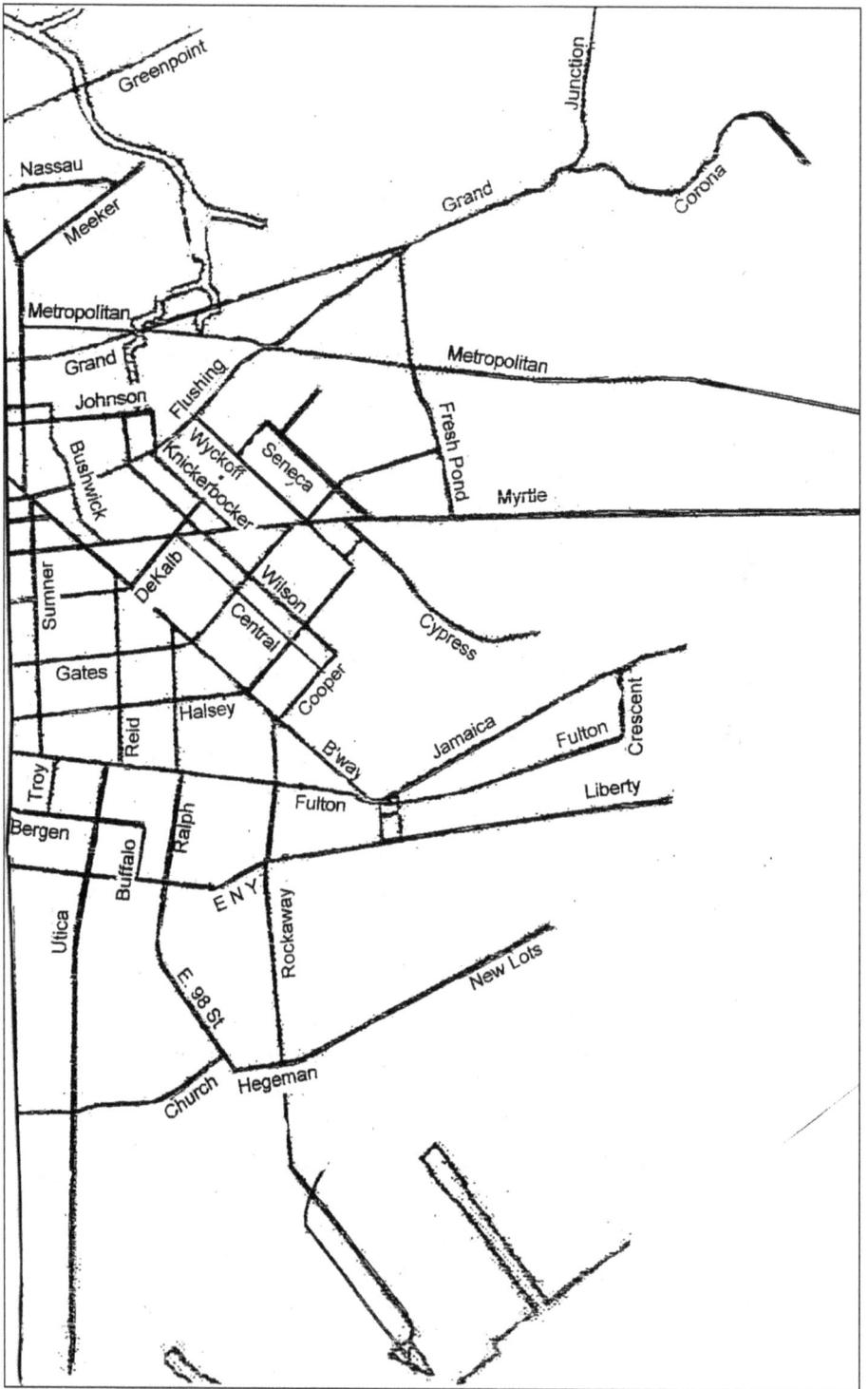

This map shows the communities of Maspeth, Newtown, Flushing, Ridgewood, Fresh Pond, Glendale, Middle Village, Jamaica, Cypress Hills, New Lots, East New York, Brownsville, and Canarsie.

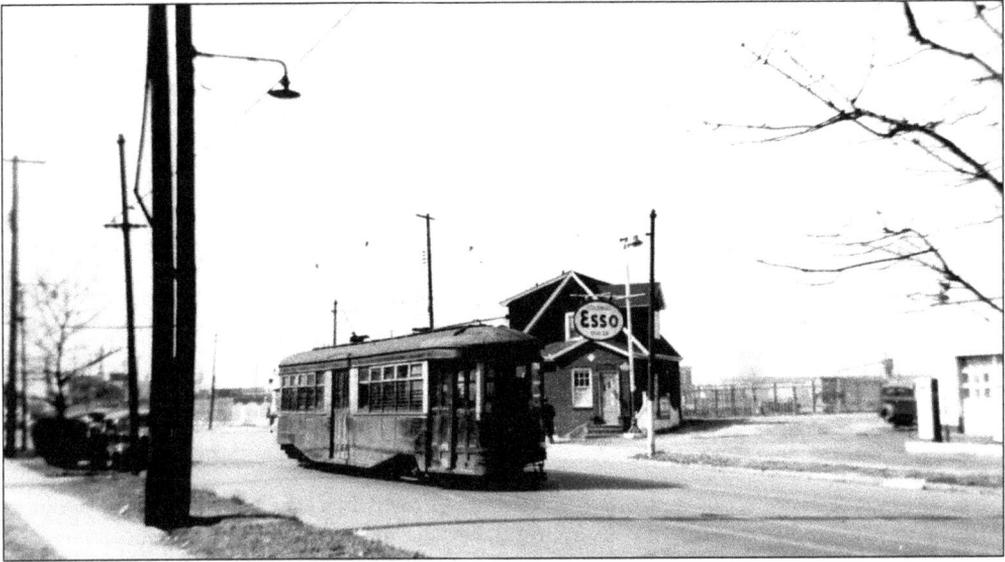

Flushing Avenue No. 5037 is at Fifty-eighth Street in Maspeth, just east of the Brooklyn-Queens border, as seen here in 1937. The first European settlement in Queens was established in this locality in 1642. (EBW/AJL.)

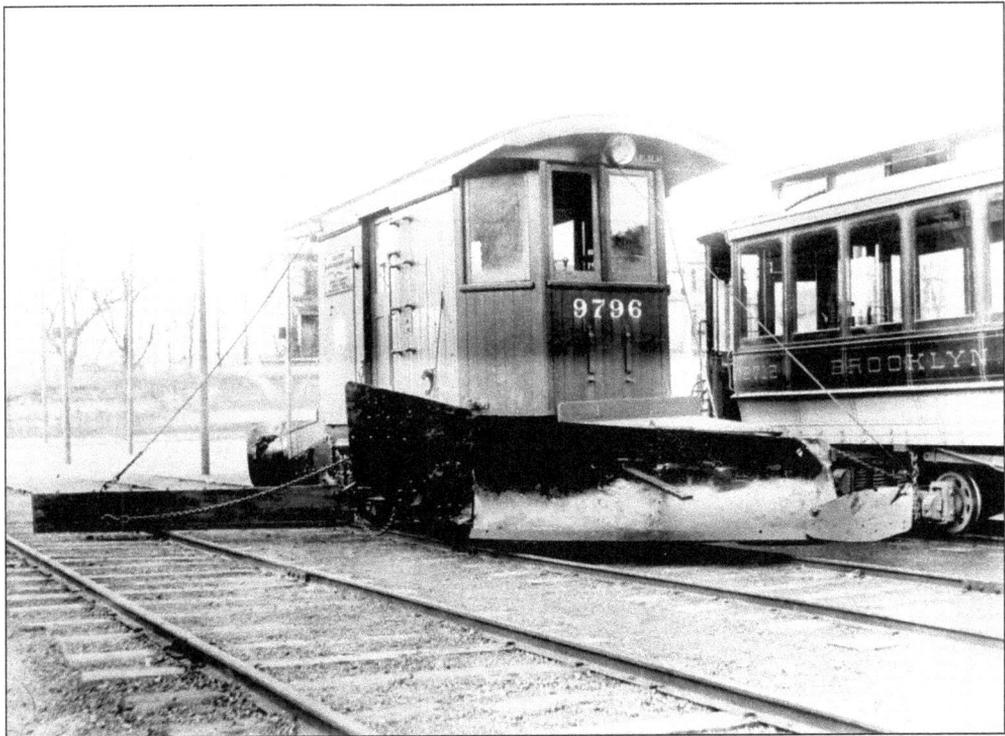

Wind-blown snow in the open country of northwest Queens often produced drifts deep enough to bury the tracks. Sweepers could not always keep these tracks clear, so one of the BRT's 29 plows went out to fight the storm. No. 9796 poses at the Maspeth depot with its wing blade extended to display its reach. (EBW/AJL.)

New York and Queens County Railway No. 333 on Brown Place heads toward Metropolitan Avenue in Middle Village. It is crossing Grand Avenue in front of Brooklyn-Queens Transit Corporation No. 8247 and No. 5076 at the 1907 Maspeth depot located at Juniper Avenue (Sixty-ninth Street). For many years, cars from Brooklyn terminated here with a shuttle operating east of the depot. (EBW/AJL.)

New York City Transit System No. 8423 passes some Twin Coaches at the Maspeth depot in 1949. Until the traditional nickel fare was raised in 1948, an additional 5¢ was collected from passengers traveling beyond the depot to and from Elmhurst, Corona, and Flushing. (EBW/AJL.)

106

Safety car No. 7043 bounces along Corona Avenue on the Flushing-Ridgewood line in 1922. Of all the lightly traveled lines on the Brooklyn trolley system, only the Flushing-Ridgewood line had all service provided by Birneys until those cars were retired. (EBW/AJL.)

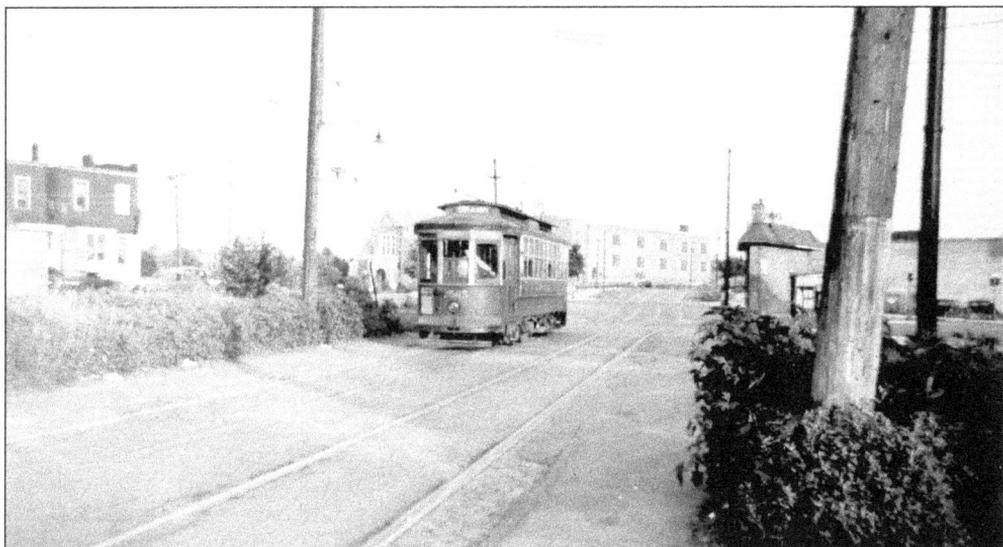

Grand Street cars from Brooklyn ran through to North Beach at various times from 1894 until Grand Street and Junction Avenue were finally split into two separate lines on February 6, 1946. Undeveloped real estate surrounds No. 2505 as it rolls along Grand Avenue in 1943. (EBW/AJL.)

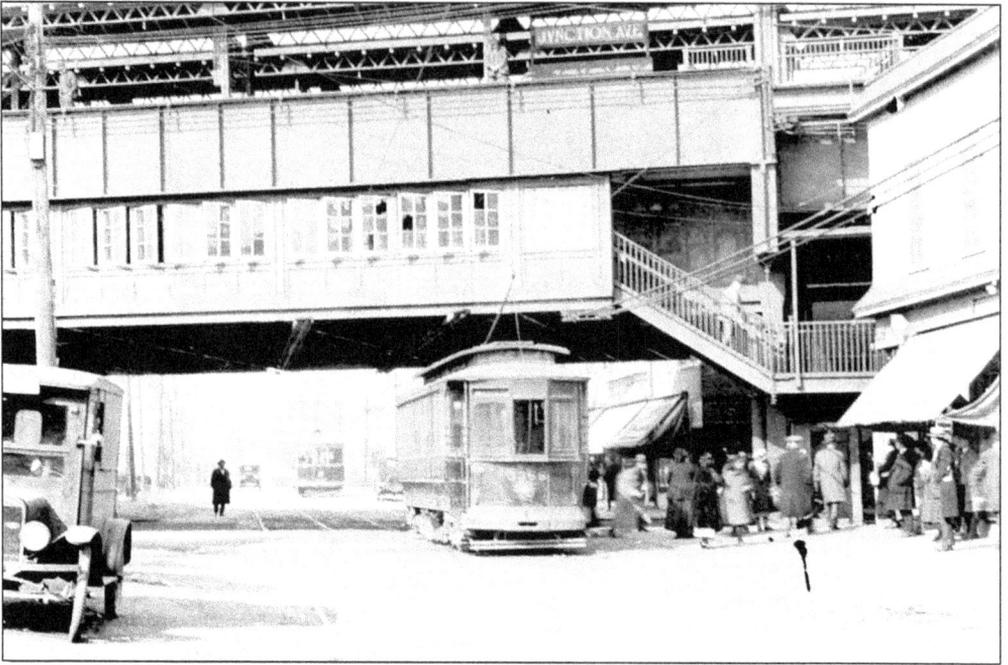

Grand Street No. 3365 terminates on Junction Avenue at Roosevelt Avenue in 1923 at the joint IRT-BMT station opened in 1917. A safety car on the Junction shuttle to North Beach is up the street beyond Roosevelt Avenue. Until the subway was extended from Corona to Flushing, the New York and Queens County Railway also ran on Junction south of Jackson Avenue (Northern Boulevard) to reach the new rapid transit line. (EBW/AJL.)

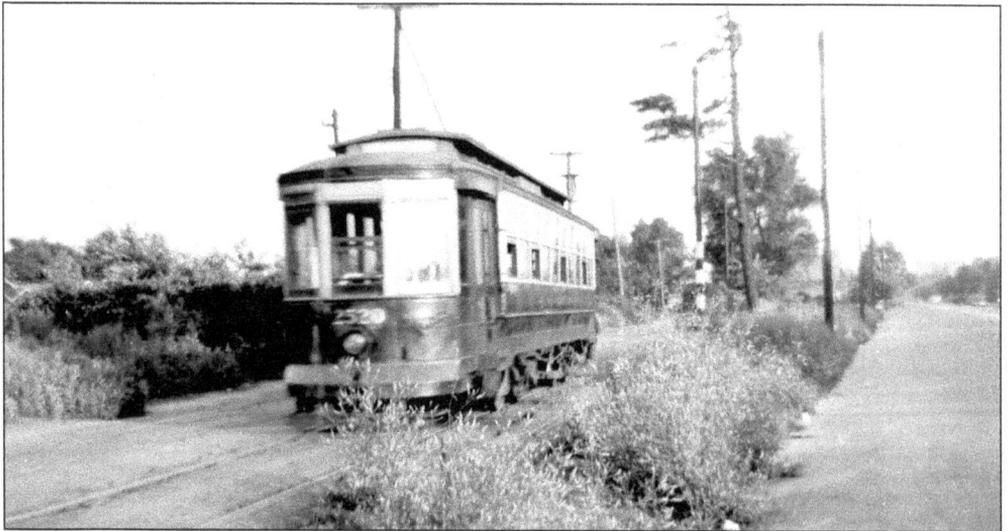

No. 2520 on Jackson Mill Road is near its junction with Ninety-fourth Street in 1943. When the line was built in 1894, Bowery Bay Road was the only street in existence north of Jackson Avenue in the largely uninhabited area, so the tracks were laid in that thoroughfare. When a grid street pattern was adopted for Queens County in 1915, the tracks were left in place and the right-of-way, meandering at odd angles through front yards, was renamed Jackson Mill Road. (EBW/AJL.)

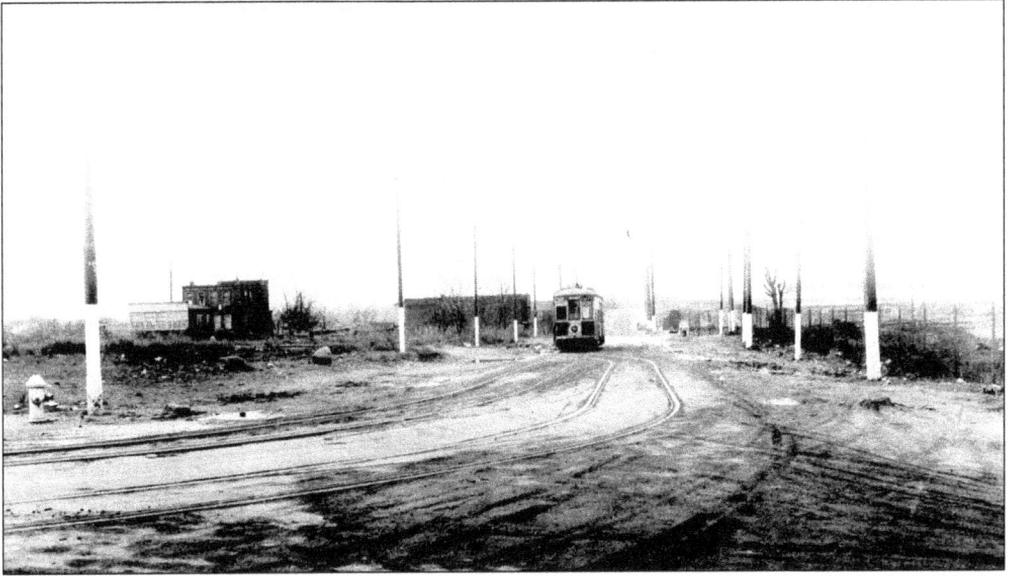

The outer limits of the Brooklyn trolley system were at the popular North Beach Amusement Park in Queens. To reach this park, the BRT built a line from Corona Avenue up Junction Avenue and Bowery Bay Road. A fire destroyed the park in 1925 and part of the site became Glen Curtiss Air Field, which opened in 1929. No. 8197 is on Twenty-first Avenue between Ninety-third and Ninety-fourth Streets on March 17, 1938, on the tracks that once looped through the park via Nineteenth Avenue. (EBW/AJL.)

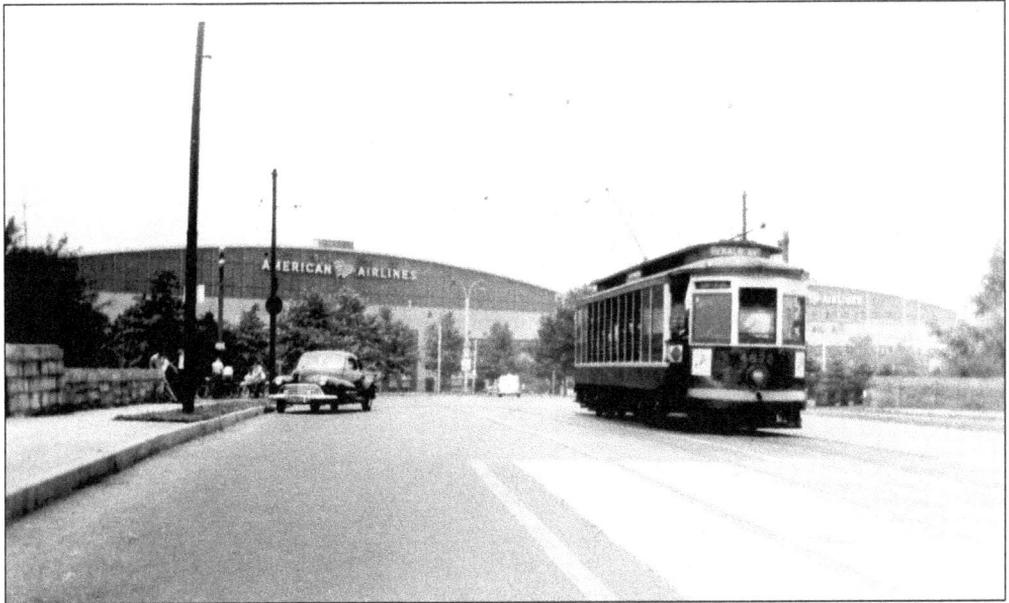

Between 1931 and 1936, the approach road to the Triborough Bridge was constructed. At the same time, Glen Curtiss Air Field was expanded and improved, reopening as the New York Municipal (LaGuardia) Airport on December 2, 1939. Excursion car No. 4573 is at the end of the track at the line's final terminal above the Grand Central Parkway on August 22, 1948. (FP.)

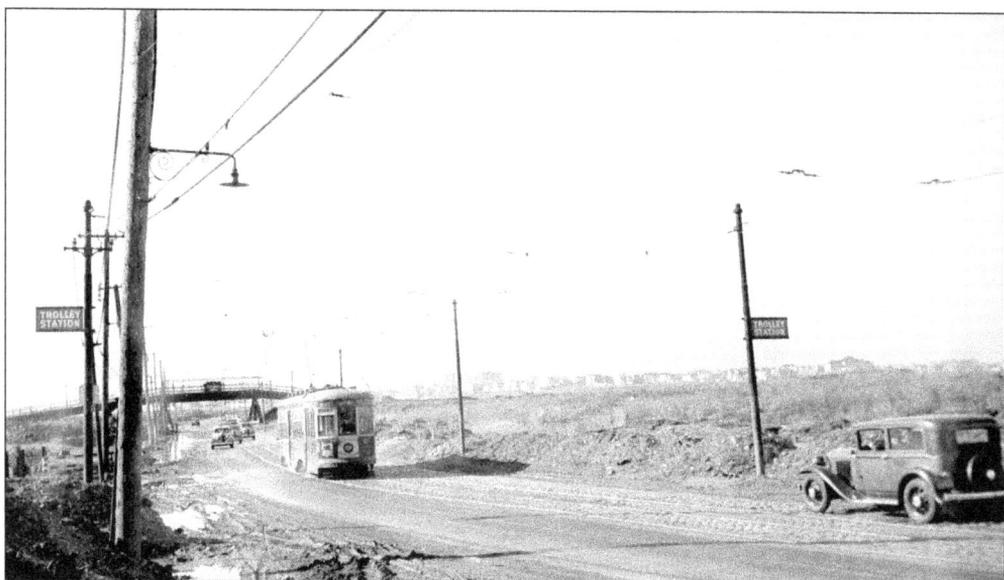

Flushing-Ridgewood No. 8155 on Strong's Causeway crosses the tidal wetlands bordering Flushing Creek in June 1937. The common name for the area was "Corona Dumps," referring to the landfill put there by the Brooklyn Ash Removal Company. Strong's Causeway, built in the 1850s, was at about present-day Sixty-second Road. Trolleys started using the causeway in November 1899. (EBW/AJL.)

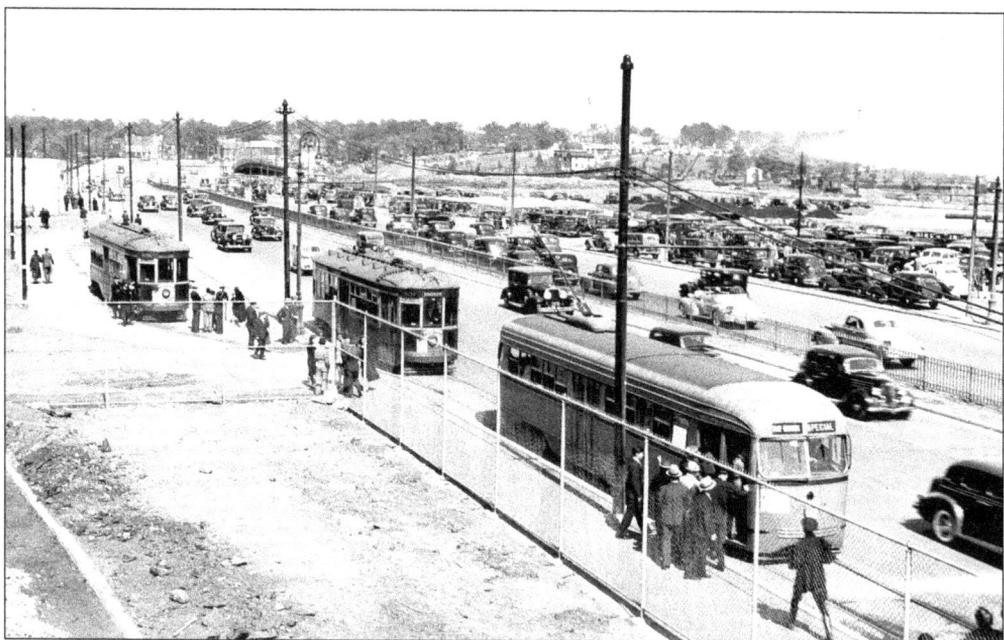

Nassau Boulevard (Horace Harding Boulevard) at about Sixty-first Avenue replaced Strong's Causeway in time for the opening of the 1939 world's fair. The PCC and following Peter Witt are on the main track at the side of the road, while the third car is on a siding. Regular service to the fair was provided by all Flushing-Ridgewood and some extended Flushing Avenue cars. A special 10¢ service from downtown Brooklyn using PCC cars lasted only for a short period of time. (BERA.)

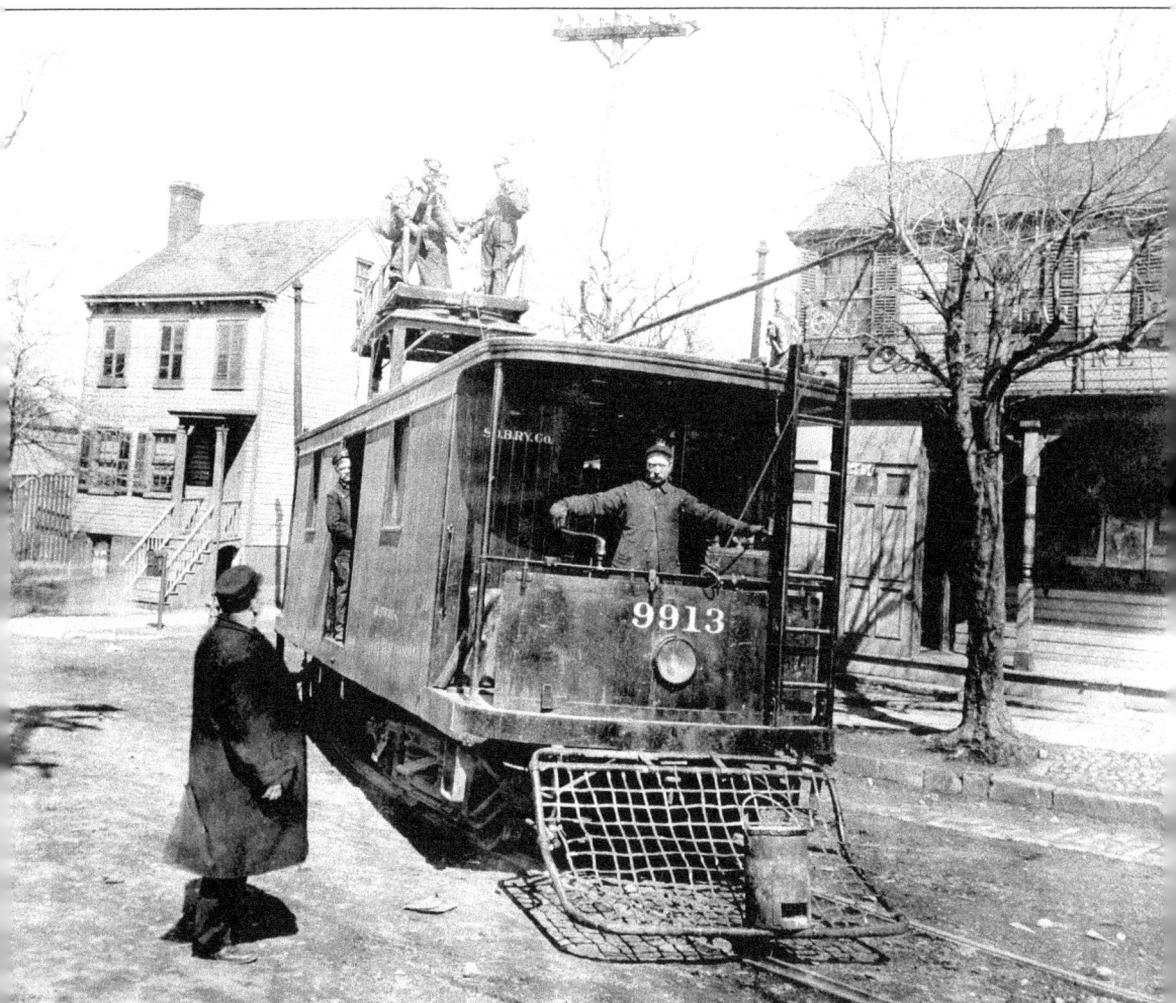

Summer heat caused the overhead wire to expand and sag, while winter cold caused it to contract and rise. Adjustments had to be made frequently to prevent poles from coming off the wire. Replacement of the wires and all the related hardware also had to be done on a regular basis. Line car No. 9913's crew performs the necessary maintenance work in 1910 at Lawrence Street and Prospect Avenue (Forty-first Avenue) in Flushing. The bulkhead S. O. B. Ry. lettering indicates the car is owned by the South Brooklyn Railway, one of the BRT's subsidiaries. (EBW/AJL.)

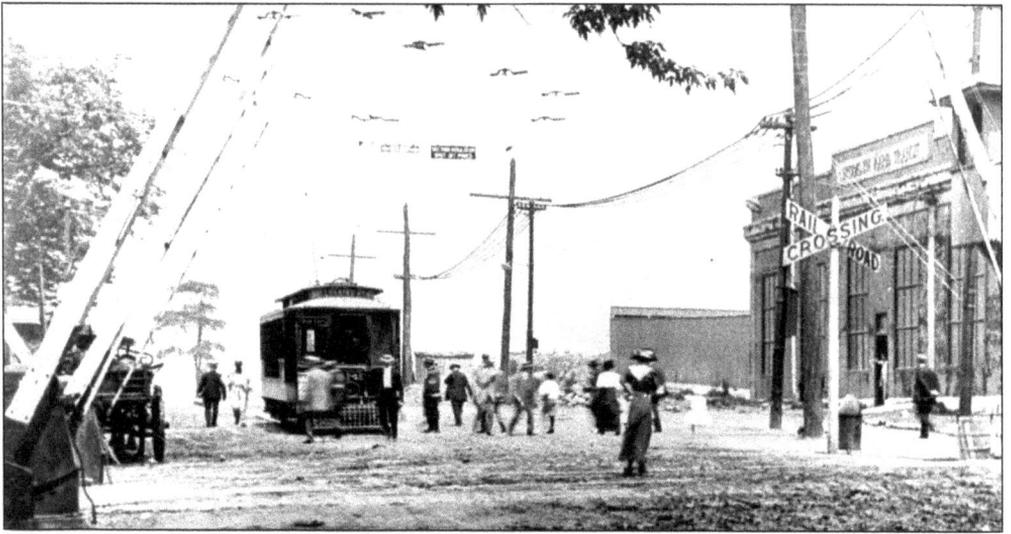

Trolley service on Fresh Pond Road started in 1896. The former Bushwick Railroad right-of-way commonly known as the Lutheran line was connected to the Myrtle Avenue elevated via an incline in 1903 and elevated trains commenced running to Metropolitan Avenue. No. 4145 is at the Fresh Pond Road grade crossing next to the new Fresh Pond depot in 1913. When the elevated structure was extended east of Ridgewood, streetcars began using the right-of-way. (EBW/AJL.)

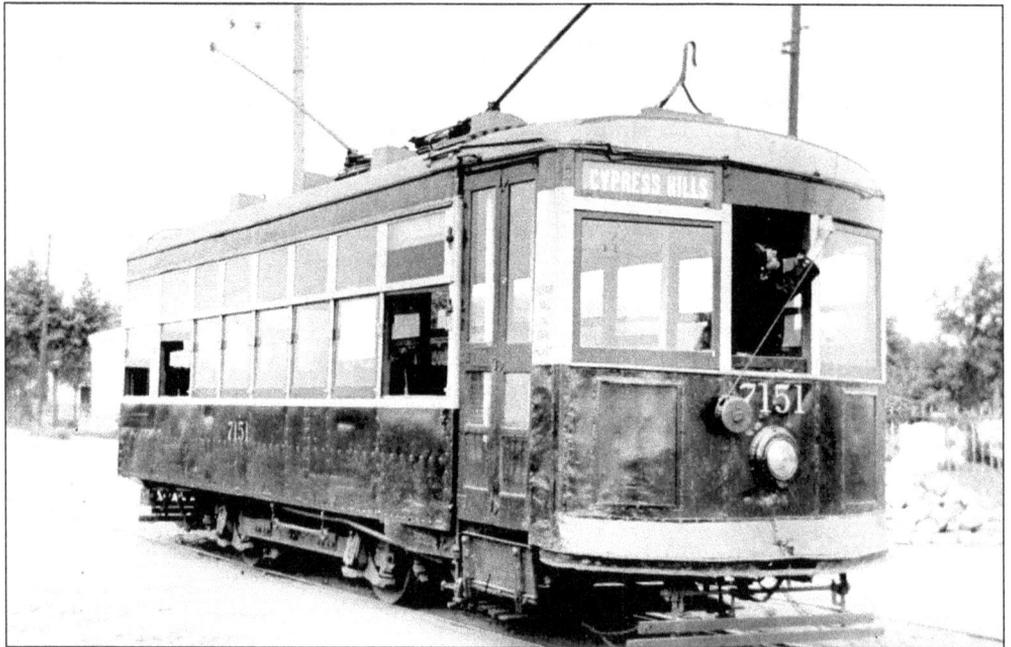

The operator of safety car No. 7151 has perfected the art of changing the pole—at least in warm weather. He is at the terminal of the Cypress Hills shuttle at its namesake cemetery on July 31, 1935. In 1847, the New York State legislature passed the Rural Cemetery Act stipulating that no burial organization could acquire more than 250 acres in one county. Speculators got around the law by buying land straddling two counties. Cypress Hills Cemetery, two-thirds in Queens and one-third in Brooklyn, is one of over a dozen cemeteries along the Kings County–Queens County border. (EBW/AJL.)

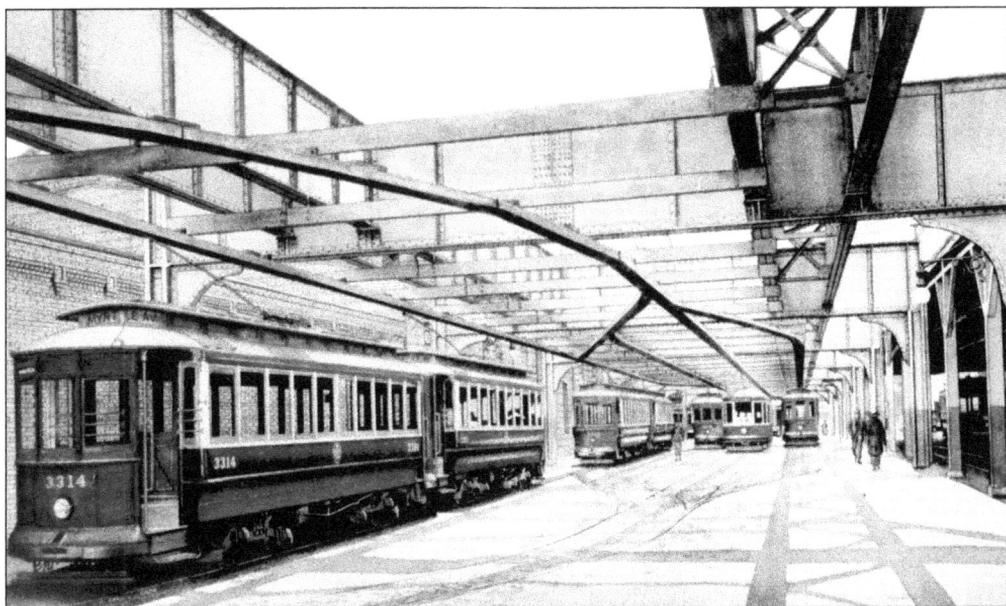

Most cars terminating in Ridgewood used the four tracks on Palmetto Street between Wyckoff and St. Nicholas Avenues. The iron bar overhead in the street was something of a Brooklyn oddity although it was often used inside carbarns. Heavy trolley traffic wore out the overhead wire, but the bar overhead was hard on the brass trolley wheels. Brooklyn used the iron bars only where operation was very slow—on the Brooklyn Bridge, at major intersections, or under elevated structures. (EBW/AJL.)

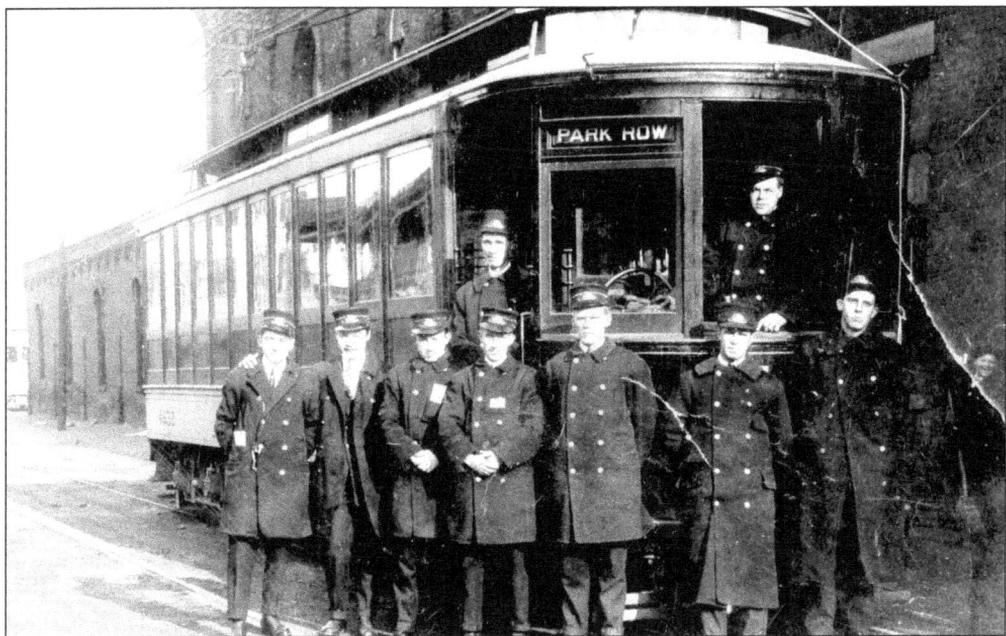

Nine crewmen pose with convertible No. 4552 at Ridgewood in 1913. There were six separate depots along Wyckoff Avenue and Palmetto Street at one time, serving the Bushwick, Flushing-Ridgewood, Gates, Myrtle Avenue, Putnam Avenue, Richmond Hill, and Wyckoff lines. (EBW/AJL.)

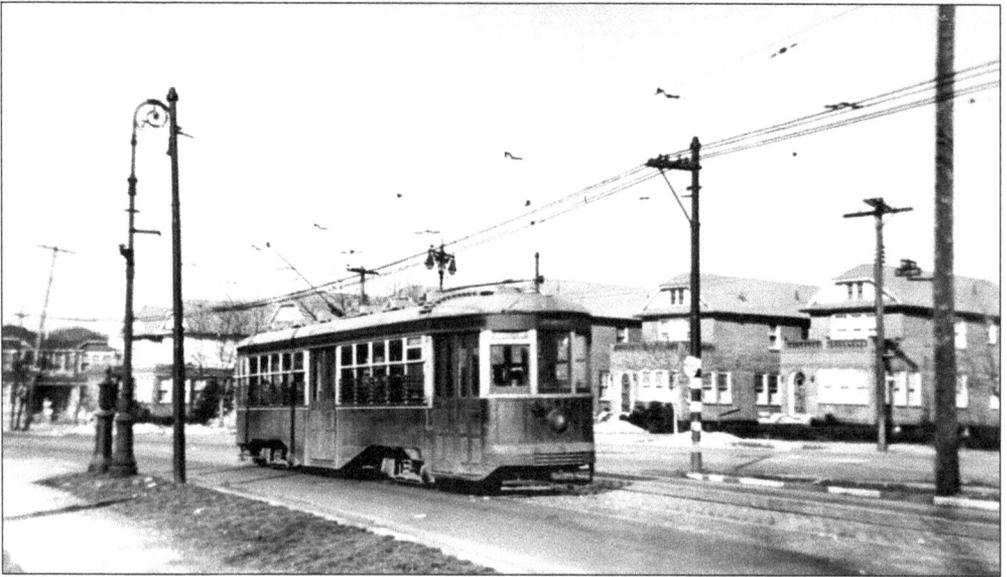

The five-and-a-half-mile Myrtle Avenue and Jamaica Plank Road opened in 1854. A steam dummy began operating along the highway on May 27, 1892, and the line was electrified in 1895. Richmond Hill–bound No. 8432 on Myrtle Avenue crosses Union Turnpike. Until 1930, there was a siding from Union Turnpike to Eighty-second Avenue to accommodate the extra cars needed to carry the predominantly German residents of Ridgewood and Glendale to the popular Schuetzen Park at this location. (BERA.)

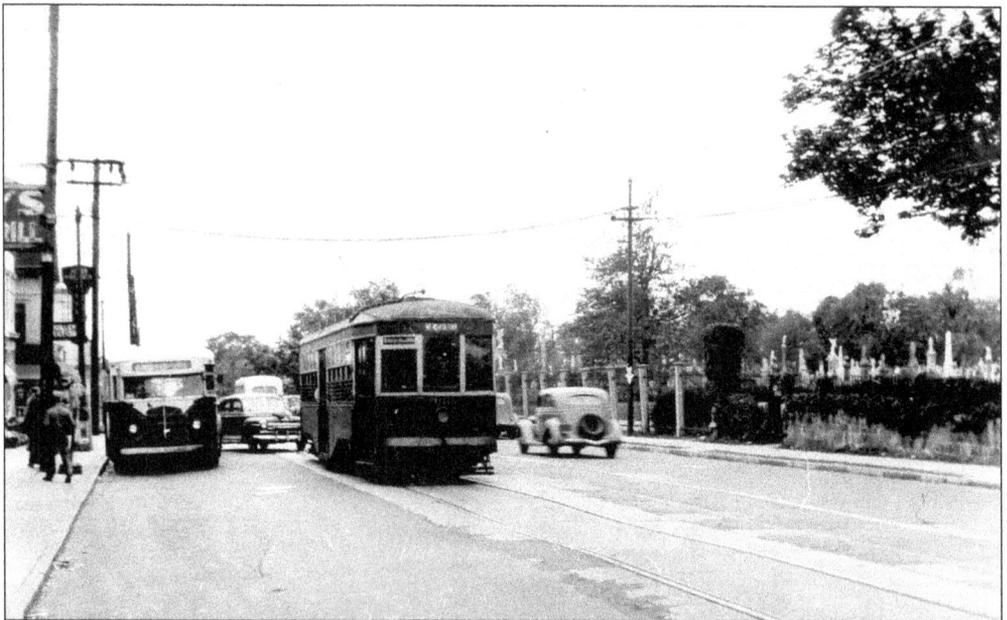

Metropolitan Avenue No. 8004 passes Lutheran Cemetery and the Myrtle Avenue subway-elevated station on June 3, 1948. Both the streetcar and rapid transit lines were built specifically to carry the profitable cemetery traffic. Metropolitan Avenue horsecars reached this point in 1867, and the Bushwick Railroad's steam dummy line arrived in 1881. In the latter year, the Metropolitan Avenue horsecar line was extended to St. John's Cemetery at Dry Harbor Road. (EBW/AJL.)

114

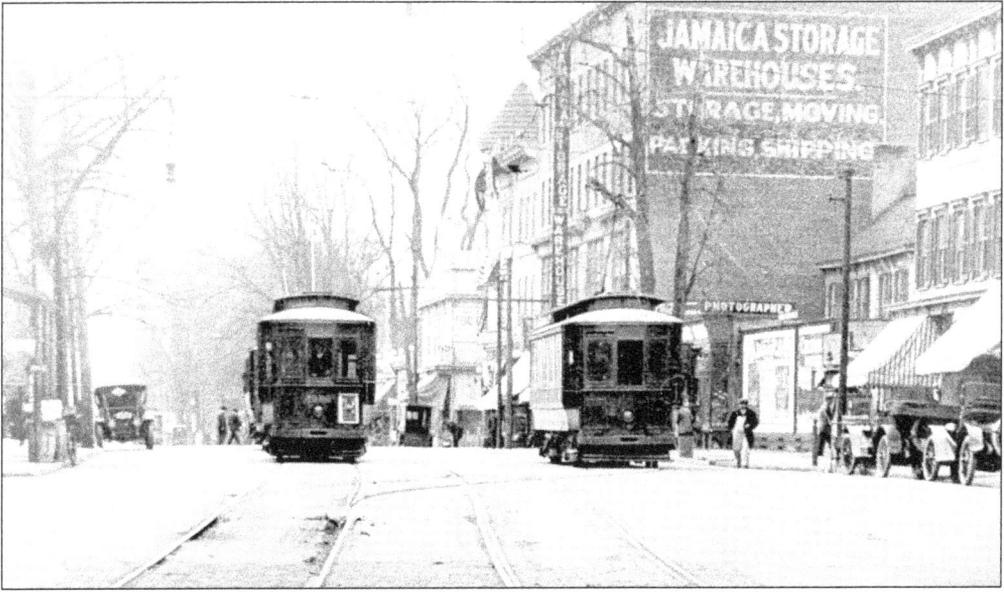

Horsecar service on Jamaica Avenue began on October 21, 1865, from Alabama Avenue to Woodhaven (Seventy-eighth Street) with an extension to Canal (168th) Street on December 8, 1866. Installation of a Van Depoele electric system led to the start of the first trolley line in Kings County on December 17, 1887. A more advanced Sprague system replaced the Van Depoele setup in 1889. No. 2988 is at Canal Street in 1916. Streetcars continued to run on Jamaica Avenue until November 30, 1947. (EBW/AJL.)

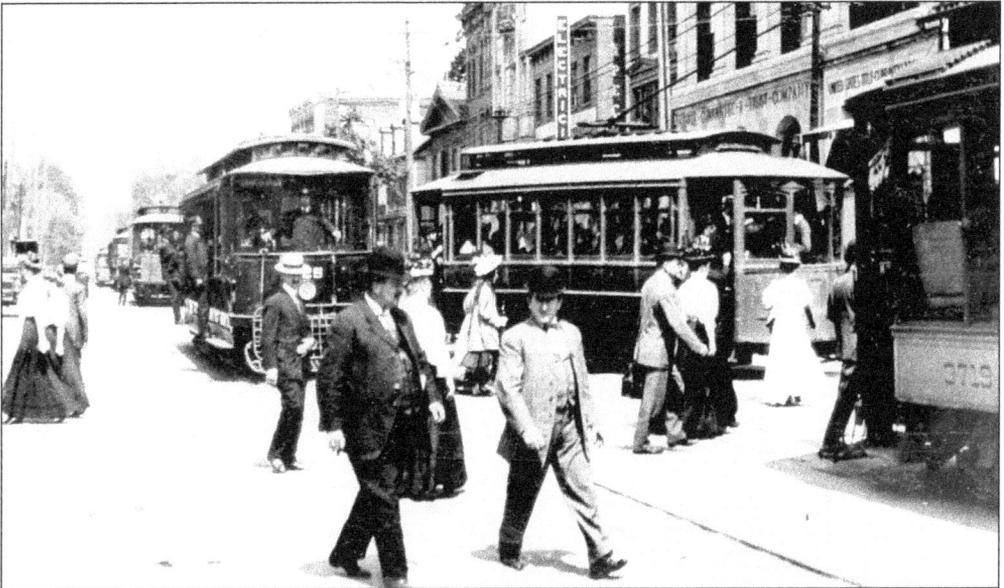

The center of Jamaica was at Fulton and Washington Streets (Jamaica Avenue and 160th Street). Before a borough-wide street plan was created and existing streets were renamed, there were more than 30 streets and avenues in the various villages of Queens County named after George Washington. When this picture was taken in 1909, the BRT connected at this corner with the cars of the New York and Queens County Railway and the Long Island Traction Company. (EBW/AJL.)

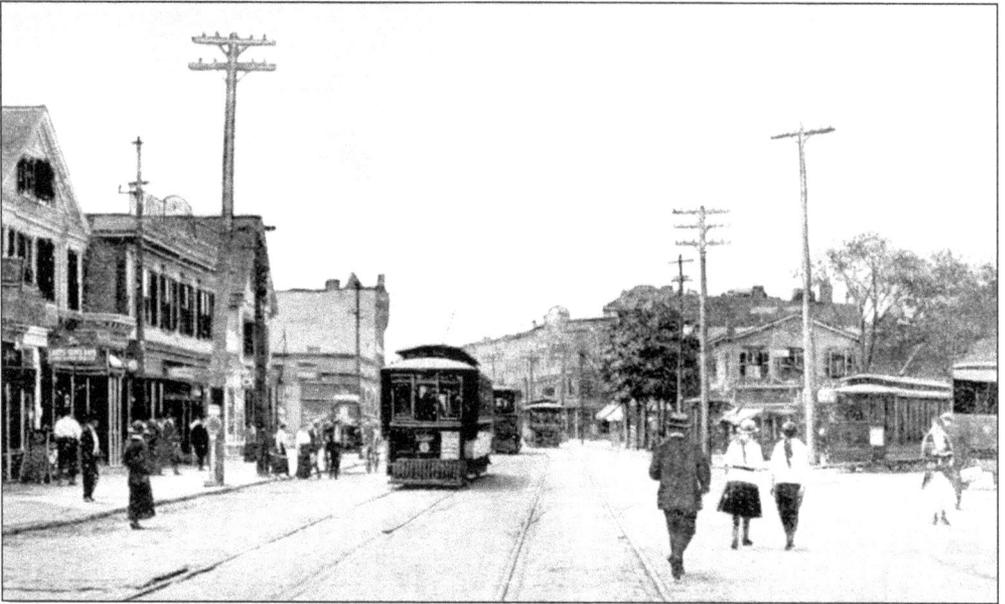

Jamaica and Richmond Hill cars connected at the intersection of Myrtle, Jamaica, and Lefferts Avenues. Richmond Hill cars ran through to Jamaica from Ridgewood between 1895 and 1898. (BERA.)

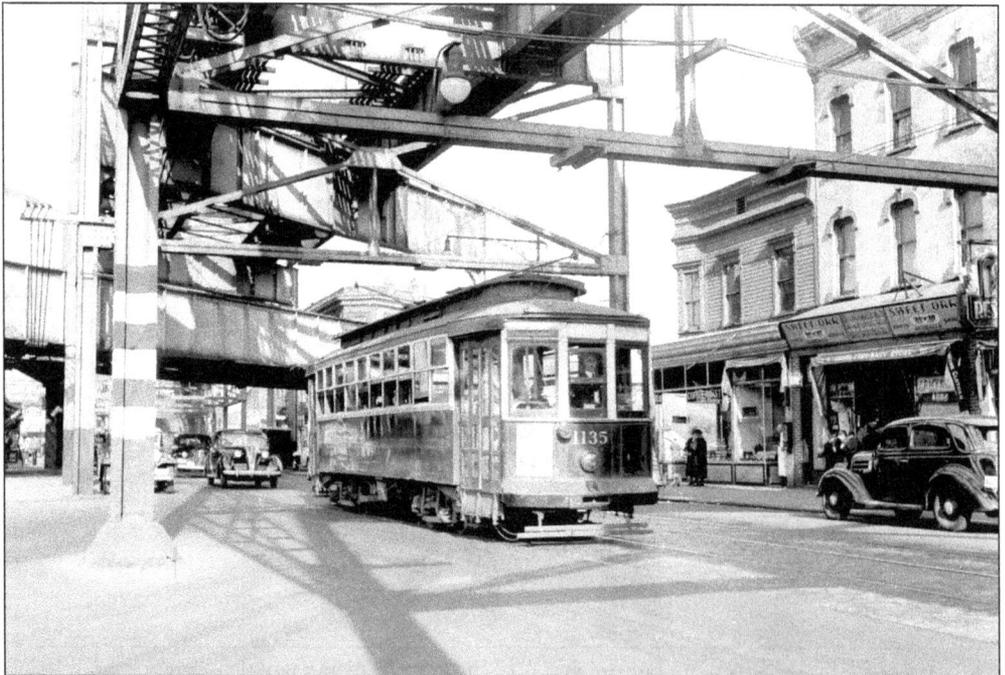

Eastbound No. 1135 is seen on Jamaica Avenue at 121st Street in Richmond Hill on September 29, 1940. The Long Island Rail Road bridge just behind the streetcar was raised two feet in 1903 to provide clearance for the elevated trains that ran on the surface from May 30 to December 8, 1903. That service was replaced by Broadway streetcars running on Jamaica Avenue and, in June 1905, by Jamaica Avenue cars operating between Crescent and 168th Streets. (EBW/AJL.)

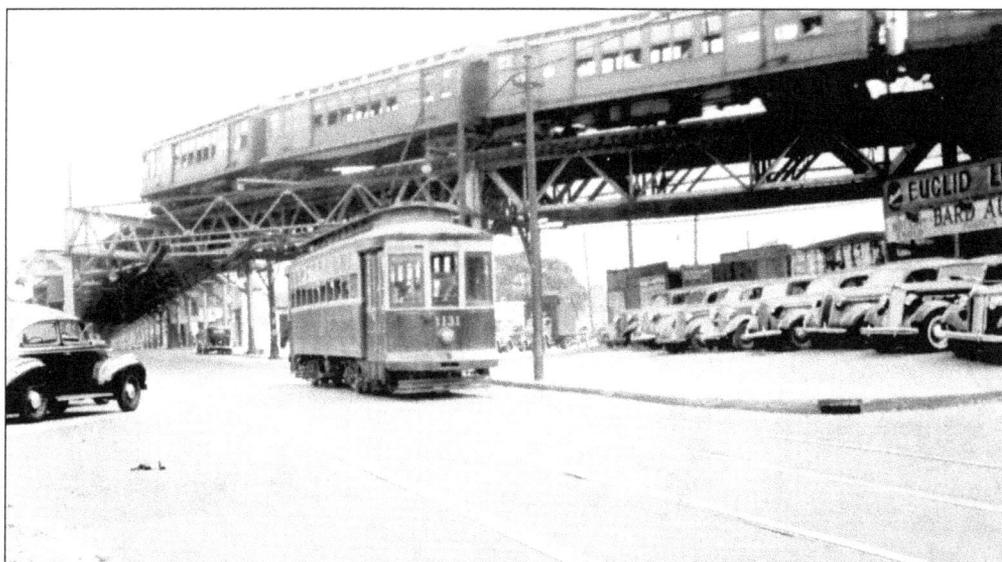

Bergen Street No. 1131 is at the end of the line on Liberty Avenue between Sheridan and Grant Avenues on August 1, 1940. This is the old city line, the Brooklyn-Queens border. The streetcar destination signs read Woodhaven although the cars never entered Queens. Liberty Avenue received its name as the free road to Jamaica as opposed to the toll road on Jamaica Avenue. (EBW/AJL.)

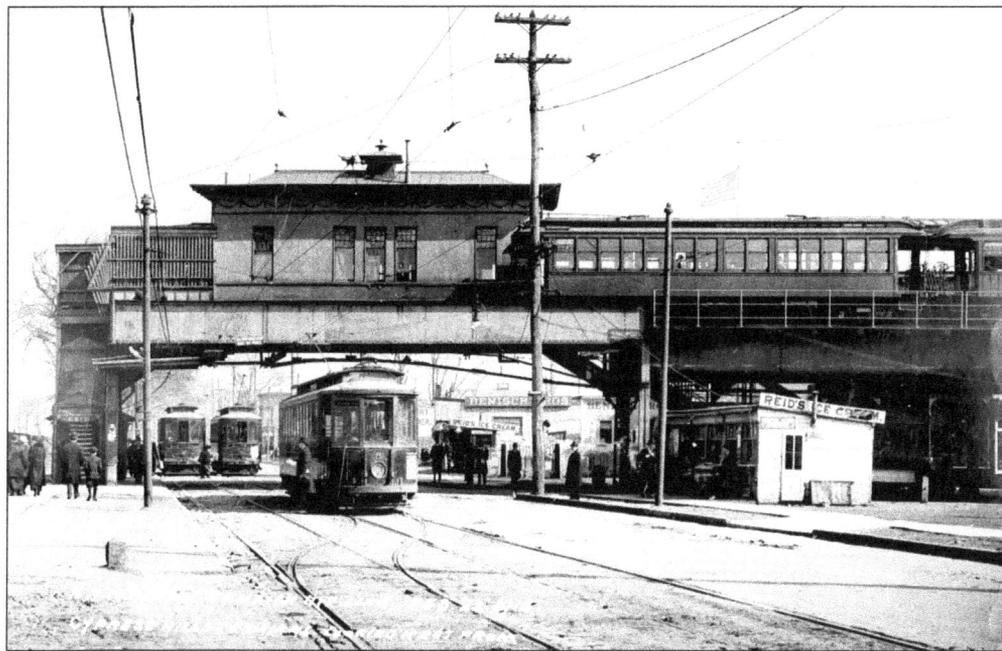

Broadway No. 3957 on Jamaica Avenue at its Crescent Street terminal is ready to head west to Williamsburg on February 22, 1915, while two Jamaica Avenue cars on the other side of the intersection wait for their next eastbound trip. Overhead is the Cypress Hills elevated station with cars No. 1447 and No. 140 at the end of a Broadway train. This was a busy place when crowds came to the many nearby burial grounds, as well as to transfer between surface and rapid transit lines. (EBW/AJL.)

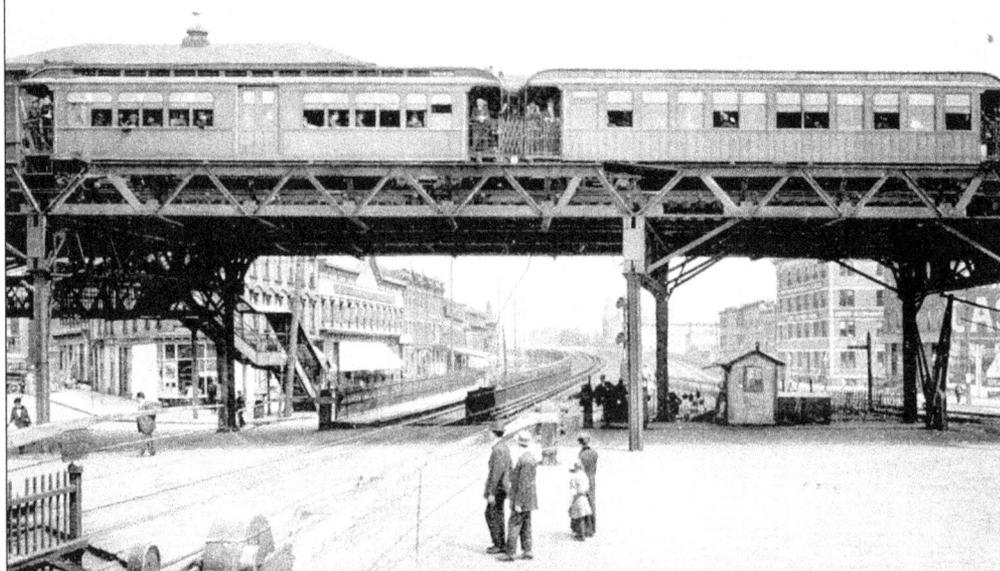

Atlantic Avenue Station. EAST NEW YORK.

A Fulton Street elevated train passes over Atlantic Avenue at Vesta (Van Sindren) Avenue. The Howard Half Way House on the next block served as a transfer point for the Long Island Rail Road, Canarsie Railroad, Brooklyn City Railroad (Fulton Street), and Brooklyn, Queens County and Suburban Railroad (Jamaica Avenue). An incline from the elevated to the Canarsie line just south of Atlantic Avenue was constructed in 1906. (BERA.)

Fulton Street No. 6154 loops via Georgia, Atlantic, and Alabama Avenues on August 24, 1940. The elevated structure was built as part of the Long Island Rail Road grade crossing elimination project of 1907. (EBW/AJL.)

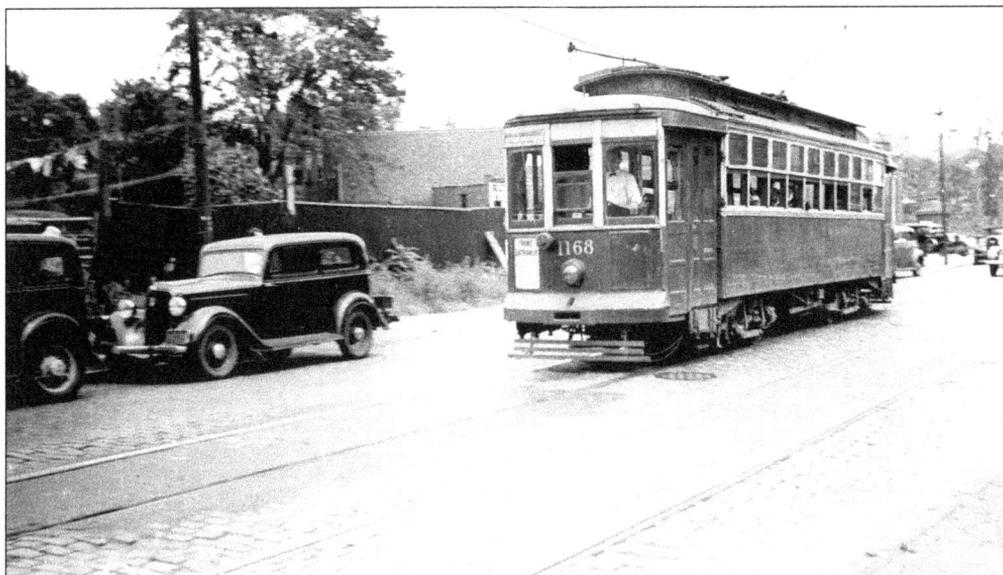

Jamaica Avenue was a part of the King's Highway created in 1704. The Brooklyn, Jamaica, and Flatbush Turnpike was incorporated in 1809 to improve the Colonial road, which remained privately owned until 1897. Trolleys originally ran next to the north sidewalk from Bushwick Avenue to the Queens County line. No. 1168 was photographed on the western portion of the thoroughfare on August 8, 1938. (FP, Charles Duncan photograph.)

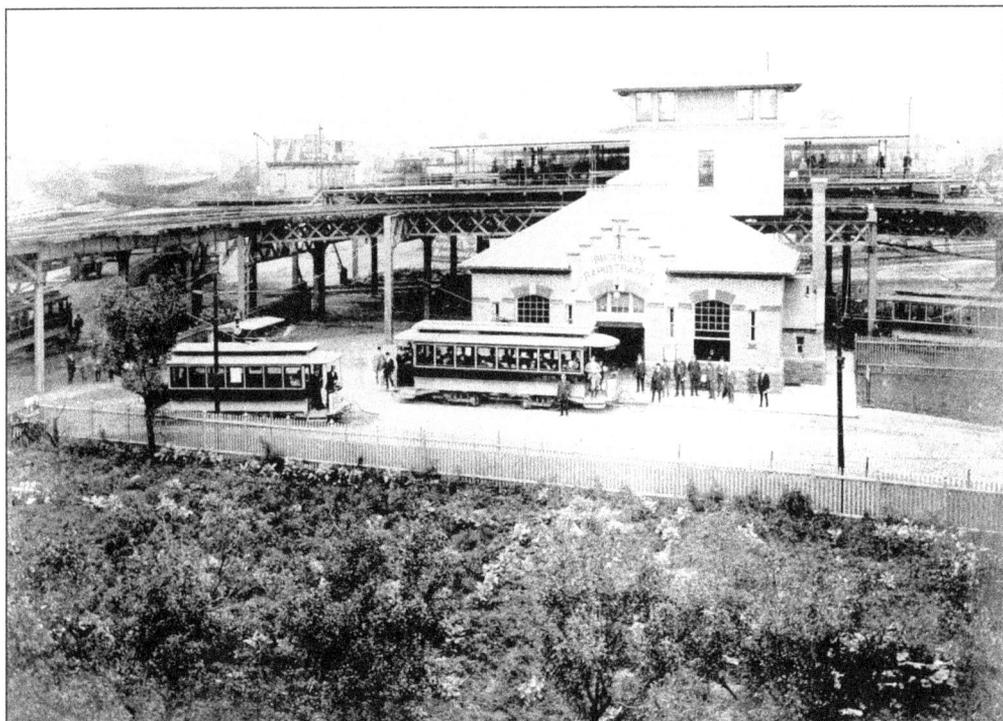

Manhattan Junction was where the Broadway and Fulton Street elevated lines connected. It was also an important transfer point between the rapid transit lines and the surface cars. This view is dated 1902. (EBW/AJL.)

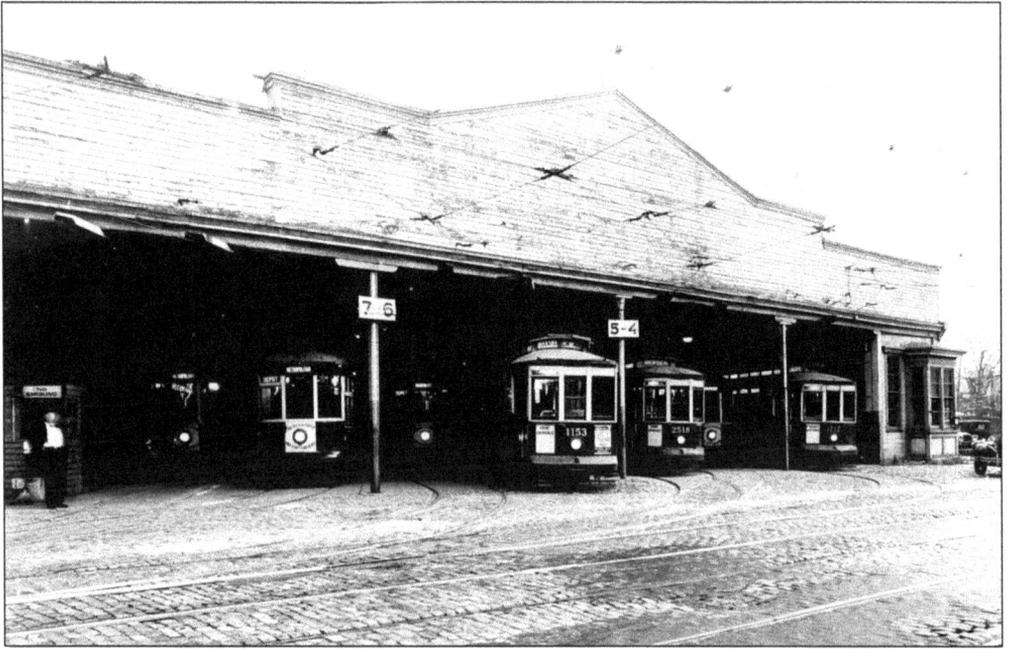

This 1937 view of the East New York depot on Jamaica Avenue shows two Metropolitan Avenue cars, a Sumner–Sackett car, Jamaica Avenue No. 1153, Bergen Street No. 2518, a Tompkins Avenue car, and Broadway No. 1137 ready to go to work. (EBW/AJL, David Gaul photograph.)

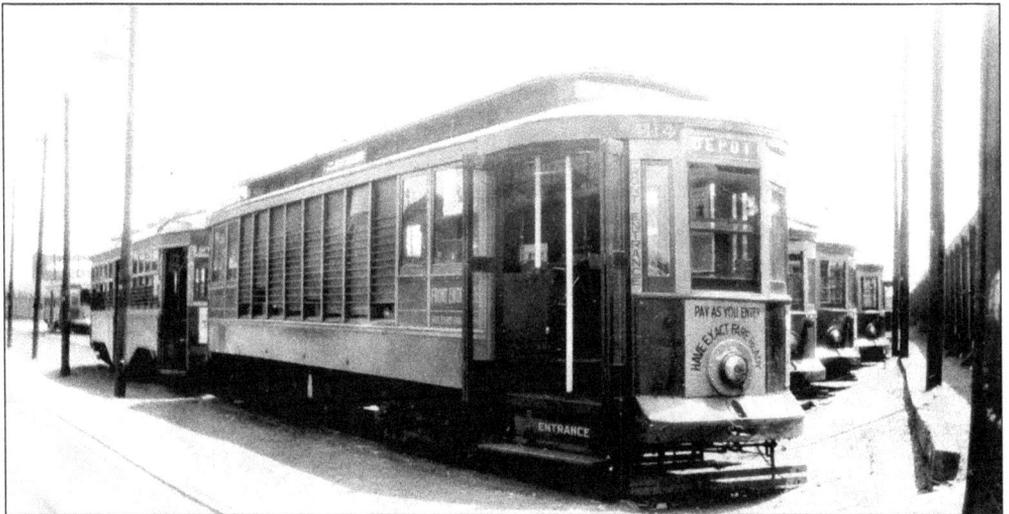

Seen here is a lineup of cars in one of the storage yards with convertible No. 4114 in the foreground. Indoor storage was provided for only a portion of the fleet, and many cars spent the majority of their long lives outside in the rain, snow, wind, and scorching sun. (BERA.)

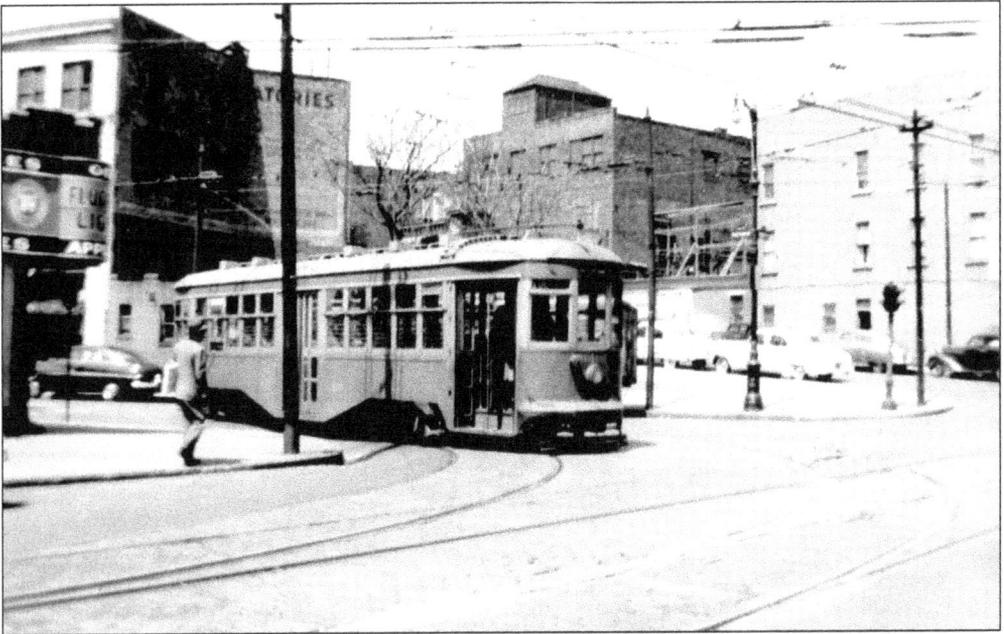

A St. Johns car turns from East New York Avenue onto Rockaway Avenue. In January 1917, the BRT began replacing its traditional registers on which conductors rang up each fare collected. Handheld Rooke registers, which recorded each nickel deposited, were introduced on the 37 Hamburg (Wilson) Avenue cars used on Rockaway Avenue. To familiarize patrons with the change, a four-page booklet in both English and Yiddish was distributed to Brownsville's 400,000 residents, 75 percent of whom used Yiddish as their primary language. (EBW/AJL.)

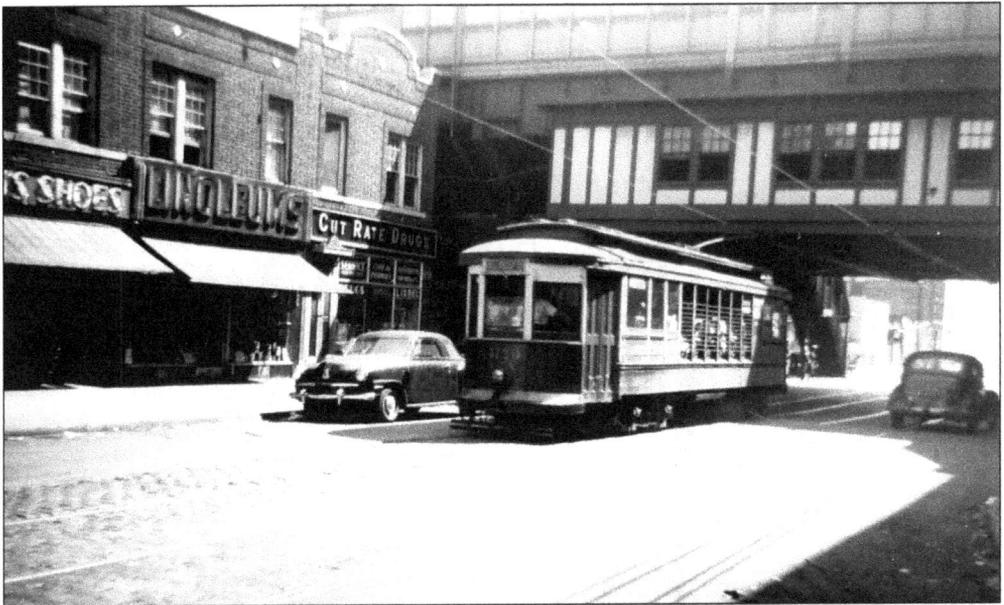

Ralph–Rockaway No. 4120 is on Rockaway Avenue at Livonia Avenue in 1947. Until the IRT subway-elevated on Livonia (formerly Linington) Avenue opened in 1922, the southern portion of Brownsville was undeveloped, and the dominant ethnic group in the neighborhood was listed as "North African Moors." (EBW/AJL.)

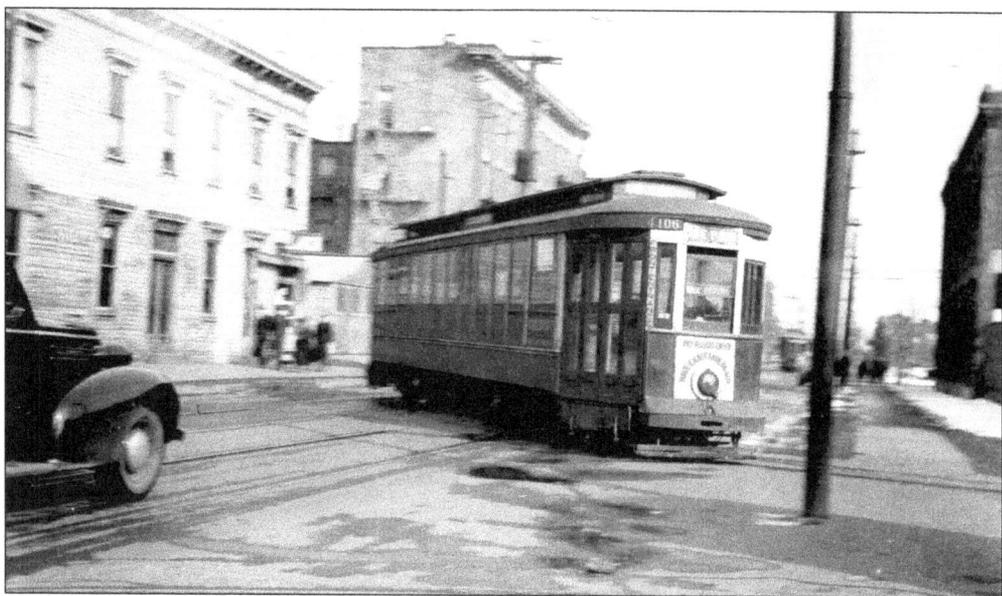

No. 4106 pulls into the Canarsie depot. After 1923, cars on Rockaway Avenue terminating at Hegeman Avenue turned around on a new loop inside the yard in front of the depot. This was necessary in order to use single-ended cars and much better than changing ends in the middle of the street and blocking traffic. (EBW/AJL.)

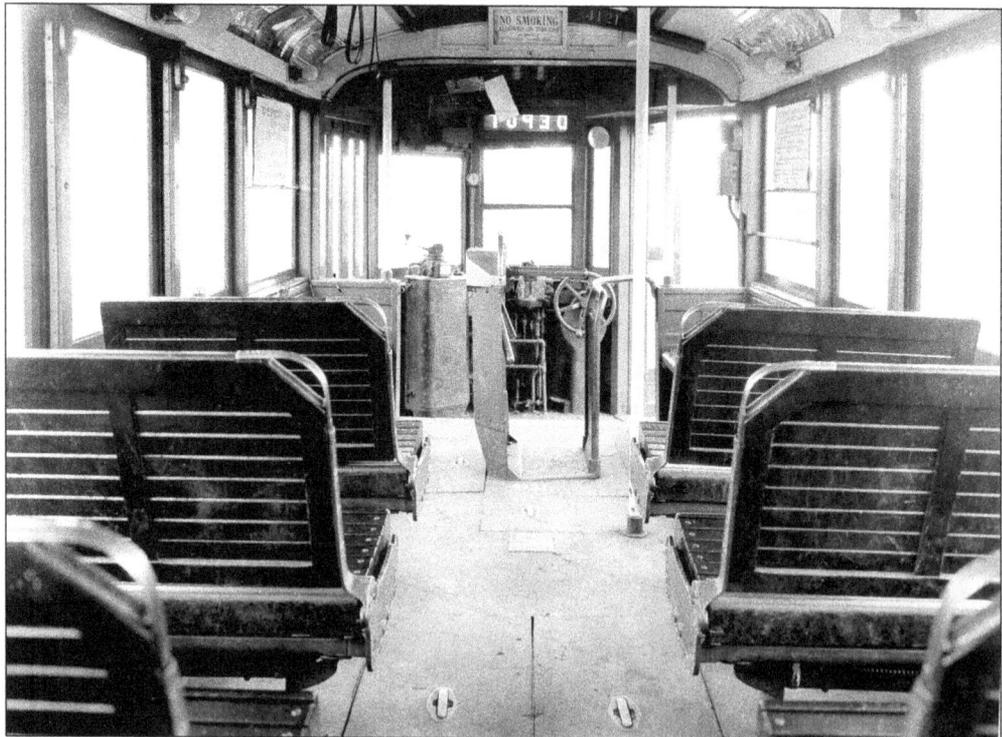

An interior view of convertible No. 4121, one of the cars rebuilt to tow trailers, at the Canarsie depot is shown here in 1936. A fare box was installed in the 1930s as part of the conversion to one-man operation. (EBW/AJL.)

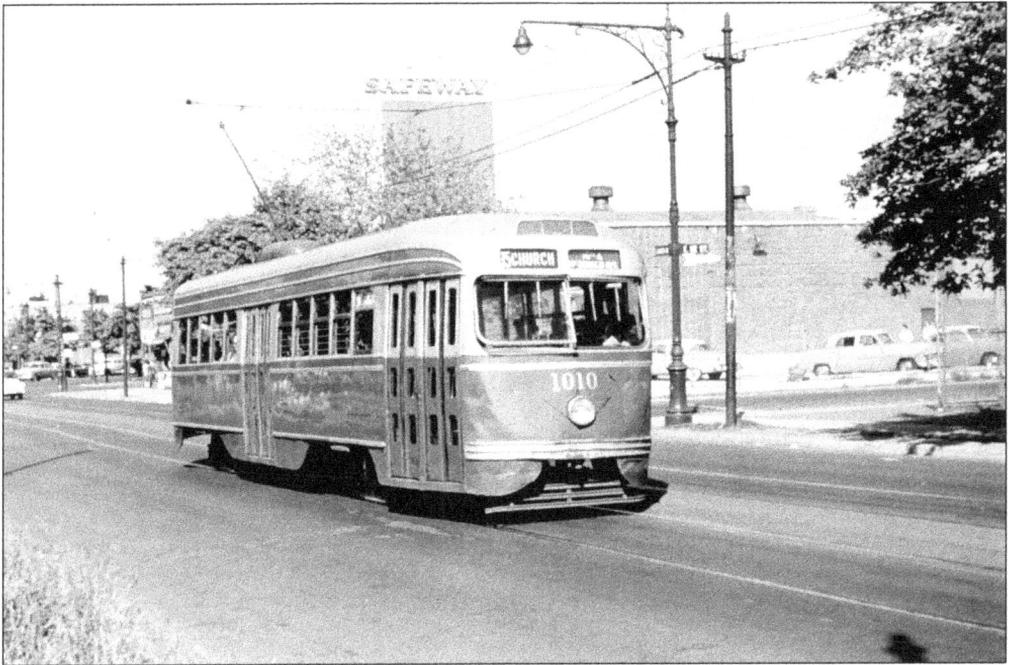

Nearly two decades on the streets of Brooklyn have put a few dents in No. 1010, passing East Ninety-second Street on Church Avenue. At one time, the New York City Transit System contemplated buying 300 additional PCC cars to equip 13 car lines. Instead 900 GM buses and 400 Macks were ordered, and all but three lines were motorized by 1951. In 1956, 318 more Macks arrived, and enough buses were available to replace the last streetcars in Brooklyn. (FP.)

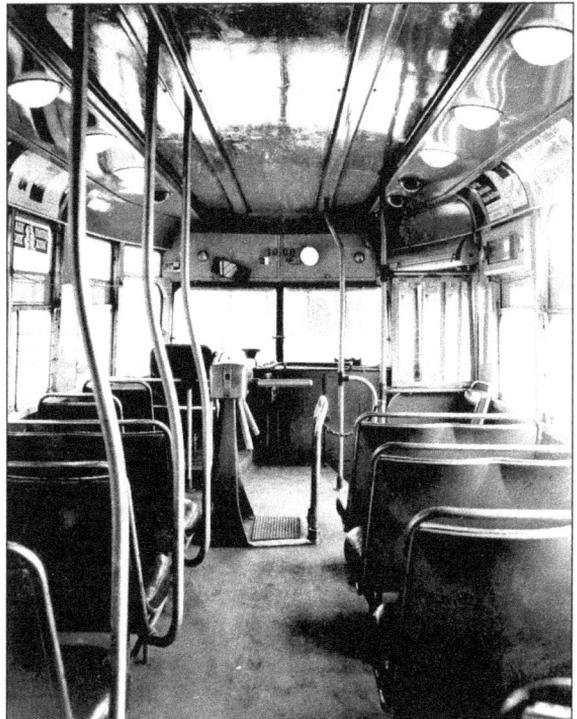

The interior of the 100 PCC cars like No. 1002 were luxurious when compared to the Spartan interior found on most of the earlier streetcars. If the passengers were pleased, imagine how happy the operator was when his wooden stool was replaced with a padded seat with a back. (BERA, Don Harold collection.)

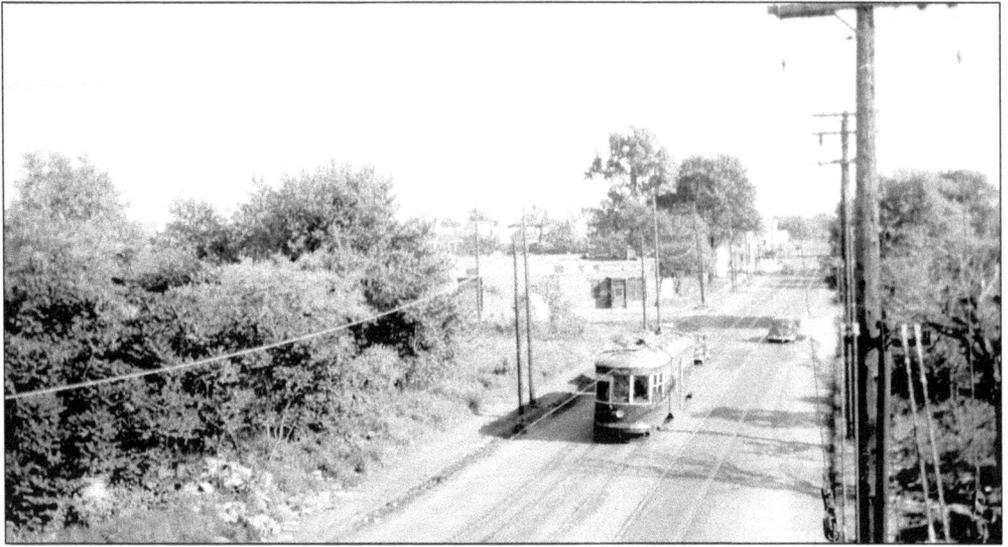

Wilson Avenue shuttle No. 8190 on Rockaway Avenue is seen from the Long Island Rail Road overpass on May 21, 1949. The shuttle ran south of Hegeman Avenue when through service to the shore was not needed. (EBW/AJL.)

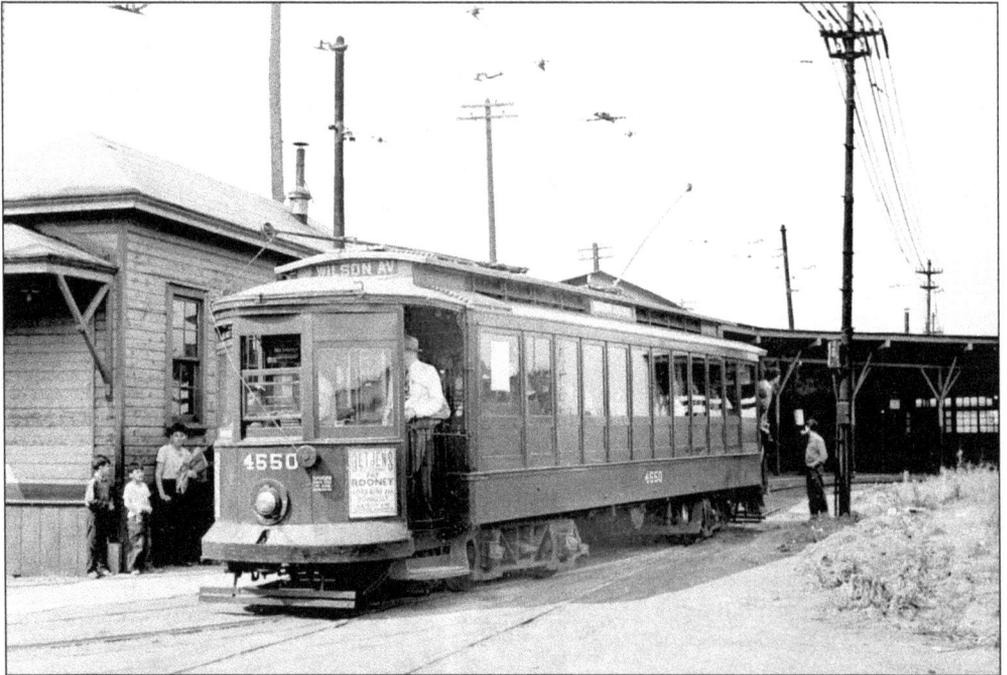

No. 4550 at the Canarsie elevated station was not regularly used on Rockaway Parkway nor had it been used anywhere in passenger service in nearly two decades. It was never converted for one-man operation and became a work car after 1934. Just before the replacement of Rockaway Parkway streetcars by buses in 1951, it passed through on this excursion. (EBW/AJL.)

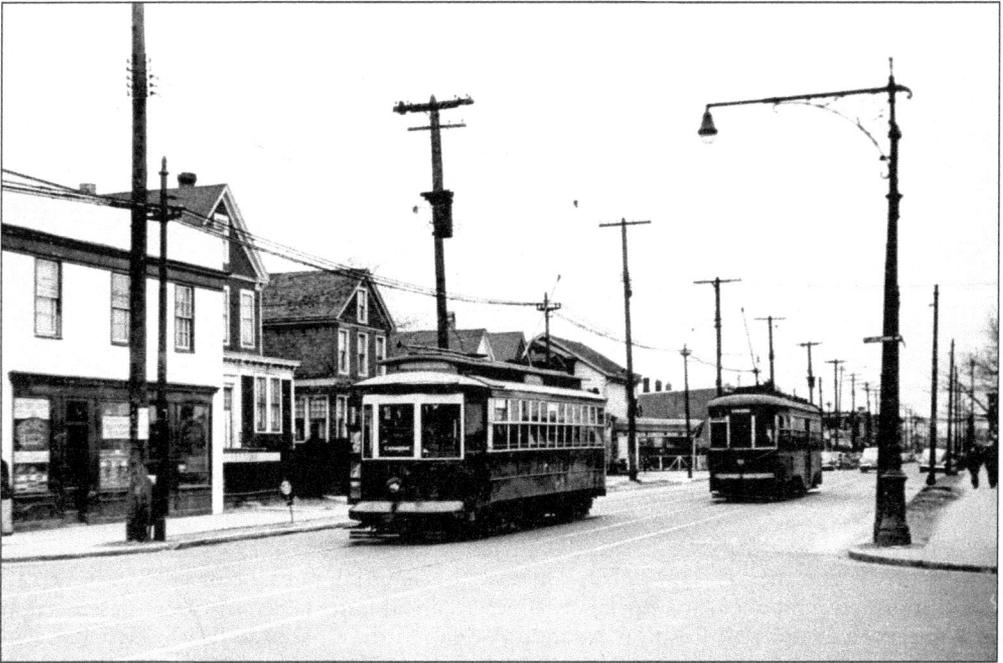

Rockaway Avenue south of Foster Avenue was renamed Rockaway Parkway in 1900. Streetcars served the street from July 28, 1895, until May 27, 1951. No. 4701 runs north from the shore to the Canarsie subway station or the depot at Hegeman Avenue. Wilson Avenue No. 8300 continues beyond Hegeman through Brownsville, Ocean Hill, Bushwick, and Williamsburg. (EBW/AJL.)

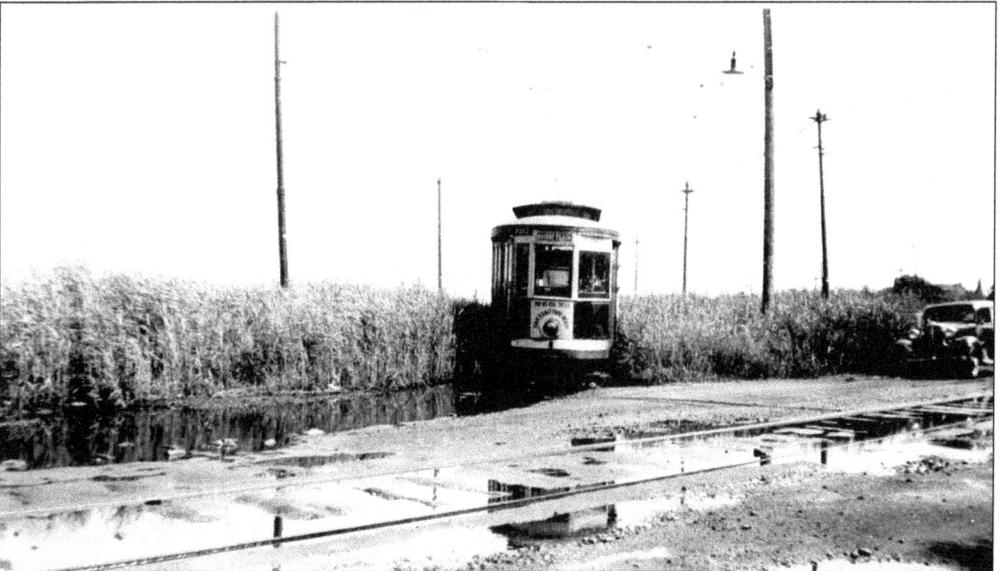

Wilson Avenue No. 4117 runs through the weeds in 1939 on the large loop around the former elevated station and yard at Skidmore Avenue. Both the elevated and streetcar lines served the Golden City Amusement Park, which extended from Seaview Avenue at Canarsie Road to the shore of Jamaica Bay. The park opened in 1907, went up in flames in 1909, and burned again in 1934. It was finally demolished in 1939 for construction of the Belt Parkway. (EBW/AJL.)

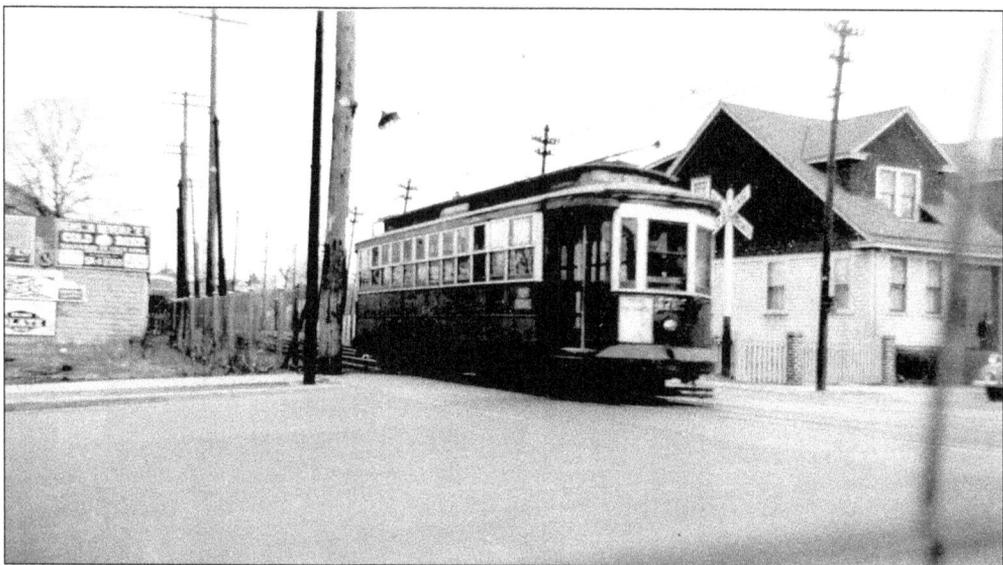

Car No. 4705 is on the right-of-way between East Ninety-fifth and East Ninety-sixth Streets in 1942. In 1866, the Brooklyn and Rockaway Beach Railroad started operating from a connection with the Long Island Rail Road on Atlantic Avenue to the Rockaway Beach ferry. Elevated trains served the electrified line after 1906, with a single-car shuttle providing service in the off-season. Trolleys replaced the elevated cars after October 18, 1920. The right-of-way was abandoned on November 23, 1942, as streetcar service was available just two blocks away on Rockaway Parkway. (EBW/AJL.)

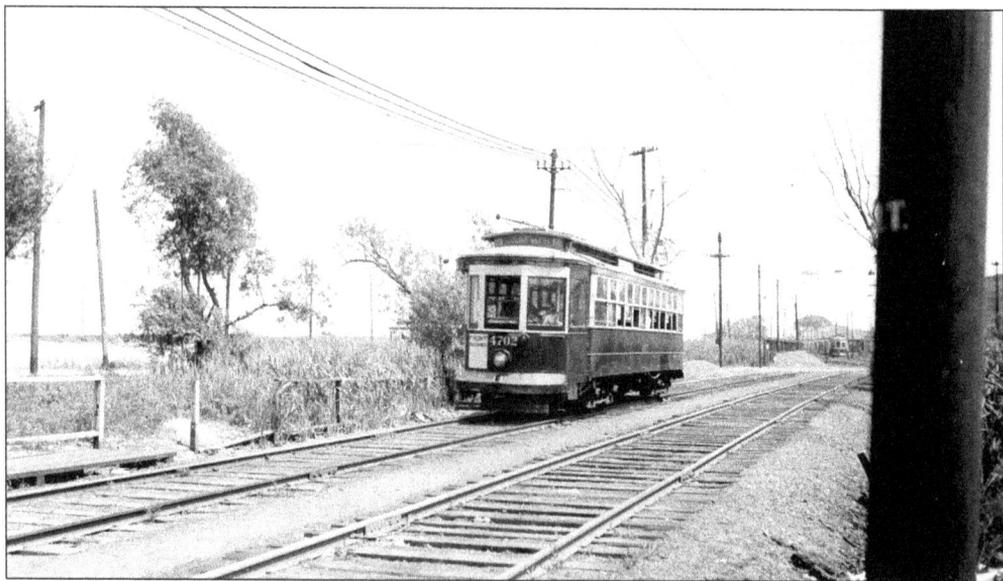

If a railroad to Canarsie seemed to be a good business venture, a horsecar line to Canarsie costing much less to build seemed be an even better investment. The Brooklyn and Canarsie Railroad tried this from September 1866 to September 1867, from the Hoyt Street line's depot at Classon Avenue via Bergen Street, Nostrand Avenue, Clove Road, Clarkson Avenue, Canarsie Lane, and Canarsie Road to the Canarsie Dock. It was not a good investment. Even in this 1935 view of No. 4702, most of the area was still desolate. (EBW/AJL.)

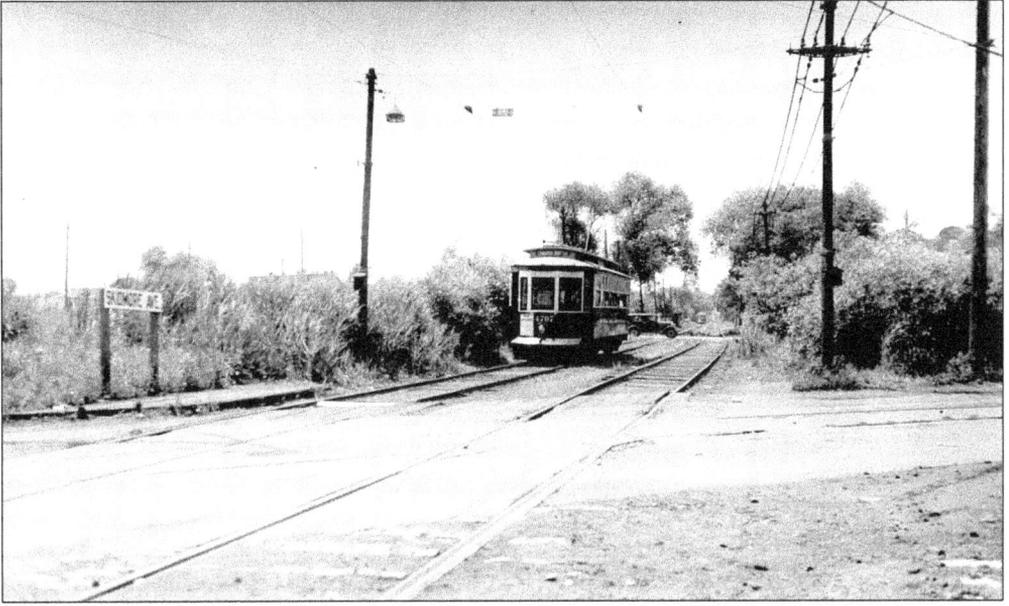

Car No. 4707 approaches the Skidmore Avenue station in 1938. Eight convertibles were rebuilt specifically for the Canarsie line in 1928 with fixed sides, opening windows, and side seats. (EBW/AJL.)

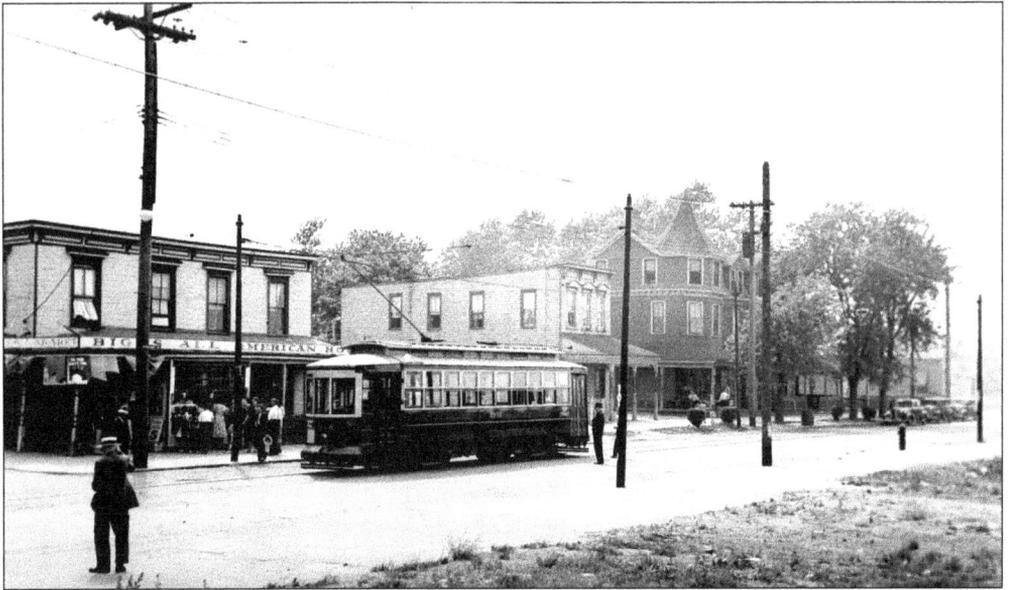

No. 2938 stops at the Canarsie landing in 1939. The Federal Writers Project guide series published that year described the place as "a forlorn beach resort and an amusement park called Golden City, a fishing boat center, a beach backed by a dump, and beery dance halls." An equally low opinion of the clientele patronizing the Canarsie shore was prevalent at the time. (EBW/AJL.)

Visit us at
arcadiapublishing.com